American Popular Song

The Great Innovators, 1900–1950

ALEC WILDER

Edited and with an Introduction by
JAMES T. MAHER

A New Foreword by
GENE LEES

New York Oxford
OXFORD UNIVERSITY PRESS
1990

OXFORD UNIVERSITY PRESS

Oxford New York Toronto
Delhi Bombay Calcutta Madras Karachi
Petaling Jaya Singapore Hong Kong Tokyo
Nairobi Dar es Salaam Cape Town
Melbourne Auckland

and associated companies in
Berlin Ibadan

11 13 15 14 12 10

Printed in the United States of America
on acid-free paper

— 1 —

The Transition Era:
1885 to World War I

Jerome Kern

George Gershwin

— 5 —

Richard Rodgers

— 6 —

Cole Porter

— 7 —
Harold Arlen

Vincent Youmans
Arthur Schwartz

Burton Lane, Hugh Martin, Vernon Duke

— 10 —

The Great Craftsmen

Here's To My Lady by Johnny Mercer and Rube Bloom. © Copyright 1951 by Edwin H. Morris & Company, Inc. Used by permission.

Give Me The Simple Life by Harry Ruby and Rube Bloom. From the 20th Century-Fox Technicolor picture "Wake Up and Dream." Copyright © 1945 by Twentieth Century Music Corporation, New York, N.Y. Rights throughout the world controlled by Triangle Music Corporation, 1619 Broadway, New York, N.Y. 10019. International copyright secured. Made in U.S.A. All rights reserved.

All This And Heaven Too by Eddie De Lange and James Van Heusen. © 1939 Remick Music Corp. Copyright renewed. All rights reserved. Used by permission of Warner Bros. Music.

Like Someone In Love by Johnny Burke and James Van Heusen. © 1944 Burke & Van Heusen Inc. and Dorsey Bros. Music Corp.

It Could Happen To You by Johnny Burke and James Van Heusen. Copyright © 1944 by Famous Music Corporation. Copyright renewed 1971 by Famous Music Corporation.

Here's That Rainy Day by Johnny Burke and James Van Heusen. © 1953 Burke & Van Heusen Inc. and Dorsey Bros. Music Corp.

Indiscreet by Sammy Cahn and James Van Heusen. From the motion picture "Indiscreet." © Copyright 1958 by Edwin H. Morris & Company, Inc. Used by permission.

The Second Time Around by Sammy Cahn and James Van Heusen. Copyright © 1960 Twentieth Century Music Corp. Rights throughout the world controlled by Miller Music Corporation. Used by permission.

Call Me Irresponsible by Sammy Cahn and James Van Heusen. Copyright © 1962 and 1963 by Paramount Music Corporation.

— 11 —

Outstanding Individual Songs:
1920 to 1950

A Young Man's Fancy by John Murray Anderson, Jack Yellen, Milton Ager. Copyright © 1920, renewed 1947 Leo Feist Inc. Used by permission.

Mah Lindy Lou by Lily Strickland. Copyright 1920, 1948 by G. Schirmer, Inc. Used by permission.

I'm Just Wild About Harry by Noble Sissle and Eubie Blake. © 1921 M. Witmark & Sons. Copyright renewed. All rights reserved. Used by permission of Warner Bros. Music.

I'm Nobody's Baby by Benny Davis, Milton Ager, Lester Santly. Copyright © 1921, renewed 1949 Leo Feist Inc. Used by permission.

April Showers by B. G. DeSylva and Louis Silvers. © 1921 Harms, Inc. Copyright renewed. All rights reserved. Used by permission of Warner Bros. Music.

'Way Down Yonder In New Orleans by Henry Creamer and J. Turner Layton. Copyright MCMXXII by Shapiro, Bernstein & Co. Inc., 666 Fifth Ave., N.Y., N.Y. 10019. Renewed MCML and assigned. Used by permission.

My Honey's Lovin' Arms. Words by Herman Ruby. Music by Joseph Meyer. Copyright 1922 by Mills Music, Inc. Copyright © renewed by Mills Music, Inc. Used by permission.

Stumbling by Zez Confrey. Copyright © 1922, renewed 1950 Leo Feist Inc. Used by permission.

I Cried For You by Arthur Freed, Gus Arnheim, Abe Lyman. Copyright © 1923, renewed 1951 Miller Music Corporation. Used by permission.

Peaceful Valley by Willard Robison. © Copyright MCMXXV, MCMLIV, MCMLV by Leeds Music Corporation. Copyright renewed MCMLII and assigned to Leeds Music Corporation. Used by permission. All rights reserved.

Sweet Georgia Brown by Ben Bernie, Maceo Pinkard, and Kenneth Casey. © 1925 Jerome H. Remick & Co. Copyright renewed. All rights reserved. Used by permission of Warner Bros. Music.

If I Could Be With You One Hour To-night by Henry Creamer and Jimmy Johnson. © 1926 Jerome H. Remick & Co. Copyright renewed. All rights reserved. Used by permission of Warner Bros. Music.

I'm Coming Virginia by Will Marion Cook and Donald Heywood. Copyright © 1927, renewed 1955 Robbins Music Corporation. Used by permission.

Sweet Lorraine. Words by Mitchell Parish. Music by Cliff Burwell. Copyright 1928 by Mills Music, Inc. Copyright © renewed 1956 by Mills Music, Inc. Used by permission.

Crazy Rhythm by Irving Caesar, Joseph Meyer, and Roger Wolfe Kahn. © 1928 Harms, Inc. Copyright renewed. All rights reserved. Used by permission of Warner Bros. Music.

My Kinda Love by Jo Trent and Louis Alter. Copyright © 1929, renewed 1957 Robbins Music Corporation. Used by permission.

S'posin' by Andy Razaf and Paul Denniker. © Copyright 1929 by Morley Music Co. Renewed and assigned to Morley Music Co. Used by permission.

Am I Blue? by Grant Clarke and Harry Akst. © 1929 M. Witmark & Sons. Copyright renewed. All rights reserved. Used by permission of Warner Bros. Music.

Can't We Be Friends? by Paul James and Kay Swift. © 1929 Harms, Inc. Copyright renewed. All rights reserved. Used by permission of Warner Bros. Music.

Fine And Dandy by Paul James and Kay Swift. © 1930 Harms, Inc. Copyright renewed. All rights reserved. Used by permission of Warner Bros. Music.

It Must Be True (You Are Mine, All Mine) by Gus Arnheim, Gordon Clifford, and Harry Barris. Copyright 1930 Mills Music, Inc. Copyright © renewed 1958 by Mills Music, Inc. Used by permission.

Sweet And Lovely by Gus Arnheim, Harry Tobias, Jules Lemare. Copyright © 1931 Metro Goldwyn Mayer Inc. Renewed 1959 Robbins Music Corporation. Used by permission.

Just Friends by Sam M. Lewis and John Klenner. Copyright © 1931 Metro Goldwyn Mayer Inc. Renewed 1959 Robbins Music Corporation. Used by permission.

Penthouse Serenade (When We're Alone) by Will Jason and Val Burton. Copyright © 1931 by Famous Music Corporation. Copyright renewed 1958 and assigned to Famous Music Corporation.

You're Blasé by Bruce Sievier and Ord Hamilton. Copyright © 1931 by Chappell & Co., Ltd. Copyright renewed, Chappell & Co., Inc., Publisher.

You Forgot Your Gloves by Edward Eliscu and Ned Lehac. © 1931 Metro Goldwyn Mayer Inc. Copyright renewed 1958 by Edward Eliscu and Ned Lehac. Used by permission.

When Your Lover Has Gone by E. A. Swan. © 1931 Remick Music Corp. Copyright renewed. All rights reserved. Used by permission of Warner Bros. Music.

It Was So Beautiful (And You Were Mine) by Arthur Freed and Harry Barris. Copyright © 1932 by Chappell & Co., Inc. Copyright renewed.

Foreword

Soon after *American Popular Song* was published in 1972, it had become a classic. Its distinctive red cover could be found on the bookshelves of arrangers and composers all across the United States and Canada and no doubt other countries too. These musicians had not only read it, they had studied it.

It is not a book one reads lightly. It requires consideration and digestion and, ideally, a piano on which to play the melodies and harmonies its author so meticulously cites. To be sure, it is possible to derive keen insights from it whether or not one is musically trained. University courses could and should be built around the contents of this book; one was, in fact, set up at the University of Wisconsin.

There had never been anything like it, nor has anything come close to it since. I'm not sure it has even been attempted.

What was so radical about it?

Several things.

For a long time one encountered, and occasionally still does, a peculiar condescension toward indigenous American art, particularly music, among American intellectuals and tastemakers, who reserved their richest admiration for things European. In Canada, where I grew up, we had a similar condescension toward things Canadian, while the best American art aroused our deep respect, as indeed it inspired much admiration in Europe too.

I was never able to understand how Americans could be patronizing toward geniuses like Kern and Gershwin and Berlin. It seemed only too obvious that these, and other American composers, were using popular music, particularly that of the Broadway musical theater, to expand that idiom and even transcend it. I once asked Harold Arlen if he and colleagues such as Gershwin were aware in the early 1930s that what they were creating was art music.

"Yes," he said.

A great many musicians, particularly jazz musicians who turned to the best American popular music for materials on which to impro-

vise, came to feel—indeed to know—that there was nothing second-rate about the best of this music. André Previn, the Berlin-born composer and distinguished symphony conductor who made his first professional mark as a jazz pianist, said to me only recently, "I have always believed that Jerome Kern was a very great man."

Alec Wilder shared Previn's respect for Kern, though he is somewhat more tempered in expressing it.

This respect for Kern—as well as Gershwin, Arlen, Rodgers, Youmans, and others whose work is examined in this book—was common among educated musicians, including many opera and lieder singers, who delighted in singing these songs in private, and in some cases such as those of Eva Gauthier, Eileen Farrell, and Leontyne Price, occasionally in public. Though a number of musicians and singers might have conceived a book like this, no one else had the particular combination of qualities that equipped Alec Wilder to write it.

He was a practicing songwriter, not a stranger looking in on the craft. The best-known of his songs are *It's So Peaceful in the Country*, *I'll Be Around*, and *While We're Young*. But he wrote many, many more, witty and tender and subtle.

Alec didn't write lead sheets, which is what musicians call a melody line with chord symbols specifying the harmony. He wrote fully notated two-stave piano scores. This probably is because he was thoroughly skilled as an instrumental composer, whose catalogue comprises several hundred orchestral, chamber, and vocal works. He was impatient with the imprecise shorthand that lead sheets often are. Alec knew what voicings he wanted. This didn't mean he didn't enjoy and admire what jazz musicians did with his "changes." Quite to the contrary; he delighted in it.

He was also highly literate, a man of wide reading and learning. I rarely saw Alec without three books under his arm. Three. No more, no less. And everyone else remembers him exactly that way.

He was quite tall, something over six feet, erect, almost stately in bearing, and extremely handsome, even as he reached his seventies and the lines grew deep on his face. I will go so far as to say that Alec Wilder was one of the handsomest men I ever met.

His hair was thick and full and straight and combed carelessly back. It always looked a little unkempt, as if he didn't care about it,

and by the time I knew him his mustache had become gray. He was inclined to tweed sports coats and flannel slacks. And he was very witty.

Alec's father was a successful banker who constructed the Wilder Building at a main downtown intersection of Rochester, N.Y. The family consisted of bankers, scholars, and bibliophiles. Alec was raised, as his friend and collaborator in this book, James T. Maher, put it, "in princely circumstances."

Rochester is the seat of the Eastman School of Music, where Alec studied composition and counterpoint with Herbert Inch and Edward Royce. He never matriculated. In New York City he became known as a composer and arranger.

Toward the end of the 1930s, Alec wrote and recorded some—for the time—revolutionary music with a group called the Alec Wilder Octet. This music was startling in the way it used elements of "classical" music and jazz. It wasn't either; and it certainly was not a vehicle for improvising soloists. But with enormous charm it suggested the way earlier composers might have written had they lived in the age of jazz. Then in 1942 he wrote six pieces for larger orchestra—four of them concertante—that Frank Sinatra heard in acetate copies of radio performances. Sinatra was entranced. And he determined to see this music on record, if he had to conduct it himself. Which he did. And his name boosted the sale of those records, three twelve-inch singles in an "album." Again there was the distinctive "classical" writing infused with a feeling of jazz. That album made me aware of the name and instrumental music of Alec Wilder.

And I think Alec at that time had his chance at real fame, big fame. He never wanted it. I accused him once of hiding in the woodwork of the music business. He avoided its corrupting pressures, suspecting, I'm sure, that he didn't have whatever it takes to submerge one's identity in the act of pleasing executives and authorities who do not know what you do. Alec was incapable of handling the politics of show biz. He loved music; he hated the music business. And so he remained a specialized taste among the comparatively few people who knew about him.

When he was in Manhattan he lived at the Algonquin Hotel, that famed gathering place of urbane wits including Franklin P. Adams

and Dorothy Parker. He liked to entertain his friends in the Blue Bar and Rose Room there; no one remembers his ever letting anyone else pick up a check.

After a while he would take up his frequently nomadic life again. Some of the time he lived in a hotel in his native Rochester whose telephone number was one of those I would call when seeking him. Or he would stay at the homes of various friends, writing his music for soloists he admired, such as Zoot Sims, John Barrow, and Harvey Phillips, and leaving a trail of read-and-abandoned books along the way, a sort of literary Johnny Appleseed. So impeccable was his literary taste that I never failed to read a book he recommended or gave me.

The age of glorious songs to which Mr. Wilder pays tribute in this book came about through a confluence of social and economic circumstances, as do all movements in art. A craze for dancing swept the country after World War I, and appropriate music for it soon was being turned out for performance in the speakeasies and dance pavilions of the nation. The "big bands" in turn sprang up to play it, along with, of course, a lot of clap-trap from Tin Pan Alley. There were hundreds of these bands in America at the peak of the big-band craze, both excellent regional orchestras and major "name" bands such as those of Paul Whiteman and Duke Ellington in the 1920s, and, in a second wave that began in 1935 with the success of Benny Goodman, the bands of Count Basie, Tommy Dorsey, Les Brown, Woody Herman, Jimmie Lunceford, Gene Krupa, and many more.

Coeval with the rise of the bands was a sudden lift in the quality of music and lyrics being written for Broadway musical theater by some of the composers who are discussed in this book and lyricists who alas are not. (Alec was very perceptive about lyrics and wrote some good ones himself.)

At the same time the major radio networks, NBC, CBS, and the Mutual Broadcasting Company, were reaching into the remotest corners of North America. And they made available, free, this remarkable musical outpouring of brilliant Broadway show tunes often performed by the bands, again, we must not fail to note, amid a lot of trash.

It was a sort of three-way symbiosis. *Begin the Beguine,* a Cole

Porter tune written for Broadway, might be forgotten had Artie Shaw
not recorded it; but Artie Shaw might be forgotten had he not had
exposure on network radio.

After World War II, the network owners turned their attention to
television, more or less abandoning radio, leaving local stations to
play records of a constantly declining quality. The young men home
from the war, and building their families, chose to stay home and
watch the new medium of TV. Not only did attendance at dances fall;
attendance at movies and baseball games went down apace.

America was changing, and changing quickly. The social circum-
stances that caused and sustained the remarkable post-World War I
outburst of superb melody by excellent composers evaporated—and
quickly, too, when you view the change from a historical perspective.

Alec restrains himself in this book. He says that the age of the pro-
fessional songwriter was ended. He once put it to me more bluntly:
"After 1955, the amateurs took over." And he meant it: the kids with
guitars, who knew three or four chords and were devoid of literate
sensibilities. They in turn affected not only the quality of the work
of the next generation of "composers" but that of the lyricists, who
weren't exposed to the words of Johnny Mercer and Yip Harburg and
Howard Dietz but only to those of the songwriters who supplied Elvis
Presley. The use of language itself deteriorated.

Something struck me in reading anew the Acknowledgments of this
book. When Alec thanked the composers and others he consulted,
they were all alive. He knew all of them. Most of them are gone now.

This lends more than poignancy to the book. It adds authenticity.
You can't go and ask Harold Arlen about his music now. Alec did.
And so this is not just the most brilliant critical analysis I know of
the work of the composers in the era of great Americans songs. It is a
report from the past by a man who lived there and knew just about
all the creators of that wonderful music.

Alec died on Christmas Eve, 1980. I still miss him.

But I have this book. So do we all.

August 1990

 Gene Lees

Acknowledgments

I should like first to thank the Avon Foundation,* St. Paul, Minnesota, for the grant that made this study possible. But for the financial support of the Foundation, and the generous encouragement of its Trustees, I would not have dared to undertake so exhaustive a piece of work. I hope that the finished book conveys, in some measure, my profound gratitude.

I am pleased to acknowledge the able guidance given the project by Mr. Harvey G. Phillips during his tenure as Executive Assistant to the President, New England Conservatory of Music, Boston. As the Administrator of the Avon Foundation grant, Mr. Phillips kept a watchful eye on every detail of disbursements but managed, nonetheless, to stand aside from the ledgers and express his warm enthusiasm during the progress of the study. His was a judicious voice in the many discussions that so complex a project generates. Mr. Gunther Schuller, the President of the Conservatory, generously befriended the project from the time my original proposal was made to the Avon Foundation.

In the early research stages of the project a number of very busy people in the world of music graciously took the time to talk to me at length about their work, and to answer my many questions about their professional experience. They may feel, should they happen to see the book, that the biographical and background information they so considerately provided served little apparent purpose. Quite the contrary, for it was only through these discussions, and the candor of my hosts, that I was able to discover what it was that I was searching for. All of them were enormously helpful in guiding me toward the central logic of the book: the music itself. I wish here to thank them for their kindness, patience, and sympathetic help. The following submitted to extended interviews:

New York City: Mr. Harold Arlen, Mr. Robert Russell Bennett, Mr. Irving Caesar, Miss Dorothy Fields, Mr. Abe Olman, Mr. Richard Rodgers, Mr. Hans Spialek. Brooklyn, N.Y.: Mr. Eubie Blake. Pacific Pallisades, California: Mr. Vernon Duke. Beverly Hills, California: Mr. John Mercer. Tarzana, California: Mr. Shelton Brooks. Santa Monica, California: Mr. Ferde Grofe. (Mr. Grofe was inter-

* Now known as the Jerome Foundation (1990).

viewed on my behalf by Mr. Rogers Brackett.) Malibu Beach, California: Mr. Gordon Jenkins. Remsenburg, Long Island: Mr. P. G. Wodehouse. (Mr. Wodehouse, whose annual new novel is not only a literary event but also a celebration of the vigor of wit in a dour world, very patiently submitted to an interview by letter.)

Mr. Duke's death deprived us of any further work from an uncommonly gifted composer. He loved American music deeply and his affection was reflected in the astonishing scope and depth of his knowledge. Only weeks before his death he took the time to write a careful commentary on the concept, and general scheme, of the present project, suggesting certain correctives in early theater music. Then, quite suddenly, this book lost an expert and sympathetic guide.

Mr. Max Morath has a rare gift for discerning what was truly fresh and original—*hip*, to be precise—about certain key songs at the turn of the century. I am very much in his debt for sharing with me those insights which it had taken him years of research, and public performance, to discover. And I should like here to mention the generosity of Mr. Rudi Blesh in discussing with Mr. James T. Maher certain aspects of ragtime which shed light on the origins of the distinctively native popular song as it emerged in the 1890's.

Other people helped me in a variety of ways in resolving both legal and editorial problems and I should like to thank them all, particularly Mr. Edward N. Cramer, Mr. Russell Sanjek, Mr. Harold Leventhal, and Mr. Joseph Taubman. Mr. Taubman served as my counsel with respect to the execution of the copyright permissions I sought. I am grateful to Mr. Philip B. Wattenberg for assistance in copyright clearance. And I was pleased to have the expert help of Miss Maureen Meloy who prepared the final, revised copyright and permissions data.

I know that it is customary to thank that silent expert who turns one's scrawl into a legible typescript. However, I find that in order truly to express my appreciation for the work of Miss Joellyn Ausanka I must describe her exceptional contribution to this book. She is an editor of children's books who happened, at the time, to be studying the organ music of Bach, an incidental condition which brought a great sense of joy to the project. Bach does that. Further, because of her affection for the songs I was discussing in the text, she played through the sheet music of all of them as it was turned over to her chapter by chapter to extract the copyright data. Needless to say, her keen eye sifted out some errors and ambiguities in the text. The intelligence, care, and critical enthusiasm she brought to the preparation of the typescript resulted in a contribution I certainly could not have anticipated.

From the beginning of the project, Mr. Sheldon Meyer of Oxford University Press persisted in his belief in the value of what I had set out to do. He felt that it should be published. I could not have asked

for more heartening encouragement. Because of his conviction, the book is done. It bears, in its final polishing, the mark of his astute editorial eye, as well as the careful concern of Mrs. Guy-Dorian Cristol, the copy editor of the manuscript (who also played through many of the songs once the sheet music got into *her* hands).

I have saved until the last a personal acknowledgment to a gentleman I much admire, Mr. Howard Richmond. I faced two severe problems in organizing my work on the book: a place to work, and a source for the music I wished to examine. Mr. Richmond solved both problems. He placed at my disposal an audition room with a piano in his music publishing offices. His staff graciously saw to it that there was always a music room available to me. Fortunately, Mr. Richmond had several years earlier asked one of his associates, Mr. Abe Olman, to assemble a sheet music library that would bring together the work of the best-known song writers. The great bulk of the songs I studied came from Mr. Olman's shelves. I was thus saved the tedious chore of searching through public and private collections for older music.

Without Mr. Richmond's concern and generosity a difficult task might have become impossible in very short order.

<div align="right">A.W.</div>

We are especially grateful to Mr. Miles Kreuger, the president of The Institute of the American Musical, Inc., and a meticulous researcher and historian, for undertaking to reread the text and compile a list of the errors that fell to his exacting eye. These errors have been corrected in subsequent printings of the book.

<div align="right">J.T.M., *1974*</div>

Author's Note

Somewhat more than three thousand five hundred measures of copyright music are quoted in the examples I have used to illustrate specific analytical points in this book. No precedent existed to guide those concerned with dealing with the complex permissions problems that arose from my need to quote from so great a volume of copyright material. Thanks to the sympathetic counsel of several of the largest music publishers a practical uniform permissions procedure was developed. All copyright permissions are formally acknowledged elsewhere. However, I should like here to express my personal gratitude to all those publishers who generously granted me permission to quote briefly from the songs they own.

A small number of publishers refused, without explanation, to allow me to quote from songs for which they hold the copyright. Several others would not even respond to our repeated requests. It was, therefore, necessary to delete from the book the analytical musical examples of those songs for which the foregoing publishers hold the copyright. Such deletions are indicated in the text by an asterisk (*). They are, happily, few in number. (A special footnote explaining the absence of any quotations from any music by Irving Berlin will be found at the beginning of Chapter 3.)

I should like to express my regrets to those composers whose songs I wished to quote from, but could not. At least one of them, to my knowledge, pleaded with the publisher of some of his songs to grant me permission to quote from several of them. He too was turned down. As a composer, I find this all very puzzling, indeed. I have, of course, been able to comment upon those songs I am not permitted to quote from. Thus, the reader will be able to get a clear understanding of my admiration for these songs and their composers.

Only one publisher absolutely refused even to consider granting me permission to quote from songs to which he owns the copyright until he could review what I had said about the songs. I found the implicit censorship appalling, and I can only report that all worked out for the worst.

To James T. Maher

for his inestimable contribution to this book,
for his truly phenomenal knowledge and re-
search, his impeccable collation of thousands
of facts, his endless patience, his tolerance of
my eccentric methods of work, his unfailing
good humor, his guidance and encourage-
ment. Also for his superb editing. If ever the
phrase "but for whom this book would never
have been written" were apt, it is so in this
instance.

Contents

Introduction

Intellectual pieties, like their religious counterparts, live long and die hard, acquiring while they endure the votive glow of received truth. This book gladly risks offending that among them which looks upon music of the daily ordinary as being beyond academic redemption. To put the matter briefly, the author takes American popular song and its creators seriously. Furthermore, he feels that the best work of the American song writers in the recent past provided an important, as well as delightful, contribution to our native arts.

However, it should be said at once that even though his intention is serious, the author has tried not to impose solemnity on the lively, and sometimes raffish, art of writing popular songs. He frequently demonstrates a warm, even eloquent, enthusiasm for truly inventive composition, but his personal observations reflect a critical detachment, a sense of measure, that keeps his discussion well in hand. He does not confuse a fine song with the Laurentian library. The guiding spirit of his manuscript as he filled a succession of notebooks reminded me of a wise and urbane gentleman, Pierre Monteux, who once warned a student away from the sin of undue gravity with a gentle remonstrance. While discussing with the young man the responsibility of the conductor to his audiences, Monteux drily observed, "We don't want to bore them, do we."

Which leads me to remark of the author that if popular song lies beyond the academic pale, Alec Wilder does not wish so much to redeem it as to join it—or, to be more precise, to make common cause with it, for he too is an exile, having long ago fled the academy, a move, one imagines, that brought comfort to both parties. He shares with the undersigned an anxious suspicion of pieties of any sort.

It need only be added here that although the author's exile may have been arduous, it has never been boring.

I

This book has evolved from two assumptions.

The first of them is that at some point in time—probably just before the turn of the century—the American popular song took on, and consolidated, certain native characteristics—verbal, melodic, harmonic, and rhythmic—that distinguished it from the popular song of other countries. It became a discrete musical entity. To be sure, it used the aural grammar of Western mensural, diatonic music, and it assumed many forms. In fact, it revelled in its variety. But the sum of its distinctions was unique.

Thus, *You've Been A Good Old Wagon, But You've Done Broke Down*, composed by the outstanding ragtime pianist Benjamin Robertson Harney, and first published in Louisville, Kentucky, in 1895, but known to have been played and sung by Harney at least as early as 1894, could not possibly have been mistaken as having come from, say, a London music hall, a *caf'-conc'* in Paris, a Berlin *musikkaffeehaus*, or the *Theatre an der Wien* in Vienna.

Nor, to amplify the point, could any of the following songs: *Mr. Johnson, Turn Me Loose* (another song by Harney, published in 1896); *Some Of These Days* (by Shelton Brooks, published in 1910, but first performed by Brooks, a vaudeville pianist, in 1909); *Alexander's Ragtime Band* (by Irving Berlin, 1911); *The Memphis Blues* (by William Christopher Handy, 1912); *They Didn't Believe Me* (by Jerome Kern, 1914); and *The Darktown Strutters' Ball* (also by Brooks, 1917).

These songs were American: unlike earlier songs published in this country (with the exception of several composed by Stephen Foster during a brief false spring of American popular song) they were native not only in provenance but in their musical character. Their vigor, novelty, and musical daring removed them light years from European precedent, even though in Kern's song one may sense certain vague resonances of contemporary London theater music.

Mr. Johnson, Turn Me Loose was as different in kind from, say, Paul Lincke's *Glüchwürmchen—The Glow-Worm*—first published in Berlin in 1902, as the German cotillion, which was introduced to the enthusiastic Second Empire nobility at the Tuileries in the late 1860's, was different from the cakewalk.

The precise nature of the musical characteristics—melodic, harmonic, and rhythmic—that distinguished the emergent native popular song of the 1890's, and its familial successors up to the middle of the present century, is the subject of this book. The author has undertaken what amounts to a voyage of exploration and discovery in unmapped areas. His goal has been to describe as accurately as possible what he has found—the *possible* in this instance being the limits of his own professional experience and taste. Although he has summarized some aspects of his findings, such as the characteristics peculiar to the style of a given composer, he has not attempted any grand generalizations. What is *American* about the American popular song changes with the qualities of the innovations each of the leading innovators brings to his work. It would take a book to summarize the succession of native distinctions properly—and it has.

A brief proviso may be in order here to prevent the confounding of simple matters. The author is presently concerned only with popular song. However, he is quite aware of the pervasive and informing presence of formal music in the development of all popular music. Thus, his praise, say, for the fresh use of a distinctive harmonic device in a given song should not be misinterpreted as saying, or implying, that such a device had never been used before in the long and complex evolution of Western music in church, theater, or concert hall—or around the haycock for that matter. What he is praising is the creative ingenuity of the writer in finding a way to make use of the device —perhaps a quite sophisticated one—within the musically narrow confines of a popular song. Nowhere has he confused the comparative significance of, say, the linking of tetrachord to tetrachord in the emergence of the Western octave with the way a clever song writer may "back up" the progression of his harmony in subtly preparing a specific effect. His sense of "just proportion" prevails.

Early in the preliminary research that led to this book, the author decided to devote its contents to the popular song *per se*. He also decided to emphasize the music, and to touch only incidentally, with respect to analysis, on the words of the songs. The two elements, as the text makes clear, cannot be separated. One may talk about *words*, or one may talk about *music*, but one cannot talk about *song* and mean anything less than the combination of the two.

Song lyrics, the author feels, are not poems and are not meant to

be, and to discuss them as poetry is to invent a pretense that is an embarrassing burden to the truly professional lyricist. He also believes that the lyrics of American popular song merit a study equal in scope to this one in order to discover what is unique in their structure, prosody, imagery, rhetoric, diction, rhymes, rhythms, metrics, affective innovations, relation to common speech, their synergistic quality when heard combined with the music of which they are an integral part, and other related characteristics and qualities. Unless one has tried to write song lyrics, it may be difficult to understand the peculiar disciplines of this, paradoxically, unsung art. The lyricist is frequently present in the author's comments, but the analytical emphasis in this book is on the work of the composers.

The history of popular song has been largely history-by-anecdote. Tales—true, false, altered, benign, malicious, witty, and dull—cling to popular songs like precious gems to a medieval reliquary. These almost byzantine encrustations create a problem in any attempt to discuss such music seriously—the problem of how to eliminate what might be called the extraneous biases that affect our way of thinking about and assessing our songs.

These biases tend to fall into two categories: journalistic and "theatrical." The first is made up in large part of anecdotes, memorabilia, impressionistic accounts of pop music, ghost-written show biz memoirs, Tin Pan Alley gossip with its tedious reverence for the "hit" song, and the ungovernable vapors of nostalgia. The second bias rises from the marvelous persuasion of gifted singers, ingenious orchestrations by equally gifted arrangers, recordings that one plays again and again, broadcasts, telecasts, and so on—any basically "theatrical" situation in which a song is made to sound better than it really is (an aural trap into which we are all quite willingly seduced).

The only way for the author to escape these biases was to go directly to the songs themselves—*to the sheet music.* Only in playing and studying the sheet music could he hope to discover the innovations he was searching for. Even then he had to allow for—"correct for," as it were—hidden distortions that mar the record. Every publisher of popular music depends upon professional editors to supply the piano accompaniment (harmonization) for any song written by someone who cannot write his own piano part, or to "simplify" the harmonizations supplied by skilled composers who overreach the abil-

ities of the consumer who buys the sheet music and takes it home to play. Many talented melodists have depended upon the editors to complete their work and get a song ready for publication. Contrariwise, gifted composers whose innovations grew out of their sophisticated sense of harmony have often fought with editors who were determined to eliminate the subtleties of their work in the cause of "simplification."

As long ago as 1895, Ben Harney was edited. The original sheet music of *You've Been A Good Old Wagon, But You've Done Broke Down*, a copy of which was studied by Rudi Blesh and Harriet Janis when they were researching their pioneer study *They All Played Ragtime*, bore the legend "Arr. by Johnny Biller." One may be quite sure that Biller's arrangement eliminated much of the complex improvisational spirit of Harney's performance of the piece.

It is not possible to document significantly the additions, subtractions, enhancements, and depredations of the editors during the more than half century covered by this book. Many, obviously, did their work well. Their ghostly presence may even hover over familiar melodies. However, it was assumed that in the case of the greater number of the composers whose music is analyzed in this book, the composer himself harmonized his own songs and wrote his own piano parts.

In summary: the published sheet music is the basic document from which the author worked.

II

The second assumption from which this book has evolved is that the unique qualities synthesized in the American popular song derive continuously from the innovations of a few outstanding song composers. It is from this assumption that the book takes its structure.

It is the unconscious role of the innovator to conserve in his creative reflexes both past and contemporary innovation while moving his own work in new directions. He assimilates what is fresh and stimulating, and he then explores his own intuitive sense of the further possibilities implicit in even the most daring forms and devices wrought by others. On the other hand, the hack song writer assimilates nothing; he stays on the surface of change, deliberately imitating innovation. His contribution is the cliché.

Perhaps the point should be made here that the author is primarily concerned with what he believes to be the most distinctive—the most creative and original—of American popular songs, those which embody innovation in some degree. And, of course, with the composers who have written such songs. He is *not* concerned with "hits" as such. Perfectly miserable pieces of hack work have caught the fancy of the same public that made some of the distinguished innovators very rich men. We all love banal tunes: how oft nostalgia doth inform against us (particularly, those of us who fondly remember *I Have To Pass Your House To Get To My House, And That's What Makes Me Blue,* c. 1934). Sigmund Spaeth once observed of the writer of *After The Ball*: "The career of Charles K. Harris remains a convincing proof of the fact that one can become an enormously popular song writer without ever writing a really good song." We're really very amiable about bad music. But Alec Wilder is a man with an almost calvinistic horror of nostalgia. If a bad song from his banjo-playing days happened to surface in his memory during our work sessions in the music room loaned to us by a kindly publisher, he exorcised it instantly.

Thus, innovation is the central concern of this book. The author pays tribute to Stephen Foster, and explores a mystery that his career raises. But the exact origin of the native song which this survey analyzes, and honors, cannot yet be discerned. Although specific information is lacking, one may safely infer that Ben Harney and other young song-writing ragtime pianists of the mid-1890's assimilated the work, now lost to us, of their contemporaries, and of musicians barely older than themselves. As Mr. Blesh and Mrs. Janis found out in dozens of interviews with elderly musicians, most of them now dead, the pioneer Negro ragtimers were a highly mobile group—a kind of floating subculture, competing vigorously with one another, and carrying the new music from city to city.

Harney and his contemporaries were not improvising in a vacuum. During a charming and instructive afternoon visit with Eubie Blake we were assured that the air was filled with musical innovation at that time. James Hubert Blake began his own professional career as a pianist and song writer in 1898, the year of the Spanish-American War, and he still approaches the piano with the verve of a man with fresh marvels to share.

It was during the late 1880's and early 1890's—the years just be-

fore Harney began to publish—that the Americanization of our popular song gathered the momentum that was to carry the process forward to World War I, by which time a native matrix, generous in its confines, had been established. We know the hits and the hit-makers of the day: *The Pardon Came Too Late*, by Paul Dresser, and *The Picture That's Turned To The Wall*, by Charles Graham, to cite two great successes of 1891. However, the anonymous pioneers, probably Negro musicians for the most part, who gave impetus to the Americanization process remain silvery shadows on daguerreotypes that have yielded their images to time. They are of a period of popular music, and popular dance, that deserves the sort of contemplative study that would go beyond research to imaginative reconstruction based upon archeological analogy.

Innovation did not, of course, end with the pioneers of change. It inheres in any creative process that has not become moribund. It follows its own circuitous logic, and it has been particularly unpredictable in popular music. Its node points, historically, have been individual careers—it has followed the metabolic rise and fall of the creative output of individual song writers. One may discern broad continuities of change in the evolution of the American popular song, but it would badly confuse matters to try to force the straight-line coherence of chronology on so diverse a development.

Innovation in popular song has been a web of chance linkings and random digressions. It has seemed to the author that the most illuminating procedure to use in surveying the musical distinctions of the American popular song would be to follow the strands of the separate careers of those composers who have contributed most to these distinctions.

III

For reasons that remain without convincing explanations, and thus tempt one to speculate on them, the theater has been far more receptive to innovation in popular song than the marketplace-oriented music publishing companies known collectively as Tin Pan Alley. Before speculating as to the reasons, I should advise the reader that the author in his evaluation and analysis of theater songs is concerned with them only *as popular songs*, that is, after they have left the thea-

ter and achieved an independent life in the pop music world. He is *not* concerned with how well they worked, or failed to work, in the dramatic situation for which they were written. That is quite another question, and one, oddly enough, that theater critics (the logical people to do so) almost never address.

One's speculations might well begin with the nature of theater. It would be presumptuous to try in a few sentences to discuss the ludic ritual-liturgical nature of theater historically, but it is useful to remember that it had its origins inside the magic circle of the shaman. And further, one should recall that theater has always *dared*. It has troubled princes and prelates alike. With circumspect cunning it invoked the protection of Louis XIV while it vexed his nobles by satirizing their *scandales*. The king was amused—for a while. Theater has served as, parodied, and undermined religion. Possibly no other art has so consistently taken such extravagant chances in provoking authority.

Even Broadway, one feral eye on Arlecchino's scut, and its survival tied to the restive whim of the democratic patron, has made profitable use of the ancient exemptions that accrue to theater. Certainly, it has permitted song writers a latitude they could not find elsewhere (a latitude that once terrified network radio's diligent censors). The author during his study of some seventeen thousand pieces of sheet music discovered convincing evidence to support his conviction that there are three levels of sophistication in the music of American popular songs: theater songs, film songs, and Tin Pan Alley songs, reading downward in that order.

It follows, then, that most of the great innovators of American popular song have worked in the theater—have, in fact, made their carees in musical theater. Some of them have also written for musical films. But only rarely, and then almost inadvertently, have they composed songs independent of theater or film productions. Musical theater, one shouldn't need to be reminded, comes in many packages, some of them shabby and meretricious. Yet, the most superficially charming *Follies*, blowzy *Scandals*, banal *Vanities*, or other similarly empty-headed serial entertainments, all good fun, have at times introduced well-written songs. The elbow room is there.

When asked why, in their opinion, theater songs are generally more sophisticated than those of Tin Pan Alley, theater composers

and lyricists tend to take refuge in somewhat over-simplified answers. They rather proudly point out that in writing theater songs they are dealing with complex matters: plot, situation, characterization, and so on. But these observations tend to beg the question. They may tell us something about the logic of theater songs—about the rationale of their verbal content, say, or about the rationale of the affective qualities of their music—but they provide no insight into the reasons for their distinctions, musical and verbal.

One listens politely to the observations and restrains the wish to ask what part plot or characterization truly played in the successes of Florenz Ziegfeld, George White, or Earl Carroll, or, for that matter, what part they played in the great body of traditional musical comedy. At any rate, there the question rests unless an occasional composer refers vaguely to the musical sophistication of the theater audience, an uncertain matter at best. It seems to me that the Broadway audience is, in fact, largely wanting in musical subtlety. For example, its mindless enthusiasm for the formulaic music of almost any production number is a poor warrant for sophistication. I'd like to return to this point in a moment, but from another perspective.

First, I should like to mention two dissimilar footnotes to musical theater history that throw some light on the question. For perhaps the last forty years, I am told, Richard Rodgers' friends and acquaintances, many of them among the most zealous and sophisticated of musical comedy first-nighters, have told him that his newest score, the one they have just heard, "isn't bad, really, and has some nice things in it, but it's, uh, not quite up to _____," each naming some previous Rodgers show, the music of which has by then been broadcast hundreds of times, and recorded by dozens of singers and orchestras. In time, of course, the score that isn't "quite up to" its predecessors yields one or several "hits" and, in consequence, assumes its place among the touchstones against which his even newer music will be measured. (The function of repetition in the success of any music, formal or informal, lies well outside the scope of these comments. Anyone interested in the crucial role familiarity plays in affecting the way we listen to music should turn to Nicolas Slonimsky's brilliant and witty essay, "Non-acceptance of the Unfamiliar," which serves as the "prelude" to his *Lexicon of Musical Invective.*)

I regret having to cite for my second footnote a too-often quoted

fragment of Broadway lore, but it has a rather alarming pertinence. I refer to the newspaper review in which the critic complained of a new score, "There's no tune you can whistle when you leave the theater," The show was "Roberta," and Jerome Kern's score included *Yesterdays, Smoke Gets In Your Eyes, Let's Begin,* and *The Touch Of Your Hand.* Musical sophistication? The evidence is not very reassuring.

Plot, situation, and characterization as the raw materials of theater songs have little, if any, substantive difference from the very similar materials the pop song writer deals with in his music (and texts). It is, one might suggest, a bit specious to presume that the range, variety, and quality of reactions to love in a musical comedy libretto are of a different order of experience—higher? more complex? more adult?—from the range, variety, and quality of the reactions generated by love in the hurly-burly of the world beyond the theater marquee, the world of the pop song writer.

Theater lyricists have the practical advantage of a ready-made program of song ideas, thin and routine as these may be, and often are. They do not have to pull their song ideas out of the air. If, as in the cases of Oscar Hammerstein II, Dorothy Fields, and Alan Jay Lerner, all fine lyricists, they also happen to have written their own librettos, they are far ahead of the pop song writer, having, of course, arrived there as the result of their of their own considerable toil. However, after having read several thousand sets of theater song lyrics while listening to Alec Wilder play through, and discuss, their music, I am moved to remark, unhappily, that many of them might have been written, not in the theater, but in the limbo of the pop song writer, a creative way-station where the average lyricist avoids risk by using formulas that have long survived at the sheet music counters. Most theater song lyrics are sadly routine, lacking entirely in invention, a condition that suggests that most musical comedy librettos of the first half of this century were similarly routine, or worse. In studying one theater lyric after another, one becomes aware that the exceptional theater lyricist is exceptional indeed. But, these are matters that need to be treated at length with supporting analytical detail, and not left solely to personal observations of so general a nature.

In the end, theater composers and pop song writers share a common

problem: the creation of the song itself. The theater song writer must write for a given musical comedy a number of songs known collectively, if ambiguously, as a "score" (which must then be *scored*, hopefully without ambiguity, by an orchestrator who, in his instrumental settings, imparts to the orchestral "score" its peculiarly *theatrical* aura, a procedure that was once executed by the composer himself). However, the preparation of these songs may be spread out over many months, several years perhaps, so the implicit quantitative difference between pop and theater song writing is not entirely real. Isham Jones, who never wrote a theater song, remembered late in his long career that he had once sat through the night in his apartment on the Near North Side in Chicago playing a new piano, the birthday gift of his wife. The splendid sound inspired him and he immediately composed a new song, then another, and another. By morning he had completed the music for three of his most famous songs: *Spain, It Had To Be You,* and *The One I Love Belongs To Somebody Else.* All were copyrighted in 1924, and all had words by Gus Kahn.

It seems to me that what distinguishes the work of the theater song writer from that of the pop song writer is his mode of solving the problem they share in common, and the conditions under which he solves it. Substitute *ambience, tradition,* and *discipline* for *plot, situation,* and *characterization* in the formula the theater writers use to define the difference between theater and pop songs, and the matter begins to clarify itself.

The theater is not exempt from banality or from scores that are barren of distinction, but it does have a musical tradition that goes back in the mists of time to the sacred grove. However, one need not invoke such ancient precedent to find in the tradition something pertinent to our question. One very absorbing aspect of it is revealed in the history of the art of orchestration, which is, in part, the story of the continuous search for greater eloquence in the theater, the eloquence that lies beyond speech. Monteverdi astonished the audience of "Orfeo," the first music drama (composed at Mantua in 1607), with the strange sounds, never before heard in the theater, of alto, tenor, and bass trombones. And in modern times Wagner, Debussy, Stravinsky, and Ravel have all added significantly to the orchestral vocabulary while seeking new sonorities, textures, aural colors, intensities—more eloquent *theatrical* means—in music drama.

Whatever its form—opera, operetta, musical comedy—musical theater inherits a rich and rigorous tradition. It demands much of those who would work seriously within that tradition. Puccini and Lehar, who well represent the diversity, the attenuations, of the tradition, provide us a lesson. Despite the fact that one wrote for opera and the other for operetta, they warmly respected each other's music. They bore in common a very old responsibility. George Gershwin's almost ecstatic sense of revelation when he first heard music by Jerome Kern put him in touch with that responsibility, and with its paradoxical implications of freedom. Gershwin's intuition responded to the tradition of sophistication in theater music. He felt compelled to write for the theater because that was where Kern wrote his music.

Could it be, then, that what really distinguishes musical theater from Tin Pan Alley is the discipline of a tradition that permits freedom of innovation while exacting, in return, that rare and peculiar eloquence which only theater music can yield, an exaction few have truly met?

One writing in the theater lives with that tradition, with its freedom and its penalties. Puccini, far off, Lehar in the middle distance, and Jerome Kern, Irving Berlin, George Gershwin, Richard Rodgers, Arthur Schwartz, and Harold Arlen close at hand are *listening*. (So, too, are P. G. Wodehouse, Lorenz Hart, Cole Porter, Oscar Hammerstein II, Ira Gershwin, Dorothy Fields, and John Mercer.) The newest song writer in the theater must answer to them, for they are the measure of what he does. Throughout his career he must stand up against the formidable witness of their best work. And he cannot wish them away for they have instructed the communal ear—their songs are part of the unconscious reflex of the common memory.

Here is the point I left suspended earlier: the theater composer learns early in his career that the audience has been conditioned *to expect a special quality in theater music*. So, even if it may not be (as I feel it isn't) truly sophisticated musically, the musical theater audience would like to be treated as though it were, a courtesy it will reward with a rather handsome tolerance for innovation. Also, the critics will expect a good deal of the theater song writer without really being sure what it is they have in mind, and perhaps not recognizing it when they do hear it.

Such, then, are the speculations of one interested party as to the

cause of the primacy of theater songs, and theater song writers, in the story of innovation in American popular song. Lest this all seem a bit rarified, let me bring the matter down to earth, down to the work-a-day world of the man who is writing theater songs at this moment. How real to him is the discipline of theater music tradition, the long continuity of high craftsmanship? Two examples should answer the question.

Stephen Sondheim, the very highly regarded composer-lyricist of *Company* and *Follies*, has publicly discussed the extraordinary apprenticeship he served under Oscar Hammerstein II, a tutor who may have had no peer in American musical theater as a librettist-lyricist. During a period of about six years, Sondheim wrote the book, music, and lyrics for four musicals, in each of which he aimed to solve a different type of basic problem that Hammerstein had set out for him. Hammerstein was a complete theater man, and he insisted that Sondheim prepare himself to be as much. Sondheim well knows who is looking over *his* shoulder.

Jerry Bock, one of the most successful composers of the contemporary musical theater (*She Loves Me, Tenderloin, Fiddler On The Roof, The Apple Tree*), and a Pulitzer Prize winner for *Fiorello!*, has encountered the reality of the traditional discipline of theater music in a very severe fashion. Three seasons ago the music critic of the *New York Times* criticized him *for not measuring up to Puccini and Verdi*. Bock had served his apprenticeship writing summer "shows"—one every week—at Camp Tamiment. He may have known when he first arrived on Broadway that his earliest professional work was being measured against the best work of his theater predecessors, but he may not have suspected that his mature scores would be tested against the best work of Puccini and Verdi.

The answer to the question, then, is that the discipline of theater music tradition is quite real—even fierce.

IV

An arbitrary stopping point had to be established for the time span covered by this book. The author was concerned that the year selected should reflect conditions that provided a natural pause, as it were, in the evolution of popular song. By 1950—the year he chose—

a long era in popular music was drawing to a close. Almost all of the great innovators had long been at work, and several of them had already died.

These men were the most respected song writers of their time. They had developed what Alec Wilder perceives to have been a professional tradition, that is, a tradition based upon a relatively sophisticated command of music. In reaching toward innovation, in extending themselves and taking imaginative risks, they made use of *all* the commonly available materials of music, formal and informal.

As they moved from craft toward art they provided fresh syntheses of these materials. They sought new means, and in their search they were instructed by the innovations of their more musically sophisticated contemporaries, the arrangers. It was during the 1920's that the young dance band arrangers were seized by the remarkable inventions, in harmony and sonority, of Debussy, Ravel, Delius, Milhaud, and other composers of like creative resources. Some of them still recall with enthusiasm, and even a sense of urgency, their first encounters with the French music of the early part of the century. "The older musicians thought the new French stuff was frivolous," one of them remembered not long ago. "They thought only German music was *serious*." In their turn, the innovators among the song writers never stopped exploring the grammar of their craft, even though they rarely ever reached the level of musical knowledge of the best orchestrators.

By 1950 the professional tradition in song writing was nearing its end, for reasons too complex to summarize other than very roughly. Consumption patterns in popular music had changed rapidly in the post World War II years. Singers and singing groups enjoyed a new primacy in the ordering of economic priorities in the pop market. The big dance bands had priced themselves into oblivion. Further, most of them, as a result of their ceaseless replication of one another's styles, had lost all claim to the attention of the pop audience, a predominantly young consumer group that is notorious for its short attention span, and its insatiable hunger for the *new* (a word that has since given way to the word *now*, with its dreary implication of manipulated hysteria).

The rock era was about to begin.

The problem Alec Wilder faced in remarking 1950 as the twilight

of the period covered by this book was how to deal with the later work of those song writers who continued to excel in the professional tradition (for the shrinking non-rock market). It would not do to leave their careers hanging in mid-air. He therefore chose simply to follow them through the 1950's into the 1960's, discussing and analyzing their best songs. At the same time, he decided *not* to study the over-all body of work of those song composers in the professional tradition whose careers did not begin until the close of the 1940's.

It thus happens that several very popular contemporary song writters have been left out of the author's discussions as a result of the time limit set for this survey. Others, of course, have been left out because he feels that their work before 1950 did not add significantly to the long story of innovation in American popular song, or that it lacked other special interest musically.

V

There are no absolutes in aesthetic judgment, and the author has not wished to invent any. It has been Alec Wilder's aim to keep his text informal, and to assume no more objectivity than his long experience as a composer of both light and formal music, and his own taste permit him.

In the course of writing this book, he discarded many of the songs he had played through in his preliminary studies. Some were without musical merit, or even incidental interest. Others had great merit, but their innovative qualities were better demonstrated in another song, perhaps one by the same composer. Thus, the absence of a song from the text does not necessarily imply a negative judgment by the author—not at all. He feels, for example, that of the songs he had originally singled out for analysis about two dozen needed to be quoted in their entirety, or not at all, for their peculiar musical distinction lay in the sum of their parts rather than in any one device or section. And, of course, it is not permissible to quote complete copyright songs as musical examples. So, in the end, those of the above-mentioned songs that lent themselves to brief comment were so treated, while those few that seemed absolutely to require illustration had to be passed over. Finally, even a large book has its limits, and this immutable condition further stayed the author's hand.

Did he miss any songs? Of course, quite a few. My own research leads me to estimate that about 300,000 "popular" songs of every variety may have been deposited for copyright between 1900 and 1950. The author "missed" about 283,000 of these. He examined some seventeen thousand songs. He has, in round numbers, cited with brief comments, three hundred of these. In the musical examples he has quoted from nearly five hundred more songs. These quotations are autographed in some seven hundred "examples" comprising four thousand measures of music. It should be noted that only published music was used in the study.

Although the innovative quality of a song was the basic criterion for its inclusion for comment and analysis, it should not be assumed that every song the author discusses brought an innovation to popular music. The author's comments clarify the inclusion of songs which have a peculiar interest for this study, but which do not meet the criterion of explicit innovation. For example, a number of songs served to maintain the high level of sophisticated craftsmanship that innovation created, and some of these are therefore included. They tended to enrich and nourish song writing, even if they fell just short of fresh invention. Theirs has been a crucial role in keeping native distinctions clear and vigorous.

The preparation of this book required the accumulation of an enormous amount of data. More than five hundred master data sheets were compiled. These contained for each quoted song the copyright data, the names of the composer(s) and lyricist(s), the name of the theater or film production for which the song was written (if appropriate), and other related information. It is quite possible that some faulty information was carried over from the original sources, or even invented in the process. The basic source of data was the copyright page of the sheet music of each song. It is a researcher's torment, but a matter of only passing general interest, that a song title may assume many forms. Frequently the title has one form on the cover of the sheet music, another form on the copyright page, and a third form on the theater program, if it is a show song. Jerome Kern wrote *Who?* (with a question mark), and Irving Berlin wrote *Who* (without one). The reader may feel sure that all reasonable care has been exercised to provide him with accurate data.

The discussion of many aspects of popular song was ruled out by

the author's decision to focus on the music. The reader should not, therefore, look for a sociological setting of the songs discussed in the text. Nor should he expect musicological examples. Some terminal cadences go up, and some go down. However, it is unlikely that anyone could prevail upon Alec Wilder to determine which do what, the incidence of the rise, or fall, of such cadences, or the median intervallic distance (expressed in logarithmic cents) between the penultimate and ultimate tones in the American popular ballad during, say, the summer of 1934. A vintage season for fine ballads, by the way.

JAMES T. MAHER

American Popular Song

— 1 —

The Transition Era:
1885 to World War I

I

During the thirty-year period between 1885 and World War I, American popular music underwent many fundamental changes. Finally, when these changes—rhythmic, harmonic, melodic—were consolidated, a unique kind of song emerged: American song. While this chapter will discuss and illustrate the roots and nature of these changes, it is not intended to be a formal history of the music of this era. Further, it is deliberately selective in its choice of songs that reveal evolution and innovation.

Stephen Foster created the first truly native songs. He approached his music from two points of view: the formal, as exemplified by *Jeannie With The Light Brown Hair* and *Beautiful Dreamer;* and the native, *Old Black Joe, De Camptown Races, Oh! Susanna.* The former style he handled in a highly musical fashion, yet it contained none of the native quality of the latter, a quality clearly rooted in Negro life and Negro music. Of course, Foster was influenced by early minstrel show music, a commercial mixture of English "Negro" songs (with no identifiable Negro characteristics), music for jigs (a freely contrived jumble of Irish and urban Negro dance tunes), urbanized Negro folk songs, and other readily available "pop" music of the day. But, granting this influence, with all its limiting stereotype characteristics, one must still recognize the direct impact of Negro church music in Foster's best songs. The point about his work I want to make

is simply this: even though he himself added to the body of stereo-type blackface music, he *did* at times use his rare gift as a melodist to rise—*soar*—above such music.

Foster died only a short time after the Emancipation Proclamation and only a short time before the end of the Civil War. And with his death something mysterious happened. The peculiarly native quality that he had brought to American popular song, a quality borrowed from Negro music, disappeared quite as suddenly as it had arrived. And it did not return until the 1880's. One need only go through the dreary melange of popular songs published between the end of the war, between Foster's death, that is, and the late eighties, to become sadly aware of *what* had happened. A vital trend, a new direction, remained entirely undeveloped. But, *why?*

I find the question so absorbing that I should like to make a guess. Obviously, Foster was unique in his sensitivity to Negro music and in his ability to transmute it into the forms and requirements of white popular song. When he died, his aeolian secret died with him. Negro music was still in the air, but no one among white song writers was listening—at least, not with his uncomplicated musical intuition.

But something more complex than Foster's death may yield the answer to our mystery. The end of the Civil War brought traumatic disruptions to Negro life. The slave had been freed, to be sure, but his new freedom, if such it may truly be called, threw him overnight into a society in which competition for economic survival was demanded of everyone, even children. Thousands of plantation Negroes drifted into the cities. Others began to eke out their subsistence in the emergent peonage of tenant farming.

This is not the place to examine in any detail the post-war rural-urban shift in Negro life, nor, indeed, am I equipped to do so. However, good sense suggests that an uneducated, untrained people turned adrift from a way of life, no matter how onerous, that had provided food and shelter, even in old age, and thus left homeless and jobless, is not likely to indulge itself freely in singing and dancing. I feel sure that for a long while after the war had ended, the vital, creative energies that had nourished plantation music were subdued. Which is not, of course, to say that music disappeared from Negro life. The human reflex expressed and preserved in music was never entirely absent from Negro life.

What had happened, as I see it, was this: the communal and familial patterns of Negro plantation music were shattered, and were not to be re-established until new patterns were created in New Orleans and a few other cities to which the ex-slaves had turned in large numbers. It is perfectly true that the diffusion of plantation music—which is to say, American Negro music—had already begun to follow certain channels before the Civil War, and that those channels remained open. For example, Negro church music certainly continued its moving and spirited evolution. And one should remember that Foster first heard Negro music in a Negro church. Further, minstrel shows had begun to make use of Negro music almost three decades before the Civil War. And after the war Negroes organized their own minstrel companies, largely imitations of white minstrel shows (which were, of course, imitations of Negro music and dancing in the first place).

However, in the long history of the minstrel shows, only Foster's songs had the secret of synthesizing a *new* kind of white song from Negro musical roots. The syncopated banjo dance (jig and cakewalk) music that went from the plantation to the minstrel show would one day surface again in ragtime and jazz. But, for the most part, blackface music in the decades with which I am concerned added nothing new to the creative legacy of Foster. Nothing, that is, that I can find. I do not know what went on in the Negro churches as far as music was concerned, but whatever it was, it did not get out into the world of white popular song.

My hypothesis is that with the end of slavery the creative center of Negro music was left homeless, and that it remained adrift until it found new roots, both urban and rural. Therefore, its historic role in the evolution of American popular song was, for a time, abeyed. This abeyance happened to coincide in its beginning with the death of Foster.

It would follow that if the center of Negro musical life, the place where both instrumental and vocal music were continuously created and revitalized, disappeared, then such music could no longer find its way to the white song writer, a haphazard journey at best. The white man no longer had access to the slave quarters, and, of course, the freed Negro certainly had no access to white publishing houses (even had he had the unexpected ability to notate his music). A mosaic of Negro ghettos began to form in the cities, and the white man did not

frequent such enclaves. Negro music had to wait its opportunity to come directly to white audiences through Negro performers.

It was not until the Negro had found a way to survive in an alien and unsympathetic society that his music began once more to emerge, and to influence popular song writing. One cannot precisely date such a phenomenon, but it appears to me that the trend, broken by Foster's death and the dislocations of Negro life, begins anew in the 1880's. (I do not find any evidence that white song writing was influenced by the Fisk Jubilee Singers in the 1870's.)

A few popular songs had, of course, shown some native vitality, some American distinctions. Perhaps the best of these were written by a Negro who very successfully brought to his music echoes of Foster and the old plantation songs. The writer was James A. Bland, who composed more than seven hundred songs for Negro minstrel companies, among them *Carry Me Back To Old Virginny* (1878), *Oh, Dem Golden Slippers* (1879), *In The Evening By The Moonlight* (1880). Ironically, he was a northern Negro who was born in Flushing, New York. It was Bland who broke down the barriers to white music publishers' offices.

The American popular song after Foster had lost all distinction. It followed well-worn ruts: terrible disasters, politics, major events, and the development of transportation (boats, canals, trains) provided much of the subject matter. And over all there hung the deadening pall of fake sentimentality.

One song cannot fairly exemplify the music of an era. However, *Cradle's Empty, Baby's Gone* (1880) was characteristic of a class of lugubrious ballad that was widely admired just before the great transition to modern popular song began. It is utterly devoid of "American" flavor. But, it provides an insight into the Victorian pleasure of a good, mindless cry. Maxwell F. Marcuse has noted that as soon as an epidemic did in fact empty many thousands of cradles, the song was quickly dropped.

Banality and bathos reigned. And Negro music was locked in the ghetto. It may have been Bland who opened the door to the future. It was not until the Negro began to attract the attention of the music publishers, and exploiters of performing talent, that his music truly got loose. In other words, not until the Negro musician and song writer were able, late in the century, to perform directly for the white

community. Then, the message slowly came through to white America that the Negro's musical talent was unique, and that something musically remarkable was emerging from the ghetto. By that time a white audience was ready for ragtime.

II

Eubie Blake, composer and still a remarkable performer, now nearly 90 (b. February 7, 1883), son of former slaves, observed during a discussion of music at the turn of the century, "People ask me where did ragtime come from and I say I don't know, I heard it all my life . . . when my mother would go out and wash white folks' clothes, I'd play music lessons the way I liked and when she came home and heard me, she'd say, 'you take that ragtime out of my house, don't you be playing no ragtime.' "

For years the only public places where a Negro could play for profit were brothels. Indeed it may be said that the first breakthrough of post-slavery Negro music into the white community occurred in whore houses, which provided an early home for ragtime, and jazz.

The origins of ragtime cannot be dated. It assumed the form of complex piano composition by the 1890's. A classic cause-and-effect can be found in the rise of ragtime (the same cause-and-effect evolution that was probably present in country fiddling): a new dance evolved and it required new music. The cakewalk, a walking, strutting dance, could not be performed to European instrumental music (gallops, polkas, waltzes). It required something new; ragtime filled the bill. Probably both evolved together.

James T. Maher expresses the state of popular music during these times as follows:

> The analogy may be a clumsy one, but one can get some insight into what happened in American popular song between the 1890's and World War I by imagining the following performing at the edge of Echo Canyon in Grand Canyon National Park:
> The Fisk College Jubilee choir richly intoning their historic "spirituals"; Scott Joplin, Ben Harney, and Eubie Blake playing ragtime piano with its broad spectrum of the vigorous and the

academic; a country fiddler racing through any of the "Turkey" variants with, or without, an accompanying string band; a Negro cotton hand chanting field "hollers"; a back country blues singer singing of the loveless love of a life dehumanized by history, in a groping form that had yet to reach the twelve-bar city formula; a good southern Negro ragtime orchestra, a strange blend of brass band and potted-palm string ensemble; a small Negro ragtime dance band from a New Orleans Saturday night function in a Negro fraternal hall; Patrick Sarsfield Gilmore's proprietory band playing a schottische, or a gallop; Naham Franko's orchestra performing Waldteufel, a favorite of the "400"; a flute, accordion, fiddle, and drum from a "tenderloin" free-and-easy wailing through a commonplace mixture of landler, hornpipe, and polka; a handful of immigrants each intoning some old-country favorite remembered with love and comfort; a good music hall singer like Emma Carus, or Tony Pastor, singing a tear-jerker and/or one of the new "ragtime ballads"; May Irwin, assisted by some of the girls from Babe Connors' *bagnio* in Kansas City singing *The Bully* (in its original scatological version); Shelton Brooks singing and playing his new song *Some Of These Days*; W. C. Handy leading his travelling band-orchestra-dance-band in his first published blues, *The Memphis Blues*, or his *St. Louis Blues* of several years later; a dozen tipsy Chicagoans blurting out *Alexander's Ragtime Band*, a song the Windy City made famous; Ben Harney and his stooge singing Harney's great 1890's songs, *Mister Johnson, Turn Me Loose*, and *You've Been A Good Old Wagon, But You've Done Broke Down* (the former employing in its title a turn-of-the-century Negro code word for *cop*); a group of Carolina mountain people singing remembered British North Country modal ballads; a cowboy singing a round-up tune; a railroad worker shouting rhythmically as he swings his sledgehammer, or gandy-dancing to a communal tune; a vaudevillian in a celluloid collar singing *My Gal Sal*; an ex-minstrel singer belting out *Hello! Ma Baby*; a parlor dandy singing *A Perfect Day*; and, King Oliver's Band (with young Louis Armstrong on second cornet) leading the entire gathering to some jubilant moment of glory. . . .

Imagine this great melange of sounds pouring down into the canyon, mixing below, then returning in a single echo and you may get some idea of what happened as American popular music achieved a native idiom between 1890 and World War I.

III

One of the best Negro writers of the late nineteenth century was Benjamin Robertson Harney. In discussing Harney's life and work with me, Eubie Blake observed, "He's dead, and all of his people must be," before adding: "Do you know that Ben Harney was a Negro?" I hadn't known, of course. Mr. Blake then provided a clue to Harney's great success as a performer. "Ben Harney played ragtime like white people played it." He managed to get his songs published as well as widely performed. He was assumed by white people to be white. And though he died in a Philadelphia Negro ghetto, the fact that he was a Negro has never been publicly stated, possibly out of a traditional concern for his surviving relatives. Harney had no children.

Rudi Blesh and the late Harriet Janis in their book *They All Played Ragtime*, the definitive study of a subject very dear to the authors, have provided a substantial biographical sketch of Harney, and an enlightening analysis of his most famous songs in the context of ragtime and blues traditions.

Until I began this survey I had assumed that the true American song evolved much later than it actually did. Shelton Brooks, with his *Some Of These Days* and *Walkin' The Dog*, did introduce a fresh point of view. But there were others before him. Max Morath, an authority on turn-of-the-century American song, as well as instrumental ragtime, considers certain songs of the 1890's to be the most significant breakthroughs in "American" non-hack writing. And they're all by Ben Harney. The first of these is *You've Been A Good Old Wagon, But You've Done Broke Down*, copyrighted in 1895, but written at least a year earlier. Although it would be printed in 4/4 time today, it is shown in 2/4 in an early copy provided by Mr. Morath.

It is comprised of a verse (not so marked), a chorus, and a "dance." In the sung portions of the song there are, amazingly, only two chords, tonic and dominant. Were one to have arranged this song at any time after 1920, or to have printed a new piano copy, the harmony would have been much less spartan. And it is my conviction that Mr. Harney himself never played the song with only the tonic and dominant chords. For the melody almost begs for more harmony.

The verse is fourteen measures, the chorus twenty-eight, and the "dance" forty. The most interesting phrases in the chorus are repetitions of the verse.

You've Been A Good Old Wagon, But You've Done Broke Down

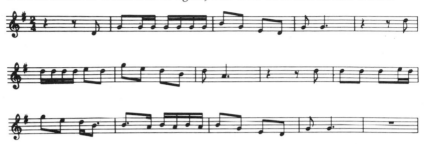

One must keep in mind not only the date, *c.* 1894, but the antique spelling of the notes. (Were the song reprinted using modern spelling, it would read as in the second illustration.)

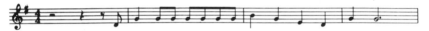

One shouldn't look for any extraordinary innovations. Rather should it be kept in mind that for its time it was far from the typical pop song. And it is unfortunate that one cannot hear a recording of it by Harney. For undoubtedly it would reveal that the printed copy is an almost totally emasculated "whitening" of the original. Surely, the melody suggests a much more swinging piano part than was published.

Eubie Blake praises Harney unstintingly as the true father of the style of piano playing made famous by James P. Johnson, to some degree, and Fats Waller, fully. Mr. Blake's praise does, I must admit, seem to conflict with his other remark that Harney "played ragtime like white people played it," but no matter.

Mister Johnson, Turn Me Loose, 1896, another Harney song for which he wrote his own idiomatic lyrics, has only a sixteen-measure chorus, but again it is a departure from the norm. It unexpectedly starts in A minor (the key is G major) and moves, after two measures, to G major. The melody in both instances follows the notes of the chords.

Mister Johnson, Turn Me Loose

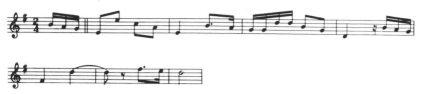

I am impelled to suggest once more than these illustrations must be viewed only as beginnings and, more than that, probably as "cleaned-up" versions. There is no need to discuss them at length but, since they are examples of Negro music's first emergence in the white man's marketplace, and since they contain, even in their pallid piano copy form, the native quality of "American-ness," they must be cited.

Although ragtime was the big rhythmic innovation in American popular music, it was largely for piano and therefore outside the boundaries of this book. For those who are interested in its fascinating history, *They All Played Ragtime* by Blesh and Janis, now revised, supplies data, music, and a colorful narrative, all carefully researched.

At A Georgia Camp Meeting, first published as a piano piece in 1897, then as a song (with words added) in 1899, is another song employing the eighth, quarter, eighth note device. Words and music were by Kerry Mills. It is a strong, memorable tune, very much in the ragtime, cakewalk tradition. There were earlier "walk around" dance songs, but Mills's song was so successful that he was long given undue credit for *inventing* the cakewalk. As has been pointed out by others, the most familiar strain in the song is an adaptation of the Civil War song *Our Boys Will Shine Tonight*. Here are the beginnings of verse and chorus:

At A Georgia Camp Meeting

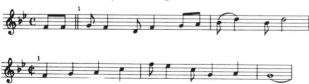

In 1899 there was also a very successful pop song called *Hello! Ma Baby* which was certainly in the ragtime genre. There is some ques-

tion as to the authorship, though the names of Joseph E. Howard and Ida Emerson appear on the sheet music as joint authors and composers. According to Maxwell F. Marcuse in *Tin Pan Alley in Gaslight*, the lyrics were written at least in part by Andrew Sterling who, Marcuse adds, "claimed to be the author of the song." In any event, the author or authors and composer were white.

It's a cheery little song, one of the many written about that new gadget, the telephone. And its lyric indicates that it is a "coon song." It is a cakewalk kind of tune, the principal rhythmic device of which is the succession of eighth, quarter, and eighth notes.

Hello! Ma Baby

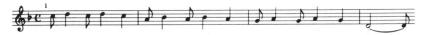

To quote James T. Maher again:

> At the turn of the century certain fruitful interactions were taking place in published music. The cakewalk and ragtime (both as a style of performance and as a form of composition) flourished. Nationality (immigrant) songs were becoming popular—but they were now not so much nostalgic for the old countries as they were reflections of a hyphenated life (Irish-American, Italian-American, and so on). Technology songs were solidly rooted: research has shown that there were probably one hundred fifty telephone songs by 1900! The melodramatic Victorian ballad—the dreadfully sad gaslit anecdote filled with glycerine tears—was losing its force. Ragtime yielded a vital new song: the ambiguously malicious "coon" song. The straight line from plantation music to the earliest recorded jazz (1917) runs through ragtime: the impact of Negro syncopation is the major force in the Americanization of our popular music. By the turn of the century the theater had heard the first Victor Herbert successes and the first Negro musical ("Clorindy"). Thus, the young song writers had a musical grammar of tremendous variety to draw from: Negro syncopated ragtime songs, such as those by Ben Harney, the smooth beauty and sophistication of Herbert ("Oh, he taught us how to lay out a pretty ballad in four," Eubie Blake recalls), and the emergent wit and brevity of a few

song writers in Tin Pan Alley. By 1900 the crucial synthesis was under way.

IV

Under The Bamboo Tree, 1902, words and music by another talented Negro writer and performer, Bob Cole, probably owed its popularity as much to its "novelty" lyric as to its music. Oddly, the chorus shifts from the 4/4 rhythm of the verse to 2/4. It's a short, sixteen-measure chorus with a single synocpated motif of one measure, with, again, only two chords. There is nothing remarkable about it except in comparison to the other songs of that period. Here is the motif:

Under The Bamboo Tree

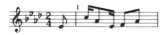

Bill Bailey, Won't You Please Come Home?, also 1902, music and lyrics by Hughie Cannon, is the last song of concern to us that bears the character of ragtime. However, it has a contrived quality which removes it, to my mind, from the more natural melodies of Ben Harney. Its first four measures suggest a more natural development than the melody actually has.

Bill Bailey, Won't You Please Come Home?

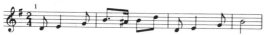

The contrived, manufactured flavor, to me, is evidenced in the seventh-measure cadence,*

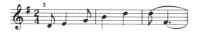

and the cadence at measures twenty-two and twenty-three.

* The resolution of a musical phrase creating a sense of conclusion, either momentary or final.

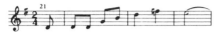

I am especially surprised, probably because for years I have heard the title of this song and presumed that its melody would have a much more natural flavor.

In 1909 Shelton Brooks wrote the words and music of a song which was truly a landmark in popular music, perhaps *the* landmark of the transition era. It was completely unlike most songs of its time. It derived from none of the popular song elements then current. It is a straightforward, well-written rhythm ballad, melodically and harmonically. Its title is *Some Of These Days*. And it has the unusual form of *A-B-C-D*. Like Berlin's *The Girl On The Magazine Cover* of a few years later, it never repeats its initial idea. It was a big hit and deserved to have been. As well, sixty years later, it is still a standard song. Throughout her long career Sophie Tucker used it as her theme song.

Considering that the melody is in G major, it is highly unexpected that after the three "held" pick-up notes, the harmony of the first measure is a B-dominant-seventh chord. This resolves in the third measure to E minor, returns to B dominant and then, after once more resolving to E minor, proceeds through E-dominant seventh and A-dominant seventh to a D-dominant cadence.

Then, instead of repeating the original idea, it continues through G dominant to C major. Indeed, it never ceases to move harmonically, far more so than most other pop songs of that time. It should be remembered that Mr. Brooks was a successful vaudeville pianist. Yet so provocative is the melody that it became an immense success, and though the harmony may have mightily pleased the players of that time, the success of the song was due surely to the melody. And I'm certain that the tantalizing suspension of the rhythm in the opening pick-up notes also had to do with the song's popularity.*

I should make note here of a piano piece, *The Memphis Blues*, copyrighted in 1910. This historic blues became a song in 1912 when it was published with words. It is discussed below.

Also in 1910 there was a song by Lewis F. Muir called *Play That*

Barber Shop Chord. Long afterward it achieved a second "success" as a result of Judy Garland's enthusiastic revival of it.

Both verse and chorus are so loose and relaxed that they might well have been written by a Negro. For up to this time there had been little evidence of white writers having absorbed, or having capably handled, the rhythmic materials that the Negroes had created. The first eight measures of the verse surely demonstrate this natural, uncontrived kind of line.

Play That Barber Shop Chord

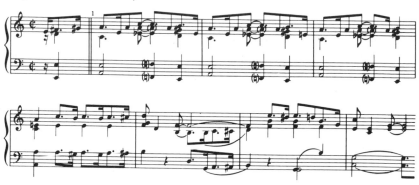

The chorus does have a degree of contrivance but this, I think, is justified by the demands of the lyric, which, as the title indicates, has to do with harmony. The last section of the song shows how much it moves about. And this amount of experimentation in 1910 was almost unprecedented, as, for example, the shift to F minor in measure thirteen and the run-down on the notes of the A-flat-major triad in measure fifteen.

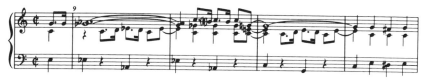

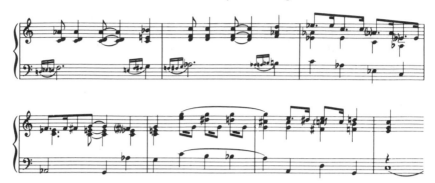

Then, in 1911, Muir wrote a great big hit which has remained a standard all these years. In *Waiting For The Robert E. Lee* Muir caught the spirit of the new rhythms that had burst out with ragtime. This song, from beginning to end, has a completely relaxed and natural flavor. And, it swings!

It has a thirty-two-measure verse and a thirty-two-measure chorus, the form of which is *A-B-A-C*. The verse is so good that I've always thought of it as an integral part of the song. And since the chorus uses the principal motif of the verse in the *B* section, I never separated it from the verse when I first heard it. Nor have I ever heard the chorus played alone.

In the printed copy the verse is in C major and the chorus in F major. And, oddly, the verse is marked common, or 4/4 time, and the chorus *alla breve*, or cut time, though the rhythm is identical with the verse. (Oh, you sleepy editors!)

It interests me that the three pick-up notes in measure four of the chorus are so much a part of the melody that it is very surprising they didn't have words to support them. The motif of the verse is instantly attractive. And the chorus enters much as does a "trio" in a march and with only that slight degree of separateness. I find the use of whole notes very effective in the *B* section, particularly when justaposed to the rhythmic phrase that follows them, which is, in turn, the motif of the verse.

This is a good song in any decade and remarkable for its time, certainly as much so as *Alexander's Ragtime Band* with its strong but non-ragtime tune.

Also in 1911 Ernest M. Burnett copyrighted a song called *Melan-*

choly. In 1912 the copyright was assigned to the Joe Morris Music Co. under the much better-known title *My Melancholy Baby*.

We've all heard this song so many times I think we may have forgotten a few salient facts about it. First, its title is most unusual, the seldom-used and dignified adjective "melancholy" qualifying the colloquial term of endearment "baby." Second, the melody is not only good, containing highly unexpected phrases for that era, but it also just might be the first torch song. Third, its melody writer, listed as Ernie Burnett, may have been a "one-shot" writer. For as far as I can determine, this was his only big song.

Until I recently saw its copyright date, I assumed that *My Melancholy Baby* was a song of the middle, even late twenties, for the writing is unlike that of any song of its period.* This isn't to say that it ranks with the great songs of later years—rather, that it is a good, well-written melody, highly unusual for its time, and certainly not a piece of hack work. Furthermore, it's unlike any other melody and deserves to remain a standard almost sixty years after its original publication.

But the great popular landmark of 1911 was Irving Berlin's *Alexander's Ragtime Band*. Its style, its paradoxical lack of ragtime, even of syncopation, and its historical role in popular song as discussed in the separate chapter on Berlin's extraordinary body of work.

V

In 1912 came the first publication of that phenomenal song form, the blues. It is an old form that may have preceded the Civil War. Harold Courlander, folklorist and author of the definitive *Negro Folk Music U.S.A.*, says, "There is no indication that something closely akin to blues was not sung in the towns and on the plantations in ante-bellum days." Abbe Niles's description and definition of this music in his book *Blues* is the best I know.

> The blues sprang up, probably within the last quarter century, among illiterate and more or less despised classes of Southern Negroes: barroom pianists, careless nomadic laborers, watchers of incoming trains and steamboats, street-corner guitar players, strumpets and outcasts. A spiritual is matter for choral treat-

ment; a blues was a one-man affair, originating typically as the expression of the singer's feelings and complete in a single verse. It might start as little more than an interjection, a single line; sung because singing was as natural a method of expression as speaking. But while the idea might be developed, if at all, in any one of many forms of songs, there was one which, perhaps through its very simplicity and suitability for improvisation, became very popular; the line would be sung, repeated, repeated once again; with the second repetition some inner voice would say "enough" and there would have come into being a rough blues.

Its tune didn't need to be new; *Joe Turner*, an old three-line song was well known to and sung by Negroes all over the South and a blues verse could be and was, fitted to its tune.

And since the emergence of the blues in published form was the work of W. C. Handy, it might be well to quote Isaac Goldberg (*Tin Pan Alley*) on him.

> William Christopher Handy, "the father of the blues," is not the inventor of the genre; he is its Moses, not its Jehovah. It was he who, first of musicians, codified the new spirit in African [Negro] music and sent it forth upon its conquest of the North. The "rag" has sung and danced the joyous aspects of Negro life; the "blues," new only in their emergence, sang the sorrows of secular existence.

And Goldberg also says, "Handy was the first to set jazz down upon paper—to fix the quality of the various 'breaks' as these wildly filled-in pauses were named. With a succession of 'blues' he fixed the genre."

Handy began with *The Memphis Blues* which was published in 1912 with words, though, as already noted, its instrumental version had been published in 1910. It's in three sections, only the second of which is not in the twelve-bar blues form. This second section leaves the traditional blues harmonic pattern and is sixteen measures long.

The classic blues harmony, in its basic form, is (in the key of B flat) three measures of B flat, one measure of B-flat-dominant seventh, two measures of E flat, two measures of B flat, two measures of F-dominant seventh, and two measures of B flat.

Within that framework Handy wrote many famous tunes, and

since then there have been literally thousands of great blues choruses improvised by hundreds of great jazz instrumentalists. Obviously, as increasingly sophisticated and complex harmony infiltrated pop music and jazz, the blues became that much more involved. But its basic twelve-bar length and, though infinitely altered, its chordal patterns have remained essentially the same.

Other innovations in pop and theater music were to be highly sophisticated and brilliantly inventive, but rarely would any of them achieve the totally indigenous quality of the blues. Of course this was in large measure due to the great blues interpreters who sang uniquely, employing microtonal notes (quarter tones in the diatonic scale) and extraordinary "bends" and "turns," bizarre extensions of natural voice range, and an almost self-hypnotized emotional state while performing. The blues is truly an agonized cry from the depths of despair, even though there has been flippancy and self-mockery in some of its lyrics and renditions. These latter, however, might be said to come under the heading of "commercial" blues, slanted for shallow nightclub audiences and feather-brained record buyers.

Note that in measure six of the chorus of *The Memphis Blues** the first half-note chord could as well have been E flat as a diminished chord and the second half-note chord in measure ten, though E flat, would have a low *f* in the bass in any version less simply edited, thereby maintaining the feeling of F dominant. Long before George Gershwin began toying with them, the flatted seventh and flatted third of the scale were conventional elements of the blues. In the first section of *The Memphis Blues* both flatted notes are used.* The flatted seventh, *e* flat, is in the second measure and the flatted third, *a* flat, is in both the fifth and sixth measures.

To jump ahead in the chronology in order to stay with the blues— in 1914 Handy published both *Yellow Dog Blues* and *St. Louis Blues*. The first of these is much more complex than *The Memphis Blues*. The section preceding the chorus is not called a verse and shouldn't be. There is no descriptive name given it. It is made up of three twelve-measure sections, the first two of which are harmonically in the blues pattern. The third is not. Again the flatted third and seventh are in evidence. And the sheet music key is D major, a key seldom used outside theater songs. The chorus deviates in the second measure from the expected harmony and as well is introduced

by three untypical "held" pick-up notes.* The minor third, *f* natural, is stressed, but not the minor seventh, *c* natural.

St. Louis Blues is particularly fascinating. It is in four parts, the first two identical twelve-bar sections, with different words, the third an unprecedented sixteen-measure minor section in a tango rhythm (filtered through from early Spanish New Orleans?), and the fourth a blues chorus of twelve measures. The harmony of the first and second sections is not in conventional blues harmony, as the second measure, instead of sticking to a G-major chord, moves to C major for a single measure. The minor third, *b* flat, is consistently in evidence. The third, minor "Spanish" section of the inspired lyric—"Saint Louis woman, wid her diamon' rings" etc.—is unlike anything in any blues, work song, country song, any song I've ever heard. In the chorus there is also a variation on the blues harmony. For the ninth measure remains G major instead of conventionally shifting to D-dominant seventh.

I don't suppose any American song is better known or has had more performances than *St. Louis Blues*. It most certainly is one of the most notable of popular music landmarks. Handy wrote many more blues, all of them interesting, some with slight alterations harmonically as in *St. Louis Blues*. They are a marvelous contribution to the body of American popular song.

VI

To backtrack for a moment, in 1913 Chris Smith wrote the music for a swinging, loose little sixteen-measure song called *Ballin' The Jack*. It was one of the earliest of the "dance instruction" songs of which there were later on a great many from *The Black Bottom* and *Charleston* to *The Varsity Drag* and countless others.

The verse is very unusual harmonically and melodically for its time, strangely in spots suggesting the much later *Heart And Soul*. The melody of the chorus is one of those like *Sweet Georgia Brown*, which is chord-based and mostly dominants. It very unexpectedly starts out with two measures of G-dominant seventh, though the key is B flat, therefore needing *b* naturals in the melody straight off.* It moves through three sets of dominant chords, two measures for each, until it comes to one of those marvelous "break" phrases in

which the band often cuts out. It is the phrase beginning at measure seven.

The lyric concerns itself solely with how you "ball the jack"; but the tune is a true early swinger.

Then, in 1915, *I Ain't Got Nobody*, music by Spencer Williams, was published. It is very well known to this day, though only a fairly good song. Its first phrase is, I believe, the sole reason for its success.* The high, held *d* natural, followed by the chromatic quarter notes, constitutes the principal characteristic. I'm surprised that the published harmony doesn't continue chromatically along with the melody notes so that the opening G-dominant chord would descend through F-sharp dominant, F-natural dominant, and E dominant to the A dominant in the third measure. All the performances I've heard of the song employ this harmonic pattern.

I've never heard the *b* flat quarter note at the end of measure three either sung or played. Here is another instance of performers improving the writer's original idea. Also the last quarter note in measure twenty-four leading back to the main strain I have always heard sung and played as a *d* instead of the *a* in the sheet music.

I've mentioned this song because it is an example of the emergence of a new, more personal point of view: the torch song had arrived to stay.

In 1916 came a delightful, jaunty little rhythm song called *Pretty Baby*, by the Negro pianist Tony Jackson and Egbert Van Alstyne. Its most provocative idea is its opening phrase, and it's another chord-based line, suggestive of an instrumentally oriented writer, though it sings with great ease. As familiar as the melody is, I'd still like to show you these charming opening measures.

Pretty Baby

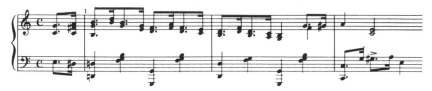

There is one measure which singers down through the years have simplified, and as far as I'm concerned, for the better. It's measure

nine, and the note that is changed is the *b* flat, the second-to-last note in the measure. It's now sung as *a*.

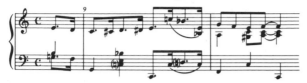

You will see that at any respectable rhythmic tempo the *b* flat is hard to grab.

I find it a healthy, natural, original song, well worth its reputation as a standard.

In 1916 Raymond Hubbell wrote his only memorable song, *Poor Butterfly*. It was from the production "The Big Show" and remains one of the loveliest ballads I've ever heard. It is extraordinary that a man who revealed such talent in this song should have failed to write anything of nearly its quality. He did write many scores for shows which were produced but, strangely, *Poor Butterfly* remains the only song for which he is remembered.

There's not a word of criticism I can conceive of for it. Its verse is written in a deliberate oriental manner, and though its purpose is strictly expositional, nevertheless it creates a proper mood for the chorus without in any way revealing what is to come. After three "held" pick-up notes the melody falls on the fourth interval of the scale which is a whole note tied to a quarter note in the second measure. It is the very best example I know of the romantic potential of this interval, which under unromantic circumstances should never be stressed simply because it then comes off as a weak note. The song's form is *A-B-A-C* and is of conventional thirty-two-measure length. Here is an instance where the entire chorus should be illustrated. But I will quote the first part of it and trust that you can recall the rest.

Poor Butterfly

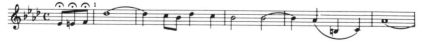

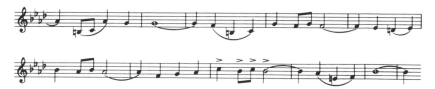

There isn't a suggestion of contrivance in this melody. It flows as freely as sometimes a song does from the pen of one who is truly inspired. It sounds as if it had come to the mind of Raymond Hubbell in a single sitting, with not a phrase polished or revised. Of course, part of professional talent is the ability to create such a seeming inspiration while actually having spent hours of change and consideration of multiple choices before finally resolving the creative problem with such a superbly natural melody as that of *Poor Butterfly*.

In 1917 Shelton Brooks erupted with *The Darktown Strutters Ball*. Frankly, I'd have been glad to settle for *Some Of These Days*. But not Mr. Brooks.

When I first heard the Six Brown Brothers' (six saxophones) record of this song many years ago, I knew I was listening to something special. Even though by 1917 writers were catching on to the fact that there was more to the American popular music potential than they had ever dreamed, this song stood out far above the average pop song of the period. And particularly unusual for those or any days, it had a very good, driving verse. There's something so free and easy, so insouciant, about a chorus which dares to start out with Mr. Brooks's line "I'll be down to get you in a taxi, honey." And the melody has the same flexible, pliant, yet swinging air about it.

Illustrations of a song as deeply imbedded in the American ear as this is needn't even be offered. But I think it wise to try to erase all memory of it, and then before memory insidiously gets a chance to reassert itself, go over the tune with complete detachment. If you can manage such a miracle, you'll find that this is a simply dandy tune.

I'd forgotten until I re-examined it that toward the end of the chorus it has two marvelous "break" moments in two successive phrases: first where it says "goin' to dance out both my shoes" and then "when they play the 'Jelly Roll Blues.' " It's as if the rest in the music following those phrases were meant for a tap dancer or an instrumental "riff." And probably they were.

Also in 1917 came George Meyer's *For Me And My Gal*. One so inevitably associates this song with Judy Garland's revival of it that it is not easy to examine it with detachment.

Before discussing the chorus I must mention that the verse employs a marvelous device in the very first measures.

For Me And My Gal

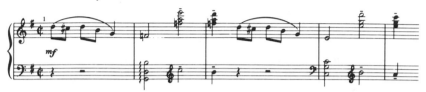

I find the *f* natural in the second measure both very effective and wholly unexpected. And its resolution in the *e* natural of the fourth measure rounds out my enjoyment.

The chorus is of conventional thirty-two-measure length and its form is *A-B-A-C*. It is a melody of narrow range, only one octave. It's by no means a great song, but it's also not a hack song. It is well-conceived vocal writing and has a charming final section, which, had you never heard the song, would come as a very pleasant surprise.

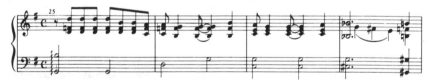

I'd like to make one point about the difference between the sheet music and any performance of the song I've ever heard. In the four measures which employ a quarter note triplet, such as the second measure (to the words "me and my gal"), I've only heard two eighths and a quarter, never the triplet.

Also in 1917, Art Hickman, a former tap dancer and successful band leader, wrote the music for a song which has been worked over with as much assiduity as *How High The Moon*. And, though it's called *Rose Room*, the title is never mentioned in the lyric of the chorus, and only for a moment in the verse.

After only the most cursory examination of the song, one can see why it was picked up by bands. It's more than the tune, though it's a good one and easily mistakable for a late twenties type of song; it's really the "changes," the harmonic patterns, which caught their fancy. There's no chord stretching which often occurs in pop songs, which is to say keeping the same chord going for longer than good taste dictates. In *Rose Room* the harmony constantly shifts and no chord is held for longer than two measures. This is meat and potatoes for a jazz improviser. The following will give you some notion of this.

Rose Room

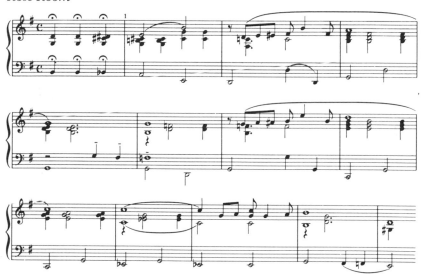

Also the fifteen whole notes in the melody provide lots of room for arrangers' figurations and orchestral devices. It's a good, loose, natural song, as I said, definitely ahead of its time. This may well have been due to its having been written by a band leader.

In 1918 Bob Carleton wrote *Ja-Da*. It's only a sixteen-measure bit of fluff, and yet I doubt if any even casual pop song listener would

fail to recall it. It fascinates me that such a trifling tune could have settled into the public consciousness as *Ja-Da* has. Of course it's bone simple, and the lyric says almost nothing, except perhaps the explanation of its success lies in the lyric itself. "That's a funny little bit of melody—it's so soothing and appealing to me." It's cute, it's innocent, and it's "soothing." And, wonderfully enough, the only other statement the lyric makes is "Ja-Da, Ja-Da, Ja-Da, Ja-Da, Jing, Jing, Jing."

In 1918 Henry Creamer and Turner Layton, an outstanding team of Negro song writers, published *After You've Gone*, one of the most long-lived jazz standards. And if by this time I haven't conveyed to you by illustration and citation what I mean by an American-sounding song, *After You've Gone* should tell you.

The verse is adequate enough for Mildred Bailey always to have sung it, but it has no special measures which suggest illustration. The chorus has many interesting characteristics. First, it is only twenty measures long. If one uses four instead of eight measures as sections, the form is *A-B-A-C* and a tag based on the opening phrase. Second, it opens on the subdominant chord (*f*, in the key of C). Third, no chord holds for longer than a measure and in most instances only for half a measure. This fact is an instant attraction to the improviser. Fourth, its seventh and eighth measures suggest a "break" (where everything but the solo voice or instrument stops). Also the lead-in notes at the end of the eighth measure I've oftener than not heard sung or played as part of the melody. If sung, words of the ilk of "oh, honey" are used for these pick-up notes. Again, I feel the performers' use of these notes as part of the melody is right. One more point: I've never heard the elided phrase (*e* and *c* eighth notes tied to a dotted half note) used in the final cadence. Simply the *c* whole note. Again, I believe this is a better choice.

If you somehow don't remember, here are the first eight measures:

After You've Gone

These measures in the closing section, to me, are as American as a song can get.

In 1919 the Negro writers Charles Warfield and Clarence Williams wrote a short, and, to me, very sweet late-at-night song called *Baby, Won't You Please Come Home*. Of course, after hearing George Thomas sing it with McKinney's Cotton Pickers, I felt an immediate prejudice in favor of the song. It's a perfect singer's song, suggesting a much slower approach than the "medium bounce tempo" indicated on the sheet music. And it, like *After You've Gone*, could have come from nowhere but here. Just the first half of the chorus reveals that.

Baby, Won't You Please Come Home

Note the phrase in measure five with its unusual opening *f* natural, and also the marvelous eighth-note triplet at the end of measure six!

Singers tend to take liberties with this melody, not impolite ones but those which the harmonies suggest, and for once I am on the side of the singers. I don't mean that the melody should be distorted to the

degree of risking its identity, but rather that it almost asks for slight vocal improvisatory moments. I may be saying this as the result of the performances I've heard. But not entirely, as, when I run over the vocal line, I find myself singing not precisely what's written. That is not to imply that the song could have been better written, simply that it has an air of permissiveness about it.

VII

The last song to be discussed in the "transition" era goes beyond our time boundary of 1920. It was published in 1921, by a "one-shot" writer, W. Benton Overstreet, and was called *There'll Be Some Changes Made*. I am placing it here because it tends to sum up great changes, and, of course, predict new ones.

I've always loved it and, until this survey, have never thought of it in terms of when it might have been written. For there it was, a good, groovy song with an equally good lyric (by Billy Higgins). It's only eighteen measures long; it attempts nothing special; indeed, its attractiveness lies in its seeming not to have tried, to have simply happened at a time and place when everything was conducive to noodling around until a happy idea unfolded and before the noodler knew it, he had a song. It has none of that Tin Pan Alley, "let's write a hit today" quality about it. And in this case, the fact that the first four measures use only two chords doesn't lessen the charm of the song at all. It's so relaxed and honest that, as far as I'm concerned, it could do, and did, anything it had a mind to.

As the title says, there'll be some changes made, musical changes, from this point on in popular music. More sophistication, more complex melody writing, much more involved harmonic patterns, shifting song form, greater elegance, and infinitely superior theater song writing. And, fortunately, writers like George Gershwin and Harold Arlen among the theater writers, and Duke Ellington and other less well-known Negro writers, never forgot the invaluable heritage bequeathed them by the early anonymous Negroes who, in spite of their dreadful, ignominious plight, had managed to create the beginning of an entirely new music.

But they weren't all just beginnings. For some of the spirituals, work songs, blues, and ragtime songs can never be improved upon and so should certainly be given the same respect as later, highly developed commercial songs.

2

Jerome Kern
(1885-1945)

I

In this flamboyant age in which it is unsurprising to read grotesquely extravagant tributes to the creations of untutored amateurs, I choose to pay my own more tempered respect to the work of a highly polished professional song writer, Jerome Kern. In an earlier age, when professionalism was considered an essential element in creative evolution, two American theater writers swiftly gained popularity—Victor Herbert and Jerome Kern. Though Herbert was a highly trained and talented writer, his songs never achieved the native quality of Kern's. And as a result he never had the influence on future writers that Kern did. Herbert remained a European operetta writer, while Kern became a master of a new kind of song, perhaps unlike any other theater music heard up to that time. An indication of this is the fact that a great many of his songs remained standard musical fare until the end of the professional writer's era.

In his earlier efforts it was not nearly so evident as later on how extraordinary his talent was. Nor did his songs strike the public as "Americanly" as did those of Berlin, Youmans, Gershwin, and Arlen. Yet one must remember that, except for Berlin, their first songs were written many years after Kern's, and that the world of American popular music had changed greatly by the time they began writing. But without any doubt, Kern does exemplify the pure, uncontrived me-

lodic line more characteristically than any other writer of American theater music. Long before I knew the first thing about music, I knew his melodies. They pleased me, they even haunted me. In the days when I first became aware of his songs, he had not become as involved in complex harmony as he did later. But even when he did use more elaborate harmony, and I had become involved myself in the excitement of lush harmonic patterns, I didn't need to know or hear his harmony in order to enjoy thoroughly his lovely melodic flights. Once he freed himself of his European predilections, and after publishing many more songs than I would have believed possible, he never lowered his sights. He continued to experiment, he took breathtaking chances, and practically every time he did they were accepted and absorbed by the public as a part of the American musical ethos as much as the songs of simpler, much less sophisticated, untutored writers.

The financier Otto Kahn, his biographer Mary Jane Matz tells us, "approached Jerome Kern . . . with a suggestion that he write an opera for the Metropolitan. It was said that he discussed a similar project with Irving Berlin. . . . Gershwin was the third composer Kahn had considered." Kern may have protested, as Berlin is supposed to have done, that he was not equipped for so musically complex a task. Whether or not Kahn did, in fact, make a firm offer to any one of these three great song writers, the tale tends to substantiate the feeling I get that Kern deliberately stayed away from large compositional forms, despite his background and formal training. He never was tempted by the evening-dress world of symphonic music, except for the *Mark Twain Suite*, which he wrote for André Kostelanetz—a composition of little distinction. He didn't use his eminence in popular music to wangle his way into the concert world through the good, ghostly offices of arrangers, orchestrators, and anonymous helpers. He accepted and was proud of his smaller framework of song. And within it he never ceased to grow.

There were, indeed, occasions upon which he reverted to his enthusiasm for English and Viennese musical manners, and he never could have been called a truly "swinging" writer of songs. One can't imagine him being excited by Duke Ellington's music, let alone the experiments of Gerry Mulligan with a ten-man group (a "tentet"). But, there stand those melodies, straight and healthy, and ever green.

Shelton Brooks had no European cage to escape from, though he grew up in Canada and loved Victor Herbert's songs. Irving Berlin fought his way up out of extreme poverty and had no time or money to indulge in "culture." As for George Gershwin, by the time he became culture-conscious, he was so indelibly labeled an American product that he risked his identity by slipping into European musical mores. Let's say he settled simply for French harmony, as did most arrangers of the thirties, excepting the driving Negro swing band arrangers.

There was, of course, a certain advantage for Kern in his reticence with regard to composing formal concert music. I once heard the composer of a small, quiet, chamber orchestra piece bemoaning his limited spectrum. Another composer, who had completed a large, imposing orchestral piece, interrupted him and remarked: "Well, who knows my piece is mine? Anyone would know right away that your piece is yours." That's the way it was with Kern's songs. They might shift emphasis, be more or less experimental in structure or harmony, but you always knew they were his. Or almost always. That can be said of very few writers.

Before examining those of his songs which I consider to be worthy innovations, let me say that I have played and analyzed 652 Kern songs from 117 shows, plays, and films. These include the posthumously published songs for which Dorothy Fields wrote lyrics. Between 1904 and 1917, inclusive, Kern had interpolated songs in at least forty-three musicals and plays. Thus, for thirteen years he was represented in an average of four different Broadway shows each year. I have examined 118 songs from these shows. It seems unlikely that any other theater composer ever equaled Kern's incredible record.

II

All the prominent American composers of modern theater music, living and dead, have acknowledged Kern to have been the first great native master of this genre. Without exception they consider his songs a greater inspiration than those of any other composer, and his music to be the first that was truly American in the theater. While no one

would deny the influence of English operetta writers in his early songs, he was, in the opinion of all the great surviving theater composers, the first to find a new form of melodic writing unlike that of his predecessors or contemporaries.

Without question he wrote a great many flawless melodies which have become as intrinsic a part of the American ethos as Stephen Foster songs, musical comedy (as opposed to operetta), jazz, detective stories, or any other of those creative phenomena which are accepted as indigenous to this culture. And yet his early songs, all of which were interpolations in stage productions of the first decade and a half, did not, with rare exceptions, reveal any characteristics which constituted evidence of his later mastery of the musical theater song form.

I realize that this opinion is a contradiction of that expressed by Kern enthusiasts, who claim that from his beginnings he revealed signs of his later superb talent. I have examined very carefully every published Kern song I have been able to find, and I admit that I was astonished to find in his early work only capable, professional, but uninspired songs in the operetta tradition, by no means superior to those of his contemporaries, and in no way indicative of what was to come. Orchestrated and sung in the setting intended for them in the theater, they undoubtedly, as theater people say, "worked." But since this survey is limited to songs per se, I cannot leave their pedestrian character unremarked. The very fact that his great songs have survived in the public ear without the aid of their theatrical setting is reason enough to ignore the criterion of workability on the stage.

Among all the songs written before *They Didn't Believe Me*, always cited as evidence of Kern's early divergence from the writing style of the era, I have found only one which bears the faint scent of his much later work. It wasn't, as some aficionados might expect, *How'd You Like To Spoon With Me?* (copyright 1905), which I find unworthy of consideration in its almost doodling slightness which, inevitably, first songs have. The song I have chosen is from a show called "The White Chrysanthemum" and its title is *I Just Couldn't Do Without You*. It, again, is slight, but it is much more inventive and less amateurish. Both songs are short but the second one contains a surprising tag* of two measures which gives the song an ingratiat-

* A short, unexpected epilogue to a song.

ing swirl. Granted that neither song has the quality of the then-current European song, yet only the second, in its difference, has character. Not a great deal, to be sure, and not by any means Kern-like, but at least direct and containing unexpected intervals and the already mentioned tag. The last ten measures of the song—nine through eighteen, with the two pick-up notes from measure eight— are shown below. (The harmony, which is without any particular interest, is not included.)

I Just Couldn't Do Without You

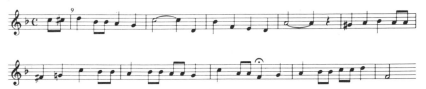

This song was copyrighted in 1907. From then until 1914 I have been unable to find any song worthy of discussion or illustration. And this in spite of a statement by Max Dreyfus, Kern's publisher for many years, who once said, "Jerry's music never changed."

Well, thank heaven it did. For I believe that had he not grown in style and invention, he would not be remembered today. And more than that, even when he did become a sophisticated, memorable writer, he still continued to change. If one chooses to compare any of Kern's early great songs, such as *Wild Rose* or *Look For The Silver Lining,* with *Nobody Else But Me* or *All The Things You Are,* it is obvious that a great change had taken place between those two phases of his writing career. And, parenthetically, in spite of their great dissimilarity, I believe it is possible to have sensed that the same man wrote all four songs, if only by a process of elimination, as no one else ever wrote naturally in his fashion.

Kern's career, as one sees it now, tends to fall into four phases: 1902 to 1915, the year of the first of the experimental Princess Theater shows; 1915 to 1927, the year of "Show Boat," another departure from the conventional; 1927 to 1935, the year of his first film score; and 1935 to his death, his years in Hollywood. Musical comedy, so-called, was not in existence here at the time Kern was writing his early interpolated songs for operettas he helped "Americanize" for

Broadway. Operetta was then the most popular form of musical thea-
ter in America. It was almost indistinguishable from its European
counterpart, which had Vienna as its center. It may be significant that
London theater composers in the 1890's rebelled against imported
Viennese and French musicals and, at the Gaiety Theater, began to
create a new form called "musical comedy." Kern, one is reminded,
began his professional theater career in London in 1902. The sense
of excitement in the air was not lost on him.

But, as his career demonstrates, Mr. Kern was a practical man. He
adjusted his sights to the demands of the Broadway producers. He had
admired Victor Herbert and, as a high school boy, had paid him the
tribute of a juvenile imitation. He had Viennese leanings, as it were,
but he may also have begun experimenting in the area of the more
American-sounding songs which were beginning to be heard in vaude-
ville, in music halls, and on records (though the latter emphasized
tried and true opera and operetta arias). But even if he were actually
trying his hand at the new music growing out of ragtime, he ob-
viously put those experiments to one side and wrote with a practical
eye on the marketplace. He wrote, that is, what was required in the
theater of the day.

He is known to have been deeply concerned with every facet of
musical theater in addition to the score, realizing the interdependence
of all of them. Yet I find no particular evidence that his early songs
bore the relationship to plot or character which his later songs did,
though, perhaps, their lyrics may have. They were undoubtedly more
attractive on the stage than in the bare bones of the sheet music, but
they contained few elements of surprise, shock, experimentation, or
the quality of having been written for an American audience.

In 1914, however, in "The Girl From Utah," Kern had an inter-
polated song, *They Didn't Believe Me*, which was a definite departure
from all the songs which preceded it. Outside of its un-Viennese
freshness, there are several interesting oddities about this song. The
verse has a trace of musical character, as had few of the many verses
of Kern's earlier songs. Yet it still seems to have been written at an-
other time than the chorus, so much so that the chorus comes as a
total surprise. It is hard to consider them as part of the same musical
experience, in spite of the adroitness with which the verse leads into
the chorus.

Harmonically, the chorus is solid if unspectacular. Indeed, the stronger Kern's melodies were, the less they needed interesting harmonic patterns, and well might have suffered from them. The melodic line of *They Didn't Believe Me* is as natural as walking. Yet its form is not conventional even by the standards of that time. In song writing parlance it may be broken down in eight-measure phrases as A-B-A^1-A^2. I can't conceive how the alteration of a single note could do other than harm the song. It is evocative, tender, strong, shapely, and, like all good creations which require time for their expression, has a beginning, middle, and end.

There is a harmonic novelty in the second, or B section of the song which lies quite outside popular music conventions and patterns, and one which suggests that the harmony may well have influenced the melody at this point. Since harmonic influence on melody in this phase of Kern's career was very rare, it may be well to illustrate it.

They Didn't Believe Me

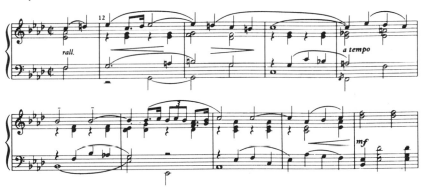

It is also interesting to note that in measure thirteen Kern slyly introduces in the melody a d natural (which is not in the A-flat scale), to prepare his listener for the d natural essential to the harmony in measure fourteen.

Before leaving this song, I might observe that writers on such matters always mention the use of the triplet in the first A^1 section. Since it is the only triplet in the entire song, it occurs totally unexpectedly and yet without awkwardness. Still, there is a mystery in the accompanying lyric. The full phrase reads: "And I cert'n-ly am goin' to

tell them." The words "cert'n-ly am" must be sung in *three* syllables to fit the triplet illustrated above. No one ever attempts this impossible feat. Singers long ago changed the lyrics to: "And I'm certainly goin' to tell them" with the word "cert'n-ly" neatly fitted to the triplet. The tale that Kern wrote the triplet to accommodate the lyric is illogical. But the mystery remains: why has the uncorrected lyric remained in print since 1914?

The second song which shows Kern's emergence from the operetta cocoon, though of coarser grain and certainly more boisterous in nature than *They Didn't Believe Me*, is *You're Here And I'm Here* from "The Marriage Market," also in 1914. Today it would be printed in 4/4 time instead of 2/4, as it was then. The song is a series of imitations of the initial phrase, the principal characteristic of which is a pronounced syncopation at the end of the third, seventh, nineteenth, and twenty-third measures. It obviously seeks a native point of view, and though it hasn't the curious quality that makes for comparative permanence (the standard song), it is worthy of mention as another bar sawed away from the cage of imported culture.

You're Here And I'm Here

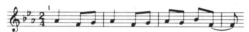

The 1914-1915 season marked an end and a beginning for Kern. "The Girl From Utah" opened on August 24, 1914. Even though Kern wrote most of the songs used in the American production, the show was an English importation, and Paul Rubens, a leading English theater composer, retained his program and sheet music credit as the principal composer. However, *They Didn't Believe Me* was so great a success that to this day "The Girl From Utah" is thought of as Kern's show, and rightly so. At any rate, Kern's career as the leading composer of interpolated songs in the history of Broadway was now over. From the turn of the year 1915 he was on his own, so to speak—the principal, or sole, composer of a long succession of "Kern shows," many of them historic. As my illustrations have implied, there was little indication in the first phase of Kern's career of what almost immediately followed it.

III

As though to signal his newly-found independence, Kern rounded out the 1914-1915 season by writing the score for "Nobody Home," which opened April 20, 1915. The few interpolations were by others. The show was the first of a memorable series, produced at the small Princess Theater, that brought a distinctively American flair to musical comedy. The second of these bright and charming productions was "Very Good, Eddie," which opened two days before Christmas 1915.

It may seem superfluous to mention a song in "Very Good, Eddie" called *Thirteen Collar*, since it was obviously not intended to be more than a framework to support a comedy lyric. However, not only is the many-noted melody of both verse and chorus loose and casual, but the harmonization and voicing of the piano part is inventive and witty. Since it is attested that Kern demanded strict adherence to his harmonizations in the publication of his songs, the published harmony of this song is worth his having insisted upon.

The chorus, as would be defensible in a comedy song, is only eight measures long, but its melodic line in the fifth and sixth measures is so entertaining and devil-may-care that it deserves to be cited.

Thirteen Collar

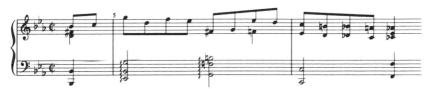

These measures have no Kern characteristics, but they denote a growing freedom, almost as if he'd just heard a Dixieland clarinet player. And, while playing the fifth measure I was forced to wonder if by any chance Kern had been bemused by *Peg O' My Heart* (1913).

Then, in 1916, in "Miss Springtime," there appeared another true Kern ballad, *My Castle In The Air*. This is the first time, in my opinion, that Kern not only wrote a fine verse, but wrote it, in a manner of speaking, at the same sitting as the chorus. The two belong together. The verse leads up to, and into, the chorus, as every proper

verse should. In this instance, P. G. Wodehouse's lyric is as lovely as the music, and it works well from beginning to end.

The verse and chorus combined are only thirty-six measures long. Yet one does not feel cheated, though choruses alone are now often a minimum of thirty-two measures. In the verse, Kern's melody is clearly guided by his harmony, which moves out of the key of C major into E major and quite acceptably back to a G-seventh chord, which he marvelously manipulates so that you don't feel he has telegraphed his punch when he winds up four measures later on a G-seventh chord. Nor, and this doesn't seem possible, do you feel swindled when the chorus continues on with a G-dominant-seventh chord. There's no doubt that Kern's melodies can be so strong as to permit him at times an abuse of harmony. In this instance, one would have thought that an editor or friendly piano player would have made a comment. And maybe one did and maybe Kern sensed that in this case he would risk wrong harmony, or at least frustrating harmony, rather than touch the melodic irresolution (the dominant) of the verse. May I presume to add that had he designed the last note of the verse so that he could have employed a chord which would have led more reasonably to the dominant seventh at the beginning of the chorus, he might not have been able to make the transition from verse to chorus sound so natural. It wasn't due to unawareness of what he was doing, for he has already revealed his awareness in his design of the verse.

My Castle In The Air

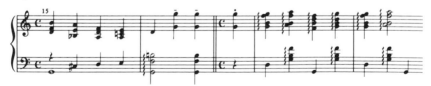

Verses, in my opinion, a point of view I happily find supported in repeated examples in the songs of Richard Rodgers particularly, should have a greater freedom of form than choruses. To be quite hardheaded, the first eight, or at most sixteen, measures of a chorus are what will determine its popularity, never the verse. Yet I, for one, have been saddened to see the slow death of verses, particularly in

ɔop songs. I can't believe that it's the fault of the singers, but rather,
the hard-sell attitude of the recording companies.

In the show "Have A Heart" (1917), with the complete score by
Kern and lyrics by Wodehouse, the hit song was *You Said Something*.
It is a solid, aggressive, rhythmic song of no particular distinction,
uncomplicated and direct. But the song from the same show which
has always caught my fancy and amazed me by its serious inventive-
ness is *And I Am All Alone*. It was fairly well known at the time of
the production's run in New York, but failed to become a standard
song. I have never understood this, unless the reason for its obscurity
lies in its melody being based upon a pattern of unusual harmonies.
I learned it at an early age without any difficulty and without being
aware of its unusual character, but lately, in reviewing it, I realize
that, in its time, it must have been a phenomenon.

Its key is F major. The three lead-in quarter notes give no warning
of the unexpected G-seventh chord at the beginning of the chorus.
The harmonic progress of the song is four measures of a G-seventh
chord, four measures of C seventh, four measures of F seventh, four
of B-flat major, four of B-flat seventh (and B-flat ninths) and, like
sleight of hand, back to four measures of G seventh, then F in its sec-
ond inversion, a measure of G seventh, a measure of C ninth, and a
cadence in F. For an average musician this may sound run-of-the-
mill, excepting, perhaps, the return to G seventh from B-flat seventh,
but for those days to superimpose an attractive melody on such har-
monies was very nearly unprecedented. Also, the use of a quarter note
triplet employed in the eleventh, fifteenth, and twenty-seventh meas-
ures is not only unusual, but the way in which the melody moves in
those triplets was extremely adroit. To judge from the first two trip-
lets, the lyric was not the cause of them, as a single syllable is used
under the first two notes of each triplet. Only in the third triplet is
a syllable used for each note. Does this imply that Kern at these
points in the song wanted to use triplets and did so in the manner of
composers of art songs who often force single syllables to serve more
than single notes? I believe that this is likely if one keeps in mind
Kern's other pretensions to elegance.

Before speculating on the reason for this curious metric awkward-
ness between words and notes in a song by a man who might be said
to have advertised his elegance through the use of concert hall diction

(*burthen, tempo di blues, poco meno mosso,* and so on), it might be useful to consider his own preference in the sequence of writing the words and music of a song. The general recollection of the lyricists still living who worked with Kern is that he much preferred to write the music to a song first and let the lyricist fit the words to the music. It is also generally recalled that he was adamant in refusing to make even the slightest change to accommodate a felicitous phrase or rhyme in the lyrics. (It might be noted that the very best lyricists, including those who worked with Kern, pride themselves on not *asking* for any accommodation, preferring to pursue their own exacting art under the most demanding discipline.)

In this instance, two questions pose themselves. If the words were written first, did Kern simply ignore them in laying out the triplets? If the music was written first, did Kern, following his usual practice of later years, refuse to adjust the music to the words? There is, of course, no way to answer either question. (It is amusing to note that Kern himself had a hand in the words; he and Wodehouse were the co-lyricists.)

By the twenties, songs which had formerly been published in 2/4 were being republished in either 4/4 or cut time (*alla breve*), and new songs almost never used 2/4. It is fairly well verified that this shift in time signatures, and the resultant doubling of the values of notes (eighth to quarter, quarter to half, and so on), was due to the shift in dance fashions.

Sigmund Spaeth (*A History of Popular Music*) has pointed out that between 1910 and 1920, "the period in which America went dance mad," the use of the *fermata* and "frequent indications of 're-tards,' to slow up the tempo" in popular ballads, began to disappear because the dancing public demanded strict-time music in 4/4 in order to fox-trot properly. "After 1910 the publishers of popular music became more and more insistent that a song be danceable in order to achieve real success." The impulse of the new songs was smooth and rhythmically regular: "mostly fox-trot '*alla breve*,' " stressing the first and third quarters of the measure.

This may well account for *They Didn't Believe Me* being printed in *alla breve*. It is conceivable but unverifiable that its note values, when first performed in the theater, were all half those in the sheet music.

But for its throw-away verse, *And I Am All Alone* is so unusual

that it deserves complete illustration. This, however, is not possible as music publishers do not allow reproductions of full choruses. And this song is hard to come by, in case you should like to buy it.

In 1917 Kern wrote other scores; among them was that for "Love O' Mike," in which there are three songs worthy of brief comment. The first, *Who Cares?*, has a verse of no more value than to help state the lyric. But the chorus is of interest in that its first seven measures have seven different time signatures: 3/4, 2/4 and 3/8, 3/4, 2/4, 3/8 and 3/4.

Who Cares?

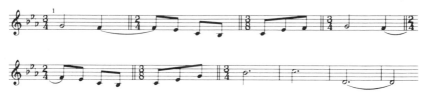

This oddity would come as a surprise even in a concert song. It could have been achieved less complexly by keeping it all 3/4, which could have been arrived at by making the three eighth notes of the 3/8 measure a triplet, as follows:

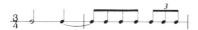

The song is charming, of a wide range, and obviously experimental.

The second, *It Wasn't My Fault*, though not a great song, should be mentioned insofar as it bears the stamp and style of the new Kern —a direct, smooth, unclever melody, unencumbered, in *alla breve* time, used here for perhaps the first time since *They Didn't Believe Me*. (One had best keep in mind that the original plates of the latter song may not have been in cut time, but 2/4 or 4/4, and were then changed to suit the then-new fox trot.) The only jarring element in the song is the last eight measures, which are uncharacteristic, trite, explainable only as an unusual concession to the lyric, and cause the song, as far as I'm concerned, to fail precisely at the point where it should succeed. The verse is pedestrian, a series of characterless imitations of its initial phrase.

The third song, with a slightly more interesting verse, is *We'll See*, again a cut-time ballad of moderate charm and certainly a more tasteful ending. It is listed here only as a small arrow pointing the way toward the Kern to come.

Now we move on to two songs from the show "Oh, Boy!," amazingly enough also a 1917 production. The more famous one is *Till The Clouds Roll By*, which was, Mr. Wodehouse believes, "more or less of a steal from an old German hymn." It does have a hymn-like purity; however, not specifically Germanic or stodgy. It's forthright and uncluttered, employing a minimal number of notes, every one of which counts. It is typical of the great Kern "pure" melodies, which need nothing besides themselves to fulfill their task of pleasing, and also of delineating all the characteristic elements of his style. It attempts no deviation from its key center; in fact, there is not a note outside its printed key. It is strong without being self-conscious, a completely natural and memorable melody, unmistakably his own.

Its verse is more ambitious and academic; to me, rather prissy and over-cute. It moves into other keys, employing what later became for Kern a distinguishing device, the enharmonic change. In this instance it is not of enough interest to quote. My lack of enthusiasm for the verse is due to the fact that I don't think it adequately prepares the listener for the ensuing chorus.

The second song is somewhat uninspiredly entitled *A Pal Like You*, with an unnotable lyric. But the song, though containing, for me, oddly unnatural juxtapositions of notes and unsatisfying phrases, nevertheless moves inexorably ahead to its untypical but satisfying ending. Kern uses the rhythmic device of a quarter, half, and quarter note (♩ ♩ ♩ | ♩ ♩ ♩ | ♩ ♩ ♩ | etc.) throughout the song, interrupting it only for whole-note cadences, two measures of quarter notes in the middle of the melody, and three measures of quarter notes just before the last cadence.

It looks to me as if, perhaps against his will, he made an adjustment to the lyric just before the song makes its restatement after the first half. For unless the singer pauses between the last quarter note of the sixteenth measure (not a lead-in note but the last quarter of a phrase) and the first note of the new phrase, there must be a problem of breathing, or if the song is played as an instrumental, a problem of ending one phrase and articulating the first note of the new one. Per-

haps this is where the singer indulges in "cheating," probably by turning the last quarter note into an eighth note, trying to sneak an unobvious breath before proceeding with the song.

A Pal Like You

There is a happy succession of quarter notes at the end of the song, twelve quarter notes, which again may impose a breathing problem on the performer. But it's so engaging that it was obviously worth the chance. The last two half notes before the final cadence are interesting insofar as this is the only occasion I know of in which Kern so employed them. Normally he would have raised the second half note to *d*.

One expects, and particularly from Kern, a rise from the *c* to the *d* and then to the *e* flat. The two *c*'s would have been less a surprise from any of a number of later writers, but from Kern, because of his tendency to write the "proper" musical phrase, it comes as a shock. I prefer his decision here because it fooled and pleased me simultaneously, as well as maintaining richer harmony as the result of the second *c*. It is a dominant ninth, always fatter than a dominant seventh.

I think that the song's sturdy, extrovert, almost march-like absence of "innerness" is what catches my fancy. Also, that it's planted on native soil, with its insistent initial rhythm, much as the songs of Youmans often were: *Bambalina, I Know That You Know, Hallelujah*, for example.

And now (and it's hard to believe) to another show, even better known, from 1917! "Leave It To Jane" contained a solidly "new Kern" score, including the standard *The Siren's Song, The Crickets Are Calling*, and *The Sun Shines Brighter*. The last two are less well known today but in their time were hits. I am surprised that *The Sun Shines Brighter* was never picked up by the big bands, for it contains all the requirements of a swinging song, though its treatment in the show might have shown no sign of its "swingingness." It would be

tedious to examine it for that quality; I'd rather say simply that as an arranger I would be pleased to work with this song for any surviving big band.

I am told that in the revival of "Leave It To Jane," *The Crickets Are Calling* was played and sung in the 2/4 rhythm in which its sheet music is printed. This seems a most unmusical mistake and represents an unawareness of the implicit sadness of the song, both lyrically and musically. It may have been due to its context in the show that it was performed as written, and Kern may even have written it without being aware of its bittersweet sadness if played or sung as a slow ballad. I'm certain that had I heard it as written I'd never have remembered it all these years.

It's a short, sixteen-measure song, with a lovely Wodehouse lyric which almost begs the listener to be sad. Its initial phrase recurs only in the two measures before the end, and in between it moves high and low without, however, becoming dramatic or melodramatic. Its only flaw for me is the same as in *A Pal Like You*, and in the identical spot, just before the second half of the song. It demands that the performer "cheat." Yet in the case of this song, it is even more difficult to cheat, as a new image is projected in the lyric which requires some kind of pause, that is, if sung. If performed as slowly as I believe it should be, such cheating would be much more easily effected.

There may be a printing error in the lyric at this point, as it reads "time always flying" when it seems more precise to say "time's always flying." In examining the verse, which is adequate but not special, I find that Wodehouse tells us that the crickets "laugh and play the long day thru; And *merrily* they sing to you." Well, those words surely make a travesty of my plea for a slow ballad. Yet I still sing it to myself that way and I'd be grateful were some tasteful recording artist to do the same.

The verse of *The Siren's Song* is a truly sound introduction to the chorus. And my remembering it, as well as the chorus. after all these years is, for me, a point in its favor. It is a short song, probably played in its later years more slowly than originally intended. It indulges in no harmonic flights, it has a recurring syncopation, it is of a very narrow range (only the spread of a ninth), and its introductory statement is repeated only at the end of the song. It, again, has the

element of "swingingness" which, though written long before bands had begun to break loose, nevertheless works naturally in that later idiom.

Another song, which was dropped from the show before the opening, seems to me to deserve mention here. It's called *It's A Great Big Land*. I had never come across the sheet music for the song until I began this survey. The lyric says little, although entertainingly, and the music of the verse bounces along pleasantly and leads very naturally into the chorus. The latter is by no means typical of this phase of Kern's writing, but it interests me because it moves about freely and almost as if Kern had been listening to some early jazz.

The very first measure fascinates me not only because of its sudden four-squareness, but because it's so unlike anything of Kern's up to this time. Then the descent to the *f* sharp in the eighth measure is in the manner of an instrumental line and totally divorced from the European musical point of view. Only on the *e* natural, the last quarter of measure eleven, followed by the *c* in the next measure, is there an intimation of who has written the song. And finally the drop of a tenth in the fifteenth measure, so instrumental in quality, convinces me that Kern had started to listen to the new music that was burgeoning all about him.

As if to prove the impossible in terms of how many songs he could write in one year, Kern wrote the score for another show flatly called "Miss 1917." In it there is only one song I find of interest, *Go Little Boat*. Here Kern wears the piping on his musical vest, which he sporadically continued to do throughout his career in such songs as *The Touch Of Your Hand* and somewhat in *The Song Is You*. In this instance it is immediately revealed by the professional use of E major (four sharps) instead of the simpler E flat (three flats) or F major (one flat). I am aware that each key possesses different characteristics and enhances either aggressive or passive points of view. For example, D flat invariably sounds warm and romantic, A flat slightly less so, B flat even less. D natural helps maintain a strong, forceful musical attitude, as does A natural. Strangely, however, E natural creates a soft, passive, pavane-like mood. Perhaps I should qualify all this by saying that this is true of these keys harmonically more than melodically.

Go Little Boat is, for the most part, a pleasant barcarolle, set up by
an accompanimental figure in the piano for two measures preceding
the chorus. But it irritates me by becoming, as it develops, over-
involved harmonically and thereby melodically, and reaches for a
dynamic and melodic climax toward the end unjustified by any such
intention in the lyric. Or perhaps the lyricist simply failed to achieve
an equivalent climactic point.

There are also two pointless measures in which two quarter notes
would serve the purpose much better than the eighth note followed
by a dotted quarter. In the first instance the words are "stars I see."
Why "stars I" are set as an eighth and dotted quarter I fail to under-
stand. Four measures later the words are "carry me." Why couldn't
two quarter notes, which would have sustained the quarter and half
note character of the song, have been used?

Go Little Boat

This song bears all the flavor of a song by a man engaged in writing
a musical comedy score who had returned to his piano from an art
song recital and decided to have it both ways.

There were, it is hard to believe, even other shows in 1917, but in
none of them were there any songs which concern us here. In 1918
there were also four new Kern scores, but few great songs. It is inter-
esting that when the situation or lyric or both called for it, Kern could
produce songs which might have been written by any competent com-
mercial pop writer. In "Toot Toot" (1918) there is a song called
Girlie, a casual waltz which bears a marked resemblance to a song
recorded by the All Star Trio, a popular group of a few years later,
called *Jerry*. Though a respectable song, not without charm, it has no
suggestion of the style which had been increasingly noticeable in
Kern's music for the past few years.

Also in "Head Over Heels" the song *Funny Little Something*, a
notey (and by analogy, wordy) little rhythm ballad, bears little re-
semblance to the Kern of "Leave It To Jane" but more to a better-
than-average writer of pop songs. There is, to be sure, evidence of

superior invention within this conventional setting. For example, the first two measures of the chorus somehow fool one into believing that the third measure will pause for perhaps a half note. The fact that it doesn't comes as a pleasant surprise. Also the song, for Kern, and even for any writer, has the odd length of twenty-four measures. Its main theme, one measure, is stated four times, and after each statement the tune takes a different twist. As well, there is no true cadence in the song until the final one. And the eighteenth, nineteenth, and twentieth measures are, though harmonically static, very cute (using the adjective as of a skipping child). They are a series of descending imitations, somehow very agreeable.

Funny Little Something

Yet they could have easily been written by Lou Handman, composer of *My Sweetie Went Away*.

In "Rock-a-bye Baby" (1918) the song *I Believed All They Said* is, strangely, back in 2/4 time, though it suggests, to my ear, the more convincing mark of 4/4. It is an attractive melody, again twenty-four measures, also without more than casual cadences, and conceivably written by anyone better than a hack writer of the time. It is clearly intended to be a lively rhythm song, a setting for an airy lyric, asking little of Kern's musical manners and receiving none. Kern gave as much to the song as its lyric warranted or, in the event that the melody was written first, as much as the situation or title warranted. His semi-dismissal of the song is evidenced by his use of dominant-seventh chords in the middle of the song: E seventh, A seventh, D seventh, C seventh, and F seventh, back to the B-flat chord.

I'm sorry to say that I find nothing worth lingering over in the shows of 1919, though there probably were current hits in them.

The first 1920 song from "The Night Boat" which must be considered is *Whose Baby Are You?*, a rouser. And since it is in D major,

Kern must have had the same convictions that I do concerning the emotional temper of specific keys. From the first note of the verse this song drives. And it leads marvelously into the chorus. Before speaking of the latter, I might add that the last four measures of the verse are the first four measures of *The Down Home Rag*, which in turn may have been a common riff among the ragtime players until it was copyrighted under that title by Wilbur Sweatman in 1916.

The song is in 2/4, but if played today would surely be shifted to 4/4. The chief characteristic of the song is the syncopation on the last eighth note of the first, fifth, fifteenth, twenty-first, twenty-ninth, thirty-first, and thirty-third measures. It is the first Kern song I have examined which contains an obvious "tag," which brings it to thirty-six rather than the more conventional thirty-two measures. The tag inevitably brings to mind a song of only two years later by Eubie Blake in "Shuffle Along," a song which remains a swinging standard today, *I'm Just Wild About Harry*. If you hum the last section of it, you'll see the similarity of concept. This forceful falling on the last eighth of the measure was also a characteristic of Vincent Youmans in such songs as *I Know That You Know*, except that by then the time signatures had shifted to 4/4, and the stress, therefore, fell on the last quarter note.

There is little concern for unusual harmonic invention in this song. The tune and the rhythm are all-important. And it never lets up even though there are breathing spells between the heavily-accented last eighth notes, which serve to further highlight those syncopations.

Whether or not one is partial to this type of song (and frankly, I'm not), there can be no denying the high degree of professional acuity and control in the choice of its notes, rhythms, and shape. It is inevitable, memorable, indeed unique. I know of no other successful, or even unsuccessful, attempts by Kern to write this kind of song, except for his even better known *Who?* and *Sunny*.

In "Sally," also 1920, there were three phenomenal songs: *Wild Rose, Look For The Silver Lining*, and *Whip-poor-will*. Granted that *Whose Baby Are You?* that same year was a splendid effort, the three songs from "Sally" were a big leap forward in invention, style, and experimentation. They were markedly distinctive, wholly detached from his operetta writing, and suggestive of an awareness, a sudden awareness, of the musical world around him. Should one keep in mind

that by 1919-1920 a revolution in dance band arranging had begun? Had Kern been listening to the new sounds, new instrumentation, new harmonic and rhythmic devices? It must be assumed so.

A song as familiar as *Wild Rose,* and as direct and "no-nonsense," suggests no comment beyond praise. Yet it's very first note was, in its day, an unprecedented one with which to begin the melody of any song, particularly a romantic ballad. It is, of course, the sixth interval of the scale, and though *Wild Rose* is a standard song to this day, such an interval may, to the average listener, be simply the first note of the song and no more. But to a musician examining styles of popular music and special characteristics of composers, this opening note is most worthy of mention.

The sheet music is in the key of E flat. The song does not begin in C minor (which also bears the signature of three flats). So it is extraordinary, in this period of popular song writing, to find that *c* is the first note of the melody, the sixth interval of the scale. Kern obviously wishes to impress this unusual entrance on the listener, as the *c* is a whole note. Then, as if to reinforce his decision to be bold, he restates the *c* an octave higher. Three notes later he uses it again for a whole note. Then two notes later he once again repeats it.

Let me say here that throughout popular music there seems to have been a hypnotic quality to the sixth interval, when reiterated. Recalling such songs as *The Sheik Of Araby, Mack The Knife, The Third Man Theme, The One I Love (Belongs To Somebody Else), The Last Time I Saw Paris, Say It Isn't So, Last Night On The Back Porch,* and countless others (one can make a game of it), one must accept its compelling power. It is not nearly so surprising to find songs concentrating on the notes of triads such as *c, e,* and *g,* since even without a knowledge of harmony, the lay listener seems able to sing and recall triadal patterns without conscious effort. But that the sixth interval should so constantly prove itself provocative is a musical mystery.

Wild Rose is a perfect instance of a song which would suffer from any other harmonization than its own. As it stands, there are literally only four chords in the entire song. And one of these, E-flat minor, occurs only three times, due to the chromatic steps in the melody in measures nine, thirteen, and twenty-five. The song is so pure that it needs no harmony, only the melody to please, as does *Look For The Silver Lining.*

Though I have on many occasions proven to my own satisfaction that the lay listener is neither aware of harmony nor disturbed by patently inept harmony, I believe that such a listener *would* be disturbed to hear an opulent harmonization of such a song as *Wild Rose*. Only the most cautious chorale-like harmonization, in which the bass line moves but without causing the resultant harmony to leave the E-flat area, conceivably could be possible. Were an arranger, accustomed to gussying up songs of an inferior or of an implicitly lush nature, to show off his harmonic prowess in this song, it would lose its character totally. I was very impressed when, in the course of discussing great songs with him, Eubie Blake, a composer and pianist capable of very rich harmonizations, proceeded from memory to play *Wild Rose* exactly as printed in the sheet music in 1920 without so much as adding a single idea of his own in the open spots. He obviously sensed that the song needed nothing more than the barest of harmonic bones.

Kern, a professional, schooled writer, had the technique necessary to create the most florid harmonies, which he employed often in his later songs. But his taste forbade his use of that aspect of his musicality in a song as strong melodically as *Wild Rose*.

Look For The Silver Lining is a similarly independent melody, at no point needing the bolstering of special harmony, though it is slightly more complex harmonically than *Wild Rose*. In comparison to such later songs as *All The Things You Are*, it is spartan.

The chorus of *Look For The Silver Lining* was so indelibly marked in my memory so many years ago that it is difficult to be detached enough to examine it clearly. Undoubtedly it is a great song. But I must ask myself if it was as much an illustration of Kern's new style as *Wild Rose*, let's say. It may be niggling of me, but as great as it was, might it not have been from the pen of an English writer? Whereas, with *Wild Rose*, the likelihood seems much less. It's not the same sort of song as *Wait Till The Cows Come Home*, yet, had I not known that Ivan Caryll wrote the latter, I could have believed that Kern did.

It in no way minimizes the merit of *Look For The Silver Lining* to speculate on its creative ethos. For since this survey is particularly concerned with "American-sounding" songs, it is of consequence to examine them both for their indigenous as well as their musical meaning. I realize that I am jostling statues but, in the name of personal conviction, I must say I believe that Kern's music became in-

creasingly American in spite of himself. I believe he was a musician like many others who so revered the glorious European musical tradition, the monumental encyclopedia of European musical works, that he may have tended to shy away from the unpolished, slangy level of American popular music, concluding, perhaps, that the only way to provide it with the elegance and sheen of true music was to write with his ear cocked east, rather than west, of Manhattan. And he may have been right, though his later career certainly suggests that he finally accepted the American musical point of view. Therefore, great respect is due the provocative strength of the unfocused yet unique song form bursting out of America, since it finally swung Kern away from his European ideal.

Undoubtedly the multi-cultural roots of the new form of popular music were the same as those which produced new mores in American society. Songs in the popular idiom are primarily for sale, so one mustn't ignore the commercial influences at work. Only the inhabitant of an ivory-tower would refuse to be influenced by shifts in public taste. And so Kern well may have noted the diminishing enthusiasm for the European-oriented song and sensibly started to experiment in ways of writing suggested by the musical scene at hand. The fact that he did slowly but surely shift, while Friml, Herbert, and Romberg, among others, did not, speaks well of his awareness of the vitality of current American music.

To return to *Look For The Silver Lining*, any writer from whatever country would be proud to have written it. A great tried-and-true folk song or hymn-tune needs no more than its melody to effect sadness, joy, sentimental longing, even tears, nor does *Look For The Silver Lining*. It needs neither theatrical setting nor a bank of strings to induce an emotional response.

Two devices in the writing should be mentioned: the simple, yet enormously effective two measures which constitute the return to the main strain, and a single measure toward the end.

There are none but quarter, half, and whole notes until the fifteenth measure, when the melody resorts to a series of dotted quarter and eighth notes.

Look For The Silver Lining

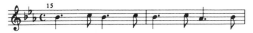

The unexpected rhythm of these measures is very winning; indeed, every time I've heard a group of friends sing this song, those who have not participated up to this point invariably join in on the fifteenth measure. Its extreme simplicity is deceptive, for it is somehow magnetic as well.

The music accompanying the last phrase of the song, "sunny side of life," employs two eighth notes for the word "sunny." I would assume that this was a concession on the part of Kern, as there is otherwise no musical reason for their existence. That isn't to say that they are not effective, but simply that after examining all of Kern's published songs, I'd presume that he would write a single quarter note, *a* flat, instead of the two eighths. And musically it would be more natural.

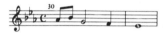

The final song from "Sally" to be discussed here is *Whip-poor-will.* The initial phrase, based on the word "whip-poor-will," is very arresting, and also very daring melodically with its immediate octave jump dropping to the minor third. Other wonderful novelties occur. For example, in the third measure the last quarter note is an *e* natural leading to a *c* in the fourth measure, under which is a C-dominant seventh. In a similar phrase three measures later, the last quarter is an *e* flat leading to *c* again, but under the *c* is now an A-flat chord. This, to be sure, may please only the professional eye and ear, but it is clever and sly and inventive.

Kern continues to play with his listener by taking him to an A-flat chord but refusing to let him rest there. This he accomplishes by changing the harmony in the middle of the measure to a C-dominant seventh, thus preparing the way for a return to F minor, the chord with which the song starts. Four measures, nine through twelve, of no great shakes, follow, but in the thirteenth measure he restates the first phrase—this time, however, in C major, descending in the following measure in much the same unexpected fashion as he has ascended in the second measure, to a low *c* based on a C-major chord. Then, with three quarter notes (unrelated to F minor), he leads into a restatement of his original theme but no longer in F minor. He has even

changed the key signature: the song proceeds to its close in F major.

The whole chorus is so ingenious, except for its weak ending, that I feel it should be reproduced in full, but, alas, this is not permitted. The rhythm of the second and equivalent measures is used in the first ending to lead back to F minor! Surely *Whip-poor-will* represents the second marked experiment in Kern's writing, the first being *And I Am All Alone.* They both desert the principle of the pure melodic line and romp about the base of the ivory tower.

The spate of scores had by 1923 subsided to a single one, that of "The Stepping Stones," in which there appeared *Once In A Blue Moon,* a short, very simple lullaby. It is a song of extreme harmonic simplicity and a narrow melodic range, only a half step over an octave. It is back in the pure area of Kern's writing. It is the kind of song one wouldn't be surprised to hear children singing as part of a sidewalk game, a gentle, child-like lullaby. It is, in fact, more than similar to *Go Tell Aunt Rhody.*

In the same score a song of cliché conventionality, *Wonderful Dad,* bears no mark of its writer but contains two inexplicable measures, the seventh and eighth.

Wonderful Dad

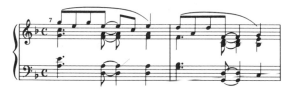

First of all, these measures constitute a "swinging" phrase of the thirties. Secondly, the exact notes of the piano part could be given to a sax or brass section and would sound precisely right in a big band of the thirties. The successive minor thirds, their voicing, and the four eighth notes tied to an eighth, all belong to a much later date, as do to a slighter degree measures thirteen through fifteen.

It sounds very definitely to me as if Kern had been listening to some of the new bands and, for those days, their very inventive new ar-

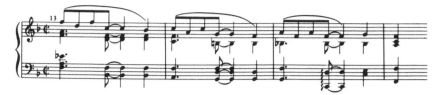

rangements. Even if he didn't hear them in public, he could have heard their records.

The title song of "Sunny," which came two years later, is of the same direct, driving quality as *Whose Baby Are You?* and *Who?*. Though five years after *Whose Baby*, and written in cut time, as it would be played now, it lacks the invention of the tag of the earlier song, and though quite professional, it doesn't really go beyond the call of duty.

More to the point and, for me, better written, was *Who?*. One could see how the very first note of the song could have risked lasting two and a quarter measures, if one knew for sure that the lyric was written first. For the word "who," with its open end, almost demands a long note, and, indeed, every time a note in *Who?* does last this long, it has the word "who" to go with it.

The song is *seemingly* the essence of simplicity. But the opening note is the sixth interval. And certainly measures three and four, seven and eight, nineteen and twenty contain unconventional skips, even though they are notes of the chords accompanying them. Successive skips of a fourth, a third, a second, and a fifth are by no means typical of relationships of notes in popular music. I've been so used to this song for so many years that it never occurred to me until I examined it that, in these areas, the succession of notes is, particularly for that time, very unusual, as are the long-held (two measures and a quarter) notes.

And, as in *Whose Baby*, the verse works beautifully, for most of it is in D minor as opposed to the chorus in D major. It is an integral part of the song and leads into the chorus perfectly.

In 1926 Kern came up with an undistinguished score for "Criss Cross." I was unable to find a single song in it of enough musical interest to discuss. Perhaps it was merely coincidental, but this somewhat barren effort came the season before what may have been his

greatest success. He was rounding out, as it were, the second phase of his long career—the years between the revolutionary Princess Theater shows and the forthcoming "Show Boat." It had been a remarkable period creatively, one in which Kern's ingenuity flowered.

IV

In 1927 came "Show Boat," and with it the best-known of all Kern scores. Kern was now at the top of his form. There remained very little to perfect in his personal style. He had learned to move about in the American musical milieu with relative freedom, even though his best songs in the native idiom lay well ahead. Immediately at hand was a curious period in his career when he would seem to go forward and sideways almost simultaneously, when he would plunge into the problems of "Show Boat," with its ambience of pure Americana, and then abandon the native implications of a realistic American theater and devote himself to a succession of romantic musicals which, while not a complete reversion, were a return in spirit to operetta. Kern strove to create a new kind of musically sophisticated theater, but always, it seems to me, the vision of a new kind of American operetta, freed perhaps of the traditional plots and machinery, tempted him away from the implications of "Show Boat." All the while the Kern melodies flowed forth, some of them suggesting new directions, some of them betraying his inner urge to impose art songs on Broadway, many of them suggesting he was slowly losing touch with the world of music around him in American life. It was for him a strange time of searching and pomposity.

Frankly, I don't believe that "Show Boat" best exemplifies Kern's work. *Ol' Man River* is, of course, the big song in the score. It is one of the best known of all American songs. The expression, "tote dat barge, lif' dat bale," is part of the language. The song is a singer's delight, having a wide range, drama, and no difficult melodic hurdles to jump. Since it does have a very wide range, an octave and a sixth, it requires a true singer to perform it. Paul Robeson of the second production of "Show Boat" could scarcely make a public appearance without singing it, and later, Frank Sinatra, though in no way associated

with any of its productions, considered it an essential song in his repertory.

Its extended verse of an odd twenty-five measures contains an eight-measure section which, with almost identical notes, is the release of the chorus. And the principal theme of the verse is rhythmically so like what one says of banjo music, "plink-a-plink," that the legend has grown in England that the sound of a banjo player idly noodling at a break in a rehearsal gave Kern the notion for the song. This is pleasant enough, considering the association in most minds of the banjo with the South, but like most such tales, it is unsubstantiated, and, of course, though it could apply to the verse, fails completely to explain the chorus.

The close musical and lyrical relationship of verse and chorus is proven by the fact that all singers I've ever heard perform the song always start with the verse.

The conventional *A-A-B-A* structure (main strain: its virtual repetition: a release,* almost always new material: and finally, a literal, varied, or extended restatement of the main strain) was used in *Ol' Man River*. Many people, including song writers who should know better, assume that this form goes back much further than it actually does. There were few instances of it in any type of popular music until the late teens. And it didn't become the principal form until 1925-1926.

Ol' Man River is not a complex song, melodically or harmonically. Its principal characteristics are the rhythmic devices of the second half of each measure (except in the release), and the extremely high ending. Undoubtedly the lyric accounts for half of the song's acceptance, though it is frowned on by the society of the seventies.

Bill, Mr. Wodehouse tells us, was written for "Oh Lady! Lady!" in 1917 and was cut out as too slow for that particular show. The verse pleasantly leads to the chorus without having the quality of being needed. The chorus, as indicated, is in a very slow 4/4 and would sound grotesque if played or sung fast.

Bill is not a great song any more than is *I Guess I'll Have to Change My Plans* by Arthur Schwartz. One is slow, the other jaunty,

* Connecting section of a song between the principal sections, or strains. Thus, in the most familiar song structure—*A-A-B-A*—the *B* section.

soft-shoeish—both given to lots of notes and both so dear to the re-membering ear that I hesitate to depreciate either. Female singers, from Helen Morgan to Peggy Lee, have loved *Bill,* so it must be re-warding from the performer's point of view. I believe, however, that its particular strength lies in its lyric, written by Wodehouse. (The sheet music from "Show Boat" mistakenly added Oscar Hammer-stein's name as co-lyricist. The error was acknowledged by Hammer-stein in a statement printed in the programs of a later production. The program for the original production of "Show Boat" correctly credits the lyric solely to Wodehouse.) Granted that no other song could be mistaken for it, yet it could scarcely be considered more than a casual contribution to popular music.

In the same score is *Can't Help Lovin' Dat Man.* I am not of the opinion that it's a great song. I should make it clear that no one ex-pects a rhythm song, as opposed to a ballad, to be melodically su-perior. But one can seek out the best of rhythm songs as such. It is not that I believe this song to be mediocre, or badly designed, or even without its moments of interest. It's more that it doesn't have the turn of phrase or over-all quality of a relaxed rhythm ballad. There is a stiffness, a contrived quality throughout, as if it had been pieced to-gether. The looseness of, let's say, *I've Got The World On A String* by Harold Arlen is, for me, wholly lacking. It's not fair to compare the two songs, as the latter was written some five or six years later, and by a man whose whole approach to writing and whose back-ground were unlike those of Kern. So let me suggest *Let's Begin,* a slow rhythm ballad Kern himself wrote five years later. The absence of contrivance, the implicit "fun to have written" quality exists throughout the song.

A kind of schizoid tip-off on *Can't Help Lovin' Dat Man* is the tempo marking at the beginning of the song. It is "Tempo di Blues." It might be the title for a cartoon of a very professorial-looking gentleman peering into the windows of a jazz joint.

To speak of those elements of the song which I *do* like, the cadences of the first, second, and fourth sections, all identical, were unusual for their time insofar as the notes of three quarters of each measure are based on a chord unrelated to the key in which the song is written and do have a resultant "blue" tinge,

Can't Help Lovin' Dat Man

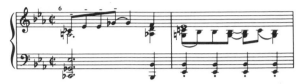

and the ascending steps of the release from the low *f* to the high *f*
certainly do constitute a dramatic climax. The structure of the song is
A-A-B-A and strictly so, in that each of the *A* cadences are identical,
whereas often in a song so designed one of the cadences might move
to a dominant seventh and another to a chord which would be a
preparation for the harmony of the release.

As for the verse, I find it looser and less contrived than the chorus.
Naturally, it makes no pretense of having more character than one
expects of a verse, but after hearing it, I would hope for a more nat-
ural chorus.

Make Believe is a lovely Kern ballad with a wholly delightful
verse. Here we are back with the kind of song so strong and of a
piece that its harmonic nature is of no consequence. The harmony
happens to be of little inventive interest, but I wouldn't change a
note of it. The structure, though thirty-two measures, is not *A-A-B-A*,
but *A-B-A-B^1/A^1*. Its rhythmic interest lies in its constant use of
dotted quarter and eighth notes which are stated immediately in the
pick-up notes to the chorus and right afterward.

Make Believe

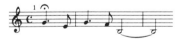

This device is maintained throughout the song.

In the verse there is implied a difference of opinion lyrically and
musically. For in eleven instances the lyric employs one syllable to
fulfill the needs of two notes. I know that this occurs often in concert
songs, but usually in such a fashion that there is no jar to the ear; nor
does one get the feeling, as in this case, that the words might have
been originally in another language and that the English result was
as close as the translator could get. For example, two eighth notes are

used over the syllable "of," two over "ing," two over "est," and, more acceptably, two half notes over the word "know." Perhaps Kern's most flagrant misuse of this license was in *The Night Was Made For Love*. In the first cadence, which occurs awkwardly in the fifth measure instead of the fourth, the word "love" is forced to sustain three notes, as follows.

The Night Was Made For Love

Why Do I Love You?, another ballad from "Show Boat," is another of Kern's best-known songs, but not of the stylishness and tenderness of *Make Believe*. There is no denying that it is a very good, well-written song, definitely in Kern's "high" style, but to me it lacks suppleness, elasticity. It tends to plod. Perhaps by now in the development of Kern's writing I have been led to expect delightful surprises and rhythmic subtleties, none of which I find in this song, although these qualities are present in *Make Believe* as, for example, in the quarter-note triplet in the sixth measure,

Make Believe

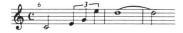

the very gentle but unusual melodic steps in the ninth and tenth measures,

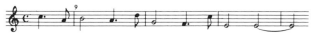

and the unexpected chromatic ascent in measures twenty-five, twenty-six, and twenty-seven.

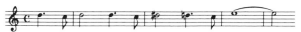

Perhaps I have become spoiled by songs like *Wild Rose*. For although *Wild Rose* is not given to much more than a splendid, straight-

forward melody, it nonetheless twice drops a rhythmic pebble in the quiet pond, the first time in the fourteenth measure, by unexpectedly using a dotted quarter and an eighth note, and as well in the twenty-sixth measure. In a song as placid and suave as *Wild Rose* this makes for a sudden, fleeting ripple of motion which is the mark of true creative invention. I don't find this, in spite of a strong, characteristic melody, in *Why Do I Love You?*.

One more word about the score of "Show Boat." Miss Dorothy Fields once mentioned, in the course of a discussion about Kern, that his least favorite song of all the hundreds he had written was a song in "Show Boat," *You Are Love*. Out of respect for his judgment I have done no more than play it through. It can't be said that we would have agreed, but I don't think it's worthy of analysis.

Two years later (1929) in "Sweet Adeline" appeared the soaring ballad, *Here Am I*. It starts, interestingly enough, on an *f* sharp (in the key of E flat) which is held for three beats, resolving on the fourth quarter to a *g*. Kern likes this device, and he repeats it twice in the next few measures. Then, in the second eight measures he moves twice from *f* natural to *g*, still employing three beats for the *f* and a quarter for the *g*. So he still hasn't moved too far away from his original idea.

In the twelfth measure, the melody moves seemingly only toward a cadence in the dominant of E flat and to a return to the first idea. This would be quite acceptable, but it's not what Kern does. Instead, he continues to develop, and with intensity, a romantic turn of phrase, even adding the surprise of imitating this phrase a third lower.

Here Am I

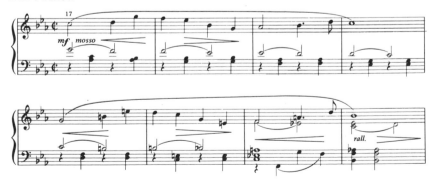

Only then does he return to his principal theme, which he follows with a high dramatic ending. The shape of the song is *A-B-C-A¹*, unlike any forms he has used up to this time in those songs considered. So this song is not only experimental in form but in content as well, being also harmonically very inventive.

The verse is also rhythmically interesting, employing both 4/4 and 3/4 time signatures, and is harmonically interesting, employing two key signatures. And its resolution and the way it leads into the unusual *f* sharp is exactly right.

There were two more equally beautiful songs in "Sweet Adeline," *Don't Ever Leave Me* and *Why Was I Born?*. Though without more than one rhythmic novelty, harmonically of only average interest, and composed, in its main strain, of series of repeated notes, *Why Was I Born?* somehow captivates completely. I don't think that it would if each statement had a so-called "male" ending (single-note cadence). But the alternation of single and double-note cadences works perfectly.

And that one rhythmic device in the musically identical ninth and twenty-fifth measures is masterful. However, the description of it is scarcely dramatic since the device is no more than the use of two eighth notes at the beginning of each of these measures. The adroitness in using these eighths lies in the fact that nowhere else in the chorus does an eighth note appear, and that they appear as the first two notes in the phrase, not as the second, third, or fourth pair. Perhaps I wouldn't make such a point of this were the song not so well known. But it is, and I believe that the principal reason isn't the main strain itself, but these unexpected eighths.

Why Was I Born?

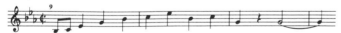

One more point: in the following illustration it is obvious that the melody could have fulfilled the intent of the lyric much more gracefully by making the *e* flat above the word "born" a half note and the low *e* flat above the word "to" a quarter note. This is what most singers do, anyhow. In my opinion, the failure to do so is a marked illustration of Kern's adamant attitude toward his melodies and con-

comitant unwillingness to roll with the lyrical punches. This un-
doubtedly accounts for the argumentative nature of lyric and music
in the verse of *Make Believe*.

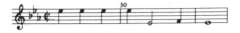

The verse was undoubtedly composed at the same time, or at least
with the chorus well in mind. For its first measure is the same as the
ninth measure of the chorus. It's a very good verse, making very in-
teresting use of quarter-note triplets and an unexpected change of
key in its last four measures. My only disappointment is its abrupt
end. Due to the shape of its early groups of eight-measure phrases, I
am induced to expect another at the end, since its initial measures are
the same, though now in G major. Overall, however, I find this song
another instance of Kern's mature style.

In 1931, from the score of "The Cat And The Fiddle," came the
song *She Didn't Say "Yes"*. One almost looks for Fred Astaire's name
heading the cast, since Kern has here begun to take on the composing
characteristics he later mastered in the Astaire movies. Incidentally,
this is the first song of Kern's I have seen without a verse.

It is one of the swinging kind, one which suggests a band arrange-
ment, and which was, in fact, arranged often for the big bands. The
fourth beat of the first measure in the accompaniment is marked with
an accent and so are all the measures imitative of the first measure.
This may be a hint not only for the piano player but also for the
arranger. The sixth interval is a recurrent note in those same meas-
ures and is a repeated note in the seventh and fifteenth measures. I
mention it only because of my conviction about the provocative char-
acter of this interval. The song resorts to an abrupt key shift in the
ninth measure and as abruptly a return to its own key two measures
later.

She Didn't Say "Yes"

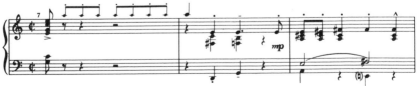

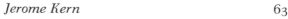

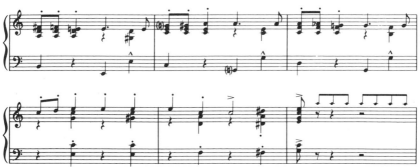

It is a twenty-measure song, only six measures of which do not use the device of the opening measure, an ascending or descending pattern of eighth notes. And whenever this is used, so is the accented fourth beat. The fact that the over-all effect of the song is one of "cuteness" does not detract from its "American-soundingness."

There's one other song in this show, a very good one, which is much less well known today—*Try To Forget*. However, it has an abrupt ending almost as frustrating as the shift of a radio dial before the end of a song.

The next year, for "Music In The Air" (1932), Kern wrote a very dear song, *I've Told Ev'ry Little Star*. It's in the conventional *A-A-B-A*, thirty-two measure form, very simply designed, but containing, in the release, an unexpected interval, *e* flat, held for a full measure, as well as a startling drop of a seventh from the *e* flat to an *f* natural. In an innately simple song this difficult relationship of melody notes comes as a big surprise. Yet it has remained a standard.

I've Told Ev'ry Little Star

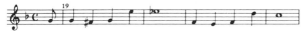

Kern must have been pleased with the release as he repeats all but the final note of it twice in the verse.

Another of the unsubstantiated tales of a song's source is told of this one. It is, simply, that while visiting friends in the country he

heard a bird sing outside his window and it inspired him to write *I've Told Ev'ry Little Star*. The only musical trace of this I can find is in the second measure.

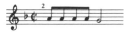

Of course, if the story is true, there may be a bird that sings something like the nineteenth and twentieth measures. But, much as I love bird calls, I'd rather hear this phrase sung or played. And, out of respect for one of the primary points of this book, I must add that the above song contains nothing of the "American" sound (which tends toward intricate rhythm or lush harmony).

The other song well worth mentioning from this show is *The Song Is You*. It is, I'm afraid, one of Kern's self-consciously elegant "art songs"; it attempts too dramatic a statement on too small a stage. And it suggests a grander voice than that usually associated with popular theater music. It borders on the vehicle-for-the-singer more than the song-in-itself, and to carp one last time, it employs rubato as opposed to steady tempo.

By no means am I denying its innate presence and superior quality as a piece of writing. It moves gracefully, and the release is masterful. Up to the release there is no particular harmonic interest, but in the release both the harmony and melody are brilliant. It is clear that the melody in this section is conditioned by the harmony and truly needs its support.

At the end of the second section of the song (it is *A-A-B-A¹*), the cadence is C major. The melody of the release opens on the note *e*, the third interval of the C-major scale, but the supporting chord now is E major. It moves through a pattern of harmony related to E major and ends on the note *b* and a B-dominant-seventh chord. The main strain continues without pause on the same note, but with a C-major chord creating a C-major-seventh chord, resulting in an enharmonic change. This *b* moves to *c*, thus totally resolving the whole problem of returning to the original key.

The musical device employed is similar to the use of the enharmonic note in *All The Things You Are* (see below) insofar as it creates the same surprise.

The Song Is You

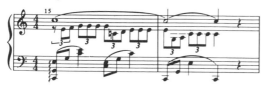

As in *The Way You Look Tonight*, there is throughout the main strain of this song an accompanimental figure which is so strong as to be an integral part of it, to the extent that most orchestral arrangements of the song include it.

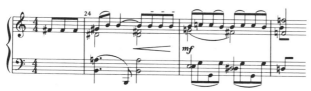

"Music In The Air" was followed in 1933 by "Roberta," a success, and in 1934 by "Three Sisters," a show that Kern and his collaborator, Oscar Hammerstein II, together staged in London but never brought to New York. In 1934 Kern went to Hollywood to work on the film version of "Roberta." Although he was to return once more to Broadway with a new score, the years ahead were to find him committed to movie work. Oddly, the demands of Hollywood musicals forced Kern to dig deeply into his resources as a composer in the American idiom and to come up with some surprisingly lively inventions.

V

The Hollywood phase of Kern's career begins with the filming of "Roberta," which was released in 1935. It was, one must immediately observe, an extraordinarily happy debut, but at the same time it should be remembered that the score had been one of Kern's finest on Broadway. The movie was, of course, leavened with new songs, one of

which had been brought over from London and dressed in newer, sprightlier lyrics.

"Roberta," originally called "Gowns By Roberta," was produced as a Broadway musical in 1933. And because there are no songs to be discussed from the years between the stage and film versions, I'll discuss both scores together.

In the stage version there was a marvelous rhythm song, *Let's Begin*. Every bit of it works—verse, chorus, and lyric—even if one's eyebrows rise slightly at the rhyme of "exempting" and "preempting" as being a bit high-flown for a popular song. Well, no matter. The same lyricist, Otto Harbach, used the word "chaffed" in *Smoke Gets In Your Eyes*.

The verse begins with a two-measure phrase which is used as a coda, or tag, to the chorus and is so typically a phrase which a trumpet might improvise as a tag to a held chord in a band that, until recently, I assumed it was an instrumental phrase some singer had heard and put words to. It's that relaxed. And the verse continues to do charmingly unexpected things, to the extent of winding up with fourteen measures instead of either twelve or sixteen.

The chorus takes off, and continues, like a song written for a singer with a jazz background and to be accompanied by a solid, swinging band. Even the bass line, never a great concern of Kern's, at least in the published music, starts to move as might one in a Gershwin or an Arlen song. In fact, this is the first time I've noticed such a thing in Kern. And the fifth through the eighth measures might have been written for three brass with the rhythm section silent but for the drums.

This song is a big departure for Kern, one in which there's no sign at all of piping on his vest—indeed, no vest. Even his shirt sleeves are rolled up, and there might be a cigarette resting on the edge of the piano. I find it a healthy sign that had I not known who had written it, it wouldn't have surprised me to be told it was by a jazz musician.

The internal structure of the song is untypical of Kern. After a series of *b* flats in the first measure (key of E flat), the second measure is repeated twice. Then, after one more measure, the sixth measure is repeated twice. Then come four measures, of which three are

descending imitations of the first. These four constitute a release and are followed by an almost exact repeat of the first eight, except that now they are extended to ten, the last two of which say that the lovers "begin and make a mess of both of [their] bright young lives." The surprisingly slangy words of this tag are quite untypical of Harbach's writing, so much so that for years I assumed they had been invented by an early singer of the song and had been used ever since because of their shock value. I am very impressed by Harbach's succinct and adroit use of idiomatic language.

Besides the marvelous words and music of the tag, there is also a simple but highly effective trick in the preceding measure. Instead of doing rhythmically what he'd led us up the garden path to believe he'd do, he does something better and more forceful. Over the words, "love and gin, wife or sin" in measures eighteen and nineteen, he has written ¢ ♪♩ ♪♩ | ♪♩ ♪♩ | leading us to believe he'll finish the song in the same rhythm. Instead, he does it this way in measures twenty through twenty-two ¢ ♩ ♪ ♩ ♪ | ♩ ♪ ▬ | ▬ |, and thus produces a surprising cadence: Mr. Kern has finally settled for native musical climate.

I Won't Dance first appeared in the English production "Three Sisters" in 1934. Then, with the same title but an almost totally new lyric by Dorothy Fields and Jimmy McHugh, it was beautifully danced and sung by Fred Astaire in the movie version of "Roberta" in 1935.

It's a very good, very swinging song with perhaps the most difficult release Kern ever wrote. It is a theory of many song writers and publishers that as long as the main strain of a song is not beyond the capacity of the average untrained ear, the release can do what it pleases, particularly since the main strain will be the last thing heard. Well, Kern must have been of this opinion, for the release jumps through musical hoops before it returns to the straightforward principal statement.

For example (the sheet music is in the key of C), the release jumps without preparation into A flat, then D flat, and then B natural before it cleverly works its way back to C. And the melody moves in wide steps while following these harmonic patterns. To show how involved the release is, the piano staves are reproduced below.

I Won't Dance

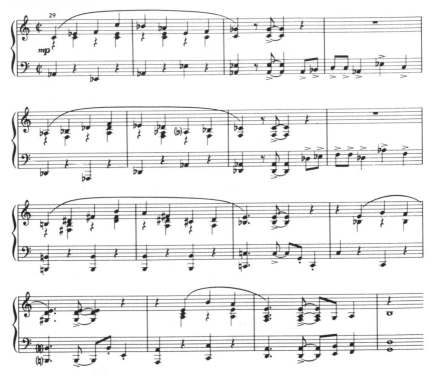

The song has a slightly odd shape insofar as the first section is twelve measures long and the other three, sixteen. In the first two cadences (measures eleven and twelve, and twenty-seven and twenty-eight) the identical device used to fill up the piano part is taken exactly from the first two measures of the verse.

The verse is a good one, setting up the mood for the chorus and leading into it by means of a kind of *ostinato* in the melody, not in the accompaniment, that suggests a preparatory vamp. In the "Three Sisters" sheet music copy of *I Won't Dance* the verse is in 2/4, changing to cut time four measures before the chorus in which the *ostinato* figure, which has words in the American version, is only a piano vamp.

Miss Fields and Jimmy McHugh used Hammerstein's lyric for

only a few lines. They both read, "I won't dance! Don't ask me; I won't dance! Don't ask me; I won't dance . . ." and then the new lyricists change the original phrase "Don't ask me to" to "Madame, with you." From there on out the new lyric uses no more of the original and is, I believe, superior. The words to the verse in the second version are all by Miss Fields and McHugh. It's another great rhythm song, suggesting no backward glance.

Lovely To Look At, the other memorable song introduced in the movie version, is short and sweet and just a trifle frustrating because it ends before you want it to. It is alleged that when Kern was asked why it was only sixteen measures long, he replied that that was all he had to say. A courageous and forthright answer. But much as I like it, I feel slightly cheated.

Yesterdays, not ever to be confused with *Yesterday* by the Beatles, was, in fact, originally published, and copyrighted, under the singular form of the title: *Yesterday.* The sheet music, deposited for copyright at the Library of Congress on November 3, 1933, also carries the original title of the show: "Gowns By Roberta." The original lyrics of the song, as well as the singular form of its title, puzzle me. The song opens with the words "Yesterday, Yesterday," but the phrase immediately following reads, "Days I knew as happy sweet sequester'd days." Not only is the plural *days* emphasized by its repetition, but *Yesterday* and *sequester'd days* provide a jolting failure of rhyme. The final cadence of the original version adds to the mystery by ending with the plural form *Yesterdays.* One can only guess that the meticulous Mr. Harbach must have felt either enraged at the publisher's carelessness, or chagrined at his own.

Kern's song was originally printed in 2/4 time, though I have never heard a record of it in other than cut time. Its later printing in the mistake-riddled Simon & Schuster book of Kern songs is in cut time, and in C minor, a key less forceful than its original, D minor.

It is another verseless song. Frankly, I can't imagine what more could have been said than was said in the chorus. It is an extraordinarily evocative song, simple in construction, narrow in range (a tenth), and unforgettable.

I knew the melody for years before seeing a copy of it or even trying to find the harmony at the piano. I was delighted, liking inventive harmony as much as I do, to find it as provocative as the

song is evocative. Here, then, is a good illustration of a song which satisfies as a melody but which is not so much enhanced by its harmony as well-dressed. It's like something I kept hearing about from older people before 1929, a mysterious prize called an "extra dividend."

The shape is *A-B-A-B*. The key of its second printing is C minor (three flats). Yet the harmony lingers around C minor for only four measures, just long enough to establish the mood of the song. Then it starts moving away, and by the eighth measure it begins a series of dominant chords, with raised fifths alternately supplied by the melody and the harmony, until it arrives very, very neatly at an A-flat chord in the fourteenth measure, and so easily back to C minor in the fifteenth.

Yesterdays

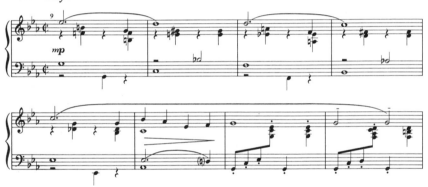

The second set of sixteen measures is identical except for the surprise cadence in C major which extends for eight measures, accompanied by an unusual series of un-Kernlike chords.

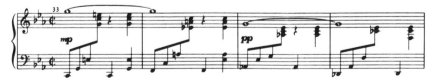

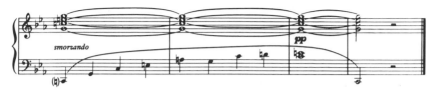

I should point out that the final cadence begins at measure thirty-three and that this eight-measure cadence might suggest that this is a forty-measure song. Obviously it isn't, since the melody is held those eight measures solely for the purpose of presenting the tasty, shifting harmony. There is no way of knowing how long the song was intended to be, due to the absence of the usual first ending given in sheet music for the convenience of those wishing to sing or perform it a second time. This is one of very few instances of a single ending.

Harbach, who gave us "tempted" and "pre-empted," and "chaffed" and "laughed," has here offered us "yesterdays" and "sequestered days," and "truth" and "forsooth," the latter being pretty hard for me to take. It's archaic to the degree that, having never heard it used and having never read it in contemporary literature, I've had no occasion to determine precisely its meaning.

Mr. Harbach, a very pleasant gentleman, once told me, a virtual stranger, that in looking through discarded, or un-set, Kern manuscripts, he came across one which he was told by the composer had been written, I gathered, in order to make a scene change in "Show Boat." It was an "instrumental" composed for a tap routine "in one" as they say; that is, in front of the curtain while the scenery is being changed. It looked like this.

Smoke Gets In Your Eyes

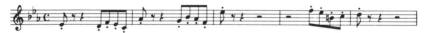

The short notes were used, obviously, to allow the taps to be heard. Mr. Harbach told me that he asked Kern if these short notes might be made long notes and that, if so, might it not make an attractive ballad? Kern agreed, and the result was *Smoke Gets In Your Eyes*.

I have no idea what the length of the original piece was; whether or not, for example, it included the release of the later song. I do

know that the song was one of Kern's biggest hits and most popular standard songs. It is also without a verse. In this instance, unlike *Yesterdays,* I feel that it might well have had one. Probably the situation didn't call for one, and it is true that the lyric begins almost as casually as the words of a verse. It is a superb lyric, whether or not "chaffed" comes as a shock. The song itself has never been one of my favorites, though I can't deny its inventiveness and its very daring release. For me it's always on the edge of artiness; in fact, the tempo marking for the release is *"un poco piu mosso,"* which really does move us back into the world of the operetta.

The five sets of four eighth-note phrases, each eight measures long, keep the melody from flowing. Many will disagree with this opinion, for this song is usually one of the most dramatically and ornately orchestrated of all Kern songs—that is, when the occasion includes an orchestra capable of making very opulent and elaborate sounds. It is unlike any other song, certainly honest and professional and containing a passage of extreme adroitness in the return from the out-of-key release back into (the printed) key of E flat.

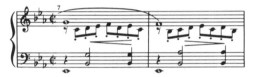

There is also in this song an accompanimental figure which has become an essential element of any performance—no arranger would ever dream of leaving it out.

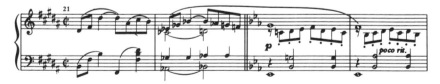

One other song in "Roberta" is, to me, a complete return to Kern's early manner of writing, having none of the flavor of the musical world around him. It is *The Touch Of Your Hand,* a very florid, rather pretentious waltz. Interestingly enough, Mrs. Kern, a lady who grew up in England in the tradition of the style of this song, once

told the musical comedy authority Alfred Simon that it was her favorite of all her husband's work.

I Dream Too Much, another waltz from a movie of the same title (1935), I have passed by, as it again reverts to the European manner. It is, however, a much less overt plunge into the theatrical wisteria mists of the past.

In 1936 came the movie "Swing Time" and in it a marvelous score for Fred Astaire which is clearly unmarked by any backward glance. *A Fine Romance* certainly sounds as if it had been written for only one person. But this may be hindsight, since once you've heard Astaire sing a song you can't associate it with any other singer. And this is a great feat on his part, since he has never claimed to be more than a dancer.

It's a good song, one that keeps piling up, tossing in pleasantries and surprises, and that has a wonderful quality of uninterrupted movement. There's no occasion in it for accompanimental figures in the cadences, as in *The Way You Look Tonight*, for the song doesn't seem to pause long enough for them. Actually, there is a cadence of sorts at the end of the first sixteen measures, but it doesn't feel like one. And I think the reason for this illusion is that the whole note which begins the song and other whole notes which follow it cause a cadence to sound like no more than a characteristic of the melody.

Its form is *A-B-A-B¹*. Its harmony is conventional. The melody is straightforward, yet it contains delightful devices, such as increasingly higher pairs of notes in the second, fourth, sixth, and eighth measures.

A Fine Romance

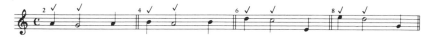

Then, in the tenth and fourteenth measures are the delightful descending notes comprised of a quarter-note triplet and two quarter notes.

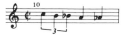

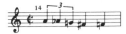

This device he uses again in measures twenty-six, twenty-eight, and thirty, the first one partly diatonic and the other two, again, wholly chromatic.

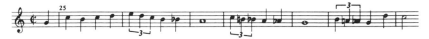

In the first ending, four measures long, he uses a figure in the accompaniment quite like that which occurs in the cadences of *The Way You Look Tonight*. This may be just a private joke. It has never attached itself to *A Fine Romance* as its counterpart did.

There is no verse to this song.

The Way You Look Tonight, also from "Swing Time," has the same first ending in its piano part as *A Fine Romance*. The deliberate similarity is the sort of trick an orchestrator might use in bringing unity to a score. It's a lovely, warm song, with a lovely, warm lyric. But before I say anything further about it, permit me to say that upon re-examination of the song I've found that not only is the accompanimental figure in the cadences an implicit part of the motion of the song, though no words are involved, it is, as well, a part of the closing measures of the song itself. For the last section is twenty instead of sixteen measures, since it has a tag. The four measures that precede the tag, which is a repetition of the ending of sections one, two, and three, are at this point hummed in accordance with the vocal direction *bouche fermée*. The hummed figure is the same accompanimental figure which before has only been played.

The song flows with elegance and grace. It has none of the spastic, interrupted quality to be found in some ballads, but might be the opening statement of the slow movement for a cello concerto; that is, if the composer were daring enough to risk being melodic. What technically is the release, but which seems more simply a natural development of the main strain, moves into the key of G flat from the key of E flat, and works its way back in the way only Kern can effect such transitions.

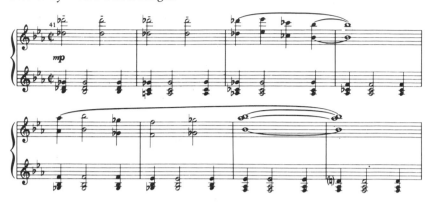

The Way You Look Tonight

Then comes *Waltz In Swing Time*. There are a few curious facts concerning this medley-like piece. First, below the acknowledgment on the first page, reading "Music by Jerome Kern," the smaller print reads, "constructed and arranged by R. Russell Bennett." There is no doubt in my mind that this means Mr. Bennett took some themes, presumably by Kern, and fitted them together so as to form a continuous piece. However, in the Simon & Schuster collection of Kern songs, the mention of Mr. Bennett has been eliminated. In fact, Dr. Albert Sirmay, long-time editor of the Harms and Chapell music companies, is credited as the editor of all the songs in the collection.

In comparing the original sheet music with the music in the collection, I find the following differences. The first half of Mr. Bennett's introduction is eliminated. The ensuing measures are identical in every respect for fifteen measures and the first beat of the sixteenth measure. Then fifteen measures are eliminated. On the sixteenth measure, the second and third beats are identical with the second and third beats of the measure just before the cut. Then the music proceeds identically in every respect for forty measures. Then, but for raising the top line an octave for five and a quarter measures and reinforcing the harmony on the second beats in the left hand (the identical harmony), the piece continues through to the end without a single change. Since Dr. Sirmay's so-called editing comprised two cuts and raising the melody for five measures and therefore cannot be construed as rewriting, why is Mr. Bennett's name not still there as the "constructor" and "arranger"?

Now a few words about the piece. There are only sixteen out of more than a hundred measures which have lyrics. Among these are two measures of *Pick Yourself Up* from "Swing Time." Also in the course of the piece there appear the first two phrases from the melody of *A Fine Romance,* which lends a further medley-like character to it. There are seven distinct themes (six in the Sirmay "arrangement"), some restated, all of them charming and ingeniously swinging in nature, not, however, swinging in the manner of a "jazz waltz," a form which developed in small jazz groups much later on. This waltz, though clever, has an air of deliberation in its "swinging-ness." And there is a section which is marked *poco meno mosso* which interrupts its drive, if the marking is observed.

Pick Yourself Up is a pleasant song, quite adequate for Astaire's needs, but somehow less a "song" song than a "material" song. Unlike many of Kern's songs during this period, it does have a verse, not a remarkable one, but again, sufficient to get the song going. The main strain of the chorus, I must admit, does suggest a theme from "Schwanda" quite definitely. It works very well. It is stated first in F major, the second time in G major, and then the release moves on, without preparation, to A-flat major for four measures. The second half, without preparation, moves to C major and back to a restatement of the main strain in F major.

In 1938 in a movie, "The Joy Of Living," there was a song called *You Couldn't Be Cuter*. It deserves mention as a song which, whether intended to or not (and one can't help wondering), really swings. When I first heard it I refused to believe it was a Kern song. It might well not have been one of his favorites, as it bears none of his characteristics. Even the release might have been that of a pop tune.

The song not only swings, but it builds in the last section of twelve measures (as opposed to the other, eight-measure sections) to perfection. Instead of writing one imitation of measure twenty-nine, Kern continues to build the end of the song by adding three additional imitations. It's irresistible.

You Couldn't Be Cuter

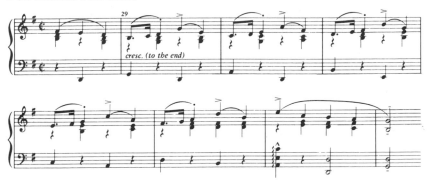

And, as well, the verse bursts right out and continues to do so straight into the chorus.

There is little of harmonic interest. Actually, I think its base notes could move more instead of sticking to the G-major chord for the first four measures. No arranger would hesitate to move them.

The ballad *Just Let Me Look At You*, still from the same film, is a beautiful, uncluttered song which proceeds from melodic point to point in one long flowing line. It's not sparing in its use of melodic invention and doesn't bother to repeat sections, as is customary in even the best of theater songs. Its form is *A-B-A¹-C-D*, which may give you an indication of how prodigal Kern could be with his material. Yet there is no resultant quality of wandering, as compared, say, with *Your Dream* (a song from "Gentlemen Unafraid," 1938), which wanders all over the lot. And as well, he never stirs beyond the legitimate bounds of the parent key. It's a singer's song, rangy and fairly demanding. This may account for its never having become one of the well-known and quickly recognized Kern songs. It should be.

Next comes Kern's last Broadway show, "Very Warm For May" in 1939. It was a complete failure; the reviews were so bad that only twenty people were in the audience the second night. It ran fifty-nine performances.

The book must have been terribly bad, since otherwise the show's failure is incomprehensible. For it had one of Kern's best scores. Indeed, there are *five* songs well worth considering, the greatest of them being *All The Things You Are*.

There is a story to the effect that Kern was convinced that a song so complex could never be a hit, but that a moment after voicing this fear to a friend he heard a passing pedestrian whistling it. Well, it's not a simple song. It starts simply enough, to be sure, but it soon becomes tricky. Take, for example, the fifth, sixth, and seventh measures.

All The Things You Are

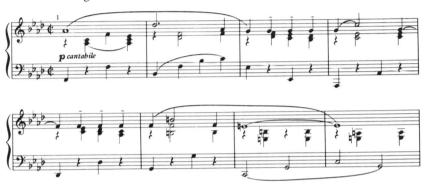

That *b* natural in the sixth measure is a marvelous twist, but not easy. Nor is the C-major cadence in the seventh measure. Of course, the *e* natural is just a half step below the preceding *f;* yet the two-measure pause in an unfamiliar key, even if the listener is unobservant of harmony, must sound strange. But maybe not, since it was a hit.

The second statement is the same as the first for five measures, except that it is four steps lower. Even the harmony is identical, four steps lower. The second cadence is in G major, and the release remains in that key for four measures, moving in imitative phrases to E major.

Now comes the great surprise, and the reason Kern thought it would be beyond the public ear. The melodic note at the end of the release is a *g* sharp with an E-major chord supporting its first measure. The harmony of the second measure is an E-augmented chord. Then the main strain returns in its original key, F minor, and its opening note is *a* flat. So here we have what is technically known as an enharmonic change. For, despite the difference in its "spelling," the preceding *g* sharp is also an *a* flat. And yet for all that, I've never

known a layman enthusiast of the song to boggle at this point and fail to continue singing or whistling it.

It's not only very ingenious, but very daring. I am as surprised as Kern is alleged to have been that it became a hit. Perhaps one should hark back to that old theory that if the opening measures of a song are singable, it doesn't matter how complex the rest of it is. After all, there is the classic example of *Blues In The Night* by Harold Arlen, which becomes increasingly difficult as it develops, so much so that I know no non-musicians who can sing more than the first part of it. (The song was long known to most laymen as "My mama done tol' me," its opening words.) But the first phrase is so immediately provocative, and easy to remember, that the public seemed to need no more in order to accept it, except, of course, its perfect lyric by John Mercer.

The second significant device used in *All The Things You Are* is a series of successive fourths, each echoing the one that opens the chorus, *a* flat-*d* flat.

The verse is in the key of G major and, while an attractive melody, seems to have little to do with the chorus. It's one of those verses which sounds as if it had been written at another time, or even originally intended for another song.

The verse for *Heaven In My Arms*, another song from the same show, is all of a piece with the chorus; indeed, measures from it are used as the ending for the chorus. In this instance, whether correct or not, the feeling I get is that verse and chorus were written in one sitting. And it's all without blemish, or better to say, it's all very charming.

The chorus is only twenty-four measures. The form is odd and the sections are of four rather than eight measures. In terms of those four measures it's *A-B-C-A-D-E*. Considering that the chorus has *five* different melodic ideas, one would assume the song to be of an almost improvisatory character. Strangely, it is not, nor could I conceive of any better or more cohesive way of writing it. One more point is that in four "open" spots, where the melody is a whole note, the opening figure of the verse is used in the accompaniment, which further binds it all together.

Another ballad, *In The Heart Of The Dark*, might easily be mistaken for a Cole Porter song because of its use of repeated notes and

quarter-note triplets, both stylistic devices of Porter. It's a very good, though little-known song. I don't believe it ever achieved the status of a standard, though the sheet music is still available.

Its verse is very gentle and simple and leads well into the chorus. The chorus bolsters my conviction about the power of the sixth interval of the scale, as it starts on it and repeats it eight times. Its form is *A-B-A-C/A*. Two of its notes both please and puzzle me: the last quarter notes of measures eight and ten.

In The Heart Of The Dark

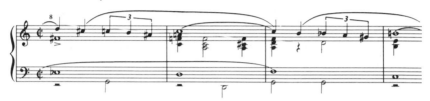

In measure eight one would expect an *a* natural and in measure ten a *g* natural. The *a* sharp and *g* sharp are marvelously surprising, but not easy for a singer to pinpoint.

There is not much to examine in *In Other Words, Seventeen*, but I can't pass it by without mentioning its innocence and naturalness. From its verse through to the end of the song it maintains quiet dignity. And yet, in spite of its innocent initial statement,

In Other Words, Seventeen

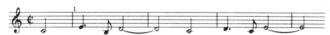

Kern does make some curious melodic moves. In measure nine, for example, against a C-major, first-inversion chord, he uses an eighth note *g* sharp. And in measure eleven, against a G-dominant-seventh chord he uses a *c* sharp. This is less of a scrape than the *g* sharp, but then, in measure thirteen, he uses another eighth note *c* sharp against a D-minor-seventh chord. And since that seventh interval is a *c* natural, the *c* sharp in the melody constitutes a very unusual, though effective, dissonance.

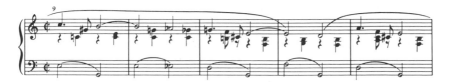

Also, in measures twenty-seven and twenty-eight, the climax of the song, the melody is less simple than the rest of the chorus but still not out of bounds, unless the *e* flat in measure twenty-eight might be considered more instrumental than vocal (being part of the diminished chord implicit in the melody notes *c, a, f* sharp, *e* flat).

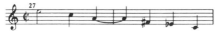

All In Fun is another very fine and untypical ballad, most of it easy, except for its opening measure. This, however, sets the bittersweet mood of the song perfectly and is well worth the extra effort it takes to settle it in your ear. Its form is *A-B-A-C* (with the opening measure repeated just before the end).

It makes no harmonic effort and doesn't need to. The rise and fall of measures twenty-seven and twenty-eight, dropping suddenly to a restatement of the opening phrase in measure twenty-nine, is very lovely, and is truly theatrical songwriting.

All In Fun

And just in case I haven't said it strongly enough, there is *always* this quality of theatricality in the best of Kern songs. You may love them wherever you hear them, but I'm sure, were you to consider their source, you'd know that it had been the theater.

The verse to *All In Fun* seems a trifle flippant for what follows, though such contrast may have been intentional.

The Last Time I Saw Paris, although it was interpolated in the film

"Lady Be Good," was actually published as a pop song, perhaps the only such that Kern ever wrote. I am not one of those who sigh nostalgically every time I hear it, very simply because I find the song dull. Its sentiment, considering World War II and the German occupation, is conducive to sadness, as is the lyric.

In 1942 in the film "You Were Never Lovelier," there were several very good songs, among them the title song. It effects no innovations harmonically, rhythmically, or melodically. It's just a good solid song in a form often used by Kern and others: *A-B-A-C/A*. It does, however, have a rather schoolmarmish verse and an unfortunately weak ending. It's not only weak, it's abrupt. It's hard to say what might have strengthened it. My personal belief is that an extra two measures added to the last section would have done it. I even have notions of what they should have been, but to describe them would be presumptuous and pointless.

I'm Old Fashioned I find a particularly splendid song. The verse is as lovely as its lyric. Its chorus is comprised of comparatively few notes, none shorter than a quarter note, and its form is very satisfying and untypical: *A-B-C-A¹*, the last section being extended to twelve measures.

The second half of the *C* section is a masterpiece of invention, moving, as it does, from A major in a series of imitations, up to a C-dominant-seventh chord as a preparation for a return to the principal statement.

I'm Old Fashioned

And it is a song of extremely narrow range, only a ninth, and attempts no climactic ending. In fact, the reverse.

Dearly Beloved has such a reputation that it is played at many weddings, which would have pleased Kern, since it was his desire to replace *Oh, Promise Me* with *Dearly Beloved* as often as possible. I

once saw a telegram from him expressing such a wish. It doesn't happen to have nearly the appeal for me that *I'm Old Fashioned* does. And were I the marrying kind, I'd much prefer the latter at my wedding (if there were no Bach available).

It has been stated that the source of *Dearly Beloved* is a duet from a Puccini opera. I can see how this might be, and I might attempt to trace it if I thought the song worthy of further discussion. I truly do not like the fourteenth and fifteenth measures insofar as they completely destroy the diatonic character of what has preceded and what follows. Nothing like these measures occurs elsewhere in the song, melodically or harmonically.

Dearly Beloved

The verse is literally a throwaway of eight measures and has no character. I apologize for speaking ill of a song which to many, by now, has the stature of a hymn.

On The Beam, a good strong rhythm song using Kern's device of restating the theme a third lower, was cut from "You Were Never Lovelier." But one might guess its general origins in that it has the mysterious vitality of the songs written for Fred Astaire.

In 1944, in the film "Can't Help Singing," there is the song *More And More*, which I had thought merited discussion but which, upon close re-examination, reveals curious lapses: The second eight measures, for example, which are completely pedestrian. This is doubly disappointing because the first eight measures, while not electrifying, lead one to expect more. And the ending is weak as well, unless one wishes to accept the second ending, an extension, ending somewhat pretentiously on the sixth interval.

There is also a breezy waltz, the title song, which works throughout. Kern wasn't given to many waltzes, and so the "waltzability" of

this comes as an added surprise. It is cheery, direct, uncomplex, and spring-like.

In "Cover Girl" (1944) is the famous *Long Ago (And Far Away)*. In this song Kern daringly restates his principal idea a minor third higher after only eight measures. When the song was first played, I was convinced that this device would be too much for the public ear, but not so, for it's a standard song.

It's an interesting departure for Kern that every eight measures he restates his two-measure opening theme. I don't know of another song in which he does this. It has a verse, but it would have been just as well if it hadn't.

I find the other ballad, *Sure Thing*, a much more endearing and melodically interesting song. Obviously the public didn't, since it is familiar to only a few. To begin at the beginning, even the verse is attractive. The chorus is wholly natural even though it moves melodically out of its key for four measures, the printed key being E flat, with a cadence on *a* natural.

The first phrase is four measures long, one element of which is restated with a slight variation and then imitated. When the song moves to G major, Kern employs six eighth notes as the second, third, and fourth beats of measures thirteen, seventeen, and twenty-five to great effect, and later twice again equally tastefully.

The shape of the song is difficult to state simply. Keeping in mind its odd length of twenty-eight measures, it must be considered in terms of four-measure phrases. So it's A-B-A^1-C-C-A^1-C. The second two C sections are the same shape as the first but with different notes. I think this is one of the most American-sounding of Kern's later ballads.

The score of "Centennial Summer" (1946) was to include a rather wild, irregular song that got cut: *Two Hearts Are Better Than One*. Its long, fascinating verse was obviously fun to write. The chorus has the distinctive characteristic of two sets of eighth-note triplets which, though they appear in only two measures (the identical third and nineteenth), nevertheless exert a strange control. Despite the tempo marking, one's impulse upon playing the song is to start at a much faster tempo than the measures containing the triplets will permit. So you set the tempo by the demands of that measure which puts you in mind of a soft-shoe dance.

Two Hearts Are Better Than One

Kern indulges in his predilection for raising (or lowering) the melody a third by doing it twice in this song. It's clever, to be sure, but it makes the song extremely difficult to sing. And I must suggest that, in his enthusiasm, he carried himself harmonically too far out to get back comfortably in time to restate his theme in the original key. I find measures fifteen and sixteen less awkward melodically than harmonically, but awkward even at that.

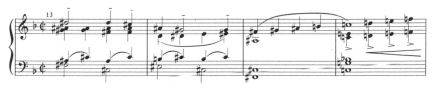

The F-sharp-major chord simply does not resolve believably into a C-natural-dominant seventh.

Kern wrote a new song for the second revival of "Show Boat," *Nobody Else But Me*. As I said before, it's supposed to be the last song he wrote. And a very beautiful song it is, though far from simple. Strangely, its chorus provides a perfect illustration of my mania about the sixth interval. Not only does it start on it and return to it twice in the first five measures, but it repeats the note with four quarter notes and a whole note just before the restatement and then continues to repeat it there. More than these insistences, in the last eight measures Kern repeats it twelve times. In all, he uses it thirty-three times (thirty-four, if you include a passing tone). According to my theory of the sixth interval, this song should have been a monumental hit. It obviously wasn't, though it became an accepted standard.

The song's greatest melodic complexity occurs early on; in fact, in the sixth and seventh measures.

Nobody Else But Me

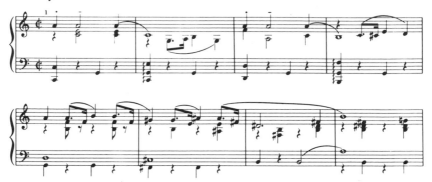

There is a degree of daring implicit in such a difficult passage and possibly in other unusual melodic innovations which Kern wrote. And there weren't many who took such chances, or who, if they did, possessed the skill and flair to do it well. Kern could have achieved as much eminence with the public without taking as many chances as he did. But by taking them he raised song writing to the level of highly distinguished melodic composition. And for this all of us, even if "us" only represents the musicians, are humbly grateful.

Obviously, there is no need to dwell on the extraordinary development of Kern's music that the later songs demonstrate. However, in passing I must note that to me perhaps the most striking quality of *Nobody Else But Me* is its "American-soundingness." It serves as a perfect epitaph to his career.

VI

Jerome Kern grew up with the development of the American popular song, lived through its flowering, profoundly influenced other writers, and died only shortly before the great shift in popular music took place in the early fifties. His whole approach to his craft, indeed, his art, was so professional, and sometimes even academic, that it would have shocked him to see the world he had helped create turn into a littered carnival ground for the untutored, undisciplined, insensitive, young player-performer-writer. The ominous cloud of anarchy moving over the musical landscape would certainly have troubled such an orderly mind, such a gentle, lyric, controlled talent.

As far as Kern's slow acceptance of the American style of song is concerned, it may well be that had he grown up in an era in which the diffusion of new sounds was more highly developed, he might very well have heard and accepted them much sooner. It is quite understandable that a young man whose mother was an accomplished pianist, and who was, therefore, familiar with a sophisticated level of music, should have turned automatically toward Europe and its vast musical heritage. Growing up in a reasonably protected environment, in the constant presence of European music, where else would a young man turn once the music bug had bitten him?

Once there, it seems that his principal enthusiasm was for London rather than the continent. He very soon came to know people working in the musical theater and, on his first trip to Europe, spent the bulk of his stay there. In England at that time the musical theater was casting off the yoke of Gilbert and Sullivan, and the new theater composers were working in less prissy forms. But whatever was stirring in America had not yet been heard in England or, if it had, had been ignored.

One sees how Kern's contemporary, Irving Berlin, a product of Lower East Side poverty, could have arrived at an American sound much sooner than Kern, simply because he was directly exposed to it in all its rawness. There was no sophisticated musical home life, no money for study, no time for anything but work. But no matter how arduous that must have been, Berlin was at least out in the street where it was all happening. *Alexander's Ragtime Band* was no accident. He'd heard what was in ferment around him and used what came naturally.

For Kern, the slow development of his American-sounding songs could be compared to removing a hothouse plant a few hours each day into the chancy weather of a garden. And there may, too, have been a degree of social snobbery which caused him to think twice before soiling his musical hands with the unpolished, unschooled, street-Arab sounds popping up in American cities. And there was also, as I mentioned before, the snobbery of the New York audiences, which were more impressed by importations or shows which looked and sounded like them. Or maybe it wasn't snobbery. Maybe that's all that was offered to them.

To a young man who has made up his mind he's going to be a

musical theater writer, the style of the time necessarily sets his own personal style. It is my opinion that this was agreeable to Kern, since he'd already indicated at a very early age his assumption that the way to Europe was the only way to music. It is ever possible that had he not found congenial friends in the London theatrical world, among them P. G. Wodehouse, he might have settled down to serious study with the goal of so-called "serious composition." He certainly left an extraordinary body of work, as well as the healthiest kind of influence on other writers, even though none of them could conceivably be called imitators.

Out of deference to those readers whose favorite Kern songs have not been examined or mentioned in this survey, may I say that their absence does not necessarily imply that I consider them inferior. Many of his early interpolated songs I do find weak and even without musical interest. But my omissions from his later career are due to the fact that I considered whatever qualities of invention they possessed to be better exemplified by other, similar songs written during that time.

The Folks Who Lived On The Hill is a case in point. Many singers and lovers of Kern are very fond of it and rightly so. But it doesn't say anything musically which he didn't say better in some other song written during that phase of his career. The one unusual element in the song is a release of only six measures. I believe that the song's adherents are more impressed by the somewhat Edgar Guestian homespun lyric than they are by the melody. This, however, is not to say that the melody is lacking but rather without special interest.

The bulk of Kern's songs were landmarks in the musical theater for thirty years, and the omissions here are in no way a denial of this fact.

There is a fugitive essence and personality that distinguishes a song as American. In the case of Kern, his songs seldom achieve the overt American quality of the Gershwin or Arlen music. But neither do many of Rodgers' songs. For a song to possess an American character it requires a subtler distinction than the presence of marked syncopation. Sometimes it is the lyric, which causes the listener to take for granted its native source. Sometimes it is the shape of the song, its unacademic looseness, and sometimes simply that it doesn't sound like an importation. Kern's songs in the beginning all sounded like importations. And he returned to this imported style from time to time

throughout his career. But this does not minimize his prowess as a great melodist. It does, however, suggest that there had been an almost deliberate isolation from the sounds all about him, implicit in these "imported" songs. They were lacking in an awareness, or acceptance, of his musical environment.

Though the audiences of the theater music didn't shut their ears to current non-theater, pop songs, they did demand or at least expect greater elegance and distinction in the former than the latter. Perhaps there was a tendency to maintain proper, textbook musical speech in the theater as a protest against the slangy "street" speech of the pop song. Yet this same slangy music produced the first elements of a new sound and a new song: in the work of Ben Harney (*Mister Johnson, Turn Me Loose*), Irving Berlin, and Shelton Brooks (*Walkin' The Dog, Some Of These Days, Darktown Strutters' Ball*).

In the heyday of American musicals only a rare talent like Berlin's managed to produce songs on both levels. It was not until much later that an average successful pop writer could move into the world of theater music with a score having little more sophistication than his pop songs. But by that time the taste of the audiences had become less demanding. They were the new, post World War II audience. The havoc of war affects every level of society, its customs, and its art forms. Invariably the new public emerges with tastes less polished and knowledgeable than its predecessors. It cannot be denied that the level of theater music did depreciate noticeably after 1945. But for a very few musicals, there has been little distinguished theater music written since then.

It is a sorrow, and an embarrassment as well, that Kern is no longer alive. If he were, he might clarify many mysteries: his attitudes toward theater music, collaboration, the distinction between American and other popular music, and the position of great popular music in the over-all world of song. There have been biographies and interviews, quotations and legends, but so many questions remain unanswered that anyone seeking the truth runs the risk of an occasional gaffe.

It is conceded that Kern was not an easygoing collaborator. So uninclined was he to make even the slightest concession to the needs of his lyricist that one tends to comment less on his incompatibility than on his absolute conviction of the inviolability of his melodies.

As of this writing only a few Kern manuscripts are known to exist, and some of them need authentication. This is particularly mysterious, as Kern was a man of unusual self-respect, always insistent, it is said, on the return of his original copies after the publisher's editors were through with them. Considering the vast number of his songs which were published, the manuscript copies would be, if in existence, a very bulky stack of paper. Yet the Library of Congress, his publisher, his estate lawyers, his daughter, close friends—none of these have so much as a clue.

This is most sad: the opportunity of studying his manuscripts would have been a valuable asset to this survey. I believe that he was very demanding about those of his songs in which the harmony was of paramount importance. There would have been no alterations of his original chords. But I cannot accept as true the claim that nothing was ever altered by his editor. Dr. Albert Sirmay was the editor of sheet music publication of most of Kern's songs. But, alas, he is no longer alive, nor would he, as a matter of polite discretion, have revealed his own contribution, if any.

I realize that I am risking irreverence, but in the name of personal conviction I must say that I believe Kern's music became increasingly American not so much because of his complete acceptance of the new sounds around him as because of the demands of public taste. I believe he was a musician, like so many others, who revered the glorious European musical tradition and therefore shied away from the unpolished expression of American popular music, concluding perhaps that the only way to give his music the elegance and sheen of reputability was to write with tradition as his mentor.

Thus, the provocative strength of the unfocused but unique song form exploding around him in America deserves greater respect for swinging Kern away from his European ideal into the brawling world of experimentation. That he slowly but surely did change his point of view, and style, while few of the other theater writers of his day did, speaks highly for his awareness of the vitality of the new music in America, as well as for that music itself.

—3—

Irving Berlin
(1888-1989)

I

I am convinced that were Irving Berlin ever to read these pages, he would be more puzzled than pleased. I think he would be pleased at the evidence that a painstaking examination* has been made of his songs, but puzzled as to why it was made.

This is by way of saying that through his long and phenomenal writing career Berlin has been a worker. In the course of his prodigious output he has written a great many memorable songs. His is probably the most widely known name in the popular music world. He has been famous for over sixty years. He has led a double life, as a pop song writer and as a theater writer. His fame has been such that he and Sam H. Harris had a theater, The Music Box, built to house shows for which Berlin wrote the scores.

And yet nothing in this extraordinary body of work ever spilled over into the concert field. I'm certain Berlin has never considered the popular song a limitation. Very poor in his youth, without musical training, he wrote and he wrote and he wrote. Whatever idealism

* Mr. Berlin has not granted the author permission to use any musical excerpts from his songs. In consequence, all the examples illustrating specific musical analyses have had to be deleted from the text of this chapter. However, as much of the technical commentary as seems to be clear without the examples has been retained. The author and the publisher regret whatever inconvenience the excisions impose on the reader.

some of his songs have revealed, the core of his work has been eminently practical: his has been truly a body of *work*.

I have not been fortunate enough to interview him, yet I feel reasonably sure that my aesthetic concerns and evaluative attitude would irritate him by seeming superfluous. This is not to say that he might feel his songs do not deserve musical examination and respect, but rather that his approach to song writing is that of a craftsman rather than a composer.

I'm sure he is as eager for praise as anyone, but I believe the kind of praise given his work in a study like this would appear to him to be a waste of time. If, on the other hand, I were making an attempt to determine the precise elements needed to make a hit song, he would probably be interested. For I think that to Berlin, as well as to many other song writers, a *good* song and a *hit* song are synonymous. Therefore, it is doubly remarkable (assuming my belief to be true), that Berlin wrote so many songs which deserve to be praised for musical reasons rather than because they were hits.

Many popular music enthusiasts do not seem to be aware that Berlin's range of writing was remarkably wide and varied. It is conceivable that the absurd legend to the effect that there was a mysterious ghostwriter tucked away uptown who wrote Berlin's better songs came into being because it didn't seem possible that one man could write on so many levels.

His output was extraordinary. Saul Bornstein, who was for many years the professional manager of Berlin's publishing company, once told me that it was a ritual for Berlin to write a complete song, words and music, every day. How long this backbreaking schedule went on, even if in actuality it consisted of a song every other day, or three a week, I do not know. Obviously, not all the songs Berlin drafted were revised and polished for publication.

However, as late as 1969 his publishing company still listed 899 of his songs: 593 were pop songs, and the remaining 306 had been used in Broadway or Hollywood musicals. Only Mr. Berlin can say how many hundreds more he wrote and threw away as not meeting his standards, which, by the way, were far higher than many people, professional writers among them, are aware. Berlin was a master of both theater and pop music.

Admirers of the music of Jerome Kern, Richard Rodgers, and Cole

Porter are, in my experience, unlikely to consider Berlin's work in the same category. I believe that out of forgetfulness and confusion, they are inclined to minimize his talent. They forget *Soft Lights And Sweet Music, Supper Time,* and *Cheek To Cheek* because they are confused by his having written *What'll I Do* and *Always.* The solid, straightforward pop songs of Berlin are minor masterpieces of economy, clarity, and memorability. But they give little hint of the much more sophisticated aspects of his talent as it is revealed in his theater and film music.

I am frankly astounded by the sophistication of Berlin's theater songs in view of the supposed lack of harmonic influence in their composition. For most of these melodies, one would say, contain the implication of specific chord progressions. Yet I heard Berlin play the piano, back in vaudeville days, and found his harmony notably inept. As well, I have heard witty imitations of his playing, exaggerated perhaps, but indicating a total ignorance of harmony.

Yet Robert Russell Bennett states unequivocally that upon hearing someone's harmonization of his songs, Berlin would insist upon a succession of variant chords for those measures in which he felt the harmonizer was wrong. And, Mr. Bennett added, Berlin was not satisfied until the right chord was found. So, since Mr. Bennett is a schooled musician and an accomplished composer, I must accept the fact that though Berlin may seldom have played acceptable harmony, he nevertheless, by some mastery of his inner ear, senses it, in fact writes many of his melodies with this natural, intuitive harmonic sense at work in his head, but not in his hands.

So, though it is known that he has for years paid a professional musician to harmonize his songs under his close supervision, it is very nearly impossible, upon hearing some of these melodies, to believe that every chord was not an integral part of the creation of the tune. Many instances of this intuitive phenomenon will follow.

Though Berlin was born in Russia, his music shows little trace of his background. Whenever it seems to, as in *Russian Lullaby*, I feel* that it is less his background emerging than his highly professional sense of the kind of melody which would fit such a title.

In his lyrics as in his melodies, Berlin reveals a constant awareness of the world around him: the pulse of the times, the society in which he is functioning. There is nothing of the hothouse about his work,

urban though it may be. Upon examination of his early songs, which include hit after hit, one would be inclined to consider him a highly proficient tunesmith, witty, entertaining, sentimental, but unlikely to mature as, indeed, he did. For he was a topical writer, a "street song" writer, little given to startling experiments in melodic writing, and yet, as examination reveals, he refused to be categorized. Note later on, for example, the unusual structure of *The Girl On The Magazine Cover*. Here the generic phrase is never repeated. No hard sell about this! Yet it was a hit. So many of his songs have been played so often that it is easy to forget, bemused as one always is by all things familiar, the truly daring succession of notes in the chromatic phrase of the main strain of *White Christmas*.

The "American" aspect of Berlin's writing is almost never absent. In his lyrics he is perhaps less sympathetic with, or aware of, the romantic panorama of the country than is John Mercer, yet he concentrates quite as much as Mercer does on aspects of the "new world."

II

To hear from Hans Spialek, the great orchestrator, that *Alexander's Ragtime Band* (1911) was the hit of Vienna and probably every large city of Europe by late 1912, and then to realize that the writer of this song, forty years later, wrote the nearly perfect score of "Annie Get Your Gun" (in a few weeks, according to Miss Dorothy Fields) comes as a profound shock.

I have heard enough ragtime to wonder why *Alexander's Ragtime Band* was so titled. For I find no elements of ragtime in it, unless the word "ragtime" simply specified the most swinging and exciting of the new American music. It is a very strong, solid song, verse and chorus. More than that, it is not crowded with notes. There are constant open spots in it. At the outset, in the verse, the first three measures begin on the second beat. This "kicks" the song, and immediately. Incidentally, this is the earliest popular song I know of in which the verse and chorus are in different keys. In the sheet music the verse is in C and the chorus in F.

One must presume that the opening strain of the chorus was the "hook" which caught the public's fancy, since the only other musical ideas in the song are quotations from other songs. The latter device

was common in the early years of American popular music, just as quotations from other songs became a popular device in the jazz improvisations of the Swing Era. In this instance one of the quotations was a bugle call and the other *Way Down Upon The Swanee River*.

Could the slight, chromatic opening phrase of the song have caused all the furor, the grass fire that spread over the face of Europe? Or was the restatement of this phrase a fourth higher the device which did the trick? In any event, the song was a high point in the evolution of popular music. And, it must be noted, this was not Berlin's first hit. He had been publishing songs since 1907, his first song having been *Marie From Sunny Italy*, for which he wrote only the lyrics.

As is indicated in this title, the primary drive of this song was toward the marketplace. There was no time for music lessons, concerts, experiments, or polite musical conversations, all looking ahead to a place in Grove's *Dictionary of Music and Musicians*.

There was poverty and therefore there was a need for money. You had a flair for making up songs? There was money in songs? Then find a publisher! Or, publish your songs yourself. What was being written about? All of the life around you! Italian girls, pullman porters, pianos, ragtime bands, bagpipe bands. And so a year after the international hit about the ragtime band came *Alexander's Bag-pipe Band*, in which Berlin collaborated with E. Ray Goetz and A. Baldwin Sloane.

It's a more musically interesting song than its predecessor, but it contains too many notes to be a good song. As an instrumental piece, I like it better than *Alexander's Ragtime Band*. Its third measure is the same as that of the earlier song, as is its shift to the key of B flat in the fifth measure. It also quotes other songs, but still includes *Swanee River*. This time *Auld Lang Syne* and another Scottish song are added. It was probably successful as a vaudeville "material" song, depending more on its lyric than its music, and never achieving the status of a standard.

In 1912 Berlin also wrote a melancholy ballad entitled *When I Lost You*. It is said that it was written in memory of his first wife, who died very shortly after their honeymoon. The song was, for those days, and even for any era, an enormous hit. It is clear, however, that the song was written as a personal testament and with no commercial reward in mind.

Any further comments, considering its inspiration, would be unmannerly. Its pertinence to this study is that none of the one hundred and thirty songs published up to this point in Berlin's career revealed this aspect of his talent, the ability to write with moving sentiment about personal trouble and pain. On its own level it is as surprising as was *They Didn't Believe Me* in Kern's career.

In 1913 Berlin published *At The Devil's Ball*. It's obviously a novelty song, stressing its grotesque lyrical premise more than its melody. Yet the melody is loose and open enough to be called "swingable." It proceeds in a straightforward, unsophisticated fashion, with an unusual twenty-six measure length. It would have been a more conventional twenty-four measures but for a two-measure tag which may have been a "riff" of its time, not at all corny, and swinging enough to deserve comment. Also, for its time, the pick-up to the restatement of the main strain has the seeds of a jazz phrase.

In 1914 came the show "Watch Your Step," with a very good score for that era. Six of the songs from the show, which was billed as "The First All-Syncopated Musical" (a slight exaggeration), merit discussion.

In the verse of *They Always Follow Me Around* it is interesting to note that there is a key shift in the ninth measure from G major to B-flat major. And it is prepared for by the three-note pick-up in the eighth measure. The key shift substantiates Mr. Bennett's observation concerning Berlin's "built-in" harmonic sense. For, without it, a non-harmony-minded writer would never consider such a shift.

The second chromatic phrase, though not a complete imitation of the first, starts on the fourth beat of the first measure instead of the first beat of the second measure. It is of no great consequence, but it does indicate a search for a novel rhythmic pattern.

Considering that it was written at this early date, the principal motif of *Homeward Bound*, from the same show, is better than average. It is followed by an imitative phrase and then a slump into clichés. But in the second half there are several intervals that were unusual for their time.

Lead Me To Love certainly should have become a standard song. But since this is an examination primarily of Berlin's music there is no reason to discuss this melody, as it was written by Ted Snyder, with only the lyric by Berlin.

The Minstrel Parade is a much better than average rhythm song
for that era. It is printed in 2/4 rhythm, yet it definitely swings, both
verse and chorus. It contains only one cliché pattern of notes, which
comes at the close of the verse, and none in the chorus. Though not a
great *song*, nor intended to be, it is another of Berlin's uncluttered
natural tunes.

The Syncopated Walk, for me, bogs down at the end, but the chorus
opens with a very provocative germinal idea, one that well may have
been a riff of that time. There are two oddities about this song: first,
though called *The Syncopated Walk*, there is very little syncopation
in the melody; second, the closing section fails to repeat its most pro-
vocative phrase, the first phrase of the chorus. I'm not certain, but I'm
beginning to believe that what one reads of as being *syncopation* in
popular music is merely ordinarily weak beats being stressed as strong
beats in order to create an eccentric pattern, as in Gershwin's *Fasci-
nating Rhythm*.

What Is Love is a most unusual melody, for any era. It's a waltz
and, speaking of eccentricity, the way the phrases fall following the
title phrase is truly eccentric and wholly unanticipatable. The fourth
measure reveals a new idea which is not only unusual in itself, but
falling on the fourth instead of the fifth measure throws one off-
balance insofar as it is *not* a fill-in or a pick-up. It is the second me-
lodic idea and a very strong one, in complete rhythmic contrast to
the preceding three measures. Mysteriously, it comes off. But it's al-
most as disturbing as the abrupt shifts in rhythm in the amateur songs
of the sixties. Yet it, unlike most of the latter, works its way back to
balance in the ninth measure, therefore justifying itself.

Play A Simple Melody is still well known today. And that's a fair
run for a song, over fifty years. It's a "double" song, probably Berlin's
first of many. In the printed copy one first hears the "simple melody"
comprised of nothing shorter than a quarter note and no syncopation.
Next comes the contrasting tune, the lyric of which "begs for a rag."
Then the two together, and very pleasant they are, together or singly.

The score of "Watch Your Step," while in no way comparable to
Berlin's later, more mature scores, nevertheless possesses a vitality
and awareness of shifting musical fashions. Granted that he had not
yet achieved an elegance or lucidity comparable to Kern's *They
Didn't Believe Me*, also of 1914, yet he hadn't lingered, as did Kern,

in an operetta world of dying subservience to European culture. Berlin, musically, was a street Arab, spinning through the musical by-ways listening to all the new sounds about him and trying to put his reflections and conclusions down on paper.

During 1914 Berlin published a song called *Always Treat Her Like A Baby*. It's a perfectly good pop song, with perhaps too many notes but swinging in nature. Its principal interest, to me, lies in the third measure of the verse. For considering all the brou-ha-ha that was stirred up by Gershwin's *I'll Build A Stairway To Paradise* some years later, this measure also should have been as widely admired.

In "Stop, Look, Listen," 1915, there was a song, *I Love A Piano*, which, while not played as much as Berlin's standards, is still heard enough to be familiar. It really has no theatrical flavor. Nor, but for *What Is Love*, did the songs from "Watch Your Step." The pop writer aspect of Berlin's talent was still predominant. While *I Love A Piano* is a pleasant, easygoing song, I feel that its principal interest lies in its lyric.

However, for the same show Berlin wrote a very interesting song, *The Girl On The Magazine Cover*, which he revived much later, in 1948, in the film "Easter Parade," and it is indeed theatrical. Though something of a hit when first published, it, to the best of my knowledge, did not become a standard.

The structure is most unusual in that the song's initial phrase is never repeated. The form is *A-B-C-D*, as in a much later Berlin song, *Lazy*. It is a song which is perfectly satisfying without harmony or orchestration or anything but itself. It possesses a curious elegance that distinguishes it as a theater song. I don't know what tempo it was originally played in, but I imagine too fast. Most everything was, perhaps due to the dance fashions of the time. But I hear it as a fairly slow ballad in which the dotted eighth- and sixteenth-note patterns are softened into triplets.

The implications of the melody are such that it is very hard to accept the fact that Berlin did not harmonize his own music. This is a splendid song, one that has stayed with me for fifty years.

In 1918 Berlin wrote an Army show called "Yip, Yip Yaphank." *Oh, How I Hate To Get Up In The Morning* was probably much closer to a soldier's heart than *Over There*. It's a perfect song for its purpose with, perhaps, a much more rousing melody than the lyric's

laments. I believe this song could have been Berlin's platform had he run for high office at that time.

Mandy is a short, eighteen-measure song (two extra measures for the tag), which has survived these many years, not one of the great standards, but still sung by such great ladies as Mabel Mercer. It's a very dear, direct, uncluttered song, words and music.

In 1919, in "The Ziegfeld Follies," Berlin fired one of his first big guns, *A Pretty Girl Is Like A Melody*. This song is definitely on a level with Kern's pure melodies. As such, it is self-sufficient. It is one of those songs not one note of which I would choose to change.

It is extraordinary that such a development in style and sophistication should have taken place in a single year, that is, if one considers *Mandy* as illustrative of 1918's songs.

Berlin has always had an uncanny ability to adjust to the demands or needs of the moment, the singer, or the shift in popular mood. And so phenomenal has been this ability that he is as difficult to define as the color of a chameleon. One searches for stylistic characteristics and is baffled. For the sea of his talent is always in motion. It's mercurial and elusive. You decide to concentrate on, let's say, pop songs such as *All Alone*. You decide it is in the same stylistic category as *Always*. So you search for parallels. There aren't any.

Or try comparing two songs from the same show, such as *They Say It's Wonderful* and *I Got The Sun In The Morning*, from "Annie Get Your Gun." How do you make out? Well, they're both great songs. They're not of a wide range. They're not difficult to learn; they're inventive; and one is as jazz-oriented, and harmonically and rhythmically vital, as Harold Arlen's music.

I've only started this attempt at analysis. I hope to find Berlin's especially loved turns of phrase, tendencies, and identifiable patterns, strictly his own. My memory tells me that if I do, I shall have to contend with many styles, and I admit that right now I'm baffled enough to be satisfied with one.

III

In 1920, in another "Ziegfeld Follies," Berlin wrote another pure melody, a perfectly beautiful melodic line, *Tell Me, Little Gypsy*. And if I am to be dutiful in my search for style, I must say that this

song shows a marked Kern influence in its extreme spareness (only fifty-seven notes), its independence of harmonic influence, and its inevitability. If one wishes to consider the possibility of the Kern influence, I suggest he consider one of the latter's songs written about this time, *Look For The Silver Lining*.

Just in case the reader has forgotten *Tell Me, Little Gypsy*, its structure is *A-B-A¹-C*, and its length is the conventional thirty-two measures. Frankly, I prefer the Berlin song in its slightly less hymn-like quality. It's somewhat more muscular, not quite so over-distilled.

In 1920 there was also a very popular non-theater song called (*I'll See You In*) *C-U-B-A*. One would assume from the title that Berlin's concentration would have been on the lyric. Well, perhaps it was, but with it he wrote a very good melody. His main strain is composed of wide steps laced together with chromatic steps and they make a very agreeable and unforgettable line. And that's another element of Berlin's songs, unforgettability. I admit to being unfond of some of his songs; yet I can sing and play, however poorly, every note of them.

Some of *I'll See You in CUBA* one might assume to have been by Kern. I'm not certain why, unless it's the fact that so many of Kern's songs start on the dominant-seventh chord. But certain measures Kern couldn't, or wouldn't, have written. Just too slangy for him, I'd say.

In the first "Music Box Revue" in 1921 there was a very famous Berlin song called *Say It With Music*. This is a very spare, strong ballad of an unusually small number of notes, fifty-two. As strong as it is (and evidence of its intention to be such is revealed in the melody being placed half the time in the left hand of the piano part), it is not to be compared with Kern. It is extremely well written, with every note weighed as if on an apothecary scale. But it very nearly offends me by its use of syncopation.

It's almost as if Berlin wanted to please two audiences simultaneously: those who would gladly settle for a pure, unrhythmic melody and those who had to be slightly jostled. And jostle me he does after that first powerful eight-measure strain when, in the eleventh measure, the words say "rather be kissed." Similar measures occur three more times; in fact, the song ends on such a fourth-beat tie-over. And so, remarkable as the song is, I find myself somewhat put off by these almost marketplace interruptions.

In the "Music Box Revue" of 1922, *Crinoline Days* was one of two successful ballads. It has, as does *Tell Me, Little Gypsy*, a markedly theatrical quality as opposed to, for example, *All By Myself*. The distinction between the two types of songs lies in both lyric and music. A theater lyric usually is more subtle, more sophisticated, and predicated on a more discerning audience. The fact that a very good theater song is ultimately accepted by the general public has always been somewhat of a mystery to me, unless it can be accounted for by the love the public has for finding within its financial reach those things designed for a privileged minority. Much advertising is based upon this sneaky, snob premise. And yet this is scarcely the complete story, since many show tunes become hits with the non-theater public without its knowing they are theater songs.

Berlin is one of very few writers who has managed to function with distinction in both areas. His extraordinary sense of proper function permits him during the same period of time to write an easygoing, unsophisticated, down-to-earth, semi-cliché song like *All By Myself* and a theater ballad like *Crinoline Days*. The latter is not a great song and doesn't measure up to the near-perfect *Tell Me, Little Gypsy*. But it has a broad, lyrical line, is uncluttered, and builds to a climax commensurate with its "period" nature. As I recall, it was sung during a virtual fashion parade of old-fashioned gowns.

On the other hand, *Lady Of The Evening*, the other successful ballad from "The Music Box Revue" of 1922, possesses more poise and elegance. In the lyric, by the way, there is nothing to imply a prostitutional meaning in the title, unless it be "you can make the cares and troubles . . . fold their tents. . . ." Well, if this lady is a whore, I prefer her to the ones in *Love For Sale*. She sounds better mannered, and better dressed.

The verse has an oriental flavor which is curiously effective, and it may be that I'm allying it with that bestseller "The Sheik" and the Arabs who fold their tents and "silently steal away." In any event this song is another of those dependent on no harmony or accompanimental device. It is strong, not un-Kernlike in its main strain, but by no means imitative. The opening chromaticism is so familiar, the song being that old, that it is easy to forget how unusual just the first two notes were. The first four measures of the release illustrate Berlin's use of the minor-seventh interval, *f* natural. The maintenance of the

G-major chord gives a modal quality to this passage and a sprinkle of theatrical mystery, which makes the "lady" more glamorous.

In *Pack Up Your Sins And Go To The Devil,* in the same revue, Berlin demonstrates his dexterity with an eccentric rhythmic device. It's as snappy and new-sounding as Gershwin's *Fascinating Rhythm,* which came two years later. If one were to don a green eyeshade and professorily break down the germinal idea, it would be two measures of 3/4 and one of 2/4 instead of two 4/4 measures. (Incidentally, I can't understand the use of cut time indicated in the sheet music, as all four quarter beats are pointedly marked in the left hand of the piano. If it were true cut time, only the first and third beats in the left hand would be written.)

There are only two moments in this song where there is a cessation of this rhythmic device, the second half of the third section and the measure before the final cadence. This insistence, I think, is quite justifiable, considering the novelty of the device. The measure at the end I find a bit out of character, as if a clarinet player had suddenly cut into the melody with an improvisatory notion of his own. But this is superfluous carping; it's a very neat and effective, hard-fisted song. And remember, it was written in 1922!

Who, in the 1924 "Music Box Revue," is a far cry from Kern's *Who?* and not to be compared with it. The former has an unremarkable but pleasant verse which leads very nicely into the unexpected opening whole note of the chorus, an *f* natural in the key of G major. Berlin proceeds from the opening four-measure idea to write an imitation of it up one step, then a shorter imitation of two measures up another step, up still another, and another until he reaches a *d* natural, after which he returns to his original *f* natural. This return is as neat as a pin and couldn't lead to that odd *f* natural more naturally.

I also like the rhythmic idea of the second measure (naturally imitated throughout the song). The two eighth notes leading to the stressed *f* natural on the second beat is very inventive and "swinging."

There was a big pop hit in 1924 by Berlin called *Lazy.* It's extremely good, both lyrically and musically, though I'm not a strong supporter of such rhymes as "wild wood" and "child would." However, I definitely defend "valise full" (of books) and "peaceful."

Its structure is highly unusual. As in the case of *The Girl On The Magazine Cover*, its so-called "front" strain is never repeated. This is remarkable for a man of Berlin's obvious practicality, since repetition is an intrinsic part of selling anything.

The structure is *A-B-C-D*. In the *D* section there is a suggestion of the initial phrase, but this time, instead of being two half notes, the second of which is tied to a quarter note, it is a quarter and a half note, which could easily be unrecognizable as even a suggestion of the beginning.

In 1925 came *Always*. It is, frankly, not a favorite of mine. I admit that I am very impressed by the song's unexpected shift, in the eleventh measure, to the key of A major from the parent key of F major. A writer with less distinguished reputation would, I'm certain, have been asked to rewrite the A-major section (unless, of course, like Berlin, he were his own publisher).

For me, there is simply too much insistence on the rhythmic device of the opening measure, that of a dotted quarter note followed by three eighth notes. (The song is a waltz.) But for the sophisticated chance-taking of the A-major section, the song is a straightforward pop tune, and, for me, a contrivance.

In "The Ziegfeld Follies of 1927" there was an extremely good rhythm song called *Shaking The Blues Away*. It's a strong, driving tune with three things about it that immediately impress. First is the concentration on the sixth interval of the scale, in this instance, *c*; second, the rhythmic device of the fifth and sixth measures; and third, the astute use of four half notes in the seventh and eighth measures to set up an unbusy contrast to the main strain. And, one examining the sheet music should note, at the end of the third measure, the inclusion of the *c* in the B-flat chord, making it a B-flat ninth instead of the then more conventional B-flat seventh. All but the last two measures of the release border on the cliché, but those two measures make you forget this. (The music-minded reader will almost certainly want to locate a copy of this song.)

Blue Skies was introduced in "Betsy" in 1927. For me its only distinction lies in its moving from a minor to a major key. It is a strict *A-A-B-A* song, starting each *A* section in E minor, winding up in G major on the fifth measure. It is a great favorite with jazz musicians, I suppose because it gives them lots of room to move around in while

improvising. I've always been puzzled by its E minor opening, considering that its title is *Blue Skies*. Only in its last statement is this minor-ity justified by the words "blue days, [all of them gone]."

Another song of 1927 is *The Song Is Ended*. I find the parenthetical afterthought "but the melody lingers on" a neat notion and the fact that the song makes its final cadence on the fifth interval unusual, but as a song I find it tunesmithy and contrived.

My great respect for his good writing suffers a body blow every time he drops back to safe commercialism. I want him to use only the best of himself. And as I hope I've made clear, this book has nothing to do with popularity based on sales but only inherent, basic quality.

IV

Authorities on the chronology of Berlin songs will notice, from time to time, glaring omissions. These are quite candidly the result of my having nothing analytical, or complimentary, to say about them.

In 1928 he wrote a very pleasing, four-square tune called *How About Me*. It is the first Berlin song I have found without a verse. This surprises me as the fashion for not writing verses did not begin until much later.

Puttin' On The Ritz was the title song of a film produced in 1929. For it Berlin composed a rhythmic device that is probably the most complex and provocative I have come upon, by any writer. It is, naturally, in a form of 4/4, but cut time. If one wishes to break this into time signatures which indicate more simply the stressed notes, it could be done this way: 3/4, 3/4, 4/4, 6/4; or 3/4, 3/4, 4/4, 2/4, 4/4. I prefer the former.

Berlin keeps you totally off-balance until the fifth bar, where he sensibly lands on a whole note tied to a half note and then whips you with the title phrase, in eighth notes. The release, again sensibly, he leaves for the most part unrhythmic. The structure is straight *A-A-B-A*. It's a marvelous song.

In "Face The Music," in 1932, Berlin wrote another one of his blockbusters. (He's very frustrating! Why can't he simply settle for great songs?) It's "*Soft Lights and Sweet Music*," a title I envy him for having thought of. (It was probably on signs all over New York ad-

vertising some ricky-tick night spot. As a matter of fact, Berlin him-self put the title in quotation marks on the copyright page of the sheet music, but not on the cover nor in his firm's own song list.)

The verse is exactly right, words and music, which I'd never heard until I examined the sheet music. The chorus is one of those with minimal notes, only fifty this time. It starts, in the key of F major, on an *e* flat. This in itself is startling enough. But the neatness with which he works his way, or I should say the way the melody flows back to F major, is remarkable. Then, having pulled off this tour de force, he proceeds with two very simple phrases, taking the tune to a half step below the *e* flat with which he begins the second half of the song. He repeats his first phenomenal statement and then, instead of repeating his second phrase, he fools you, delightfully, by zooming up to a high *g* natural. One should examine this song carefully; it's a marvelous example of a great natural melodic talent.

May I add at this point a report of no progress? I have been search-ing assiduously for stylistic characteristics in Berlin, but I can't find any. I find great songs, good songs, average songs, and commercial songs. But I find no clue to a single, or even duple, point of view in the music. Is Berlin's writing experience one of such enormous in-tensity that the song being written is totally isolated in his mind, to the exclusion of every other song he has written, resulting in a unique form and style for each one? How else can it be explained? There are, to be sure, occasional indications of other writers, at one phase, Kern, and at another, Arlen. But this discovery does little to solve the mystery.

Another report will follow after I've examined about twenty more songs.

Again in 1932 *Say It Isn't So* appears. And again I'm thrown off-balance, for now here is a song the principal device of which is re-peated notes. Well and good, but Berlin has never resorted to them before. As unenthusiastic as I am about Gershwin's endless use of repeated notes, I'm almost hoping that Berlin continues to use them in later songs so that I can claim to have found a stylistic device. In spite of the reiteration of repeated notes throughout the song, they somehow do not produce a monotonous effect. It all works.

It is another song without a verse.

In *I'm Playing With Fire* (1932) the verse is a trial balloon for the main idea of the chorus of *I've Got My Love To Keep Me Warm*. And, thank heaven, he does continue to use repeated notes! The first section of the chorus consists of a whole note, *d*, moving to four repeated *e*'s in the second measure, back to a whole note *d*, then up to *f*-natural repeated notes, back once more to *d* and then, instead of moving a half step up from *f* natural to *f* sharp, he moves to *a*.

The second section is ingenious in that now he starts from a high *d* and drops to *f* natural, a sixth interval, moves to a whole note *c*, down to *e*-flat repeated notes. The last quarter of that measure is a low *d* moving up to a whole note *b* and then, remarkably, down to a *c* sharp, which moves up in an A-ninth scale line instead of repeating itself.

It is not a great song but it surely is a much better than average pop song. Its form is *A-B-A¹-C*, and in its *C* section, while it remains inventive, it doesn't continue to surprise.

How Deep Is The Ocean, still 1932, is another verseless song. It certainly needs none. For it is expertly written, lyrically and musically, and all within the confines of an octave, with three instances of a low *d*, a half step more than the octave. Though it is a melody of small steps, never resorting to an interval wider than a fourth, it makes one totally unexpected move in the *B* section, dropping to a *g* flat at the end of the first phrase and then restating this note twice more in the last half of the section. (The form is *A-B-A-B'/A*.) It is a superb example of what can be done within the confines of popular music form. No range, no extension, no great demands for the ear, and still a total statement, or, in this instance, question.

In 1933 Berlin wrote a masterful score for "As Thousands Cheer," a revue. The star was Ethel Waters, one of the great singers of that time, and so Berlin, in his phenomenal ability to adjust to any given musical and lyric state of affairs, proceeded to write a score in, as far as I'm concerned, a wholly new manner. (I can't say "style," as I haven't been able to determine what Berlin's style is or if it exists.) For example, whenever before did he write a song like *Heat Wave*? He has written songs that swing, but not the way this does. When did he ever write a verse that sets up a chorus the way this does? Or supplied a rhythmic section like the patter of *Heat Wave*? Perhaps in *Puttin' On The Ritz*. Yet this one uses another trick.

The way the melody of the chorus drops in the fourth measure is perfect for Ethel Waters' voice, as is the long, held high *e* in the release. Berlin obviously listened very carefully to this lady sing and found notes and phrases and words to her liking. She could never have sung them as she did if she hadn't liked them.

In the verse the song simply jumps out at you. And in the ninth measure, without warning, it leaps up a minor third from G major to B flat and back in ample time to prepare the singer for the chorus, again in G major.

The chorus is simply a swinging affair with nothing specific to remark. In the patter, however, the rhythmic trick is worth a study. One may divide the patter more than one way. I prefer 3/4, 4/4, 5/4, and back to 4/4 in the fourth measure. Then it repeats a minor third higher, in E flat and all around again, with an adjustment for the return to the chorus.

The rhythm ballad *How's Chances* is a very strong, straight-ahead melody, flowing, undevious, nothing labored. But who, will you tell me, wrote the "second eight"—the *B* section of this *A-B-A-C* song? Well? Is it Rodgers, Kern, Schwartz, Arlen? Naturally not. It's the ever-new Berlin. Where, now, are the repeated notes? At least there were a few in *Heat Wave*. And the last eight measures are just as baffling.

Then, Berlin proceeds to wallop us with a verseless marvel called *Supper Time*. This song, particularly in the release, goes farther out melodically (all with implicitly indicated harmony) than anything up to this time. It's a mounting cry of anguish sung by a Negro woman whose man has been lynched and who must now tell the children. No pretense or artiness mars its slow, tragic pulse.

In the long, sixteen-measure release Berlin does many marvelous things. After six measures of dark, broody, minor lines, he resorts to a totally unexpected *e* natural in the seventh measure. Following this he moves through B seventh to E minor, then from D seventh to a B-seventh-suspended chord. Then he repeats the closing word of that phrase, "Lord," a half step higher on *d* sharp and it takes on an almost despairing meaning. The line is "how can I be thankful when they start to thank the Lord?" And then, suddenly overwhelmed by the intolerable burden of fate, the bereaved woman cries out "Lord!"

Nowhere else in American song have I heard a single note and a single word combined so shatteringly. This note then leads her directly to the restatement.

Berlin has done nothing like this in lyrics or music up to this point.

Even in *The Funnies*, a melody set up to show off the lyric, the tune is ingenious and fresh, and a theater song to boot. And here's another one!—*Not For All The Rice In China*. At least Mr. Berlin has been kind enough to give me a hook to hang a stylistic tendency on: the repeated note. On the other hand, I'd best be careful not to emphasize it as so many other writers, from Gershwin to Porter, are also given to the repeated note.

It's altogether an open, healthy, extroverted song with a marvelous verse which has the distinctive flavor of a Richard Rodgers verse. I could do without the false rhyme "doors" and "yours." But perhaps the singer was from Oklahoma.

Interestingly, in *Harlem On My Mind*, which Ethel Waters sang perfectly, she didn't sing all of Berlin's notes. And I must admit her slight variations were, for me, more apt. For example, her drop of a third brought out the word "Harlem" much better, as did her uneven rhythm. Though the tempo is marked "Slow Blues," Miss Waters sang the verse out of rhythm and, again, it worked better than a steady tempo.

An example of Berlin's adjusting a song to a singer's style is beautifully illustrated in the verse. The sixth and seventh measures are perfect for her voice and style.

Maybe It's Because I Love You Too Much, a pop song of 1933, is a reinforcement of the repeated note device and has some innovative moments but, overall, I find it only a good exercise in song writing, slightly on the tossed-off side.

V

I've been so busy trying to ferret out elements of style in Berlin's writing that I've failed to comment on his growth as a writer. He was never concerned with extended forms or songs of unconventional length, even though from the very beginning, he used odd forms such as that of *The Girl On The Magazine Cover*.

However, throughout his career up to this point he has become

more sophisticated and more theatrical in his theater music. His pop
songs have always been better than average, but only occasionally
have they benefited from his more complex theater writing. It's al-
most as if he had deliberately isolated these two points of view, and
from a practical, business point of view, he was probably right. For,
after all, each type was written for a specific listener. And no matter
how sophisticated Berlin's theater songs may have become, he was
more concerned, I believe, with song writing as a business than as an
art form, if, indeed, it can truly be called the latter in other than ex-
ceptional instances. However, even his experimental pop songs like
Lazy made money. I am only surprised that he didn't write more.

In "Top Hat," a film of 1935 starring Fred Astaire, he certainly
tossed all his writing habits aside with *Cheek To Cheek*. For it is a
highly extended song having the structure *A* (16 measures)-*A* (16)-*B*
(8)-*B* (8)-*C* (8)-*A* (16). It's the added *C* element which amazes me.
With Astaire, however, anything could happen, and maybe he had a
need for this extra phrase. Berlin was a very practical writer and if a
production number could be enhanced by an unusual adjustment, he
undoubtedly would have made it.

I'd like to point out something here that has greatly impressed me
—every song written for Fred Astaire seems to bear his mark. Every
writer, in my opinion, was vitalized by Astaire and wrote in a manner
they had never quite written in before: he brought out in them some-
thing a little better than their best—a little more subtlety, flair, so-
phistication, wit, and style, qualities he himself possesses in generous
measure. And *Cheek To Cheek* is a case in point.

In any event, it is a very fine song, as unforgettable as Wagner's
Wedding March. And even with its long phrases it never lags or wan-
ders or becomes contrived. I am particularly impressed by the daring
implicit in opening a song with the word "heaven" without any pick-
up notes to provide room for the words "I'm in." It may be an over-
subtle point, but any song without pick-up notes is more immediate
and attention-getting than one with them.

The development of this seed, two notes a step apart, is very in-
genious. He develops it first by adding two pick-up notes to the
second phrase which is a repetition of the first, then he truly develops
it by walking up for two measures in a series of imitations. Then

instead of writing an imitative descending phrase, he writes a phrase of the same number of notes but unlike the first in its sinuosity and lyricism. And then, instead of keeping his cadential phrase in straight eighth notes, he makes them all syncopated. And this, I believe, is definitely the result of Astaire's presence.

The *B* section risks monotony by repeating a phrase *six* times, interrupted only once by another phrase. I believe another writer, Kern, for example, might have moved that phrase through a series of key changes, thereby pleasing his fellow musicians and confusing the lay listener. Now, instead of returning to *A*, as one would expect, Berlin introduces a brand new idea bearing no relationship to anything which has preceded or which follows. It's very attractive, even if bearing a slight similarity to shifting speed after driving at a steady rate on an arrow-straight road. Fortunately, the harmonic color changes with it so that it comes off as ebullience. It is interesting to me that only while writing for Astaire did Berlin ever resort to such an experiment.

The verse of *Top Hat, White Tie And Tails* is a gem. It consists of two contrasting phrases, repeated literally except for the final cadence. The first phrase could be divided into the time signature 5/4, 5/4, 2/4 and still swing.

The main strain of the chorus is no great shakes, more like a dummy tune for a dance. Of course, if you have ever heard Astaire sing it, you'll disagree, since he could make *Trees* sound good.

The release is another burst of inventiveness, a single wild phrase, repeated. And, marvelously, it is a *five*-measure phrase. Unheard of, perhaps, in popular music of that time. One could argue for a one-measure cadence turning it back into a four-measure phrase. Yet the three quarter note pick-up into the main strain five measures later is essential, and so the first phrase should remain five for balance.

Isn't This A Lovely Day is an ingenuous little song, kind of an amalgam of styles; the second eight measures are not unlike Gershwin with its quarter rest followed by three repeated quarter notes. The end of the section is not only unexpected, but difficult to sing. However, it has great shock value and falls wonderfully with its lyric phrase, "oh! what a break for me." But for this *B* section (the song is *A-B-A-C*) the song might pass for a pop tune.

In 1936 came the film "Follow The Fleet." In it were two verseless songs. The first, *Get Thee Behind Me Satan*, is replete with repeated notes and simply doesn't come off as a song but rather as a mood.

The song is A-A^1-B-A^1-C and therefore an extended form. The B section definitely sounds as if Berlin had taken a section from an entirely different song, and pop, at that. At the A^1 section following this patchwork there is a quarter note triplet pick-up, not to a literal restatement in the melody but to a quarter and a dotted half note. But under those two notes the piano part has the restatement. This is highly unusual, particularly so for Berlin.

I'm aware that *Let's Face The Music And Dance* is a very well-written song, that the lyric is particularly "civilized," that it is uncluttered, makes every point it sets out to make, indeed, deserves high praise. Yet I must admit to irritation in the presence of this form of miniscule melodrama. I call it Mata Hari or canoe music, but I am told that, had my youth been accompanied by more movies and moonlight nights on the local lake, I'd love this kind of song.

There are things in it which rise above the moonlit lake, such as the wholly unexpected *e* natural in the eighth measure. For the melody up to this point has been in C minor so that the *e* natural in the melody moves it almost magically into C major. Also the first section is fourteen measures, another first for Berlin. And the *C* section, though not extraordinary in its shift from the C-major cadence to A-flat major, serves (in two suave four-measure phrases) as a sunny shift in mood from the somewhat brooding main strain. And the last section is eighteen measures, containing a high, dramatic, four-measure tag.

There happen to be repeated notes in the melody of the title phrase, but they are not typical of the song itself, so again I am baffled about its style. The main strain does have a Cole Porter, somewhat portentous, flavor.

In 1937 there was "On The Avenue." In it there were two good songs. The first I'd like to consider is *I've Got My Love To Keep Me Warm*, the seeds of which are to be found in the verse of an earlier Berlin song, *I'm Playing With Fire* (1932).

It is breezy, healthy, and forthright, with no aspect of contrivance about it. It's also clever in its use of chromatic notes in the main

strain. The three pick-up notes, two eighths and a quarter, over the words *"what do I* (care how much)*"* I've never heard sung as such, but rather as a quarter note triplet, which I think is better and more lyrical. Sometimes the singer senses a phrase better than the writer.

The song is in sixteen-measure phrases except for the release, which is eight. But this doesn't create any imbalance whatsoever. It's one of the most smiling of all Berlin songs.

The second good song from "On The Avenue," *You're Laughing At Me,* is most unusual. Its verse is run-of-the-mill, but the chorus is very special. In fact, for a song which begins as it does, the second section is as far out and as unanticipatable as anything in popular music. It begins, I'm glad to say, on the sixth step of the scale, and its principal, provocative device immediately follows, the drop of a half step. This happens again, a fifth higher, in the second phrase, and that half step has become the song's "hook."

I would have been content with repeating the *A* section. But not Berlin. He unprecedentedly veers into G-flat major, using *b* flat, the tone common to both E flat and G flat, for his repeated note melody. And, in the tenth measure, he drops from *b* flat to *d* flat, not easy to sing without the support of the harmony. He continues in G flat with a virtual chord line phrase ending on *d* flat, which he raises to *d* natural in the thirteenth measure, supported by a B-flat major chord. This is wilder than some of Kern's releases. Berlin then returns to the main strain.

In the last section, he has a very lovely little descending line which one finds at measure twenty-six. The high *f* natural in this phrase gives the song an unusually wide range. In fact, it shares with "*Soft Lights And Sweet Music*" the distinction of having the widest range Berlin has employed so far, an octave and a fifth.

VI

At this point I begin to see more clearly at least one aspect of Berlin's style.

Now It Can Be Told appeared in the film "Alexander's Ragtime Band" (1938). In analyzing this song I can close in a little more on Berlin's use of the repeated note device. With Gershwin it was almost

always a quarter note which was repeated. With Berlin it's an eighth note. However, he doesn't use his repeated eighth notes amidst other short notes, but rather as a contrast to long notes, as in *Say It Isn't So, You're Laughing At Me,* and this song.

So much, in an evaluation of it, depends upon the harmony. The very first measure, for example, would be much less interesting if an E-flat-major chord were used throughout. The dissonance of the D-major chord against the *e*-flat bass note resolving in the second half of the measure, sets up an immediate intensity.

The second strain is in marked contrast to the first. It is lyrical in a manner new to Berlin songs up till then. But why should I be surprised, when he's as difficult to anticipate as The Man of a Thousand Faces? Just recall this second phrase! Have you heard a similar phrase in any of his songs?

Also in 1938 there was the movie "Carefree" with *I Used To Be Color Blind,* a very sweet song with a particularly ingratiating lyric. As satisfying as the melody is, there is nothing to speak about besides the sudden shift from C-dominant seventh in the fourteenth measure to an unexpected A-flat-major chord and melody made up of its notes.

Change Partners is another ballad of sixteen-measure sections except for the release, which is eight. It's a perfectly good song, for me in the "canoe" category. I wish it were a waltz, frankly. I believe it could have had more verve and elegance. There are enough quarter note triplets in it already to give it a waltz feeling. So why not go the whole hog?

Because of my perverse memory, the release recalls *Oh, How I Hate To Get Up In The Morning.*

"Louisiana Purchase" (1939) brought Berlin back to Broadway with another fine theater score. *Outside Of That I Love You* is a dandy little truly swinging tune. Its verse is a very good one, a little song all by itself.

There aren't many plain swinging tunes among Berlin's songs. So when one appears, it's a very pleasant surprise. And one mustn't confuse the kind I mean with the deliberate and effective rhythmic trickery of such songs as *Puttin' On The Ritz* or *Pack Up Your Sins. Shaking The Blues Away* is more to the point.

It's A Lovely Day Tomorrow is a pure, hymn-like melody recalling Kern at his purest or Arlen in *My Shining Hour*. For some it might seem just a degree too innocent to the point of being studied simplicity. I don't find it so, perhaps because I'm a musician and I know how enormously difficult it is to write a bone-simple song, within the range of an octave, and employing neither artifice nor cleverness. Frankly, if this had been the melody of *God Bless America*, I'd have been far more inclined to favor it over *The Star-Spangled Banner*.

And here comes another, *Fools Fall In Love*. Why it never became a standard is beyond me. It's simply delicious. In it Berlin does something I've seen only Rodgers and Porter do, the former more often than the latter. He makes his first cadence on *a*, his second on *c*, and his last cadence on *d*. These are the cadences of the main strain, so it amounts to a development in the structure of the melody.

The form of the song is unusual. It is *A* (6 measures); *A¹* (6 measures); *B* (8 measures); *A¹* (6 measures); *B¹* (8 measures). At the end of the first *B* section the music upsets the applecart, bringing envy to my eye (and ear).

The seed of the song is not an uncommon one. But whatever other writers have done with it, Berlin has done as well, or better. This is a fine little swinging tune.

The title song, *Louisiana Purchase*, is based on a kind of blues riff and stays pretty "bluesy" throughout. I don't think the music should be marked "Moderate Bounce Tempo"; it demands a slow, rocking blues tempo.

It's another little-heard song, and I can't see why. Of course, with most of the bands gone it's no wonder. But even when they were still blowing, I never heard this song.

You're Lonely And I'm Lonely is a well-constructed, acceptable ballad, but somehow it lacks true theater music elegance. It feels put together and somewhat labored, however professional and knowledgeable the hand.

Also in 1939 there was the film "Second Fiddle." It has in it a pleasant little, semi-cliché rhythm song called *Back To Back* that rollicks along spreading cheer but has no special virtue besides swingingness. It's release slightly recalls that of *I Got Rhythm* but is much less four-square, by which I obviously mean it's much better.

In the film "Holiday Inn" (1942)—whose most famous song was *White Christmas*—there was a very sweet pop rhythm ballad called *Be Careful, It's My Heart*. It concentrates much of the time on quarter and half note repetitions and, in the second half of the second section, it resorts to an unexpected shift from F to the key of A flat. And it doesn't make for easy singing. But, in its unexpectedness, it's delightful.

In 1946, when any writer of Berlin's age would have been willing to call it quits, he produced probably his greatest score in "Annie Get Your Gun."

The Girl That I Marry. It's a very simple, innocent, memorable waltz, all within the range of an octave, needing no harmonic support, a teddy bear of a song. For the record, it has no verse.

I Got Lost In His Arms. This ballad wins the repeated note contest, unless it is topped by the "scale" song Hildegarde used to sing. I'm aware that the use of repeated notes is, in this song, a deliberate device. But Berlin is so adroit that at the precise moment I begin to resent the repetitions, he raises the melody one step. Then he pursues that raised note across the page, but again, just in time, raises it. He even does it once more, but then, in the lyric phrase "there you go," having moved up, by now, five steps, he ascends to an *e* and drops it a sixth to a *g*. It's absolutely marvelous. And note how he drops down again to *d*!

I Got The Sun In The Morning is a flat-out swinging song. The *A* strains are six-measure phrases with a little "walk around" added, I *was* going to say, for good measure.

Now you see him, now you don't. For where did this release come from? Berlin, obviously. But never, not once, has he ever used this kind of a dance band, instrumental approach to a melody line. Well, he did and it's great. And so is the marvelous tag at the end.

I'll Share It All With You: talk about taking chances! This song had to be a labor of love. For who, even among professional singers, could adequately sing it, let alone the poor untrained public?

The melody follows a series of chord lines resulting in innumerable notes totally outside the parent key of E flat. Just try whistling or singing the first eight measures without going to a piano—or crazy. I'm fair at it but by the seventh measure I've foundered. Mind you,

I love it! But, truly, one writes this kind of song for one's friends in Jim and Andy's, the jazz musician's bar.

And the verse is a swinging one, a set-up for a swinging chorus if there ever was one. It's positively bewildering, because Berlin, to my knowledge, never attempted a song like this one before. And how many times have I said that?

I'm A Bad Bad Man. It's a marvelous down home, square dance, wear-your-boots song. Exactly right, even though it's clear that the lyric is the point.

Moonshine Lullaby. Where does this man find these tunes? One may say that he practiced up for this one with *Louisiana Purchase,* but surely that's no answer. For this song sounds as if he had been writing in this vein all his life. And from the record of the published songs it's obvious that he hadn't.

There is a curious absence of ego implicit in all this. For most writers have been very concerned about writing songs which were recognizably their own and no one else's. But if one is to judge Berlin from his published work, all he is concerned with is the best possible song for the occasion, for the situation, for the lyric, or for the current fashion.

The sheet music or the record label announces who wrote the song, for those who wish to know. The press, magazines, radio, and television inform the mass public who wrote *Moonshine Lullaby.* So what does it matter if the public recognize the writer when they hear it? He wrote the best song he could, he put out his best efforts, the hits made him rich, the press takes care of his reputation. What else matters? Simply the small conceit of people knowing whose song it is because of stylistic characteristics. And, to Berlin, this couldn't matter less. At least that's the conclusion I've come to.

My Defenses Are Down. This is a somewhat old-fashioned rhythm ballad, but again, perfect for its purpose, a kind of soft-shoe song, with a very good, point-making lyric.

They Say It's Wonderful. It's the "big ballad," as they say, of the show. I don't think it's a great song as great theater songs go, but it certainly is a very good song. And it doesn't, as do some ambitious ballads, try to stand in the wings of the concert hall.

Perhaps the "big ballad" of a show should have a somewhat broader line, a slightly less safe and sane feeling about it. But it does do some

very attractive things, such as the two phrases accompanying the word "wonderful" in the two *A* sections, and also the resolution to the *c* in "so they say."

I'm particularly impressed by the cadence in A minor at the end of the release, followed by the half step lower whole note *e* flat which brings the melody back to its starting note, *d*. Also, on the *e* flat the lyric word is very simply and daringly, "and." Granted that it rhymes with "grand," but even so, only a master lyricist would trust such a bland connective word to bear such weight.

Then there were the comic songs—*Doin' What Comes Natur'lly, You Can't Get A Man With A Gun,* and *Anything You Can Do*— plus the surefire curtain song, *There's No Business Like Show Business.* A fantastic piece of work!

In 1947 Berlin wrote a pop song which I am completely captivated by, *Love And The Weather.* It's a totally unpretentious, unambitious, warm little song with a verse of only eight measures which is just right.

The chorus is based on the one, six, two, five ("we want Cantor") bass line, a novelty for Berlin. The tune just loafs along in a slow swinging fashion, and the lyric is nice and bittersweet.

The principal interest for me in the pop song *It Only Happens When I Dance With You,* from the film "Easter Parade" (1948), are the first three measures and their relationship to the opening measures of *White Christmas.*

Another affecting song from the same film is *Better Luck Next Time.* I'm hooked immediately by the first measure. I hate to be so repetitious, but this is a kind of phrase I've yet to find in a Berlin song. It has a very special quality of tenderness about it. And, needless to say, the bartender would have to throw me out if I found it in the juke box. I can't understand why this song has not been heard more often.

In 1950, in the show "Call Me Madam," there was a song which is so charming that it's a wonder Astaire didn't get his hands, and feet, on it first. It's called *It's A Lovely Day Today.* I can see Astaire strolling elegantly down a lovely springtime street, twirling a cane, and singing to smiling people.

There are two unexpected and marvelous moments. One occurs at the end of the second section, on the words "like to," when you antici-

pate two quarter notes over "like to" and are fooled by two half notes. Then, at the end of the song, a chromatic descent interrupting the *d*'s is very witty. This descending passage is an extension, making the song thirty-six measures.

You're Just In Love is Berlin's other successful "double song" which is laid out the same way that his early one, *Play A Simple Melody*, was. It needs no further comment than that Berlin had an unerring sense of how to write these. I'm sure if I were to examine either closely for proper contrapuntal relationships between the melodic lines, I'd find everything technically wrong. But they sound great when sung together, and that's the best rule of all.

The Best Thing For You, also from "Call Me Madam," is a good, strong, long-time, semi-rhythm ballad. Berlin obviously believes in the melody, for it appears in the first four measures of the left hand of the piano part. It is unusual in that it starts harmonically with a B-dominant-seventh feeling, moving skillfully through a series of E-minor, A-dominant, D-minor, F-minor chords to C major. The release is in A flat major, with only fifteen notes, and every one of them right.

The song *Free* (dropped from "Call Me Madam") interests me only in its use of an unusual syncopation in the first phrase and all imitative phrases, which I have never seen elsewhere in popular music.

Sittin' In The Sun, a pop song of 1953, proceeds on its leisurely way through the release when, suddenly, all hell breaks loose. And I'm frankly flabbergasted. I'm by no means sure why the song busts loose the way it does. It's as if Berlin had just finished writing the end of a release when a great jazz improvisation drifted in through the open window from a neighbor's record player and so affected him that he said in effect, "Oh, the hell with conventional forms or the return of the main strain! I'll just wail!"

VII

There are hundreds of Berlin songs I haven't mentioned, many of them very good. But, as I have said elsewhere, the purpose of this book is not to be all-inclusive. Rather, it is to seek out and examine all those songs which are models of their kind and which are so well written as to exemplify a high level of musical composition and, of course, innovation.

Also, as has been mentioned, the concentration has been on those

songs which best illustrate a way of writing which had its roots and sources in America and which, until the fifties, grew to a point of professionalism which gave the songs dignity and compositional status.

Berlin has most clearly been one of the great contributors to this medium of music and, unlike many of the great song writers, has never deviated from his purpose of writing songs which stem from the music of the people, whether it be ragtime, swing music, country music, or the work of his contemporaries. He was obviously a persistent listener. Anything which he liked he absorbed and re-created in his own uniquely singing fashion.

And he is unique in other ways. For example, until you reach a swinging song in his long list, you don't expect to find one. And I think it's because he has given you no hint in his other songs that he has that talent or even that concern.

Let me illustrate the point this way: if a film composer is asked to write "storm" music as one of the many cues in a movie score, no one is surprised to find he can do it. For it is primarily a trick. Maybe he hates both storms and music describing them. But his profession demands that he be able to devise and contrive.

But a swinging song is much more than a trick. For if you don't feel it, in fact love it, you can't write it. Oh, you may write an imitation, but it will sound false and phony. And so, considering that Berlin wrote convincingly on any level, he must have loved all levels. And he must have been an intuitive scholar of popular music. For he represented, in song, every phase of musical fashion for forty-five years or more.

He did produce occasional yard-goods songs: he couldn't upon every occasion have whipped himself into as fine a creative frenzy as upon some others. But it is by means of those pedestrian pieces that we are able to gauge the enormous devotion and dedication to his craft in the good and the great songs.

Here is a list of his songs, each of which is in a style unlike that of any of the others:

> *Alexander's Ragtime Band*
> *What Is Love*
> *Tell Me, Little Gypsy*
> *Lazy*

Supper Time
"Soft Lights and Sweet Music"
Cheek To Cheek
It's A Lovely Day Tomorrow
I Got The Sun In The Morning
I'll Share It All With You
Love And The Weather
Sittin' In The Sun

There are other songs not in any of the above styles but which had stylistic devices or attitudes which *were* repeated, such as *You're Laughing At Me*. For example, though not the same, the release of *Top Hat* had the same deliberately experimental rhythmic device as the main strain of *Puttin' On The Ritz*. And this approach is not to be found in the songs listed above, nor is the repeated note approach of *You're Laughing At Me*. So that comprises fourteen stylistic points of view.

This is not to say that he was the best writer in each and every area of popular music. And since this is a qualitative not a quantitative analysis, his having made a large fortune from his songs is of no concern here.

Let it be said that he is the best all-around, over-all song writer America has ever had. In this area or that, I will say, and have said, that I believe so-and-so to be the master. But I can speak of only one composer as the master of the entire range of popular song—Irving Berlin.

4

George Gershwin
(1898-1937)

I

George Gershwin was almost unique among famous song writers in that his ambition, talent, and search for ever-larger forms resulted in a double career: popular song writer and formal composer. Though well-launched on a song writing career, and though relatively untutored, he began experimenting with larger musical forms while continuing to perfect the smaller ones.

He wrote a short "Opera Ala Afro-American," which, because its somber mood was out of place in a revue, was dropped after opening night from "George White's Scandals of 1922." He then composed *Rhapsody In Blue* (1924), a piano concerto (1925), other works for orchestra, and, finally, the so-called "folk opera" "Porgy And Bess" (1935). He received wide acceptance in these larger pieces and, but for his untimely death, might have become a major American composer. Since it is not the purpose of this book to examine any music but popular songs, however, any comments from me on this more complex aspect of Gershwin's talent would be beside the point.

Victor Herbert had managed to function in both areas of music, but he is less well known for his larger efforts than was Gershwin. And Vernon Duke, whose familiar pseudonym was suggested by Gershwin, also wrote large works under his real name, Vladimir Dukelsky.

After having examined nearly all of George Gershwin's published

songs, I would say that the writing of his more ambitious compositions did not cause his songs to become too complex for popular appeal. Paradoxically, his last songs became *less* rather than more complex.

Having heard that he superimposed his songs on opulent harmonic patterns, I expected to find melodies often distorted as the result of the harmonic demands. But though I don't believe he was in the same league as Jerome Kern or Richard Rodgers as a pure melodist, I was considerably surprised to find his tunes seldom needing the harmony to justify their existence. He did have a superb harmonic sense. But his melodies have a life of their own.

He was an aggressive writer. His was the "hard sell," as opposed to the softer, gentler persuasiveness of, say, Kern or Irving Berlin. If I were to compare his songs with Kern's, I'd say Gershwin's were active and Kern's passive. The constant, and characteristic, repeated note found throughout Gershwin's songs is a basic attestation of this aggressiveness. I believe that his most popular melodies contain this drive, while those I consider to be more moving, and more interesting musically, are, for the most part, his less commercially successful, more graceful, delicate melodies.

One would assume that a man so concerned with the wide scope of larger forms of music would have experimented more with the popular song form. Yet there are almost no instances of this. In fact, the bulk of his songs are in the conventional *A-A-B-A* pattern, and were so written before it became a convention. I should qualify this by saying that often the second *A* would be a variant *A¹* and the final *A* a still different variation, *A²*. Since he had worked for a music publisher before he had his first hit, he may have developed an unconscious acceptance of the evolving conventional forms.

In the survey that follows, I will be found guilty of heresy on many occasions, as my enthusiasm often guttered out when I closely examined some of his sacrosanct songs. On the other hand, I sometimes had to steel myself to maintain detachment, mistaking memories evoked by certain songs for their intrinsic quality.

Gershwin's extraordinary popularity was undoubtedly deserved, yet it should be kept in mind that the advent of radio occurred just as his career was getting under way. The enormous exposure provided by this medium had much to do with the public's enthusiasm for his

songs. For the jazz musician liked his songs and, more important, so did the dance-band arranger. Between the two a greater coverage was given to Gershwin's songs than to those of most other writers except, perhaps, Vincent Youmans.

It must be pointed out that during the early years of Berlin's and Kern's careers there were only vaudeville, primitive acoustical recordings, and stage productions to promote their songs, and neither of these men wrote as much to the liking of the players and arrangers as did Gershwin.

There is another aspect of Gershwin's great acceptance which should be mentioned. The years of his greatest popularity were those of the Depression. And since Gershwin was rarely given to sad songs, what could have been a more welcome palliative for the natural gloom of the times than the insistently cheery sound of his music?

II

Gershwin's first published song was copyrighted in 1916. That year he was seventeen years old. I could dismiss it as deserving of no further consideration as it is, for the most part a product of the pop music mill. But besides bearing one of the longest titles I've ever seen (*When You Want 'Em, You Can't Get 'Em; When You've Got 'Em, You Don't Want 'Em*), it does have a few measures untypical of a ground-out tune. They reveal a desire to break away from the normal clichés to be found in the pop songs of that era. My guess is that these measures resulted from Gershwin's greater concern with harmony than that of the average tunesmith.

Starting with the two-note pick-up leading into measure nine, the main strain is restated. It continues until the two pick-up notes leading into measure eleven. These reveal Gershwin's need to break away from the hack writer pattern. For the second of these pick-up notes is an *f* sharp, which is obviously not in the parent key of C major. By means of it he leads the song harmonically into E minor and then, in measure twelve, by means of an A-dominant seventh, to a D-dominant-ninth chord in measure thirteen.

Melodically, in measure thirteen and the first half of fourteen, he devises an unconventional stunt of which I've never seen the equivalent in popular songs of that time. Though the notes are contained in

the D-dominant-ninth chord, their juxtaposition is daring for their time.

When You Want 'Em, You Can't Get 'Em; When You've Got 'Em, You Don't Want 'Em

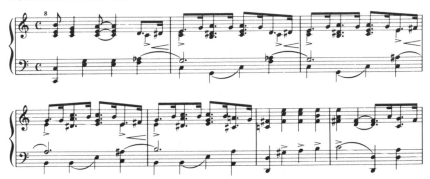

The first two measures of the main strain are disappointing insofar as they are almost a facsimile of the first two measures of the verse of *Alexander's Ragtime Band*.

There can be no doubt of Gershwin's inventiveness. In 1918, when he was only nineteen years old (and *They Didn't Believe Me*, by Jerome Kern, was only four years old), he wrote a song called *Some Wonderful Sort Of Someone*. The show title on the sheet music cover is "Look Who's Here," but the show was known as "Ladies First." This was an instance of the common practice of printing the music before a show reached New York where the title was sometimes changed.

The song is not one of the Gershwin standards, nor was it one with his brother Ira's lyric. In fact, Gershwin's first hit was a year away. But it's extremely inventive, though not in the manner of his later, characteristic style. Its form is A-A^1-B-A^2. Section A^1, the second set of eight measures, is the same as the first set, but a major second higher. This puts it in the key of B flat, whereas the first eight measures are in A flat. Such a device was extremely unusual for that time, and it is possible that the shift in key feeling, entailing notes out of the key of A flat, may have had to do with its relative obscurity. In the release, or B section, Gershwin toys with a phrase he must have liked, as it later became the principal idea of *Fascinating Rhythm*, a song of 1924.

Some Wonderful Sort Of Someone

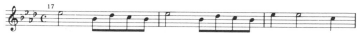

In "Good Morning, Judge" (1919), there was the song *I Was So Young, You Were So Beautiful*, which has nostalgic value for some—indeed, it is still printed as one of a series called "Hits Of Bygone Years." I mention it only for this reason, as it not only has no nostalgic value for me, old as I am, but it does not seem to me much more than a better-than-average pop song. It contains one line in the course of a less-than-inspired lyric which suggests an operatic aria rather than the unimpassioned tune it is set to: " 'Twas then I realized why men go mad."

The same year came Gershwin's first hit, *Swanee*. It was in the Capitol (Theater) Revue, where it failed to catch on. However, it did attract the notice of Al Jolson, and was interpolated in "Sinbad," a Sigmund Romberg show. It then became famous.

According to Irving Caesar, it was a manufactured song, deliberately contrived from currently popular devices. Once the song is heard, this claim cannot be contended. It's cheerful and aggressive, but without any distinction. Were it not known to be by Gershwin, I doubt if even the most observant authority could name the writer from the hundreds writing at that time.

Such an authority might have been startled, however, by a device in the verse, one both melodically and harmonically beyond the limitations of an average writer. This occurs more than once, but its first announcement is at measure nine. The verse is, for the most part, in the key of F minor. At the ninth measure, however, the melody introduces a *d* natural, supported by a B-flat major chord, returning to F minor in the tenth measure: a modal cadence.

Swanee

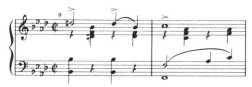

In 1920 there was a song of little character which I should mention only because, according to Isaac Goldberg, a Harvard University scholar who served as Gershwin's earliest biographer, it was the first song in which Gershwin employed a "blue" note. It was called *Yankee* and below is an example of this note, a *b* flat.

Yan-kee

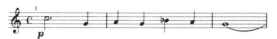

Also in 1920 there was a very pleasant and tender song called *Waiting For The Sun To Come Out*. If my memory is not playing me false, it was enough of a hit to have reached my ears far from New York. With only records to convey it, it must have had a certain success, though nothing to compare with *Swanee*. It also bears the name of Arthur Francis, the lyric writer—a pseudonym for Gershwin's brother Ira, and so is probably one of the first songs in which the two Gershwins collaborated.

Before examining the next song, I should say that up to this point only two of the six songs mentioned bear the character of theater music, though all but one appeared in theatrical productions. The two which bear a theatrical stamp, to me, are *Some Wonderful Sort Of Someone* and *Waiting For The Sun To Come Out*.

Though not a great song, *Drifting Along With The Tide*, from "George White's Scandals" (1921), shows signs of musical ambition. The verse, though in G major, starts out in E major in a rather mannered fashion. While a musical example would not illuminate matters much, the song is worthy of mention insofar as it demonstrates, as did *Some Wonderful Sort Of Someone*, Gershwin's desire to burst out of the restrictions imposed by song writing conventions. And it is clear that, much as he is known to have admired Kern, his melodic inventiveness does not lie in Kern's direction.

Then, for the "Scandals" of 1922 Gershwin wrote *I'll Build A Stairway To Paradise*, which, for most of his fans and collectors, is the true beginning of his style and career as a theater writer. It is also, along with *Swanee*, one of the earliest of his songs associated with the broad definition of jazz given in those years by non-jazz writers and critics.

Its piano part particularly emphasizes four beats to the measure, and the minor seventh (in this case *b* flat in the key of C) is a marked part of the melody. After the first four measures, when the melody moves into the key of F, the *e* flat (the minor seventh in that key) is stated.

In the non-jazz atmosphere of the musical theater of the early twenties, this song probably thrilled listeners familiar with the more polite melodies of Friml and Romberg. Vincent Youmans, of course, had already started on his own path with rich harmony and unmistakably native rhythms, but without neon arrows pointing at the blue notes. However, Gershwin's bald insistence here on notes which had been virtually the early jazz players' and blues singers' private property must have been delightfully shocking to the average theater-goer.

Though I was listening carefully in those days, I always found *I'll Build A Stairway To Paradise* stiffly contrived and synthetic. I agree with a friend who calls it "show-biz jazz." And I find the verse of the song, though curiously reminiscent of Ethelbert Nevin, much more exciting and inventive than the chorus.

At the close of 1922, in "Our Nell," appeared a natural, loose, swinging little song called *Innocent Ingenue Baby*. The original sheet music bears the show's out-of-town title, "Hayseed." The main melodic idea of the song is like the rhythmic figures called "riffs" by jazz players. It is easy to sing but suggests a trumpet or clarinet as much as the voice. No lush harmony clouds it. Instead, a casual descending bass line indicates harmony enough to support the tune without intruding. Its form is *A-A-B-A*, a form still not in full flower, and most effective for this pleasant, non-"show-biz-jazz" song.

Perhaps I shouldn't stop to indulge in idle speculation. Yet I'm fascinated by a song in the 1924 "Scandals" called *I Need A Garden*. I have to believe that Gershwin wrote it under duress; it was part of his contract. It shouts of resplendent production—even a stage filled with young ladies dressed as daffodils and hollyhocks, and frozen in graceful floral postures. The song might have been dashed off at a party as an imitation of a Kern ballad but given scarcely more attention in its published form. I believe that both Buddy DeSylva and Gershwin perpetrated a jape for a florid production number which must have bored them both to extinction. And I think a glance at the lyric would partly prove my conviction.

In the same show there appeared one of the most played and sung of all Gershwin songs, *Somebody Loves Me.* Compared to *I'll Build A Stairway To Paradise*, it is leagues ahead as a standard song. It ranks with *How High The Moon* by Morgan Lewis as a favorite of small groups that get together to "jam." Interestingly enough, the refrain is marked *molto legato.* I can't recall the last time I heard it as a ballad.

III

It may be appropriate here to comment on why jazz musicians have chosen certain songs to have fun with. The answer is very simple: the melody should be spare, containing a minimal number of notes, and the harmony should be similarly uncluttered, almost skeletal. In this case the song has sixty-eight notes, making it not as spare as, let's say, *I'll See You In My Dreams* by Isham Jones, but spare enough. Also, it has two-measure cadences which give the improviser extra room to move around in.

However, the principal jazz interest in any song lies in its "changes": its harmony. And this harmony mustn't change too quickly. For if it does, the player will be unable to fool around within the confines of the chord. Notice the first strain of *Somebody Loves Me,* an *A-A¹-B-A¹* song: one measure of G major, half a measure of A-minor seventh, half of D-dominant seventh, one measure of G major, one measure of C-dominant ninth, one measure of G major, half of C-dominant ninth, a quarter of A-minor seventh, a quarter of D-dominant seventh, followed by the two-measure cadence in G major. So in eight measures there are four chords. And its enduring appeal for jazz musicians lies not so much in the fact that there are so few chords as that in all but one instance they last at least half a measure.

I don't consider *Somebody Loves Me* a great song. On the other hand, I don't think it was intended to be. It's straightforward, little concerned with syncopation, and spare. Probably the out-of-key *b* flat whole note comprising the fourth measure was the novelty which had to do largely with its initial success. For in 1924 this was the same kind of departure from conventional song writing as was *Stairway To Paradise*, but much more smoothly arrived at. Plus which, the song has a novel, provocative verse.

The same year, in the show "Lady, Be Good!," came the song *Oh,*

Lady Be Good!. It is also admired by jazz musicians, meeting, as it does, the same requirements fulfilled by *Somebody Loves Me*. Its special trademark is the quarter note triplet.

It is a strict *A-A-B-A* song, very spare in its use of harmony and without syncopation. I have always found it monotonous and almost pedestrian. Without the recurring triplet, its only unusual characteristic, I don't believe it would have had the success it did. As in the case of *Somebody Loves Me,* the tempo marking indicates it is to be sung or played as a ballad. It is marked with an adjective and an adverb: "Slow and gracefully."

Another of Gershwin's most famous songs, *The Man I Love*, was composed for the same show, but was dropped before the opening. In this song there again looms the minor seventh, the *b* flat in the key of C. Unquestionably it is an unusual song, dependent, as it is, upon the shifting harmony. In this instance I truly believe I must suspend my conviction that the layman doesn't "hear" harmony. Without the harmonic pattern of the main strain, I don't believe the song would have survived. In fact, so prominent is the harmony in the piano part that in the song's final statement, the *e* natural harmony note, which descends chromatically measure by measure for six measures, is printed as an octave.

The melodic fragment which constitutes the principal idea is just that—a fragment. It is an *A-A¹-B-A¹* song, containing a release which, fortunately, is truly a release from the reiteration of this fragment and, in its fourth-measure cadence, ingenious. After all these years the song has become so familiar that the *c* in the melody at the beginning of the fifth measure of the release right after the preceding whole note *g* flat no longer constitutes the difficult step it once was (and, used in an unfamiliar context, still would be).

It's neither here nor there, but I have a musical friend who believes that the release of *The Man I Love* should be employed in any *A-A-B-A* song by any player who has forgotten the proper one and no one will ever know the difference. He hasn't said why he feels this way, but I think it is because it cries out, "I am a release!" It simply couldn't be anything else.

The song had an unusually checkered career until it finally was accepted. For those interested in such rather arcane matters, here is its history:

1. In 1924 a verse was written by the Gershwins. It had a strong melodic line. It was rewritten as a song chorus, *The Man I Love*. Then a verse to this new chorus was written. But—and this requires fairly strict attention—the last "two lines" of the original verse (by now the chorus) were used, as far as I can determine, as the second four measures of the release of the new chorus. In his delightful book *Lyrics upon Several Occasions*, Ira Gershwin calls this segment the "vest" of the verse. Why, I do not know.

2. The new chorus, with its new verse, was put into "Lady, Be Good!" for Adele Astaire. She sang it in Philadelphia. After one week it was taken out.

3. Later, in New York, Lady Mountbatten asked Gershwin for an autographed copy of the sheet music, which had been printed for sale in the lobby of the theater during out-of-town tryouts. She took the music home to London and turned it over to her favorite dance band to play.

4. The song was then played in London and Paris by other dance orchestras as well.

5. In August 1927, it was put into the original production of "Strike Up The Band," which played Long Branch, New Jersey, and Philadelphia, then closed. It never reached New York. However, in Philadelphia, Morton Downey sang a male version, *The Girl I Love*.

6. Edgar Selwyn, the producer of "Strike Up The Band," released the song to Florenz Ziegfeld for use later that year in "Rosalie," to be sung by Marilyn Miller. Ira Gershwin kept the title of the song and rewrote it at least twice for "Rosalie." He does not recall that Miss Miller ever even rehearsed the song.

7. Max Dreyfus, their publisher, asked the Gershwins to take a slightly reduced royalty rate and then published and exploited the song. Helen Morgan and others took it up. And so *The Man I Love* wound up as a pop song, and maybe one of the most complex of that genre ever written up to that time. Ira Gershwin's lyrics complement his brother's melody with great sympathy and adroitness. Their partnership, just then getting into stride, was to prove remarkable. Probably no collaboration in theater music worked as smoothly as theirs, excepting, of course, that of Rodgers and Hart, a conviction I will discuss later on.

In the same show appeared *Fascinating Rhythm*. It has been shown

that the germinal idea of this song was first announced in the release
of *Some Wonderful Sort Of Someone*. Though in 4/4 rhythm
throughout, the first three measures of the chorus could be changed
to 4/4, 3/4, and 5/4—or even 4/4, 3/4, 3/4, and 2/4. But it would
not be so "fascinating," as the underlying chord progression re-
peats itself in a pattern of four beats, producing the juxtaposition of
opposed rhythms.

The song's form is *A-B-A-(B¹-A¹)*. The *B* section is in contrast to
the principal rhythmic idea and has as its fourth measure a paren-
thetical line of lyric and notes which I have never heard played or
sung—a wise omission. It is an extension of the cadence in the third
measure. To see why it has been ignored it should be illustrated.

Fascinating Rhythm

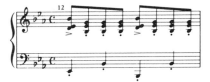

As you can see, it says little and says it poorly, both musically and
lyrically. In fact, the entire lyric is scarcely to be recommended as an
illustration of Ira Gershwin's great talent.

There's one more interesting song in "Lady, Be Good!," *Little Jazz
Bird*. It's a very relaxed little song, making no great strides, but cer-
tainly another instance of unstiff swingingness, uncluttered and un-
forced. Its form is *A-B-A-(B¹-A)*.

It has a very good verse, both melodically and harmonically, of an
odd number of measures, twenty-five. I see no need for the twenty-
fifth measure, as the pick-up notes to the chorus could have been
fitted very comfortably into the twenty-fourth. An even number of
measures has always been a convention; it is an element in the struc-
ture of popular songs expected by players and singers. That is, until
the recent explosion of the amateur writer. I'm not saying that an
even number is better—simply that it has been part of song and jazz
tradition.

In "Tip-Toes," also in 1925, there was a song, *Looking For A Boy*,
loved by Gershwin enthusiasts but not, I'm afraid, by me. It has an

admirable verse which I like more as a verse than I do the chorus as a chorus.

The charm of Ira Gershwin's lyric may have much to do with the status of the song as standard. I find myself as distracted by the persistent use of dotted quarter and eighth notes as it is said Max Dreyfus was when Vincent Youmans played him *Tea For Two* the first time.

Probably its popularity was due in part to the device of building up to a *b* natural in the melody, then to a *b* flat, then back to a *b* natural and then again to a *b* flat.

Looking For A Boy

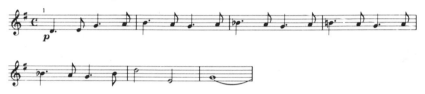

When Do We Dance? is a light-hearted little song from the same show, two moments in which I'd like to illustrate. The first two measures of the verse sound exactly like the beginning of what later song?

When Do We Dance?

A very effective jostling of rhythms occurs toward the end of the chorus, too neatly written not to illustrate.

Now comes *That Certain Feeling*, also from "Tip-Toes." To me this is mint Gershwin. It is *A-B-A¹-B¹*, a conventional thirty-two bars,

only three of them containing syncopation. This simple fact brings to mind the curious paradox that though Gershwin is considered the great "jazz" song writer, his songs show less syncopation than do those of many other contemporary writers. This may imply that the native song is less distinguishable by its syncopation than by other, more rarefied elements.

One of these is boldness; another is wit. Still another is unexpectedness. Syncopation is only the obvious device. The others aren't as simply arrived at, and rarely can be effectively employed by means of analytical imitation by someone with no love or flair for the idiom. For example, it seems to me that Kurt Weill often manages the astute imitation without the quality of self-involvement.

The most effective song I know written in the manner of the opening measure of *That Certain Feeling* is *Why Was I Born?*. But the former (forgetting for the moment the lyrics and their mood) pleases me more by means of a single eighth note in the third and its imitative measures.

That Certain Feeling

This eighth note is as unexpected as the quarter rest and repeated *c*'s in the first measure are bold. And it is not only unexpected, it is sly in its function of "kicking" the rhythm.

Yes, this song is neat as a pin. For example, in the last phrase of the B section (the song is *A-B-A¹-B¹*), the thirteenth measure repeats the initial idea of a quarter rest followed by repeated identical quarter notes. In this case, they are repeated *d*'s. The fourteenth measure imitates the second measure, but then completely fools me by returning to repeated *d*'s in the fifteenth measure, resolving in the last quarter note *b* flat, tied syncopatedly to a whole note in the sixteenth measure.

And notice the alternate half-note chords under this passage: B flat major and G minor. This constitutes style. Though there were subsequent writers who revered Gershwin and, consequently, imitated him, I believe I would know these four measures were by Gershwin even if they were played isolatedly and for the first time.

In the second half of the song, I admire the way he raises the repeated notes each time they occur, particularly the *unexpected* series of *e* naturals. But then I am disappointed that they don't proceed to their begged-for destination, *f* natural. Instead, they drop back to *e* flat.

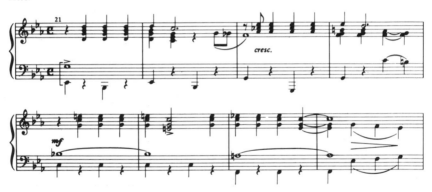

The song is so direct and unbusy, so strong without being aggressive, that I am doubly disturbed by this curious lapse. It certainly isn't due to the problem of wide range—always a hazard in popular music because of the average singer's narrow range. For if the *e* natural had been raised to *f*, the song would have had a range of only an octave, a less-than-average range for a popular song and very narrow for a theater song. *That Certain Feeling* is the first in a long line of songs in which Gershwin's obsession with repeated notes is evidenced.

One more engaging song from "Tip-Toes" is *Sweet And Low-*

Down, another direct rhythm song, perhaps a bit "notey," yet making its point, which is, in a word, a crescendo. This is achieved by means of three rising one-measure phrases which imitate the first phrase.

Sweet And Low-Down

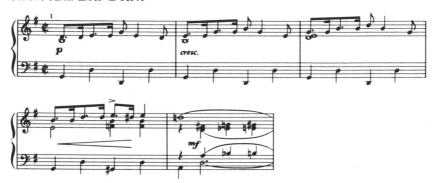

It's in the *A-A-B-A* form and has a riff-like release in which, after two measures, a two-measure phrase is stated three times with shifting harmony. My only critical comment is that the seventh measure, though consistently repetitive in the piano part, has no melody line but instead the word "professor" with the instruction "spoken" over it.

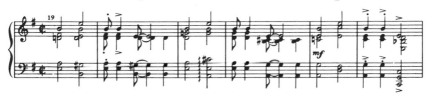

IV

Even Gershwin could be the victim of the audience's indifference to a truly fine song. In 1926 the show "Oh, Kay!" was produced, which had a treasure trove for Gershwin lovers but slightly less than that for me. However, one of Gershwin's loveliest songs was introduced during the Philadelphia tryout and dropped after one performance. Its title: *Dear Little Girl.* Ira Gershwin told me that it was the only song he remembers having written the lyrics for which elicited not

one hand-clap of applause originally. He said it was introduced in a matinee and dropped the same evening.

But it was returned to the score before the Broadway opening and Oscar Shaw sang it for the run of the show. I am told that in order to maintain the Gershwins' reputation for avoiding sentimentalism in their ballads, the song was sung to a group of girls, one by one. This, in spite of its romantic, and extremely intimate, nature. The song was not published until 1968, thirty-one years after Gershwin's death. The sheet music cover promoted Julie Andrews' film "Star."

Gershwin, unlike Kern, was not given to long-line, pure, overtly sentimental ballads. With few exceptions, his melodies were governed by rhythmic devices or an active, as opposed to a passive, point of view. It was seldom that energy did not supersede contemplation in his songs. They were certainly more extravert than introvert.

But in *Dear Little Girl* I find a notable exception to this rule. First off, one should ignore the 2/4 rhythm in the printed copy. By 1968 it was unthinkable to publish a ballad in this rhythm: 4/4 had long been commonplace. The melody is a gentle, passive line, easy to sing and as marvelously evocative as the scent of lilacs on an April night. It seems almost an insult to it to make analytical comments. I'll say only that it is harmonically and rhythmically simple and uncontrived and that its form is novel in that it is A-A^1-B-B^1-A-A^1. In its published 2/4 rhythm it is forty-eight measures long, with a single ending as opposed to the conventional first and second endings.

As opposed to the above, there is *Clap Yo' Hands*, a rhythm song which spilled over into the status of the standard, though lyrically it is limited to the requirements of a production number. In the seventies, after years of racial upheaval, the title is as out of bounds as the lyrics of *Shine*.

The song is strong, direct, and markedly rhythmic, but of no great interest except insofar as it reveals the first instance of Gershwin's concern with the pentatonic scale. In the published key of this song, F, that scale would be *f*, *g*, *a*, *c*, and *d*. As can be seen, the principal idea is limited to these notes.

Clap Yo' Hands

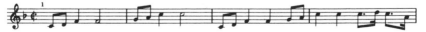

Do-Do-Do, from the same show, may be the first of those songs in which the word "baby" makes its presence persistently known. Sometimes it's acceptable, but sometimes it functions only as a note-filler.

I find the song's principal interest is the *B* section, measures eleven through fourteen, and in the *B¹* section, measures twenty-five through twenty-eight. (The structure is *A-B-A-B'/A*.)

Do-Do-Do

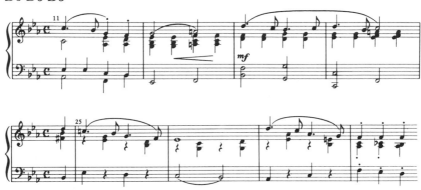

These measures are inventive and of a spontaneous rather than a ground-out quality. But for the *d* natural, the main phrase of the song is pentatonic.

The only marking in the song *Someone To Watch Over Me* (also from "Oh, Kay!") is "scherzando" at the beginning of the verse. This bears out what I have heard about the tempo of the song in the show: fast to the degree that none of the ballad quality associated with the song for so many years could have been present.

If the faster tempo was intended, as is indicated, it is difficult to discuss it in the slow tempo, as I have always heard it. For if I say that I feel it is too fragmented into one-measure imitative phrases to be truly a ballad, I'm ignoring the rhythmic intention of the song. It must have sounded like a tap-dance tune.

So all I can say is this: I like the verse very much, both melodically and harmonically, from start to finish, but . . . at a slow tempo. The *A* strain of the chorus I find harmonically ingenious, with a very effective chromatic bass line, but . . . I like the release better. It's freer, less spastic; in fact, soars like a ballad. But there we are again.

For it isn't a ballad; that is, if one accepts "scherzando" as the intent.

The last song from "Oh, Kay!" to be considered is *Maybe*. This is a true ballad—clean, spare, inventive, yet uncontrived. It is spare to the degree that it has only fifty-one notes.

The verse is charming and leads musically, as one wishes all verses would, into the chorus. The chorus is extremely simple, but for one somewhat complex section preceding the return of the main strain. I find it all totally satisfying.

Maybe

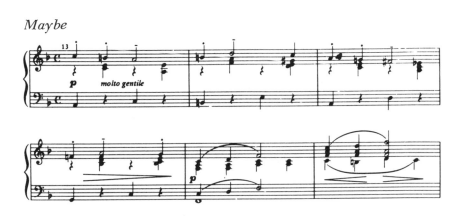

The illustration includes two measures of the song's restatement, to show how gracefully the preceding notes return to it.

My only reservation about the song is that I find the ending abrupt. I wouldn't presume to suggest an alternative nor should I carp about any aspect of such a lovely song. It is wholly in a pentatonic scale.

The 1927 version of "Strike Up The Band" was withdrawn during its tryouts. I don't find any of the published songs interesting enough to discuss. The title song was obviously written as a big finale production number, and why it has survived outside the marching bands is a mystery to me. For no matter how reverent the public's memory of Gershwin, this song could have been by a capable hack, and, having no characteristic of Gershwin's style that I can find, does nothing to enhance his creative reputation.

In "Funny Face" (1927), the title song is still in print (1969).

And I can't see, frankly, why it should be. As a melody it does little, goes no particular place, and makes no particular point. If one examines the chromatic figure used to fill up space in the accompaniment, the playing of the song becomes slightly more interesting. But even this palls. In my examination of many examples of this kind of song, I have found few which achieve any objective except *Thou Swell* by Rodgers and Hart.

Next is *'S Wonderful* from the same show. Its verse is a monotony of imitative phrases which no amount of adroit harmony can leaven. The chorus is part of our musical language. But it, too, I'm afraid, I find monotonous. It is, as are most of Gershwin's songs by this time, A-A^1-B-A^2. The germinal idea of the song is repeated, before it's over, seven times and, with one imitation of it, eight. Perhaps the intention is monotony, but unless I hear it colorfully arranged, it leaves me cold, except for its *B* section. Though it is comprised almost entirely of the note *d*, it manages to make more of a point than the main strain. That is, for me.

I believe this song is a perfect illustration of the great strength of Ira Gershwin's lyrics. For I believe the lyric in this case is much stronger and more memorable than the tune. The tune is memorable, granted—but it is so, I think, because of its association with the lyric.

The device of the apostrophized " 'S"—a truncation of "It's"—before the adjectives and nouns is the attention-getter of the song. Its shameless adherence to such a word as "paradise"—" 's paradise"—does the trick. It's not one I particularly cotton to, but it's one that works.

Let's Kiss And Make Up, from "Funny Face," is fascinating in many respects. First, it has an extra-long verse, thirty-two measures, and very good throughout. The last four bars are very like *That Certain Feeling* and are a reminder of Gershwin's stylistic device of the repeated note (the release of *'S Wonderful* and much of *That Certain Feeling, Sweet And Low-Down, Strike Up The Band, Clap Yo' Hands*). This device adds rhythmic emphasis and is akin to pounding a table, beating a drum, saying "yes, yes, yes!" instead of "yes."

The rhythmic device in the chorus of this song is startling and by no means simple. In order to play it with consistent correctness I had to divide the first four and all similar measures into 3/4, 3/4, 2/4; 3/4, 3/4, 2/4.

Let's Kiss And Make Up

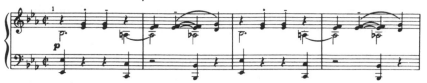

Note the left-hand staff. The bass notes fall on the first and fourth beats of the first measure and only the third beat of the second, and so on.

Again notice the constant use of repeated notes: in measures six and seven there are five *b* flats; in fourteen and fifteen there are five *e* flats; in seventeen and eighteen five *e* naturals.

The song is too interruptive to be a ballad, but whatever it is, it deserves praise for its experimental nature.

He Loves And She Loves, from the same show, is a good, solid, somewhat contrived song, made up of nothing less than a quarter note and never resorting to the repeated note. In fact, its principal characteristic is the big leap, as in the first four measures.

He Loves And She Loves

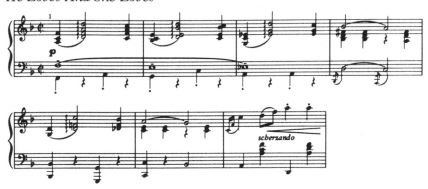

These leaps are continued in the release and just as effectively. I like the song, though it smacks more of high-class pop writing than theater writing.

The World Is Mine was cut before "Funny Face" opened on Broadway. It is a song of no consequence whatsoever, but *is* interesting

because the left hand of the piano part in measures one and two, five, nine and ten, thirteen, twenty-five through twenty-nine, is that of the main strain of *Fascinating Rhythm.*

<center>V</center>

In 1928 "Rosalie" was produced. *How Long Has This Been Going On?*, the first song from it which I'd like to discuss, didn't attract much attention until Peggy Lee recorded it with Benny Goodman's band. Since then it has been a standard (that is, for those staunch enough to sing a distinguished song today).

The song is marked "moderato," but every time I've heard it it has been played or sung very, very slowly, and rightly so.

Gershwin is back to his characteristic repeated note device and here it works very well. The main strain harmonically is very fine. The seventh measure is just a trifle disappointing, leading to the minor seventh with a curious self-consciousness. At a very slow tempo it sounds less calculated. Most of the performances I've heard change the notes slightly. The original is as follows:

How Long Has This Been Going On?

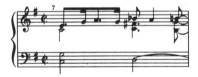

And here is the alteration:

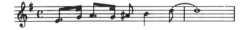

I prefer the latter.

The release (and it is another *A-A-B-A* song), is very good and is an intrinsic part of the song. A release is often musically independent of the main strain, conceivably written by another writer or even the same writer a month after he'd written the *A* section.

Oh Gee!-Oh Joy!, also from "Rosalie," is a very obscure song de-

serving more familiarity. It's not great, and it's back to the repeated note compulsion with a vengeance, but it "works," and has a charming release.

It has a neat little rhythmic trick in the fifth and sixth and similar measures. It's so simple it's odd that it's not easy to play. I think that, truly written, it would be in two rhythms: 3/4 and 5/4. If I count it this way, it immediately becomes easy.

Oh Gee!-Oh Joy!

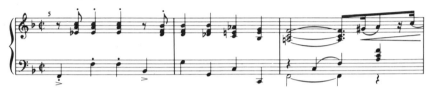

There is a phrase in the release that was echoed in the middle section of Gershwin's *Bidin' My Time* two years later.

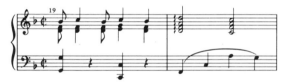

The verse is also neat and in the key of C, leading wonderfully to the chorus in the key of F. By the way, I haven't found many Gershwin songs with the verse and chorus in different keys.

I notice that Ira Gershwin had not yet become his brother's sole collaborator. For in *Oh Gee!-Oh Joy!*, P. G. Wodehouse is listed as co-lyricist. Wodehouse's great friend and collaborator, Guy Bolton, was the co-author of the book. Wodehouse was also the co-lyricist with Ira of *Say So!*, a swinging little song, *A-A-B-A*, of no great matter but certainly a good, direct rhythm song, unreminiscent of any song that I know.

Here is another Gershwin song with verse and chorus in different keys: *Feeling I'm Falling*, from "Treasure Girl" (1928). It's a good, relaxed, yet untypical song. Its device is step-wise writing, carried

through into the release. (When "release" is used, let it be assumed that the form is *A-A-B-A.*) The first four measures will serve to illustrate this way of writing, which I associate more with Rodgers' writing than Gershwin's.

Feeling I'm Falling

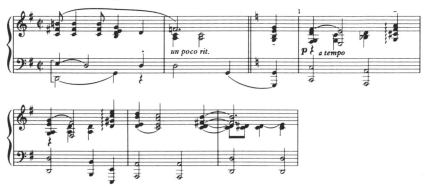

The verse is in G major and it makes its way very neatly into the chorus, which is in C major—no great feat to be sure, but done as if with compassion for the singer, so that they could find the new key without having to hear the harmonic resolution.

What Are We Here For? from the same show is another obscure song. At least it's unfamiliar to me. Its obscurity might be due to the fact that it possesses only two Gershwin mannerisms and only fleetingly: the first two measures of the release (as an entity) with its *e* flat in the melody and the F-dominant-ninth chord, and then the repetition of the half notes *e* and *a,* preceded by repeated quarter note *e*'s.

What Are We Here For?

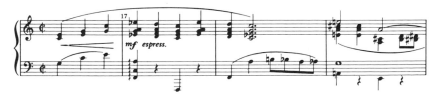

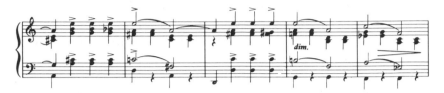

Except for these Gershwin devices I might have mistaken it for a Kern song, and a good Kern song, to boot. By this time I suppose Gershwin's listeners expected a specific style from him and wanted nothing else. (But if I'm right, how does that account for the popularity of *Strike Up The Band!*)

In 1929 came "Show Girl," in which there was a song mysteriously dropped before the Broadway opening, *Feeling Sentimental*. It must have been cut from the score for other than musical reasons, for it is a very good song, both verse and chorus. The lyric by no means measures up to the tune, but the latter is so good it doesn't matter.

It's the kind of song I would think a singer like Frank Sinatra or Jack Jones, or a player like Tommy Dorsey would have performed. For it's as natural a melody in the slow rhythm ballad tradition as one could ask for. But I've never heard it sung, perhaps because of the weakness of the lyric.

The release is an integral part of the song, takes it into new territory, and leads back smoothly into the return of the main strain. Here is the principal idea:

Feeling Sentimental

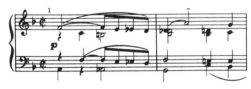

I like all the harmony except that of measures five through eight. It's all based on F major and C seventh and, with but a little searching, could have been more interesting. A good arranger would find adequate harmony in no time. But this is a minor matter. The song is very good.

And then there's *Liza*, which I'd hesitate to criticize, even if I

didn't like it, for fear of bodily harm. Fortunately, I do. Perhaps the only song comparable to it in style is Rodgers' *The Girl Friend*. This might not be obvious to a non-musician, as the similarity is mainly harmonic. *Liza* is, however, I believe, a better song. But it should be: it was written at a later time, when American music had become much more sophisticated and swinging.

The bright thought implicit in building up his tune for four measures and then continuing after a quarter note rest shows Gershwin's mastery of craft. And to close the section with a totally unexpected riff is a further proof of professional, as well as witty, writing.

Liza

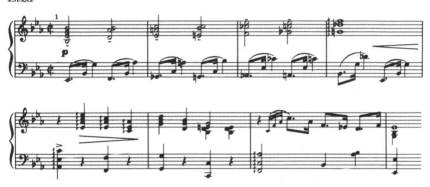

Then the first measure of the release daring to be a whole note, followed by a rhythmic phrase after an empty downbeat—this all adds up to expert handling of the tools of one's craft.

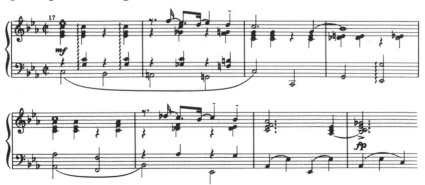

For the second version of the show "Strike Up The Band," in 1930, new songs were written. And one I had never heard before I started this survey is *Hangin' Around With You*. I'm very fond of it. The main idea is repeated twice and makes perfect use of the minor third.

Hangin' Around With You

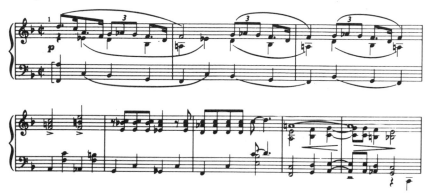

Here the melody suggests an instrument as much as a voice.

I find the release a very good one, building up all the time to the return of the main strain, properly marked "*p*." Building up dynamically to a sudden soft phrase is often more effective than when the phrase plunges on *fortissimo*.

I am perplexed because the title uses the word "hangin'" while the lyric itself uses "hanging." I think Ira was right the first time. "Hanging" has nothin' to do with this song.

I've Got A Crush On You I have never been able to think of as a theater song; in fact, my consciousness of it is irrevocably influenced by Sinatra's recording. If I think of it as a very evocative pop tune, all is well. But I can't compliment it in terms of theater music any more than I can *Between The Devil And The Deep Blue Sea* by Harold Arlen.

I am quite certain that five notes were changed by Sinatra in his recording, one in the very attractive verse and four in the chorus. I believe they are better than the original ones. The first occurs in measure twelve of the verse. Sinatra sings an *a* as the last eighth note instead of an *f*.

I've Got A Crush On You

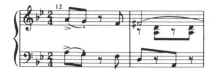

He then sings, in measure seven on the last eighth note, an *e* flat (as happens in the second half of the song) and a *d* on the last eighth of measure eight (as later on).

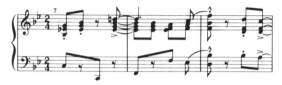

At the last cadence of the song he sings an *f* the second eighth of the thirtieth measure and a *g* the last quarter note of that measure.

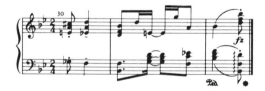

So enormously powerful were Sinatra's interpretations of songs that even now, looking at the sheet music, I find it impossible to disassociate the printed notes from my memory of his singing.

By 1930, the copyright date, the song should have been printed in 4/4. It has always been played in 4/4. Or was it written much earlier when 2/4 was the norm and the editor never thought to re-edit it in 4/4?

I know I'm again treading on sacred ground when I speak slightingly of *Soon*, a famous song from "Strike Up The Band." I must say what I believe, and it is that even as a pop song I find *Soon* almost totally a contrivance. It contains none of the elements I so admire in a great song: unexpectedness, subtlety, wit, inevitability. Perhaps it

does have the latter, but in this case it comes off as expectedness. It has boldness, to be sure, but here it borders on coarseness.

I know from experience how easy it is to let chords guide the fingers that are choosing the melodic notes. And the melody resulting from the chords of the first eight measures of *Soon* is a cliché and always has been. The second eight measures employ some characteristic repeated notes. If there are any happy moments in the song, they occur at the three points where the repeated notes drop a minor seventh, as in measures eleven and fifteen and twenty-seven (here it is a sixth).

Soon

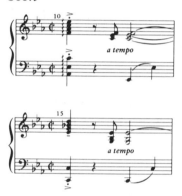

Let me say that I like the verse of *Soon* very much.

VI

Boy! What Love Has Done To Me!, from "Girl Crazy," also in 1930, is basically an "instrumental." And as such it is splendid. The lyric is witty and full of clever rhymes; the harmony and the chromatic bass line are all that a musician could ask for, and yet, though obviously singable, since it has been sung, it is not song-like.

Perhaps I'm being too harsh, considering the fact that the intention was wit. So, assuming that the words would and should attract most of the attention, why not sneak in some wild melodic intervals, some off-beat harmony, and generally have a ball? No romantic

mood will be shattered, no lover of pure melodic line will be insulted. For, after all, they're all laughing at the words.

The release is marvelous but I admit, though my ears are fairly acute, I have a tough time singing it without the help of the chords. But here again perhaps I'm demanding too much ease in a melodic line.

But Not For Me is a masterpiece of control and understatement from begining to end, verse and chorus. Because everyone knows the song and its author, it is hard to realize that it is not by any means typical of Gershwin's most characteristic style.

Almost as simple as *Dear Little Girl*, it has a range of only one note over an octave, only two notes not in the parent key, and minimal syncopation. Its form is *A-B-A-B¹*.

In the verse, Gershwin once again uses his repeated note device, but contrasts it with moving lines. As a verse it couldn't be better. The entire song is Gershwin at his purest.

Embraceable You, also from "Girl Crazy," is another of those Gershwin untouchables, as well as a song in which I believe that his brother's lyric functions as an intrinsic part. Any Gershwin enthusiast is as aware of the words, "Come to papa, come to papa, do!," as they are of the repeated notes that make them singable.

I don't suppose anyone really knows which of all the Gershwin songs has had the most performances. But *Embraceable You* might be neck-and-neck with *The Man I Love*.

Its form is *A-B-A-C*, an unusual one.

After attempting to disassociate myself from the hundreds of hearings of this song so as to consider it with detachment, I can say that it is undoubtedly a marvelous illustration of simplicity and economy.

First off, the device of starting the first phrase after a quarter rest and, in the second measure, imitating it, is inventive and unusual. Then the abrupt eighth note on the downbeat of the third measure, followed by a half rest, eighth note, and two quarters tied to a whole note, all constitute an unexpected phrase.

Embraceable You

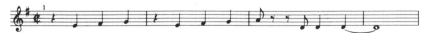

The two smooth quarter note measures at the beginning of the *B* section are competent contrast to the interruptive nature of what has preceded. And then to repeat the eighth note, quarter rest, eighth note and two quarter notes is, again, unanticipatable and highly unusual. The imitated phrase at the cadence of the *B* section in which the melody drops an octave is enviable writing.

In the *C* section, the "come to papa" phrase is almost the hallmark of the song. It is so unusual that one must wonder if it resulted from the lyric. Its only comparable phrase in popular music occurs in *How About You?*, by Burton Lane, where the lyric says, "I like potato chips, moonlight and motor trips." The surprise is similar and it is also accomplished by repeated eighth notes. The final unexpectedness of Gershwin's melody is the eighth note *e* flat on the last "brace" of "embraceable" in the final cadence.

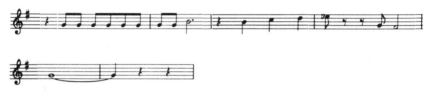

The harmony of the song is not of sufficient interest to illustrate. This is not to imply an inadequacy. Were I to make an orchestral arrangement of it, I'd use every chord and almost every bass note.

Perhaps this might be the place to make an observation that has been much on my mind as I have reviewed Gershwin's songs. Not enough has been said of his avoidance of harmonic clichés and of his constant and unerring use of the proper bass notes and, wherever feasible, bass lines. As well, he seldom, if ever, allowed his harmony to remain static, as did so many other writers. Following are examples of two of the worst, and most often employed, harmonic clichés:

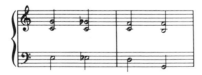

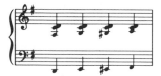

It was this sort of hack work that Gershwin always avoided in favor of fresh harmonic ideas.

One last comment on *Embraceable You*: at the close of the verse there is a measure of eight repeated eighth notes over the words "listen to the rhythm of my." It is conceivable that this isolated instance of repeated notes may have spilled over into the "come to papa" phrase.

Bidin' My Time is a winning little piece of unaggressiveness. I remember, in "Girl Crazy," four cowboys sitting on a fence, playing it on a harmonica, a jew's harp, an ocarina, and a tin flute. And it sounded mighty sweet. I've often wondered, for no particular reason, how long it took to teach four actors to play the song in four-part harmony.

I know that *I Got Rhythm* has been played ad nauseum by jazz groups since the time it was first heard. And if it made many players happy, I'm glad. But to be candid, my particular gratification is that, since jazz presumes improvisation, in all my hearing of the song by jazz groups, I've always heard endlessly different variations of the original.

It was a high point in the show. It was a great vehicle for Ethel Merman, and again I'm glad. But as an effort by a major writer, I find it a passing fancy, enormously successful though it obviously has been.

It might be wise at this point to consider this anomalous writer. It should be kept in mind that in the midst of his growing career as a writer of theatrical songs Gershwin had startled the musical world by composing *Rhapsody In Blue, An American In Paris*, and a piano concerto. They had all been performed with extraordinary success and he was, by the time of "Girl Crazy," firmly established in both worlds.

Such a situation was unique. As I've said before, not even Gershwin's hero, Jerome Kern, had achieved such eminence. This state of

affairs was the first proving, or at least testing, ground for Gunther Schuller's "third stream." Not until the Duke-Dukelsky one-man tandem of talents came into being had there been an analogous situation, but for Victor Herbert.

Since he had managed to plant a foot in both camps, would Gershwin's song style be noticeably affected by his other, more complex compositions? Or would he be able to maintain each, uninfluenced by the other, as well as Duke did later on? Vernon Duke's tragedy was that he never managed to achieve an equal acceptance for his Doppelgänger, Dukelsky.

Blah-Blah-Blah, from "Delicious" (1931), is a very sweet and sadly obscure song. It is probably because of the "blah" title. Actually, the song is a very tender ballad. But I can understand a good singer shying away from the problem of making the "blahs" sound romantic. The lyric was an effort to inject a grain of cynicism into what would otherwise suffer from the stigma of sentimentality.

The song was probably very touching in performance, due again to Ira Gershwin's adroitness in dropping key words which set the sentimentalism of the song—words such as "moon," "croon," "above," "love." And the more-than-adequate verse uses sensible words throughout, setting up the nonsense of the chorus.

Love Is Sweeping The Country is a rouser in 2/4 rhythm, from "Of Thee I Sing" (1931). There are pleasant moments in it— it *is* a standard song—but to me it belongs on the stage or in a marching band. Or perhaps I should say a swinging marching band, for it does both march and swing. It's very energetic and syncopated and occasionally surprising, but, overall, it has a made-to-order quality about it which I believe should have limited it to theater use.

The title song is also similar in most respects: it is a rouser, it marches, it's aggressive, it's a standard and, for me, it belongs only on the stage.

The verse begins in the key of E flat, shifts to G and again to the key of C in the chorus. All of which implies an approach to the realm of what might be called "swinging operetta."

The "hook" in the lyric is the juxtaposition of the afterthought, "baby," following the noble sentiment "Of thee I sing" and its connotation of patriotism. This is further attested to in the somewhat chauvinistic line, "worthy of a mighty nation." Never having seen

the show I don't know whether it was a wry line or whether the chorus was costumed in the stars and stripes.

Who Cares? is a marvelous rhythm ballad, moving naturally and purposefully ahead, seldom employing big melodic leaps.

Its form is *A-B-A¹-C*, and its accompanying harmony is interesting without ever demanding distortion in the melody. Jazz players have always found it a favorite.

VII

Out of respect for Miss Mabel Mercer, who continues to sing *Isn't It A Pity?* from "Pardon My English" (1933), I'll include it in this survey. She always could make a listener believe he was hearing a great song. Yet even she couldn't convince me of the worth of the third and fourth measures of this song's release, neither the static music nor the vapid words, "You, with the neighbors; I at silly labors."

The main strain is simply adequate. It runs its predictable course with a series of imitative phrases, eliciting interest for me only in the use of triplets.

Isn't It A Pity?

Lorelei is a loose, swinging, "riffy" song one doesn't expect of Gershwin this late in his career. But for the release, it's a very direct and simple song. The release continues to be simple, but becomes very difficult in its last four measures and gets back barely in time for the restatement of the *A* section. But it's extremely clever and Gershwin is clearly having a good time. Besides, as I have said elsewhere, difficult releases have never disturbed publishers or the public, as long as the main strain was easily assimilable.

My Cousin In Milwaukee, from the same show, is another unlikely song, or perhaps I'm so lately arrived from the stiff squareness of *Of Thee I Sing* that these "night spot" songs come as a shock. Both verse and chorus sound as if Gershwin had just come home from listening to a good band and, in his high spirits, forgot all about being self-

conscious. It's a slow rhythm song, the kind I'd have been happy to hear Helen Ward sing with the Benny Goodman band backing her up. She'd have to have fought for the verse, but it would have made a prettier package.

In "Let 'Em Eat Cake" (1933), there is a marvelous, nutty little twenty-four measure song called *Blue, Blue, Blue*. It's like no song I've ever heard. It puzzles while it pleases. It may have been intended only to fulfill some production function.

The verse is a monotony of repeated notes. But the piano part looks as if Gershwin were making a sketch for a new concerto. As I said, I'm puzzled. Its main strain is eight measures, followed by an unpredictable section of four measures made up mostly of eighth notes. Then follows a repetition of the first eight measures and a last section of four measures wholly unlike the first four-measure section.

The lyric has to do with painting the White House blue and that's about all. It does qualify the matter by saying "not pink or purple or yellow, not brown like Mister Othello," which might ruin its chances for revival in the seventies.

I've enthused about it, so I should offer an example of at least eight measures.

Blue, Blue, Blue

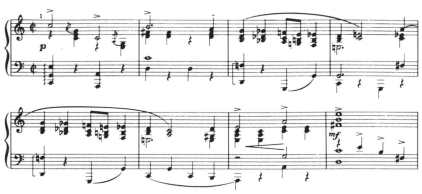

A song from the same show very enthusiastically associated with Gershwin's name is *Mine*. I have to admit that the principal melody does not impress me as more than a backdrop for the counter-melody,

which is superimposed on it the second time around. Nor do I find the counter-melody more than a "vamp" figure which deteriorates into a chromatic obligato along the way. Harmonically, practically the whole song is a series of vamps. Curiously, though neither tune has little to recommend it, when they're put together the result is very effective. But at best it's a stunt.

"Porgy And Bess" was first produced in 1935. It lost a good deal of money, and, in general, the opera critics dismissed it. Then in 1942, five years after Gershwin's death, a revised version of the opera was produced. The editing considerably shortened the running time, and the work was now acclaimed by the critics and the public alike. It was now a financial success.

"Porgy And Bess" was originally billed as "a folk opera," a description that is still in common use. Because it is universally accepted as, and treated as, an opera, it should be studied and evaluated in terms of operatic traditions and standards. In short, it should be measured against operatic criteria, a procedure that certainly lies outside the scope of this book. It is, of course, a tribute to Gershwin as a melodist that the lullaby *Summertime*, a poignant *arietta*, became very popular beyond the opera house and recital hall.

In 1936, after having written this large and ambitious work, Gershwin, for some inexplicable reason, chose to write a song for Radio City Music Hall, not with his brother but with Al Stillman, a less-than-inspired lyricist. With a long list of popular as well as concert successes to his credit, how or why Gershwin could have taken on such an assignment is a mystery. The song is called *King Of Swing* and it's hack work.

By Strauss, from "The Show Is On," is the only Gershwin waltz I've come across. It's attractive from start to finish. The chorus is so sweet that I'm a little sorry that the lyric is so jocose. It's another of those songs no one, unless told, would ever dream was by Gershwin. And I have come to realize that these are the songs of his I like the best.

Let's Call The Whole Thing Off, from the film "Shall We Dance" (1937), really isn't so hot. I'm certain that its popularity stemmed from Fred Astaire's stylish performance, both in the film (with Ginger Rogers) and on records. He was a magician as a singer, and he made listeners think lots of songs were better than they really

were. I happily include myself among the bemused, for the tune in this case is just a hook to hang the fairly amusing lyric on.

The title song is a lively one with a very happy verse. In the chorus Gershwin is back at his insistent repeated notes, particularly in the last half of the *B* section and in the last half of the closing section. Why, he even ends the song with three *f*'s. The form is *A-B-A¹-C*.

In *Slap That Bass*, Gershwin drops back stylistically to his early writing days. But by 1937 it's simply too late for that kind of don't-worry-about-me-I-know-all-about-jazz kind of writing. It comes off as what a friend calls "ole folks makin' rhythm."

On the other hand, *They All Laughed*, in the same film, comes off as a completely timely rhythm song. It starts in swinging and never quits. The repeated *d*'s leading into the release won't let the song rest. Nor should it. And the three *d*'s (two quarters and a half note) over the words "Ho! Ho! Ho!" are perfect. And so are the *ho-ho*'s.

The main strain of this song avoids the fourth and seventh intervals of the scale and so may be said to be pentatonic. But after reviewing almost every song Gershwin published, I can't find a disposition on his part to use this scale, though he is said to have been fascinated by it.

The last song from "Shall We Dance" I wish to mention, and the best, is *They Can't Take That Away From Me*. It's etched like acid into my memory bank.

The verse is extremely inventive and gives not a hint of what is to follow. Well, you're right! It's repeated notes, but handled as I've never known them to be by him—perfectly.

At the end of the seventh measure he makes his cadence with very daring abruptness on the final eighth note. He must, so that a singer or player may grab a quick breath before the almost immediate pick-up notes.

They Can't Take That Away From Me

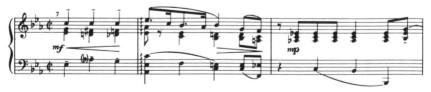

There is an extension in the last section of the chorus, and a beautiful one. The arresting nature of the *b* flat over "No!" in the thirty-second measure is a masterpiece, as are the quarter and half notes of the ending, achieving a calm, pastoral resolution in the face of the lyric's refusal to be separated from all those loving qualities. A beauty!

"A Damsel In Distress" was a film released on November 19, 1937. Gershwin had died on June 11th. So this and "The Goldwyn Follies," released in 1938, were the last productions, either on Broadway or in Hollywood, over which Gershwin could have exercised creative control. Therefore, these films are, I feel, the last works of his that should be considered.

A Foggy Day, from the first of them, is certainly one of the most famous Gershwin songs, and contains one of his brother's best-known lyrics. It's truly extraordinary how constant is Gershwin's use of repeated notes. They are more usually to be found in rhythm songs, but are seldom absent, even in a tender ballad like this. For example, the very first three notes are repeated. And the notes accompanying "I viewed the" and "The British" are repeated.

In any type of song but a romantic ballad, Gershwin's angularity may produce the most effective result. But the proof that there are no hard and fast rules is *A Foggy Day*. For in it there is no step-wise writing, and there are many leaps of fourth and fifth intervals. Yet, it remains a most tender and moving, a far from aggressive, song.

I should make it clear that I do not view the repeated note songs with alarm. *A Foggy Day*, for instance, has a heartbreak quality, not one note of which would I change. Right away I am captured by the *e* flat accompanying the word "day." And I am given, as a dividend, the avoidance of the cliché of the diminished chord. The bass line of the first four measures has been done to death by popular song writers. Perhaps its most attractive use has been in Harold Arlen's *Stormy Weather*.

But Gershwin uses, instead of the diminished chord, a minor sixth chord, which is much more winning. And he remains consistent, by moving up another minor third in the melody in his second phrase, to *a* flat, and also up a fifth again at the end of the phrase.

A Foggy Day

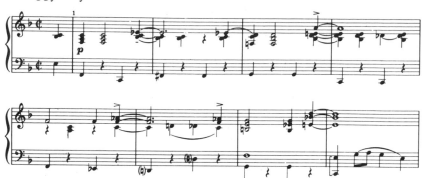

At the end of the *B* section (the song is *A-B-A-C*), the drop to the *d* in the cadence is truly gentle and loving. It's as personal as the revelation of a secret.

And this is followed by the truly chilling wedding of the word "suddenly" with the two *f*'s and the *d*.

He then winds it up by extending the last section two measures longer than is customary, in the course of which he writes a pastoral, vulnerable, childlike phrase to go with the beautifully resolving lyric.

The elegant verse resolves on a tonic chord, as might a chorus, whereas verses usually reach a dominant seventh in preparation for the tonic of the beginning of the chorus. Gershwin was uncannily right to resolve the verse. It suggests a deep breath.

The verse to *Nice Work If You Can Get It* is especially fine, with an expert triplet unexpectedly showing up in the middle of the fourth measure, unrepeated at any point. It's a swinging verse, combining an opening figure almost instrumental, moving into the by-now expected repeated note style, and again resolving to the tonic. This time he does it for another reason, which is that the chorus starts on a B-dominant-seventh chord.

It's a very clever song. The contrast between the smooth, unrhythmic first four measures and the exploding measures that follow is very satisfying. The restatement adds a quarter note triplet in the last half of its third (and eleventh) measure, a charming variant, whether or not the result of an extra syllable in the lyric.

The release is one of the best Gershwin ever wrote. I'm slightly embarrassed, however, by its cadence, since it is a somewhat lordly allusion to a phrase from *I Got Rhythm*. No doubt the Gershwins were right: everyone *did* know the earlier song. But it does seem a bit like boasting.

The last section of this song, too, is extended to ten measures and to great effect, as shown by the cadence.

Nice Work If You Can Get It

And there's another great song in this film, *Things Are Looking Up*. It's so good that it didn't even need Astaire's strange magic to prove it. It's all there, from the first note of the verse through to the final cadence of the chorus.

The repeated notes do appear but not in the opening phrase of the chorus, which has the sinuous shape of a lazy wave. Although the form is *A-A¹-B-A²*, the first two *A*'s are ten measures long. The release is strictly based on repeated notes and is a minor masterpiece of understated invention.

Things Are Looking Up

Also worthy of mention is the harmonic sequence in the final cadence.

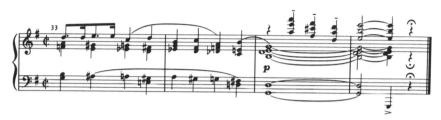

"The Goldwyn Follies" was released in February 1938, with the score completed by Vernon Duke. Though highly competent, *I Was Doing All Right* is, for me, not as good as *Things Are Looking Up*. I juxtapose them only because they're the same kind of song.

I Was Doing All Right starts out with repeated *d*'s, repeats them again, then repeats three *b*'s, followed by a marvelous cadence, unlike any I've ever heard.

I Was Doing All Right

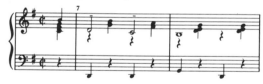

The release is very good and also chancy for the singer. And its return to the main strain (now ten measures) is very astute.

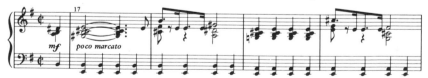

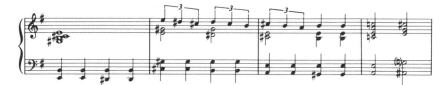

Either of the following songs, both beautiful, may have been Gershwin's final song.

Love Walked In is very restrained, lucid, direct, warm, and without pretense. Gershwin, and forgive my repetition, again makes repeated notes an integral part of the song.

He told a friend of mine that this was his "Brahmsian" song. I can't say that I agree, but it surely is close to a concert song. And Ira Gershwin's lyric is just as pure as the melody.

Love Is Here To Stay is an equally beautiful song, if slightly less pure in its flow, and containing a much more interesting verse.

The form is *A-B-A-C*, as is that of *Love Walked In*. There is much less of the repeated note and, like the other song, no effort to be clever. Rather, there is restraint, a tight rein at all times, and a lovely, final cadence, enhanced mysteriously by a quarter rest preceding it.

VIII

Probably with no other writer is the personal character of this book more apparent. Upon rereading my words, I find that I jump from enthusiasm to critical reservation like the lines of a fever chart. Yet I must defend myself by reminding the reader that this survey is based upon personal opinion.

No other writer of songs causes such disparate attitudes from me. For however excitingly native his writing may have been, I feel that there was a scrim—a vaguely transparent theater curtain—between him and what he sought musically. I'm trying to say that, for me, there is one step missing in his restless movement toward a totally American expression.

True, he was listening, experimenting, moving into the environment of the upheaval of jazz. But he never "walked right in, sat right down" and made himself at home. Perhaps, on the other hand, if he had come any closer to the native jazz sources, he might have

been content with less complexity and style. And he might have become, therefore, an inadequate white imitation of a Negro writer.

I must qualify this last opinion by adding that, though I believe the Negro was the primary source of the emergence of a new native music in America, I do not mean to imply that the Negro was solely responsible for its development.

Probably there needed to be a transmutation, a polishing, and a formalization of source material before the emergent new music could assume its proper function in the theater. I am speaking specifically of the era in which Gershwin was writing—the twenties and the early thirties. And this process of transmuting the wild amalgam of the native pop music that grew out of ragtime into theater music may have been, in part, the scrim I mentioned.

In any event, scrim or no, the memories of all but the young are filled with Gershwin songs. Were the layman to be asked to give the name of the writer most associated in his mind with theater music, I believe he would mention George Gershwin first, even though, if reminded, he would gladly acknowledge the mastery of Kern, Rodgers, and Porter.

—— 5 ——

Richard Rodgers
(1902-1979)

I

After playing almost all of Richard Rodgers' published songs, I chose for more intensive examination about one hundred and twenty-five, or somewhat less than half of them. This final choice wasn't easy: there is an extraordinary incidence of inventiveness in practically all of Rodgers' songs. So if I've failed to include a deserving song in my analyses, it's undoubtedly because I happened to choose another which is similar in spirit and intent.

Of all the writers whose songs are considered and examined in this book, those of Rodgers show the highest degree of consistent excellence, inventiveness, and sophistication. As well, they bear the mark of the American song, excepting a few pretentious ballads written in the later years of his career with Oscar Hammerstein II.

I have been aware of Rodgers' work since "The Garrick Gaieties" and have remained highly impressed from then till now. But after spending weeks playing his songs, I am more than impressed and respectful: I am astonished.

As in the case of Jerome Kern and Vincent Youmans, all of Rodgers' songs were written for the theater. And they all bear its stamp. They have that elegance, sophistication, and "created" quality which, until the recent influx of non-theater writers writing for the theater, used to distinguish theater songs from pop songs.

His distinction stems more from remarkable melodic sensibility and

experimentation than from new departures in song structure. Which is not to say that he wasn't capable of doing structurally startling things as in, for example, *Little Girl Blue*. But Rodgers achieved his amazing innovations without resorting to more than an unexpected note here and there, completely startling at first hearing, and ever after a part of one's musical memory.

Though he wrote great songs with Oscar Hammerstein II, it is my belief that his greatest melodic invention and pellucid freshness occurred during his years of collaboration with Lorenz Hart. The inventiveness has never ceased. Yet something bordering on musical complacency evidenced itself in his later career. I have always felt that there was an almost feverish demand in Hart's writing which reflected itself in Rodgers' melodies as opposed to the almost too comfortable armchair philosophy in Hammerstein's lyrics.

Rodgers moved out of the song world only long enough to write a ballet, "Ghost Town," and a television score, "Victory At Sea," the former orchestrated by Hans Spialek, the latter by Robert Russell Bennett, both of them brilliant creative craftsmen, and the latter a respected composer. And since Rodgers settled for song writing as his métier, so did he consistently grow creatively from his virtually uninterrupted concentration on it.

Legend has it that somewhere amongst the many radio stations of the United States a Rodgers song may be heard at any time, day or night, the year round. Well, I, for one, hope this is so, though how such a state of musical affairs could still be true at the beginning of the seventies I don't know.

As this chapter progresses it will be seen that, though capable of highly sophisticated harmony, Rodgers never became so concerned with it as to cause it to distort melodic flow. It may well be that the delicate balance between melody and harmony may have had much to do with Rodgers' phenomenally high level of writing.

II

Rodgers' first published songs were copyrighted the same year as Gershwin's first pop hit, *Swanee*, 1919. His first published song writ-

ten with Lorenz Hart, *Any Old Place With You,* also 1919, was interpolated in a show called "A Lonely Romeo"; music by Richard C. Rodgers, at that time sixteen years old. It is a harmless little song, professionally written, but of no distinction, and certainly containing not a clue of his future style.

The next year, 1920, three Rodgers and Hart songs from the composite score of "Poor Little Ritz Girl" were published. Rodgers has said that this music was largely from his first college show. One of these songs, *You Can't Fool Your Dreams,* shows an emerging style. It is only twenty measures long and, in terms of four-measure phrases, its form is *A-B-A-C-C¹*. Its principal characteristic is the repetitions of a measure in the *C* and *C¹* sections, complemented by and perhaps due to three rhyming words. In terms of later songs it is slight, but considering Rodgers wrote it at the age of seventeen, it is worthy of illustration.

You Can't Fool Your Dreams

Nothing of consequence was written for five years. But then, in 1925, erupted "The Garrick Gaieties." Rodgers said of this show, "that really put us on the map."

A little-known song from it is a very daring waltz called *Do You Love Me?*. It is an extremely good song from beginning to end. In the six years since his first published song Rodgers has found himself and is in complete charge of his melodic and harmonic tools.

The verse instantly takes hold, indeed introduces a descending chromatic bass line, a device rare for those days. After twelve measures the melody moves from the key of F major to A minor, and then closes with a very neat series of imitative phrases, written by a professional hand.

Do You Love Me?

The chorus is so "far out" that perhaps its unusual intervals may account for its obscurity. In fact, it's so unusual that even the printer seemingly couldn't believe it, as he failed to put a flat in front of the *g* in the fourth measure, or a flat before the *e* in the twelfth measure. In the following illustration, try singing the third and fourth measures without any accompaniment!

It's not a great song, but it's very effective, experimental, and under control. A proof of this last claim is shown in the neat return to the neighborhood of the parent key, both melodically and harmonically, in the fifth measure. Later on, though the device is different, the song never strays into uncontrolled cleverness. Just a sudden, startling trick and then back to safe ground.

Rodgers' and Hart's first hit was *Manhattan*. And it remains a very active standard after over forty years!

Since there are four sets of lyrics in the printed copy it is safe to suggest that this song had more lyrical value to the show than musical, or at least it was intended to have. But it is my conviction that, assuming the lyric to have been written first, Hart must have been considerably startled by the charm of a melody which probably was intended to be no more than a clothes horse for the lyric.

It's a gentle, evocative melody, suggestive of a more sentimental lyric, though inextricably interlocked with the lyric it has, which contains dozens of clever rhymes with all the familiar place names in the New York area.

Its form can be made clearer by considering it in terms of four-measure phrases. It is then: *A-B-A-C-A-B-C-A¹*. Harmonically it contains nothing startling, but every progression it has works perfectly.

On With The Dance is a lively, but unmemorable rhythm tune with, however, a verse which begins with such marvelous unexpected casualness as to deserve illustration.

On With The Dance

There is another straightforward song from "The Garrick Gaieties," a standard of later years, but one which, to me, could as easily have been by Jerome Kern, *Sentimental Me*. Its principal device is the repeated note, which, as in many of Gershwin's songs, tends to lose my interest when belabored. This is not to say, however, that the song is without character because of this device.

In the autumn of the same year (1925) "Dearest Enemy" was produced. In it there was a solid *A-A-B-A* song, *Here In My Arms*, also destined to become a standard. As strong as it is, there is a predictability about it that comes off more stolid than solid. It does make one unexpected move in the *B* section when it reintroduces the main strain in the related key of B flat (the song is in F) for two measures

and then resorts to something new, which, by the way, takes the melody up to a high *g,* giving the song the rather wide range of an octave and a fifth.

Here In My Arms

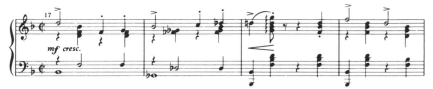

A song in the "Fifth Avenue Review," a night club revue of 1926, should be mentioned principally for a phrase in it which later became a phrase in *Glad To Be Unhappy.* The song is *Where's That Little Girl (With The Little Green Hat).*

Where's That Little Girl (With The Little Green Hat)

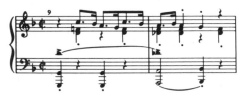

There is a seldom seen innovation in measures thirteen and fourteen. Not only does the melody introduce notes outside its parent key of F major, but it eliminates right-hand harmony and left-hand bass notes.

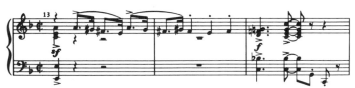

Then comes "The Girl Friend," also in 1926, in which there were two big songs. *The Blue Room,* which I never knew until recently

contains "the" in the title, is, to me, the first wholly distinctive Rodgers song. (*Manhattan* is a fine song but somehow not so specifically what we have come to recognize as a Rodgers song.) *The Blue Room* has a provocative, unforgettable verse of just the right length. Here are the first three measures of it.

The Blue Room

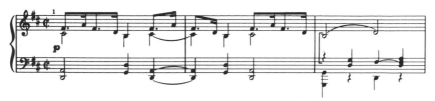

The song is printed in D major and I presume it was at Rodgers' request, as D major is seldom used in sheet music. Most publishers would prefer a half step higher, E flat. (I have never understood the preference for flat keys as opposed to sharp keys.)

The Blue Room is a strong, uncluttered, direct statement. In it is the first instance of a Rodgers stylistic device which he continued to use throughout his career, that of returning to a series of notes, usually two, while building a design with other notes. This device is marvelously employed later on in *Bewitched*. Here he keeps returning to *b* and *a* while ascending from *d* to *e*, to *f* sharp, to *g*, and *a*.

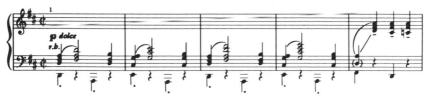

The song's form is *A-A¹-B-A¹*.

And the lyric, a vision of newly-wed bliss, is vintage Hart: "You sew your trousseau, and Robinson Crusoe" and so on. Come to think of it, though, I'm slightly perplexed by "trousseau" as I was under the impression that it was sewed *before* the wedding.

The Girl Friend fascinated me from the first time I heard it, principally because of its chromatic bass line. I had never heard one like it and didn't again until three years later in Gershwin's *Liza*.

The Charleston rhythm in all of the *A* cadences is there quite specifically because this dance is mentioned in the lyric of the verse, and for good reason, as it was the rage during those years.

The chorus bears more similarity to *Liza* than the bass line, insofar as the melody begins on the fifth interval and climbs step-wise for four measures almost identically. I happen to prefer Gershwin's device of creating a contrast between the first four smooth measures and the following break-away rhythmic measures.

The Girl Friend is in strict *A-A-B-A* form.

Then, only two months later, came a second "Garrick Gaieties." What a racing back and forth from rehearsal to rehearsal there must have been in those days when writers wrote several shows during the same year! In later years, however, it was no novelty for a musical comedy to be in the making for two or three years.

In this second "Gaieties" there was a great rhythm song, *Mountain Greenery*, which, when one stops to think of it without all the familiarity induced by memory, is a very unusual title.

Verses are another of Rodgers' talents. More often than not one feels that he has given all due consideration to them, that he realizes their rhapsodic, free potential, and that he seldom writes one which causes you to think he tossed it off casually simply because the production or the lyricist needed it. It's almost always interrelated to the chorus. In *Mountain Greenery* the verse is precisely right.

The song is a true swinger. And maybe there is validity to my theory about the aggressiveness of repeated notes, since this is one of Rodgers' most driving songs. And it's certainly predicated on repeated notes, right from the start.

This is Rodgers' first use of the *ostinato* bass line, in this case *c*, *a*, *d*, and *g* which, later on, one could find tucked away underneath all manner of songs, from Gershwin's *Soon* to Vernon Duke's *I Can't Get Started*.

The release, the *B* section, of the song is one of those song writer's dreams, seldom achieved, often dangerous, but when right, as in this case, perfect. For me, aware as I am of harmonic shifts, it's especially satisfying.

Mountain Greenery

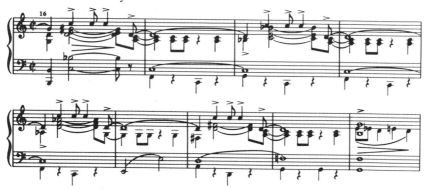

The song also includes what is termed *trio-patter*. This has no particular meaning outside the theater since the melody of it is primarily a support for the clever, engaging rhymes of Hart.

The form of the song is *A-A-B-A¹*.

What's The Use Of Talking is in the same show. The integral nature of Rodgers' verses is well illustrated in this song, as the device of descending steps, plus their rhythm, are to be found in the third and fourth measures of the verse and later in the first and second measures of the chorus.

The rhythm of measures two, three, and four is not without precedent, but used here so smoothly and resolved so well it deserves illustration. Note that these measures might be spelled as four 3/4 measures instead of three 4/4 measures. And note also Rodgers' marked return to a strict 4/4 feeling in measure five.

What's The Use Of Talking

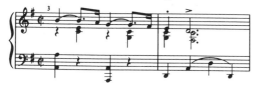

Below are the measures of the verse that are similar to the first two measures of the chorus.

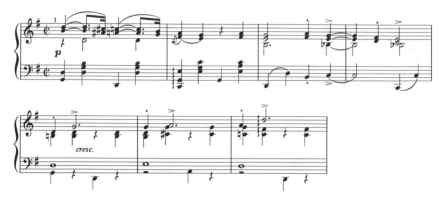

In December of 1926 came "Peggy-Ann," in which the song *Where's That Rainbow?*, though never very well known, has been kept alive by "cocktail" pianists and occasional record performances. It's a better than average rhythm song with Rodgers' usual much better than average verse.

The chorus should have resorted to the *c, a, d, g* ostinato in the bass; probably it is used by arrangers, because the song begs for it. The sixth interval is the principal note of the chorus, one more instance of my theory regarding its provocative nature. The first, third, and fifth measures are identical, and since the form of the song is *A-A-B-A*, so are all the measures of the *A* sections. This obviously means that the first measure is repeated eight times, which I guess comes under the heading of hard sell. In this song, however, it has more the quality of a desired restatement than one forced on the listener.

The first and fifth measures of the *B* section are noticeably conditioned by their supporting chords, mentioned here only because Rodgers resorts to harmonically controlled melodic lines so seldom.

Where's That Rainbow?

The first measure of the chorus, so many times repeated, should be shown here followed by its changing alternate measures.

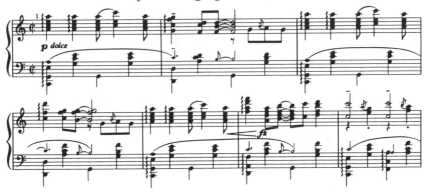

III

When a show fails, its songs may also disappear. One of Rodgers' finest songs slipped into oblivion when "Betsy" (1926), a show written for a star of that time, Belle Baker, lasted only thirty-nine performances. The song, *This Funny World*, seems to have remained all but unheard until Matt Dennis, a very talented song composer, arranger, and night club singer, rescued it about twenty-five years later. Outside of the copy used for study I've never seen the song before, let alone heard it. A friend brought it to my attention, having heard Dennis sing it.

The lyric is very gloomy and cynical, which may account for the song's obscurity. The instructions before the chorus are *very slowly and tenderly*. And rightly so, for it is a song Rodgers must have taken very special care of. There is no curse of cleverness on it, rather is it a melody which takes full consideration of the bittersweetness of the lyric. It could easily have been written in a minor key. But Rodgers achieves his atmosphere of loneliness within the confines of a major scale. And this couldn't have been easy.

He makes one melodic move I've never come across except in so-called "country" music. In the second measure (the song is in G major), he drops to the fourth interval, *c*, and never resolves it to *b*, the third interval. This is so unusual in theater music that, at first hearing, it is not easy to reproduce.

This Funny World

When I pointed this out to him, Rodgers seemed puzzled and then said, "Oh, you've got to have fun." Well, the choice of this interval is quite the opposite of fun to me. It's the perfect mysterious note to choose for this moment in the melodic line. Hart's opening line of the chorus is expressive of the "lost" character of the rest of it: "This funny world makes fun of the things that you strive for."

You're The Mother Type, a song of no great merit, was cut before "Betsy" opened. I mention it only because, in playing it through, I came across a few seeds which a short time later sprouted in *You Took Advantage Of Me*. Below is the melody of *You're The Mother Type* from the third measure on:

You're The Mother Type

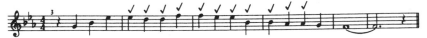

In 1927, in "A Connecticut Yankee," there were two splendid songs. The first, *My Heart Stood Still*, is one of Rodgers' best known. It's a perfect example of his mastery of step-wise writing. He employs it throughout this song with the exception of cadences and pick-up notes.

Only in the verse, another great one, does he make marked use of unusual harmony. Without disturbing the melodic line, he shifts, in the second measure, to G-flat major from A flat in the first. In the

third and fourth measures he repeats this, but moves farther away in the last quarter note of the measure, leading to *a* flat in the sixth measure, supported by an F-flat major chord; then in the seventh measure he works back to *a* flat through B-flat minor and E-flat-dominant-seventh chords. One assumes he will repeat these measures but, instead, he moves from A flat to C major, to a suspended G-dominant seventh, to a G-dominant seventh, to E-flat major. And even more.

It is a verse replete with harmonic invention but only slight melodic chances, such as that in which the harmony moves from A flat to C major.

Rodgers' increasing flair for unusual releases appears in this song. The repetition of the nineteenth measure in measures twenty-one and twenty-three is very effective and very courageous. My impulse would have been to find different notes each time, particularly as there is no rhyme to go with the first repetition.

The second fine song from "A Connecticut Yankee" is *Thou Swell*, a song with a marvelous verse, as if written for Fred Astaire. It starts out innocuously, but in the fifth measure it resorts to a series of leaps which fall in odd places just as a dancer might like them to.

Thou Swell

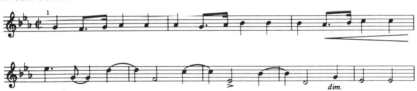

There is an added section to the verse which, for me, is a letdown, but which was undoubtedly needed to fulfill the needs of the lyric.

The chorus is unique. I know of only one song like it, *Funny Face* by Gershwin. It employs what I choose to call backed-up harmony. Ordinarily I am disturbed by it, but not in this case. For example, the chord of the pick-up to the chorus is F-dominant ninth. It proceeds properly to B-flat seventh. But then the pick-up to the next phrase is F-dominant ninth again, whereas the conventional progression would be to E-flat seventh or ninth. The second eight measures are a marvelous bundle of rhythmic phrases.

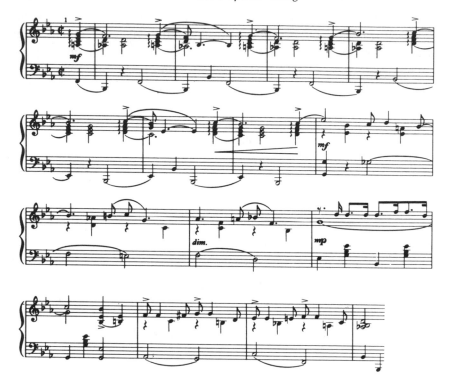

The form is not *A-A-B-A* but *A-B-A-B/A*. Needless to say, Hart's lyric is superb.

(*To Keep My Love Alive*, written for the 1943 revival of "A Connecticut Yankee," should also be mentioned here. The lyric, among Hart's last, is very witty and Rodgers might, without censure, simply have carried it along with a string of suitable notes. Instead, he wrote a perfectly delightful madrigal-like song, most worthy in itself.)

The verse is a little gem, both melodically and harmonically. The chorus breaks loose harmonically in the release, causing the melody to include some notes out of the parent key. Yet so neatly written is it that one is only further pleased, rather than startled. Which is as well since there is plenty to startle in the cheerily macabre lyric.

By continuing to use the device of the two eighth notes followed by a half note in the release, Rodgers brings a cohesion to the whole melody. For example, see the second measure of the chorus and then the second measure of the release.

To Keep My Love Alive

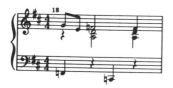

In "Present Arms" (1928), there are pleasant surprises in *Down By The Sea, I'm A Fool, Little One, Do I Hear You Saying I Love You,* and *Crazy Elbows,* but they're not substantial enough to warrant close examination of the songs. These surprises are tricks. They're clever, and they arrest both eye and ear, but the songs in which they occur are, overall, not up to the level Rodgers' songs have led us to expect.

However, one song in this show, though a trifle "notey," comes off not so much as a theater but as a superior pop rhythm song. It's one of Rodgers' best loved songs, indeed, a standard: *You Took Advantage Of Me.*

It is strictly *A-A-B-A* in form. The verse is ingenious and of a piece with the chorus without being special. The chorus has an instrumental flavor, influenced considerably by its harmonic patterns throughout. It's been current for so many years, it's easy to forget that such measures as the very first one were most unusual for their time.

You Took Advantage Of Me

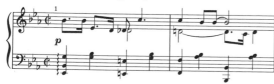

Also, the chromatic movement of the release is far from ordinary, and though controlled by its harmony, quite singable after a hearing or two.

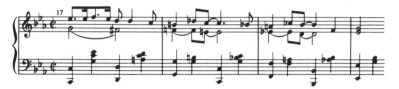

Also in 1928 (didn't Rodgers ever take a vacation?) "Chee-Chee" was produced. In it there is a very lovely song which was unknown to me until recently, and I can't understand why. I'm sure it isn't because I've failed to hear it. It simply never broke through, never became popular. Its rather undistinguished title is *Dear, Oh Dear!*.

The main strain is announced by a series of descending fourths which are the song's most provocative trait. It then resorts to a repeated phrase which falls on an accented fourth beat. Here are the first seven measures:

Dear, Oh Dear!

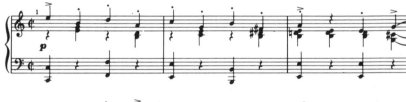

The release is bone simple, a series of descending quarter notes preceded by a quarter rest and ending in an ascending scale of quarter note triplets.

The verse is also very attractive and essentially simple. But it must be admitted that the lyric is not up to Hart's usual level of excellence. And so this just might be a reason for the song's obscurity.

Up till now I've said nothing of Jerome Kern's influence on Rodgers. Since Kern has been acknowledged by Rodgers to be the first trail blazer in theater music, one would have expected his influence on Rodgers' style to have been in evidence by now. It so happens that those songs in which there is such influence I have ignored on the grounds of their weakness and inadequacy.

In the case of *Dear, Oh Dear!* there is a Kern quality: its smoothness, its absence of short repeated phrases, its sinuousness, and its concentration on melody unintruded upon by fancy harmony. If popular music were still concerned with this sort of professional song, *Dear, Oh Dear!* would be the first I would attempt to revive.

I Must Love You is another warm, affecting ballad, with another very good verse which in its second phrase contains an allusive phrase from Tchaikovsky. The verse, may I add, is another of those which occasionally occurs with an odd number of measures, twenty-five in this instance. It's so well conceived that this extra measure is unnoticeable.

The chorus is again Kern-like in its purity and harmonic simplicity. Perhaps its release is not so much so, being rhythmically a little more swinging than Kern. I would be happier if its ending were a little less four-square. This may be finicky, but the measure before the final cadence doesn't have the grace which the song leads you to expect.

Better Be Good To Me, also from "Chee-Chee," is a very interesting song, verse and chorus. But in both instances I'm thrown off by devices. In the case of the verse, by the concentration of repeated notes made interesting only by the shifting, unexpected harmony. Of course I should keep in mind the Oriental cast of this show and lyric and that the repeated note is typical of Oriental music. The chorus may, for all I know, still be an attempt to further the Eastern flavor, as in the last half of the second measure.

Better Be Good To Me

In this *A-A-B-A* song I am slightly disconcerted by the length of each *A* section, seven measures. I believe in experimenting and perhaps I'd like this odd shape if, for example, the first cadence weren't a *c* and the second an *e* flat.

The release jumps about so much that it is hard work to find the notes without the aid of the harmony. I'm aware that, particularly in theater music, releases are privileged to slip the moorings of the main strain, a fact which may even account for the word "release." And in the case of a song which through constant playing has been unconsciously taught to the public ear, the experimental movement of the melody may have been dimmed by familiarity. In the case of *Better Be Good To Me*, a totally unfamiliar song, the circumstances aren't the same. I can only say that even after many hearings, I believe this release still remains more like work than pleasure to listen to.

Next comes a very famous Rodgers song, *With A Song In My Heart*, from "Spring Is Here" (1929). This doesn't happen to be one of my favorites. It's very well written, to be sure, memorable, strong, dramatic, and undoubtedly theatrical. But for me it smacks of the same arty tendency one finds in Jerome Kern. It is certainly to be considered outside the pale of Rodgers' work insofar as it is printed in two keys as well as for a duet. Singers outside the idiom of popular

music perform it on radio, television, and records in the manner of an art song.

The lyric is lovely, made of singing words. Incidentally, the only other time I have seen the word "and" used under a whole note is in the Berlin song, *They Say It's Wonderful.*

The form of *With A Song In My Heart* is *A-B-A-B/A.*

Part of my prejudice is due to the monotony of the basic idea, the chromatic interplay between two notes, as in the opening measures.

With A Song In My Heart

I don't wish to leave the impression that I have a prejudice against dramatic songs. Perhaps the best way to clarify my attitude is to say that there is a point at which the dramatic and the elegant in theater music become melodramatic and over-elegant. When a song reaches this point, it seems to me to fall between two stools. For it is neither what one expects from musical theater (after the decline of operetta) nor what one asks of a true art song.

A less dramatic song from the same show, *Yours Sincerely,* has been a favorite of mine since I first heard it. It is gentle and simple and has one of the most perfect melodic progressions into a release I have ever heard. Moreover, it is dramatic.

It is interesting that so short a time after the publication of *Dear, Oh Dear!* this song should appear, since the salient melodic device in the case of each are sets of descending fourths. In *Yours Sincerely* the device is differently used but equally endearing.

Yours Sincerely

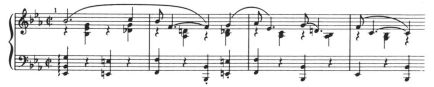

The sheet music is in the key of E flat. Therefore the marvelous whole note, *e* natural, which effects the transition to the release, is the least simple note in the song. However, it is reached step-wise from *d* natural and moves only a half step to *f* natural, the first note of the release. It is a marvelous suspension, sung to the open sound of the word "day" and ascending to a perfect word needed for what amounts to a form of climax, the word "oh."

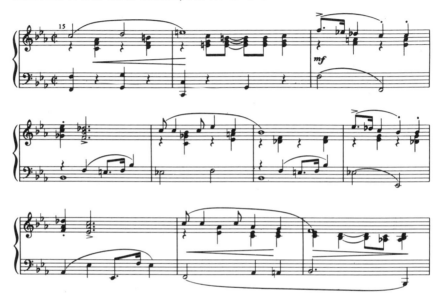

And once again Rodgers fashions a special, "releasing" but not tangential, *B* section. The form is *A-A¹-B-A¹*.

Still in 1929 (it seems incredible how much work the writers of those days produced compared with twenty-five years later), in the show "Heads Up," there was a lively, swinging song called *My Man Is On The Make*. In the verse Rodgers romps about hither and yon, perhaps more in the manner of an instrumental than a vocal piece. Though difficult, it's very good. The chorus has no special virtue beyond its loose, swinging character, the kind of song that's fun to orchestrate, and probably to play as well as sing. It's in strict *A-A-B-A* form.

It might be well at this point to note that the bulk of Rodgers' songs

up to now have been in this form, that most used in non-theater songs since about 1924. It was, however, more likely to be displaced by other forms in theater songs than in pop songs, due probably to the assumption that theater audiences are more receptive to complexity than the man in the street.

In the same show is *A Ship Without A Sail,* a marvelous, sophisticated ballad, full of surprises and, as printed, one of the very best piano editions of a song I've ever seen. Keeping in mind the fact that simplicity is the essential demand in sheet music, this one manages to meet that demand while also pleasing the more informed musician.

When one considers all the ideas presented in the first twelve measures, it is astonishing that it's all of a piece. There are four distinct ideas, the principal one in the first two measures (slightly varied in the third and fourth), a second idea in five and six (including an entrancing triplet), and a fourth in the concluding measures. As you can see, this is a departure in form, the first strain being twelve instead of eight measures.

A Ship Without A Sail

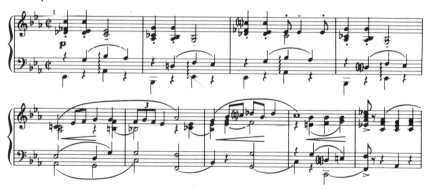

In the second half of the twelfth measure there is a three note pick-up to the second section. This is much less complex, even pastoral. It is followed by an almost literal repetition of the first section. Its only difference is the measure before the cadence. So this turns out to be a brand new form: *A* (twelve measures)-*B* (eight)-*A¹* (twelve).

It's an extremely fine, though not famous song.

IV

A good song will usually find its way to the public, provided, of course, it gets to be heard. *Dancing On The Ceiling* was written for "Simple Simon" (1930), but was dropped before the New York opening. However, later the same year it was used in London in "Evergreen," and British theater-goers and dancers were enchanted by it.

For one who frowns on an over-use of repeated notes, I'm scarcely in a position to wax lyrical about the verse of this song. It's loaded with them. Yet, I find them attractive because of the twirl of other notes which ends each repetition. And I love his dropping into F minor on the fifth measure and his suspending a C-seventh chord for three beats on the melody note *f* sharp in the sixth measure. To continue my splurge of enthusiasm, I also like his seeming resolution to F minor in the seventh measure only to have it turn out to be F major.

The chorus is a masterpiece of understatement. It has fewer notes than most songs, it has a minimal range of a ninth (one note more than an octave), and it flows like a quiet stream. Its initial statement is an ascending scale line; its secondary statement starts as a descending scale line for one measure, but surprises the listener by jumping a seventh and resting for a half measure on an out-of-key note, a *b* natural. This, very sensibly, resolves in the next measure to a *b* flat.

Dancing On The Ceiling

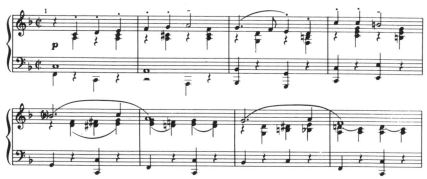

Even the *b* natural comes off as an integral part of the melodic flow rather than as a stunt. It is gentle without being weak, sophisticated without being pretentious.

The release is almost totally passive but for accented fourth beats in the nineteenth and twenty-third measures.

I find this song, music and lyric, a high point in theater song writing.

Another song cut from "Simple Simon" before the opening, *He Was Too Good To Me*, also illustrates pure melodic writing, purer in fact than *Dancing On The Ceiling*. And I think it's because the melody gives the illusion of a broader sweep, though also limited to a ninth. It alternates between step-wise writing in the main strain and the broad arc of the second strain. And in that second strain, Rodgers' use of a descending chromatic bass line is enviable, as is the melody where the words say "making me smile" and "that was his fun."

In the illustration below, note the Kern-like paucity of harmony in the first eight measures.

He Was Too Good To Me

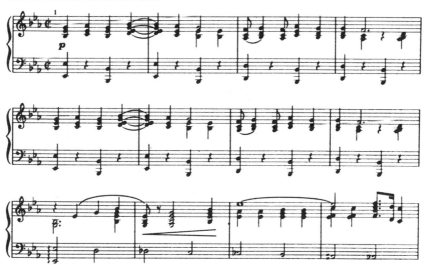

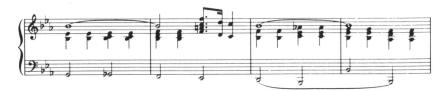

The form of this song is *A-B-A-B¹*.

I tried to discipline myself by glossing over the verse. But even the ostinato in the two measures preceding the melody are too good to omit.

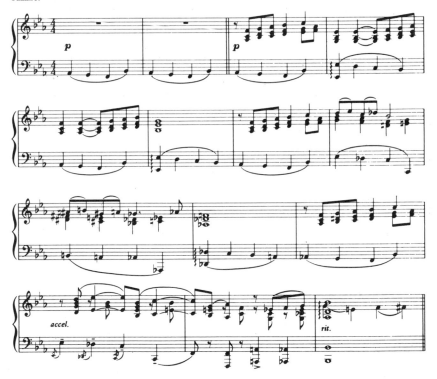

I Still Believe In You, while very beautiful throughout, is so in the manner of Kern's pseudo-hymn writing as to bear none of Rodgers' style, unless it be his great facility for step-wise writing. So I'll say no more about it as it tells us nothing about Rodgers, except that he had a high regard for Kern.

Ten Cents A Dance, another song from "Simple Simon," is one of the best remembered of Rodgers' songs. However, to me it is, at best, simply another competent pop tune to be regarded more highly for its lyrical than its musical merit. It has the quality of a song written for a specific singer, but not as an intrinsic part of a show score; in fact, it sounds almost like special material. Rodgers recalls that Ruth Etting learned the song between the Boston closing and the New York opening, due to the indisposition of the original singer, Lee Morse.

In "America's Sweetheart" (1931), there were two marvelous songs and one only a little less so. *How About It,* while strong and rhythmically interesting, somehow lacks the directness and avoidance of tricks which the other two maintain. The rhythmic device in the second and third measures is neat but needs, as far as I'm concerned, all the panoply of production to make it properly effective.

How About It

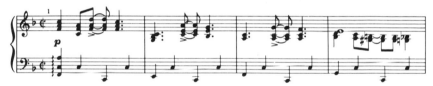

It's more a "number" than a song.

Just by the way, the first two measures of the verse may have been recalled four years later in the writing of *Down By The River.*

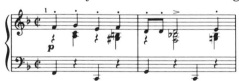

But for its too abrupt ending, I find *We'll Be The Same* a delight. Perhaps I have a special fix on fourths, for here they are again, four sets of them from the third through the sixth measures.

We'll Be The Same

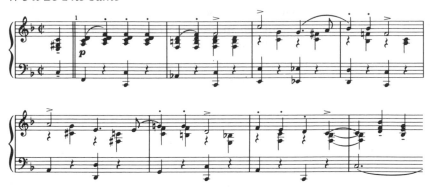

And the release truly swings and lets no complex notation get in its way.

Because this song is so little known I think its verse should be illustrated, if only by means of the melody line.

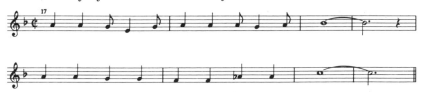

I only wish the ending were extended in any fashion to keep it from being hooked off stage so abruptly.

The other fine song from the same show, *I've Got Five Dollars,* is so inextricably jammed in my memory vault that I find it difficult to achieve a detached, critical perspective. I believe, however, that I have, and I find that the song is still just as favorable as my memory of it.

In this song Rodgers again resorts to a characteristic device, that of constantly returning to a group of notes, usually two, while expanding his melody elsewhere. Here the returned-to notes are *g* and *b* flat. The illustration shows their recurrence.

I've Got Five Dollars

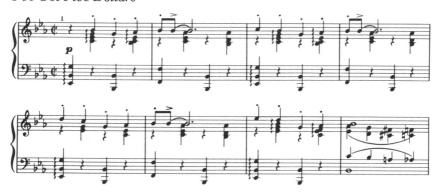

There is little of harmonic consequence, nor need there be, until the sixteenth measure where, although the melody note again is *b* flat, the supporting chord is most unexpectedly G-flat major, resolving in the next measure to B-flat-dominant seventh.

The release is wonderfully spare, mostly made up of quarter and dotted half note measures. The final *A* section is a variant of the first two, living right up to Lorenz Hart's lyric, which has just said "take my heart that hollers" and proceeds to holler "Everything I've got belongs to you!"

In the film "Love Me Tonight" (1932), there were three very interesting and completely dissimilar songs. The first, *Lover*, was already well known when Peggy Lee made her extraordinary, driving, almost whiplash version of it on a record. It's one of her best-known recordings. Its point of view was far from the original, as sung by Jeanette MacDonald.

It's a fascinating experience, this song. But for the life of me I can't see why it would be to a non-musician. For it is only a series of chromatic intervals made palatable by means of an interesting chord progression which, however, once the pattern is established, telegraphs its punches. The *B* section (for it's an *A-A-B-A* song with sixteen-measure sections) comes closest to true melodic design and remains consistent with the chromatic structure of the main strain.

Mimi, the second interesting song from "Love Me Tonight," was written for Maurice Chevalier. It is deliberately cute and very successfully so, cute as a kitten or a small child. It's innocent, and with-

out a moment of trickery or cleverness. Its harmony is very simple, indeed, not needed at all for complete enjoyment of the song.

The third is a perfect song: *Isn't It Romantic?*. It has a very beautiful verse, the first phrase of which suggests the first phrase of *Easy to Remember*, to follow four years later.

Isn't It Romantic?

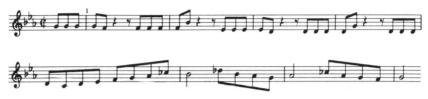

The pick-up notes of the chorus are similar to the first notes of *With A Song In My Heart*, about which I've admitted I'm not enthusiastic. Why, then, do I find the four introductory notes of this song so attractive? I would like to pull a musical rabbit out of a hat but I can't. It may well be that the development of this melody is such that it causes me to accept its germinal notes, whereas the development of the other song causes me to reject the beginning notes which I might otherwise have accepted. As an obscure song title once pointed out: *It's Not What You've Got (It's What You Do With It)*.

The rise to the *d*-flat whole note ending the first eight measures is the first charming unexpectedness, then comes another, the descending scale line of the tenth measure.

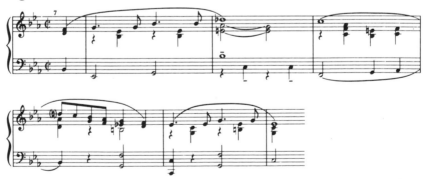

The most startling interval in the song, and a courageous one, is that between the last note of the fifteenth measure and the first note of the sixteenth. It is a minor seventh.

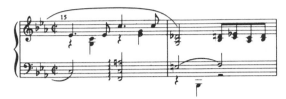

It's a marvelous preparation for the *d* natural which begins the re-statement of the main strain, but to sing the drop from a *c* to a *d* flat, which is not even in the key of E flat, is very difficult, but well worth the effort.

The climax of the song is beautifully executed without a trace of bravura, with the climactic note falling on the word "love." And then, to restate the opening notes in the final cadence an octave higher!— that's superb writing.

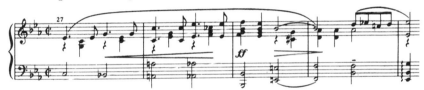

Blue Moon was first called *Prayer*. It was written for Jean Harlow to sing in "Hollywood Revue of 1933," released in 1934 as "Holly-wood Party" without the song. New lyrics with a new title were written: *The Bad In Every Man*, sung by Shirley Ross in the film "Manhattan Melodrama." This picture was released in 1934. Then came another lyric and the permanent title, *Blue Moon*, copyrighted in 1934. It is the only Rodgers and Hart song the public took up which was not, as far as most laymen knew, associated with Broadway or Hollywood. It became famous as the radio theme of "Hollywood Hotel."

It certainly is one of the most performed of the Rodgers and Hart songs. I have never been attracted to it, though I recognize it to be competently written. It employs the vamp or ostinato harmonic de-

vice of I, IV, II, V, or, in the published key of E flat, E flat for two beats, C-minor seventh for two beats, F minor for two, and B-flat-dominant seventh for two. In its release there is a pleasant harmonic progression in its fifth and sixth measures, but, compared with what Rodgers had been doing up till that time, the song, overall, was definitely undistinguished.

In "Hallelujah, I'm A Bum," a film released in 1933, there is a very pretty ballad, *You Are Too Beautiful*. Its verse is surprisingly dull, even though shot through with interesting harmony.

The chorus I always assumed to be a superior pop song, and only when I found it was by Rodgers and Hart did I learn it was theater music. Though quite memorable and accompanied by a very good lyric (if one can forgive "found you" and "bound you"), it still bears the slight taint of contrivance. There's something lacking in spontaneity about the *b* flat of the second measure and the *a* flat of the third as opposed to the complete natural flow of the first measure.

You Are Too Beautiful

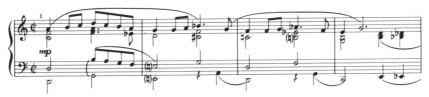

In fact, though they're the hallmark of the song, those two notes are the only ones I find bearing the smell of cigar smoke.

Up to this point in Rodgers' career, twelve years, he has written many fine songs. And, during this time, certain characteristics of style have emerged: great facility in step-wise writing, the adroit use of successive fourths, opulent but unintrusive harmonic progressions, special talent for writing verses (which are almost always in the musical character of the chorus), a great gift for writing waltzes, a preference for the *A-A-B-A* form. Yet were I to choose from among the songs written up to this point, let's say *Mimi, Manhattan, Lover,* and *A Ship Without A Sail,* would I find within them sufficient stylistic qualities to be able to identify them as Rodgers' songs? Even though

I like and highly respect every one of them, if I didn't already know that they were his songs, I doubt I could tell it from the content.

This conclusion in no way affects my estimation of the songs. What it does do, on the other hand, is make me less concerned with recognizability and accept the multi-faceted nature of Rodgers' writing, and thus seek only for manifestations of good taste, musicality, inventiveness, wit, and sophistication.

By now I have no possible doubt that I'll find more than one of these characteristics in most of his songs. This is not to say, however, that I won't be on the lookout for increasing evidence of a more highly focused, personal style in future songs.

For those of you with a quick reference memory, it might be interesting to run over in your minds the following songs and notice the enormous range of melodic invention Rodgers has produced up to this point: *Manhattan, The Girl Friend, The Blue Room, Mountain Greenery, This Funny World, My Heart Stood Still, Thou Swell, To Keep My Love Alive, With A Song In My Heart, A Ship Without A Sail, Dancing On The Ceiling, He Was Too Good To Me, Ten Cents A Dance, I've Got Five Dollars, Lover, Mimi, Isn't It Romantic?,* and *Blue Moon.* I ask you, how can one say "this is Richard Rodgers' style"?

And the very next song to be examined is one wholly unlike any he has written so far. It's *That's Love* from the film "Nana" (1934). Though in the realm of the arty theater song, it is in this instance so right and unmannered as to be almost a true art song.

The verse is largely chromatic in structure and a perfect preparation for the chorus.

It is a curious coincidence that this is the only Rodgers and Hart song I've seen (and it may be the last) that was published by Irving Berlin, Inc. For the principal statement of the song could have been from the pen of Mr. Berlin. Its brooding Russian flavor is far from Rodgers' point, or points, of view.

When it arrives at the restatement in the second half, however (and this time it's in D major instead of D minor, with resultant melodic shifts), one is no longer reminded of Berlin. The latter was too seasoned in the pop song world to desert a good thing when he had it, so it is likely he'd have persisted in the minor key. Nor is the shift

due to less dependency on the lyric. In fact, the shift to the major is somewhat jarring: it occurs at the point that the lyric is saying "If I'm your light of love, who cares?" Despite this conflict, it's a lovely, pure melody.

There are many ways to set words to music, but in this instance I think most composers would have taken the melody to a high note on the last word of the phrase "I'll never ask you why." But Rodgers instead drops the phrase to a low note, thus saving the climax for the phrase "that's love goodbye."

The form of *That's Love* is *A-B-A¹-C/A*, a departure for Rodgers.

In another film, "Mississippi" (1935), there were three beautiful ballads. The first is *It's Easy To Remember*, reminiscent in its opening measures of the verse of *Isn't It Romantic?*.

The sheet music is another instance of conveying the most within the confines of required simplicity. The song is of a very narrow range, only an octave (but for three eighth notes a half step beyond the octave). And its form is strict *A-A-B-A*. It's beautifully written, gentle, evocative, and intensely aware of Hart's equally lovely lyric.

One may say that in this song there is another illustration of Rodgers' liking for a return to a pivotal point, in this case the four repeated *b* flats. As you can see, he keeps dropping down through *a* flat, *g*, and *f*, and returning to the *b* flats.

It's Easy To Remember

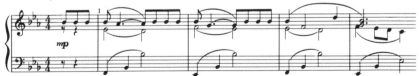

And then he introduces a wholly new idea for the second four measures. Without this astute contrast, the repeated notes would become monotonous. And here, by the way, is a complete refutation of my theory that repeated notes constitute aggressiveness. For what could be less aggressive than *It's Easy To Remember?*

The repeated introductory notes to the release are derived from the main strain and therefore tend to make the release an integral part of the song rather than simply a bridge between repeats of the main strain. Both the melody and harmony of the second half of the release are so sensitive and knowledgeable as to deserve quotation.

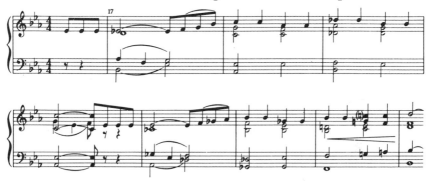

Down By The River, while in no way reminiscent of Kern, has the hymn-like strength of Kern songs in this style. It is a song of comparatively few notes and every single one of them counts, including those of the verse. Even the harmony is hymn-like. The smooth stepwise writing contrasts beautifully with the occasional wide leaps of fourths and octaves. The form is *A-B-A-B¹*.

I find the lyric unusually disappointing. Such lines as "full was the river, yet more full my heart" are far beneath Hart's highly polished poetic imagery.

Speaking of recognizable style, I believe that, upon hearing *Soon*, also from "Mississippi," the first time with no knowledge of its author, I'd know it was Rodgers. But why?

Well, take the descending pattern of thirds comprising the second half of the first measure and the first half of the second. They're akin to his love of descending fourths (as in *Dear, Oh Dear!*) and, if only by elimination, they would point to Rodgers. Who else ever used such a device in a ballad? Only Vernon Duke, so far as I can recall, in

What Is There To Say?. But those were half note triplets, another matter.

Second, notice the way the melody rises to *d* in the eighth measure as opposed to *c* in the fourth. This is not unique, but it's a clue of sorts.

Third, listen to his shift into G major in the ninth measure, using a fragment of *It's Easy To Remember*, and observe his device of dropping down and returning. Surely, this is a definite clue.

Soon

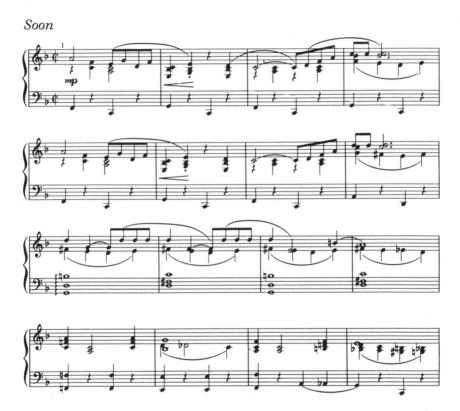

I suggest one more, subtler clue. Just before the first restatement at measure twenty-nine there is a phrase which accompanies the words "our hearts will be in tune." I believe that any other writer at this point would have resorted to an ascending line making a climactic note for the word "tune." Rodgers' sense of fitness and the under-

stated nature of true sentiment chose the quiet design. Incidentally, his choice of a B-flat-seventh chord for the *g* of "tune" is much more satisfying than the more expected G-dominant seventh with the sixth added. Further, he increased the value of the word "soon" by making its preceding accented note, *g*, a step below it.

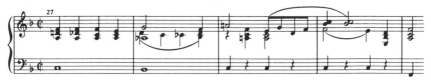

I think it is recognizably a Rodgers song and a very beautiful one. With the harmony, the verse is luscious. Without it, the melody is strangely stiff.

V

In 1935 Rodgers and Hart returned to Broadway with "Jumbo," which was produced at the old home of extravaganzas, The Hippodrome. This theater, which is now a garage where you pay as much to park a car as you once paid for a ticket to a show, was across the street from a hotel where I've lived for many years, The Algonquin. John Murray Anderson produced the show, and one afternoon his brother took me across to see from the balcony the beautiful, huge, white, circular tent whose sides miraculously rolled up. It was the same day I heard that the show cost the enormous sum of $400,000. For that time, so great a cost was unheard of.

And, oh, those songs!

Little Girl Blue, a verseless song with an added "trio" in 3/4 time, has an odd shape, *A-A-B/A,* in which the *A*'s are twelve measures long and the *B/A* only eight. It's another loving, tender song, containing in its simplicity only one note out of the F major scale, a *c* sharp. In it Rodgers once more uses the by now familiar device of returning to the same notes. In this case they are three *f*'s. He moves from the first three to a *d*, from the second three to a *c*, and from the third three to a *b* flat.

Little Girl Blue

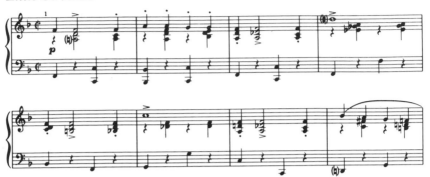

The *B/A* section is particularly interesting because it ends very unexpectedly, but without frustrating the listener. Also, Hart manages a set of three rhymes in this section with great panache.

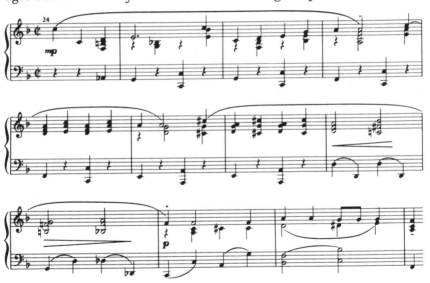

One more word about the lyric before moving on to the trio. Only a master such as Hart was would have dared to begin a lyric so prosaically and know that its effect would be poetic: "Sit there and count your fingers, what can you do?" And the next time he totally captivates by saying: "Sit there and count the raindrops falling on you."

Except when he resorts to "whopping" rhymes in a comedy song, Hart writes with total sincerity and not a trace of contrivance or pretension, even when, to gain an effect, he must resort to skill.

Since it mentions the circus and the ring, the trio's lyric may have had to do with a production situation, but the music simply swirls out in a lovely short waltz, at the end of which the chorus returns, so that the trio serves as an interlude.

The Most Beautiful Girl In The World is Rodgers' second major waltz, a form in which he became a master. It has a long, sweeping verse, virtually a song in itself, except Rodgers won't let it stand completely alone, since by its very nature it must be dependent on the chorus. It has pleasant instrumental interludes between the vocal phrases, which add to its sweep.

And then the chorus moves ahead, keeping itself fairly subdued, but for a rhythmic device, until it reaches the *B* section which has risen an octave from the opening phrase. It is an irresistible song and a truly "waltz" waltz.

Throughout he uses the device of a stressed third beat, usually tied over to the first beat of the following measure. The song is fairly rangy, an octave and a fourth, with only one note out of the parent key, F major. It is a wonderfully arrived at *e* flat. The form is *A-A¹-B-A¹* with a tag of eight measures. The sections are sixteen measures long. So it is a seventy-two measure song and shouldn't be a measure less.

It's interesting that *The Most Beautiful Girl In The World* can sustain such a romantic mood while being accompanied by such an irreverent, clever lyric, which for example, rhymes "Dietrich" and "sweet trick."

I am pleased to note that in the tag, which lies at the top of the song's range, the melodic line is in strict imitation of the opening phrase, only a ninth higher.

My Romance, also from "Jumbo," is perhaps on the edge of Rodgers' art song style, yet so skillfully written as to deserve praise. It is a perfect example of step-wise writing, intervals of a single diatonic step, wisely contrasted with wider intervals in the second statement. The primary melody is a scale line and continues to move step-wise until the ninth measure where for four measures the intervals are fifths and fourths, returning to single steps after that.

It's a true theater song with a dramatic climax supported by equally dramatic lyrics: "my most fantastic dreams come true." And the final cadence does something rarely attempted. In the measure preceding the cadence the melody descends in quarter notes through the notes of an F major-seventh chord so that the fourth interval of the C-major scale, *f*, is the penultimate note of the song. The only song I can remember which employs a somewhat similar device in its final cadence is Harold Arlen's *Let's Fall In Love*.

The verse of *My Romance* is, unexpectedly, disappointing and one of Rodgers' very few that sound unrelated to the chorus.

In 1936 came the Broadway show "On Your Toes," with a distinguished score. *Glad To Be Unhappy* is one of the best known of Rodgers' songs and deserves to be. The twist of the title is an immediate attention-getter. But the great skill with which the unlikely state of mind is developed and resolved is Hart at his best.

The verse is a charmer, so gently refuting my repeated note theory. However, I do prefer its later measures, which move more sinuously for four measures. The chorus has a curious shape: *A-B-A¹*. Again, as in *A Ship Without A Sail*, the absence of the second *A* is highly effective. I believe this may be because the first *A* section is divided into two four-measure statements which virtually repeat themselves.

The sheet music contains a note I have never heard played or sung. It is the sixteenth note *g* at the end of bar seven. I've always heard an *e*.

Glad To Be Unhappy

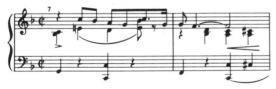

The *B* section is as simple and casual as that of *Dancing On The Ceiling*. Perhaps more so, because it has no accentuation at any point. I'm fond of this almost interlude-like section; its extreme simplicity took courage. Hart's daring is revealed in his rhyme with "unhappy": "With no mammy and no pappy." None but a master could have risked that.

It's Got To Be Love has another inventive verse which gives no warning of the swinging chorus to follow. Perhaps the four-measure vamp at its end, interrupted marvelously by the phrase *"mais oui,"* constitutes a shift of mood.

The chorus is in the form of *A-B-A-B/A*, and it never stops swinging, both musically and lyrically. There are vague hints in it of other songs which I can't put my finger on except that they're Rodgers songs. One of the hints calls to mind *Thou Swell*. But what difference?

Just to give you a taste, here is the first half of the melody.

It's Got To Be Love

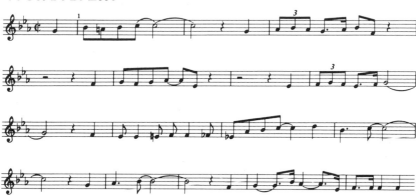

Quiet Night is much too beautiful to be so little known. It has a Kern-like calm, a tranquillity achieved by great spareness and, but for the climax of sudden brilliance, complete simplicity. Its concept is contained in the three notes of the opening phrase, "quiet night." This phrase is heard, in all, seven times, and there's not one repeat too many. Here are the first eight measures.

Quiet Night

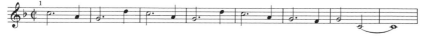

And here is the climax and its resolution:

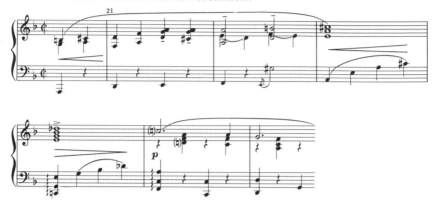

The Heart Is Quicker Than The Eye is slightly known but deserves greater exposure. Both verse and chorus, lyric and melody, are charming and unpretentiously clever. The lyric is flippant and cynical. But if you hadn't heard it, you'd be inclined to treat the music much more sentimentally than the lyric suggests. Only in the release and the cadences where the title line occurs does the music engage in any flippancy. Take, for example, the melody of the second *A* section; does the melody suggest any flippancy?

The Heart Is Quicker Than The Eye

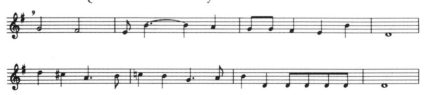

Rodgers and Hart, particularly Rodgers, must have had a great deal of pleasure writing *There's A Small Hotel*. The verse is a marvel and, though making no pretense of being any more than an introductory statement, is still a very special piece of music all by itself. As a writer, I find it perhaps more interesting than the average listener might.

For example, Rodgers starts on the fourth interval, not any easy note in the scale to pick out of thin air. But the last eighth note of the

first measure, which could easily be a *c* natural, is instead a *c* sharp. It, too, is not an easy note. He does this again in the third measure and, though it pleases me, I wonder why the sharp? And then, in the sixth measure, I find out: he has, perhaps unconsciously, been preparing the listener for a full treatment of *c* sharp, and with harmony that creates a suspension which never resolves.

This, to a writer, is fascinating. But what makes it even more so is that in the second half of the verse he returns to an identical phrase, but this time he drops, not to a *c* sharp, but to a *b* natural. In effect, after a long wait, he resolves what has been in a state of suspension for seven measures.

There's A Small Hotel

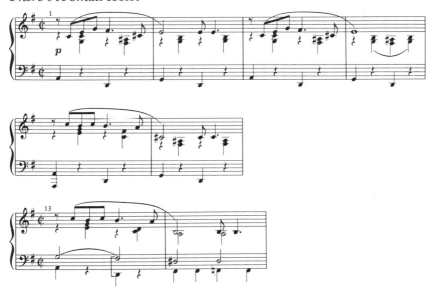

The chorus is part of theater music history, a simple, direct, perfectly disciplined song, and like all simple things, hard to analyze. But there are a few devices I'd like to mention. First, the subtle way in which the second measure is developed in the fourth and fifth measures. I find this high style.

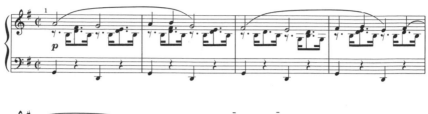

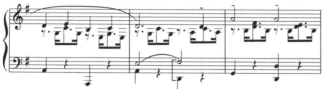

Second, increasing the intensity by shifting the second *A* section cadence from an *a* to a *b*, and in the third *A* section to a *d* (on which, the fifth interval, the song ends). Finally, the deceptively simple release, which makes subtly effective use of a half-step drop in the fourth measure, and reconfirms this melodic notion by repeating it, and then wraps it up by doing it twice more with other half steps.

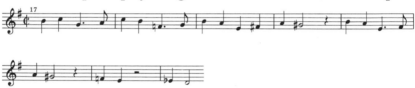

For those who don't know, there is such a hotel on the Delaware River which announces itself as being the hotel Hart had in mind. I admit I forgot to look for the steeple because, at the time, there were too many people.

In "Babes In Arms" (1937), there was a song—*I Wish I Were In Love Again*—I heard for the first time much later on. Fortunately I heard it sung by a man who had realized the extraordinary level of the lyric and so sang two sets of lyrics, both by Hart, of course.

Let me say that the melody, from verse through to the end, is a perfect set of notes for the lyric. It is even strong enough to sustain itself as an instrumental piece. But once you've heard the lyric, your attention must be drawn toward the words.

Johnny One Note is a rouser, the obviously principal device of which is that "one note" which can be sung continuously throughout

the song no matter where it goes, even into F minor in the trio. The "one note," in the sheet music, is *c*.

In *The Lady Is A Tramp,* to judge from the inside cover of the sheet music, which is given over to three extra sets of lyrics, the song's principal value in the show was Hart's words. And yet the music of the chorus of this song is a big favorite with all jazz musicians. And rightly so: for it swings. It pretends to do no more than move the lyric along, but in the course of that, it moves itself along.

The opening phrase is very provocative, and so much so that the listener is hooked.

The Lady Is A Tramp

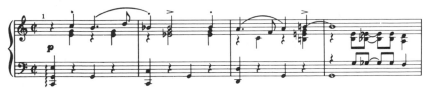

I'm particularly pleased by a harmonic progression I've never come across before or since, that from C major in the first measure to C-minor seventh in the second. As well, I'm impressed by the skill with which Rodgers gets the listener out of the *b* flat feeling not only by dropping to *a* in the third measure, but by accenting the *b* natural on the fourth beat of that measure. I also admire moving the C-minor-seventh chord to the D-minor-seventh chord in the third measure.

Perhaps I haven't made enough of a point of Rodgers' bass lines. So I should say here that, as an arranger, I'd be inclined to follow almost all of them, a procedure I would rarely follow even with better than average songs.

VI

I once heard that night club singers loved *My Funny Valentine* so much that the owner of a formerly famous East Side New York club inserted in all contracts with vocalists a clause which stated that they were forbidden to sing it.

The song was in "Babes In Arms" (1937). Its verse, like an air for

a shepherd's pipe, is printed without any piano accompaniment. I've never seen this before, but it is exactly as it should be. Any accompaniment would vitiate the pastoral purity of the melody.

This song must have meant a great deal to both writers. The lyrics show Hart's ability to keep his detachment and sympathy in perfect balance. The structure is new for Rodgers (though one should always keep in mind that these departures from conventional form may have been the result of the lyric, in the event that it was written before the music). The form is A-A^1-B-A^2- *tag*, and what I have called the tag is a repetition of measures nine and ten.

The principal idea is extremely simple. It is a phrase of six notes, each a step away from the next. It is then repeated. The harmony is basically C minor for four measures, shifting slightly each measure due to an essential chromatic whole note descending line which I've never known any good pianist or arranger to ignore.

In the second four measures the idea is elaborated. Then the idea is stated a minor third higher with the same chromatic line as at the beginning (all variants of C minor), with a further elaboration. Finally, a new idea is introduced with major rather than minor harmony. Here Rodgers uses his device of moving his prominent notes against an identical series of notes, in this case, six.

My Funny Valentine

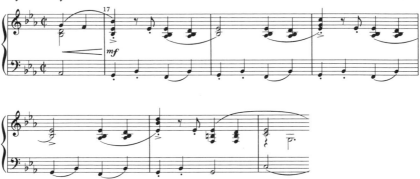

Notice how these prominent notes build up from *b* flat to *c*, to *d*, and how he keeps returning between them to the *e* flat, *d, e* flat phrase.

The first idea returns and builds to a remarkable climax which is

the same idea an octave higher, with fuller harmony and fitting the climax of the lyric: "stay, little Valentine, stay!"

It then drops down to the same notes of measures nine and ten and resolves in E-flat major. This is as finely distilled a theater song as I have ever heard.

The score of "Babes In Arms" contains still another famous Rodgers song, *Where Or When*. Because of its unprecedented octave and a fourth climb, step-wise, which constitutes the closing statement of the song, it must be considered a dramatic song.

Until this occurs, however, there is no indication that it will take this kind of turn. For example, the direction before the chorus is "with tender expression." And that is what the song deserves—until this almost melodramatic ending.

Except for this device, it is a memorable song, using a very interesting pedal point for nine of the ten measures of its opening phrase, and for nine measures of the immediate ten-measure repeat. But I find that I balk at the plethora of repeated notes. In this song they become monotonous, broken only by the release. And frankly the long, long climb to the high ending comes off, to me, as a contrivance. The ladder of notes provides only climax, and the way to it is pedestrian.

On the other hand, the rising scale lines in *Have You Met Miss Jones?* from "I'd Rather Be Right" are far from pedestrian. They float. Hart once told me that this song was written to avoid the prosaic plot problem of introducing two characters. Well, I for one am very happy that it was resolved in song.

To begin with, its verse is a dream: graceful, sad, sweet, and romantic. The chorus has all the charm, grace, and eloquence which we have come to expect of both Rodgers and Hart. My impulse is to quote the whole chorus. But I'll compromise by quoting the carefully fashioned, but uncontrived release, and the last section.

Have You Met Miss Jones?

In "I Married An Angel," a show of 1938, a very tasty little rhythm song appeared bearing the title of a very successful "ho-ho," strong-handshake, look-him-straight-in-the-eye book called *How To Win Friends and Influence People*. In spite of this demerit, the result is a good, swinging rhythm song, including the verse.

Once again we find Rodgers, in the chorus, at his favorite device, repeating notes and changing those all around them.

How To Win Friends And Influence People

And in the same score is another shattering ballad, *Spring Is Here.* (Truly, these men are fantastically talented! Each time I reach for another song I think, "Well, along about now there has to be a drop-off. They simply can't maintain this level of excellence." And what happens? *Spring Is Here!*)

It has another lovely verse, short this time, of only twelve measures. The chorus is extremely simple. It is virtually all step-wise writing, and the form is *A-B-A-B/C* of conventional thirty-two measure length.

The eighth-note triplet employed in the extension of the opening idea becomes a characteristic of the song. The harmony is unintrusive but very effective, often dissonantly set against a pedal point *a* flat.

The lyric is Hart at his best, including the closing line: "Spring is here, I hear." Considering the loneliness of the character, this line wryly sums up his point of view.

In "The Boys From Syracuse" (1938) is another of Rodgers' and Hart's great waltzes, *Falling In Love With Love.* Since the lyric of the verse has to do with weaving, it may account for the considerable monotony of the melody and for the piano interlude which occurs three times (a spinning-wheel motif?).

The lyric of the chorus is so adult, made of such wonderful images, comprised of such "singing" words that they influence my opinion of the melody. Rodgers once wrote of Hart in his introduction to *The Rodgers and Hart Song Book*: "His lyrics knew . . . that love was not especially devised for boy and girl idiots of fourteen and he expressed himself to that extent."

As I have repeatedly stated, I tend to shy away from songs which are based on repeated notes. They tend to deny the first function of a melody, that it move. In the case of this song, I believe I would find the repeated note characteristic in it less acceptable if, at the end of each set of notes, he didn't move his melody with as much grace as

he does. But each phrase is turned so poignantly that my prejudice fades. The repeated notes become almost the testing of a springboard before the swimmer flies out in a lovely arc. The entire song is a series of these phrases, except for the last one which is made of five dotted half notes preceding the final cadence. So the form of it could be said to be *A-A¹-A-A¹/C*.

Sing For Your Supper is a good strong rhythm song, perhaps not as loose as one would like, a trifle too much starch in it. It isn't easy to pin down this impression. The song moves ahead, doesn't dawdle with tricks, or if one is used, as in the last measure of the release, it furthers the motion of the song. It may be that the initial phrase not having a counterpart makes the listener feel cheated. For this phrase is a "kicker" and the measures that follow are essentially bland, excepting the lively release.

This Can't Be Love is a splendid song, a great illustration of control, direction, choice, and what I might call essence. It's not unlike Gershwin but, to me, it's a step forward. The song has that glow about it which suggests great fun in the writing of it.

Frankly, I find Hart much neater in his "switched" titles than Hammerstein. *This Can't Be Love* is immediately clarified in the qualification "because I feel so well," whereas *If I Loved You* edges archly on about the possibility, keeps the conditional "I'd," and winds up saying "Never, never to know how I'd love you, if I loved you." Well, we all know the point Hammerstein is making and I, for one, could do with a little less lyrical eye batting. I must remember, however, that Julie in "Carousel" was of such shyness as to have been incapable of making a direct affirmation of affection.

The verse of *This Can't Be Love* moves about in chromatic sinuosities, but carefully stops in time to prepare the listener, by means of whole notes, for the more straightforward diatonic half and quarter note line of the chorus.

Rodgers uses the C-dominant-seventh chord in much the same way that Gershwin does in *Somebody Loves Me* and, coincidentally, in the same printed key, and after continuous G-major chords.

As in *There's A Small Hotel*, but in a different position, Rodgers keeps raising an isolated accented note in each *A* section. The first time it's *a* (downbeat of the fifth measure), the second time it's *b*

(downbeat of the thirteenth measure, the fifth's equivalent) and *d* the last time (downbeat of the twenty-ninth measure).

The release is a marvel of invention and restraint. It should be shown.

This Can't Be Love

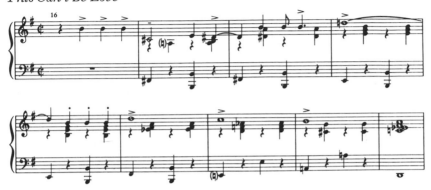

Rodgers is so at home in ballads and waltzes that I'm always afraid to examine closely his so-called "up" tunes for fear they won't come off. Well, they all don't, but when they do, as in this instance, stand back!

I admit great affection for the little-known song from the same show, *You Have Cast Your Shadow On The Sea*. Its ingenuity, the opulence of its harmony, its wise contrast of long notes with simple harmony, following the lush opening with shorter notes, make it a very special song.

In spite of this enthusiasm I am irritated by the continuous repeated notes of the verse. As a piece of music to be played it's very nice with its accompanying figuration, possibly in deference to the movement of water, but it simply isn't melodic movement.

The demanding phrase of the song is its initial idea. It's not easy to sing and it *does* need the harmony to be truly effective. Marvelously, while the closing note of this first phrase is holding for a measure and a half, the piano accompaniment restates the initial phrase even under the half note *b* flat lead-in to the next phrase.

You Have Cast Your Shadow On The Sea

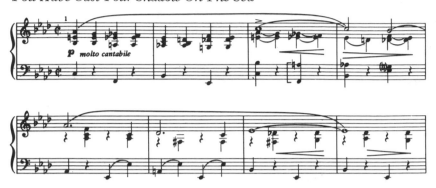

Notice how the melody smooths out in the second phrase. Rodgers is clearly as fond of this harmonic and melodic sequence as I am, to judge by the last eight measures.

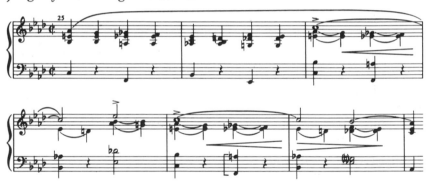

In October 1939, "Too Many Girls" was produced. In it were many good songs but one in particular was a great ballad, *I Didn't Know What Time It Was.*

I'd like to comment here on Hart's particularly astute use of colloquial expressions for his titles. Naturally all lyric writers draw on the current speech around them for the very good reason that they are writers of "popular" music. But Hart had a remarkably sensitive ear for the best of street speech: *It Never Entered My Mind, My Heart Stood Still, What's The Use Of Talking, This Funny World, If I*

Were You, Yours Sincerely, How About It?, It's Easy To Remember
—and, of course, this song, *I Didn't Know What Time It Was.*

Its verse is elegant in the manner of a theme from a movement of chamber music, complete in itself. It can't be said to lead into the chorus, nor should it, I feel, be played as slowly. But in spite of its independent quality, it is a good counterbalance for what follows. The melody of the chorus, due partly to the unusual opening harmony, has a *mysterioso* quality about it. One can't determine if it will be resolved in E minor or G major.

Its release, due to the interplay of *a*'s and *f* sharps in measures eighteen, nineteen, twenty-two, and twenty-three, runs the risk of angularity. Yet again, Rodgers mysteriously escapes an apparent difficulty, perhaps by means of the lyric. As a matter of fact, these inter‑ plays probably came into being because of the series of lyrical elements: for example, "to be young, to be mad, to be yours alone" and "feel your touch, hear your voice, say I'm all your own." Toward the close of the song, as the lyric reverses its original statement to "and I know what time it is now," the song does resolve into G major.

One more word. Rodgers' style has at this point become so distinctly and recognizably his own that one is not surprised to find a characteristic of it in evidence in his lovely use of the fourth interval, *c*, for his cadence in the eighth measure, and the fifth interval, *d*, in the equivalent cadence in measure sixteen. And his climbing a step higher to the *e* to open the release, illuminating the word "grand" as well as making the melodic line continue rather than start up again, is all part of Rodgers' consummate talent as a melodist.

In *I Like To Recognize The Tune,* also from "Too Many Girls," he sets up a simple scale line which is instantly recognizable. Then he returns to his affection for series of descending fourths.

I Like To Recognize The Tune

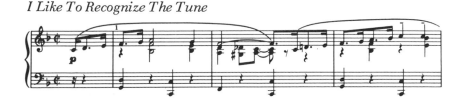

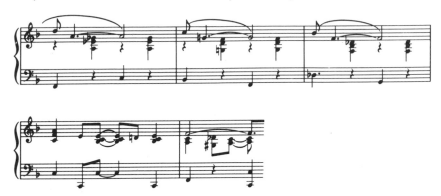

It's a light, airy plea by a writer who probably too often found his tunes disappearing in over-grandiose radio and dance band arrangements.

Ev'ry Sunday Afternoon, from "Higher And Higher" (1940), is a song I knew I liked but thought maybe not enough to stop for. But it's too good to gloss over. The verse, from a musical point of view, is a fascinating experiment in chromatics. Perhaps because of its odd drops into chromatic phrases, it is less a melody than an instrumental piece. Yet it is interesting as composition.

The chorus, on the other hand, is pure song, initially a descending scale line containing a sly *d* flat (the song is in E-flat major) followed by longer notes, more sinuously related. Rodgers seldom fails to provide these contrasting elements in his ballads (though this one might be qualified as a rhythm ballad).

The lyric is happy and free and bright. For example: "Leave the dishes, dry your hands. Change your wishes to commands." What joy to write music for such lyrics!

The song's form is *A-A¹-B-A²*. The closing section contains two rising lines, but unlike *Where Or When,* there is a skip in the ladder which instantly cancels the monotony.

Also from "Higher And Higher" is a very beautiful ballad, *From Another World.* All of it is fine writing. And it astonishes me how lyrical Rodgers' music often is in the face of completely irreverent and unlyrical lyrics. The lovely closing musical measures of the verse are accompanied by these words: "Were you that dumb? She loves the bum"!

Ev'ry Sunday Afternoon

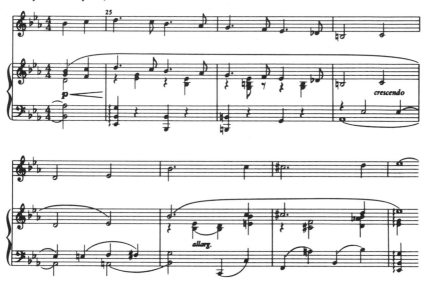

The chorus, in G major, starts on a dotted half note, *g* sharp, supported by *c* and *e* in the harmony. This is marked in the superimposed guitar symbol as a C-augmented chord. To be sure, it is. But more musically speaking it is a suspension leading to the final quarter note, *a*.

The song is spare, containing only fifty-six notes. Successive fourths again occur in the melody, first an ascending pattern followed by a descending pattern.

The structure is too complex to reduce to lettered themes (A, B, and so on). The second eight measures begins as the first did, but develops into the rising pattern of fourths. The third section begins as did the other two but a fourth higher and imitates the pattern of the second eight measures, though now with descending fourths. The fourth section begins with the opening phrase but uses successive fourths higher and farther apart.

One of Jerome Kern's later songs, *Here Am I*, used a similar suspension, *f* sharp (in the key of E flat), also a doted half note, rising to *g* the last quarter of the measure.

It Never Entered My Mind employs a very strange and effective

harmonic device I've heard only one other time in popular music, in Cole Porter's *Ev'ry Time We Say Goodbye.* For six measures it moves back and forth every half measure from F major to A minor. The melody in these measures is very simple and somber.

At the seventh measure the harmony is announced only on the downbeat (G-minor seventh) and the melody seems to float up from its despondency. The second section is almost a complete restatement. The release is less gloomy, rising to a climax, accompanied by a clinically dry remark, "and now I even have to scratch my back myself." The last section is extended to ten measures, rising semi-climactically at one point before ending quietly and surprisingly in F major.

In "Pal Joey" (1940), there was another series of greatly admired songs. *Bewitched* is probably the best known. It's a very stylish song, with a brilliant lyric and a memorable verse. I happen not to be as enthusiastic about it as I am about many others and it may be because I find it so notey.

In the main strain Rodgers uses more thoroughly than ever before his device of keeping a set of notes and moving the rest of the melody. In this case his two anchored notes are *b* and *e.* The rest of his melody moves up from *e* to *f* to *g* to *g* sharp to *a,* between each of which we hear the *b* and the *c.* And even after the *a,* he repeats the *b* and *c* again. Maybe that's my problem: I find this device brought to a sort of negative fruition in that it finally obtrudes as a contrivance.

In the release Rodgers continues to return to a set of notes. In the first four measures they are *b* and *a,* eighth notes, repeated three times, and in the second four measures *c* and *b,* repeated only once.

I don't know what sort of situation *Happy Hunting Horn* was used for in "Pal Joey," but the equivocal meanings of "quail" and "mice" in the lyric suggest a lot more than the melody does. It's a very innocent, child-like melody, even though punched by off-beat rhythms some of the time.

I Could Write A Book is curiously old-fashioned, much in the manner of Kern and really without any more than a well-shaped but, to me, uninspired melody.

In "By Jupiter" (1942), *Ev'rything I've Got* leaves me with similar disappointment. It's well known, and yet, as a rhythm song, it sounds old hat. As we used to say, "rip-tip-tippy."

Jupiter Forbid swings considerably more and has the happy device

of starting on the second half of the first measure. Poorly written, this could sound like pick-ups into a downbeat, but here it doesn't. The first measure is established as such and halfway through it come four aggressive eighth notes, the start of the song.

Nobody's Heart is one of the loveliest songs Rodgers or any other theater writer has ever written. In the area of this form of music it is a masterpiece.

The last song Rodgers wrote with Hart that I wish to speak of is *Wait Till You See Her*. The first time I heard it sung was by Mabel Mercer. She told me when I asked about the song that she had received the full score of "By Jupiter" before it opened and was continuing to sing *Wait Till You See Her*, though it had been dropped early on in the run. I believe that her faith in this song largely contributed to its position today as a standard.

It's one of the loveliest of all Rodgers and Hart waltzes. Its pure melodic writing and pure lyric writing are of the best. The scale line used to achieve the climax of the song (on the lovely word "free") is in Rodgers' most mature manner, and that the eight-measure extension of the last section, in its use of four dotted quarter notes, closing with a restatement of the first two measures of the song, is all I can ever ask of a writer.

VII

From this point on most of the songs to be mentioned have lyrics by Oscar Hammerstein II. While Rodgers continued to write great songs, and even to top himself, generally speaking I find missing that spark and daring flair which existed in the songs he wrote with Hart.

At first this is not apparent. After all, "Oklahoma" (1943) was perhaps the most successful show Rodgers ever wrote (unless one wishes to consider the phenomenon of the film of "The Sound Of Music," which is said to have made more money than "Gone With The Wind"). Certainly no bloom was off the peach in *Out Of My Dreams,* a simply superb waltz.

This song has no verse, only an interlude which adds nothing to the song as such. Its principal idea is a step-wise ascent and descent followed by wider steps. In the course of its progress it does many lovely things. For example, at the twentieth measure, it introduces a

wholly new idea which is immediately imitated, to bring the melody within two chromatic steps of the original statement. The effect of this is magical.

Out Of My Dreams

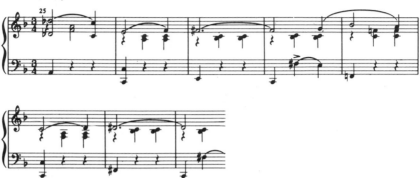

The lyric is highly poetic.

Boys And Girls Like You And Me is a short song, only sixteen measures, originally slated for "Oklahoma" and not only unused in that show but existing today only in the full score of "Cinderella," at the stiff price of ten dollars. It is a song of great gentleness and most endearing turn of phrase. It attempts to do no more than make a hand-holding, summer-strolling statement of affection. I think it is a shame that it has never been published separately. Any song with such a captivating opening phrase deserves to be.

Boys And Girls Like You And Me

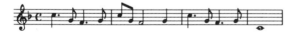

It is said that the melody of *People Will Say We're In Love* originally had an earlier lyric by Hart. The Hammerstein lyric is extremely fine, finer for me by far than the melody which, in spite of its popularity, has never appealed to me, nor does it represent the high level which, at this point, Rodgers had reached.

In 1945, from "Carousel," there were many highly respected songs. I'm sorry to say that outside the theater, as songs per se, I don't find

them as ingratiating as others do. *Mister Snow* I am very touched by in its first half, but find myself thrown completely off by a spoken measure just before the restatement. This, frankly, makes it impossible for me to say more than that these spoken lines probably were very effective in the theater. The more I examine this song, the more I'm certain that it should not be judged out of its theatrical context.

In the film "State Fair" (1945), there was a wonderful song, *It Might As Well Be Spring*, unlike any song Rodgers had ever written to this point. It's almost instrumental in its disposition of notes in the third measure.

It Might As Well Be Spring

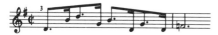

This kind of measure occurs nowhere else but in the restatement.

The last section is extended from eight to sixteen measures and this extension is most unexpected and effective. The only thing I dislike is the use of two notes for the single syllable "might." For the three notes in that measure suggest the phrase "might as well." I wouldn't mind as much hearing the word "be" sung to the following three notes, if only to avoid the awkwardness of the other.

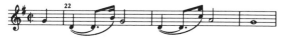

Hammerstein's lyric is truly a treasure of sparkling imagery.

It's A Grand Night For Singing is a charmingly direct, four-square, old-fashioned back-porch waltz. Nor do I mean any one of those attributes to be taken negatively. It's all very healthy and the dividend of the tag makes it even better. The lyric is fresh and cheery and uncontrived. There is no verse, but an interlude of no import.

That's For Me is another good song from the same film, with an excellent lyric and verse. There are two aspects of the chorus worth mentioning in terms of special interest. The first is the unexpectedly long second phrase starting at measure five. The way it builds both musically and lyrically to the high *e* where the strong word "that's" occurs is worthy of illustration.

That's For Me

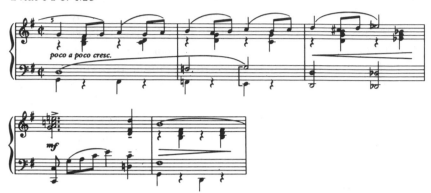

Also, note the telescoping of the short release with the second phrase of the song and the extension that follows.

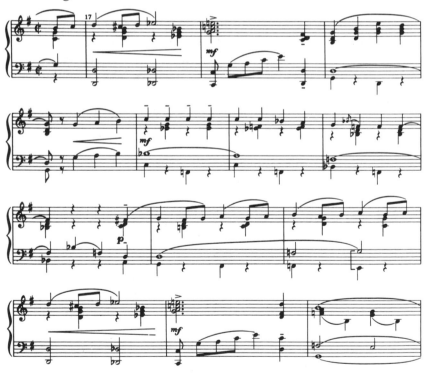

The Gentleman Is A Dope, from "Allegro" (1947), was, I presume, what they call a "follow-up" to *The Lady Is A Tramp.* It's a much, much longer song, with curiously shaped sections. The form is A-A-B-A^1 and the first two A's are eighteen measures long, the B, sixteen, and the A^1, twenty-two.

It should be a great song. After the first section, you're sure it is. Then (due to its length, I think), the second A begins to lag. The B section somehow falls flat. It doesn't belong in the song. And by that time, the last A^1 lasts too long and disappoints with its f sharp in the penultimate measure suggesting a major ending. You're somewhat saved by its turning out to be minor, but I can't find the wit in the f sharp. And I must assume that it was intended as such.

None of this is due to Hammerstein's lyric, which is extremely good. But in the event that the melody was written to the lyric, then it *is* the fault of the latter. Better to have written two sets of lyrics and halved the melody. Then what about that curiously alien release?

I'm sorry to say that the melodies from "South Pacific," immensely popular though they were, took on a kind of self-consciousness that is akin to the piping on Kern's vest that I mentioned many pages ago. I almost feel as if I should change into formal garb before I listen to them. Or it may be that I've stopped believing. Something's missing: fire, impact, purity, naturalness, need, friendliness, and, most of all, wit.

No, I don't like *Some Enchanted Evening.* I find it pale and pompous and bland. Where, oh where, are all those lovely surprises, those leaps in the dark, those chances? I'm in church and it's the wrong hymnal!

In "The King And I" I find *Hello, Young Lovers* right back on home base. Not so the verse, which tries too hard. But the chorus is enormously touching, beautifully written, harmonically colorful and unintrusive, indeed, one of Rodgers' finest waltzes.

The pedal point fifth (c and g) throughout the first six and all equivalent measures sets the mood of the melody with a kind of sentimental sense of sound. The unexpected E-flat-major chord in the eleventh measure is an inspiration. Also the extended ending is unusual and marvelously effective in its use of chromatic steps.

But for the, to me, highly inappropriate and unrelated last section, I very much like *Do I Love You Because You're Beautiful* from a tele-

vision play, "Cinderella." I can't imagine what went wrong, but I feel as if someone had turned a radio dial just before the end of the song and there I was listening to an opera audition, perhaps.

I very much like the last six measures of the release of *A Lovely Night* from "Cinderella." I'm sorry to be so choosy, but these measures are very engaging and the main strain is not.

A Lovely Night

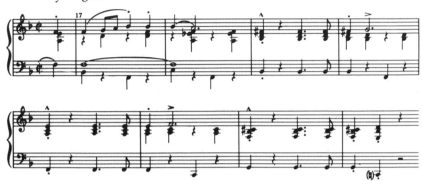

In "Flower Drum Song" there is a very interesting song unlike anything of Rodgers I know, called *Love, Look Away*. The verse is a small cloud moving inexorably toward *Fly Me To The Moon*. But the chorus holds up beautifully until its second-to-last measure. It's such a good song I wish I could say otherwise.

My Favorite Things, from "The Sound Of Music," though a material "list" song, has a very effective, curiously brooding melody which eventually works its way out into the sun.

I've examined, and very carefully, all of Rodgers' songs up to 1970. And since I must be honest, I can find no whole song about which I want to talk, or whose merits I am impelled to praise. It must be clear by now that I am more enthusiastic about the majority of his songs than about the majority of those of any other writers. But from *Hello, Young Lovers* on, as is evident, I can find only odds and ends which bring me out of my seat.

As I said at the beginning of this chapter, Rodgers' songs have, over the years, revealed a higher degree of consistent excellence, inventiveness, and sophistication than those of any other writer I have studied.

——6——

Cole Porter
(1891-1964)

I

There is considerable irony in the fact that, though Cole Porter was the most thoroughly trained musician of all the writers discussed in this book, he is better known and more highly considered for his lyrics than his music. And there is no question but that his lyrics were high fashion, witty to a markedly sophisticated degree, turned out, oftentimes it seemed, for the special amusement of his social set.

Yet they seldom risked or indulged in tenderness or vulnerability. Even when concerned with emotional stresses, they often managed to keep at a polite distance from true sentiment by means of a gloss, a patina of social poise. Indeed these lyrics never did "touch too much." Or else they resorted to melodramatic clichés. The light touch, the mordant turn of phrase, the finger-tip kiss, the *double entendre*, the awareness of the bone-deep fatigue of urban gaiety, the exquisite, and the lacy lists of cosmopolitan superlatives—these were the lyrical concerns of Cole Porter.

I may be over-stressing the world-weariness in his lyrics, for he wrote many uncynical, straightforward love ballads. My attitude is probably conditioned by the greater degree of vulnerability and exceeding tenderness to be found in the lyrics of Lorenz Hart and the fact that Porter's most quoted lines are all the East Side New York sophisticated kind. But no matter how distant or unrealistic, no matter

how weary or cynical they may have been, Porter's lyrics were astonishingly softened and warmed by his music.

While his scores were very popular with theater audiences and deserved to have been, I find it surprising that the general public found them as attractive as they did. For they made no attempt to adjust to the considerably less sophisticated taste which prevailed outside the large urban centers, or even in them. There is possibly a parallel between this audience and the small-town subscribers to *The New Yorker*. In both instances those who had no opportunity to live the "big city" life could feel less an outlander and more related to urban ways if they read about them and sang the songs which reflected them.

<div align="center">II</div>

Esmeralda was Porter's first published song to appear in a show ("Hands Up," 1915). *Two Big Eyes* appeared the same year in "Miss Information." Both were interpolated and of no consequence. He was only in his early twenties. He had, however, written many songs for college productions at Yale. He wrote them for smokers, the Glee Club, the college theater group, and fraternities. *Bull Dog* is one which is still sung.

In 1916 Porter wrote his first professional theater score. The show was a thumping flop, playing only fifteen performances. It was called "See America First." Porter, who had a brilliant flair for titles and clever phrases, believed that he was the first to use the catch-phrase/slogan "See America First." It is perfectly possible that he did coin the phrase.

The only song of any particular character was *I've A Shooting Box In Scotland*, more to be praised for its lyric than its melody, which, however, was catchy and entirely serviceable. The lyric revealed Porter's talent for provocative rhymes and images, but the song could have been by any competent tunesmith.

Not until 1919 did he write anything remarkable. And then, though I've always believed this song to have been written tongue-in-cheek, he did write a very successful ladies' luncheon song called *An Old-Fashioned Garden*. It appeared in "Hitchy-Koo of 1919."

This song haunted my early years, as its first measures appeared

on the back cover, it seemed to me, of every piece of sheet music I bought. It was my introduction to Cole Porter. And though only eight measures were available on these back covers, I was never inclined to find out how the plot unfolded.

Porter confined himself within the city limits. I have been unable to find any excursions further into the country than *An Old-Fashioned Garden*, *Don't Fence Me In* (scarcely a paean to the great outdoors), and *Get Out Of Town*, in which the race to the countryside is only suggested, although somewhat urgently, at the end of the lyric.

In 1919, in an English musical, "The Eclipse," there was a very warm little sixteen-measure song, *I Never Realized*, which might well have been written by Isham Jones. But the tune wasn't even written by Cole Porter; it was by an English song writer, Melville Gideon. Porter wrote the words.

In 1923, as evidence of Porter's musical training, a ballet by him called "Within the Quota" was produced in Paris as a curtain-raiser for Milhaud's "La Création du Monde." It was enthusiastically reviewed in Paris, but it failed in New York.

There followed four years of the doldrums. Then, according to his biographer George Eells (*The Life That Late He Led*), Porter in 1927 auditioned for Vinton Freedly and Alex Aarons at a piano in the pit of a Broadway theater. He played and sang a broad range of his songs. Freedly and Aarons were then riding high as Gershwin's producers. Aarons thought Porter's songs were old-fashioned compared to Gershwin's. Freedly thought them too esoteric for a "book musical."

This criticism may have been deserved, as there had, as yet, been no sign of a really good song from Porter, at least among those published. But then, in 1928, came "Paris," which was the turning point in Porter's career. It wasn't a brilliant score, but it had a more professional approach than the preceding ones, as well as a song which has remained a standard ever since, *Let's Do It (Let's Fall In Love)*.

I find this title a perfect illustration of the distinction between the spirit and the letter of the law. The parenthetical section of the title obviously made radio performance possible, as opposed to the unequivocal *Love For Sale*.

The melody of *Let's Do It* is very solid from the verse to the end. The chorus is simple but not too much so. Its use of the chromatic

descent throughout is very adroitly conceived, a device that became a constant in Porter's style. The use, for example, of the *g* flat on the accented third beat gives immediate character to the melody.

Let's Do It (Let's Fall In Love)

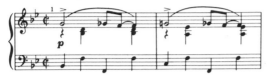

And notice how the most stressed note in the song is the sixth interval, the most provocative note, if constantly stressed, in popular music.

In the release (the song's form is *A-A¹-B-A¹*) Porter continues to use the descending pattern and with the same syllabization, but with a new idea in the nineteenth and twenty-third measures.

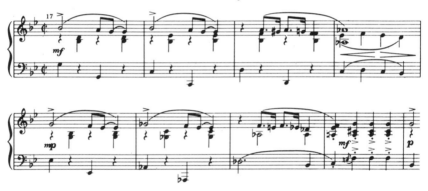

Notice, too, how he drops from the *a* natural in measure nineteen to *a* flat in twenty, *g* natural in twenty-one, to *g* flat in twenty-two.

It's a very good song which might easily have achieved its forthright lyrical purpose without such a competent tune.

With the score of "Fifty Million Frenchmen," Porter had become, willy-nilly, our house composer for "French shows." What Broadway wanted was nothing more than musical French post cards: slightly dirty, but cute. Luckily for Porter, he had both the musical and verbal skill to transcend this drearily juvenile role. Nevertheless, his songs

for Irene Bordoni did have a certain manufactured naughtiness that now seems terribly dated.

In this show, however, there was one extremely fine ballad, *You Do Something To Me*. Indeed, it is both musically and lyrically without guile or cynicism. It's a straightforward love song, not unlike Kern, but for an unexpected rhythmic stunt he performs at the end of the release. At this point both the lyric and melody are unmistakably Porter with "do do," "voodoo," and "you do."

You Do Something To Me

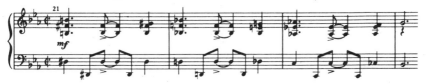

Up to this point there have been many verbal but no musical devices which are distinctly his own. And, but for a pleasant but not particularly unusual verse in *Let's Do It* (*Let's Fall In Love*), there is no sign that Porter wishes to take advantage of the implicit freedom acceptable in song verses.

In the London production "Wake Up And Dream" (1929), there are several good songs. The first is *I'm A Gigolo*. It's a comedy song and, so, not without deliberate musical cliché phrases written, obviously, to reflect the lyric, and yet containing a good, swinging opening section worth illustrating.

I'm A Gigolo

Here Porter uses interesting harmony and bass lines as well as a melody line that, because of its opening *a* flat and avoidance of *a* naturals anywhere until the end of the second section, implies the key

of E flat. The F-dominant-seventh cadence in the eighth measure
furnishes the necessary clue to the song's being in B flat.

Here again is an instance of the music being better than it need be,
since the lyric is sufficiently witty to get by with a lot less in the
melody.

Looking At You I had always assumed to have been by Vincent
Youmans. Admittedly it is a good song, but as unlike a typical Porter
song as no other I can think of except *Ev'ry Time We Say Goodbye.*
The best-remembered Porter songs, most quickly recognizable as his,
are not notey and are mostly in *alla breve* rhythm: cut time.

What Is This Thing Called Love?, also from "Wake Up And
Dream," is one of Porter's best songs and is accepted as such. To be-
gin with, its verse is the first of Porter's I've examined so far which
sounds as if it had been given great care and consideration.

The chorus is highly unusual. In the first place, it begins on the
minor seventh, a *b* flat in the key of C, and its supporting harmony is
a C chord. The melody then resolves, unexpectedly, to F minor, in-
stead of F major. In the bass there is a pedal point of *c* for four meas-
ures. From the nature of the melody up to the close of the first sec-
tion, the listener must anticipate a cadence in C minor. Yet the
cadence is, remarkably, in C major and the melody note, *e* natural
to make the effect more dramatic, is the determining factor.

What Is This Thing Called Love?

The release is based on the main strain, a fourth higher. But it
varies in the eighteenth and twenty-second measures so as to develop

the song. The harmony of the release is extremely unusual to the extent that, were I given its chords without its melody, I would be baffled by the problem of creating a believable melody for them. The release is, in fact, a wonderful amalgam of superior melodic writing and highly unusual harmony.

Notice how Porter introduces three quarter-note *b* flats as pick-ups to the main strain. By means of them he makes the unusual *b* flat which begins the phrase seem completely familiar. Here is an illustration of a highly acceptable repeated note.

And again, due to the high half-note *e* flat just before the final cadence, one expects a minor ending. But no; again it is in major. This is marvelous musically, yet, considering the unresolved nature of the lyric, I am puzzled by Porter's choice of a major ending.

As well I am puzzled by the awkward attempt at rhyming "Lawd" with "called." I realize it nearly achieves what is known as an assonant rhyme. But this sort is frowned upon in lyrics for theater songs and is almost unprecedented in the writing of Porter.

Love For Sale, in "The New Yorkers" (1930), could never be played over the air. It is said that this pleased Porter highly. In the case of *My Heart Belongs To Daddy,* extra lyrics for radio consumption were written by Jack Lawrence. Evidently, Porter himself wouldn't go to this much effort, though I presume he must have sanctioned the less gamey version.

Love For Sale is a famous song, extremely well written, though definitely an applicant for the art song series. I find it maddening in its

pretentiousness, both musically and verbally. And yet, from start to finish, it is a very well-constructed song, verse as well as chorus. Certainly it was a daring song for those days, so far from the present new juvenilia of stage nudity and graffiti words. But the attempt of its lyrics euphemistically to prettify a rather drab profession embarrasses me. And the melody, well-written as it is, resorts to such humorless melodrama, including the vocalese at the end, as to negate the astute professionalism of the writing.

In 1932, in the musical "Gay Divorce," there were three very fine songs. The first is *After You, Who?*. The lyric is one of Porter's finest, with never a forced rhyme, with a direct, uncynical statement, with open-ended words for the cadences, indeed, a model of writing.

The melody is one of those having adequate but totally unintrusive harmony. In fact it is one of those rare melodies of such character and strength as to need no more than itself to be enjoyable. It is a very evocative melody, one which never loses its bloom. It doesn't experiment in form or design and so needs no illustration. But it has the absence of contrivance that suggests its having been written swiftly and with intuitive sense of balance. I have heard it said that Porter was given to drawing up virtual blueprints of songs before he wrote either words or music, in effect, a design. If he did, it is remarkable how uncontrived so many of them sound: for example, *After You, Who?*

The most famous song from this show was *Night And Day*. The story goes that when Porter played this song for Max Dreyfus of Harms Music, he received an unenthusiastic reaction due to the bass notes beneath the melody at its opening. The resultant dissonance convinced Dreyfus that it would prejudice the audience. These bass notes are very daring and highly unusual, but if you look at the closing measures of the verse, you can see how the *c* flat in the bass against the *b* flat in the melody was inevitable.

And there was no indication of prejudice when it was performed. If a melody appeals, it would take a cacophonous background to turn an audience off. As I have said before, very few non-musicians hear any harmony, good or bad.

Unfortunately, the editor of the sheet music guitar part didn't examine the piano part thoroughly. For the chord of the first measure of the chorus is not E-flat minor. It is C-flat-major seventh. It then

subsides to a B-flat chord (not seventh as stated in the guitar symbol), then, in the second half of the second measure, to B-flat seventh. Finally, in the third measure it resolves to E-flat-major seventh and in the fourth measure to E-flat sixth.

Night And Day

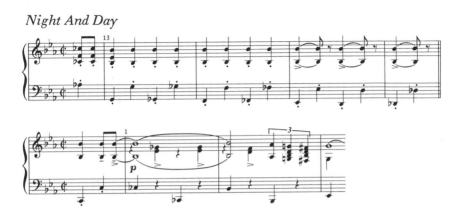

Throughout the chorus Porter uses chromaticisms in both melody and harmony, and to great effect. For example, notice both in the following:

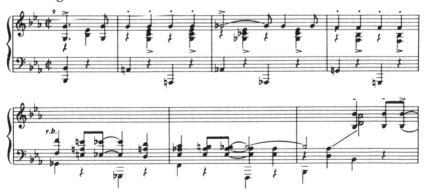

The form of the song is unusual in that it is *A-B-A¹-B-C-B¹*. Although the *A* strain does not end the song, as one would normally expect it to, it doesn't need to, since the *B* section ends with the same notes and rhythm with which the *A* section begins.

Though *Night And Day* is a marvelous song, it is so beautifully fashioned that it may, indeed, have been preceded by a blueprint.

What can I say about the many repeated notes? Well, by virtue of the endlessness implicit in the title, I think Porter wished to inject the element of carefully controlled monotony in the melody. After all, the chorus did stem from the "beat, beat, beat" and "tick, tick, tock" of the verse.

The *C* section breaks loose by leaping into G-flat major, without, however, deserting the repeating *b* flats common to both G-flat major and E-flat major.

Altogether this is a remarkable piece of craftsmanship, even though it lacks, for me, the kind of spontaneity I prefer in love songs.

In *I've Got You On My Mind* there *is* that element and the song is as loose as a good dancer.

The verse and chorus are inextricably wrapped up; their initial phrases are almost identical. That of the verse starts with a fourth beat pick-up, while that of the chorus starts on the second beat. This difference is too neat not to illustrate.

I've Got You On My Mind

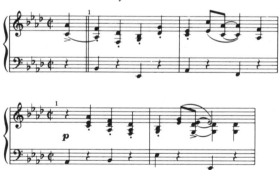

The verse is twenty-four measures. It adroitly drops its initial idea after eight measures. For if it were maintained, the opening measures of the chorus would lose their impact. Very, very neat.

The chorus is a conventional shape and size, *A-A-B-A¹*, and thirty-two measures. Except in its lyrics, it contains no specific characteristic of Porter, such as his predilection for chromatic phrases. For the most part, the main strain comprises a series of imitative phrases

which follow chord lines. And there's nothing unexpected about it. It's simply delightful and it swings. The first two *A* sections have a charming little cadence on the fourth interval. This *is* unusual insofar as ordinarily the note would be an *e* flat.

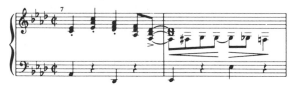

In 1933, in "Nymph Errant," an English musical, there were two fairly memorable songs. The first, *Experiment*, has been a favorite of some singers, but my prejudice against it has existed ever since I heard the title. And when put together with the music, I am even more irritated by it. The word is not only an unlikely word to make prominent in a song, being as uneuphonious as it is, but the musical phrase which carries it, to me exaggerates its unwieldy unsingingness.

The other song, *It's Bad For Me*, is a beauty. It's a great rhythm song, loaded with all sorts of unexpected delights. For example, consider the harmony of the main strain: A minor for one measure, E minor for half, C-dominant seventh for half, F major for half, C dominant for half, F major for half, G dominant for half—oh, why not simply show you?

It's Bad For Me

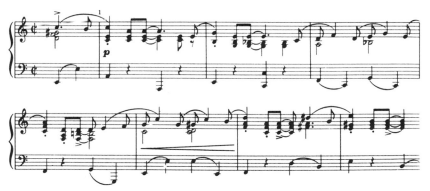

I stopped somewhere in the middle, but please notice how he climbs into an E-major cadence through the *d* sharp. This is pretty astute and happy writing. For though I am impressed by his original harmony, those who couldn't care less don't have to in order to enjoy the tune. Granted they will have to work considerably harder than usual, but so have they had to with many of the great, more complex songs.

It would be acceptable if the last section ended wherever it pleased, as far as I'm concerned. But instead, Porter pulls out all the stops and miraculously threads his way through to a C-major cadence. Look at the brilliance with which he does it.

III

When the 1934 film version of "Gay Divorce" was made, the title was changed to "The Gay Divorcee" on the grounds that audiences would be offended by the frivolous idea that a divorce could be "gay." Today, according to a friend, one would drop the title "Gay Divorce" entirely for fear it would wind up in the Times Square homosexual movie houses.

With the exception of *Night And Day*, the Hollywood producer

dropped every Porter song in the original score. Ironically, Con Conrad wrote a song for the film which won an Oscar. It was *The Continental*.

"Anything Goes" was produced late in 1934. It had a remarkable theater score, Porter at his best.

There is an anecdote about Porter listening to a French singer who, in the course of singing *All Through The Night*, lopped off a two-measure cadence. Instead of being angry, Porter was fascinated to the point of changing the song. Rightly remembered or not, the point of this story is right. Porter saw the value of allowing a lyric phrase to determine the musical phrase. If only one good thing has come out of the experiments of the rock era, it is the natural phrase, whether or not it be an even number of measures. Oddly, the credit for this should go principally to Bert Bacharach, who is certainly not a rock composer.

All Through The Night, given one slight nudge in the wrong direction, could have become an arty piece of melodrama. But it isn't, and I'm not quite certain why. It's fearfully complex for a theater song, unexpectedly moving into new keys and of twice the conventional length. It is almost totally a chromatic melody. In the course of its sixty-four measures there are only eight melodic steps that are not chromatic. The fact that these half-step melodic lines manage to maintain tension throughout and not fall away into affectedness indicates the mastery of the writing. The opulence of the harmony is such that each time the song returns to its parent key, F major, one is astounded—a small miracle of craftsmanship.

But one must remember that one of the most marked characteristics of Porter's style is his use of chromatic lines in both his melodies and harmonies. And, as always is the case with something you love to do, you do it better than anything else. In *All Through The Night* it's as if Porter were rising to his feet in a crowded room and calling out "here I am!"

As far as lopping off measures of cadences, for the life of me I can't see where Porter may have made the changes unless it be in the cadence before the final return to the main strain. For, unlike most of the cadences which are four measures long, this one is only two.

There isn't space to illustrate the whole chorus, but a sample should be shown.

All Through The Night

Porter certainly flowed full spate in this show. A title song is often a dud. Not this time! *Anything Goes* is a great rhythm song, both verse and chorus.

Without troubling himself with more than needed harmony, Porter produces as the principal idea a marvelous, complex rhythm tune.

Anything Goes

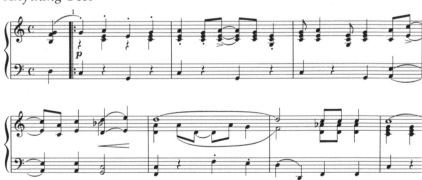

Then he wins me over completely with the release.

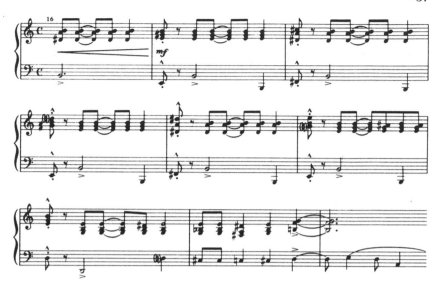

Notice how he builds his first beats up from *b* natural to *e* natural and then, with great suavity, instead of maintaining a high register, drops down and stays down. Beautiful!

Blow, Gabriel, Blow is a real rouser, a kind of country rhythm song. Similar songs are *Louisiana Hayride* and *A Gal In Calico*. However, this song is a big production number and runs to seventy measures. My feeling is that, while it must have been perfect in the theater, it is too long as an isolated song. And along the way it uses two measures of quarter note triplets four measures apart. They seem to me out of character in this type of song. But such criticism is really beside the point: the song belongs in the theater.

I Get A Kick Out Of You is certainly one of Porter's best known and most performed songs. For the most part it is written in stepwise phrases. The initial idea is a scale line, as are all other first phrases of each section. There is only one big step in the whole song, that at the end of the first half of the release, the drop of a seventh. There are also no harmonic fireworks. Indeed, the melody is self-supporting.

Its spelling in many places is ignored by singers. I know of none who sing the half note triplets, in the second measure, for example. They sing a half and two quarters. It is clear that Porter uses this

unusual device to further the flow of the melody. However, unless it is very carefully sung it will turn into a waltz. Another reason for this spelling is to provide contrast to the flowing phrase that contains the line "that I get a kick out of you." Here the song has a strict feeling of four and so "kicks."

I Get A Kick Out Of You

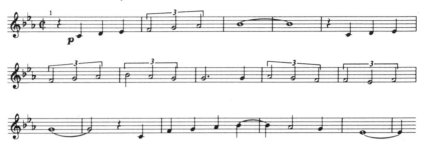

It is interesting to find a phrase from the chorus in the verse. This takes place in the sixth and seventh measures.

This is a very good, essentially simple song, in spite of its half note triplets, but, as is almost always the case with Porter songs, it is popular as much because of its lyric as its melody.

This, however, is not true for jazz musicians who like it for its looseness, which provides ample room for improvisation. Needless to say, the half note triplets are, for the most part, ignored by them.

I am interested in the fact that I have never heard a complaint from a singer concerning the need to sing the two-syllable sound of "vious" in "obviously" with only a single note. My hunch is that they usually solve this by singing two notes, the first a grace note, so that it winds up two syllables after all.

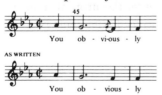

You're The Top is probably the greatest of all the Porter "list" songs. It's lyrically a true tour de force. But in the enthusiasm over the lyrics, the extremely unusual device employed in the musical main strain is ignored. Instead of the first two notes of the song being pick-ups to the first measure, they take place at the end of the first measure. And the beginning of the first measure is a carefully calculated instrumental figure. I'm quite certain I have never seen this device before in popular music.

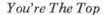

You're The Top

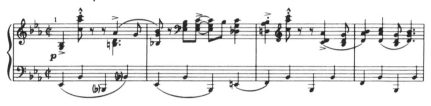

Notice all the space between the first and second phrases. Here is an instance where the fill-in material becomes an intrinsic element of the song.

The form is simple, *A-B-A¹-C*. And here again no effort is made to create more than essential harmony.

IV

By this point in his career Porter was in full control of his musical craft. He was experimenting, doing daring things, and writing in many styles, though this last seems less obvious because of the immediately recognizable style of his lyrics. His musical training constantly reveals itself in both his melodic as well as his harmonic invention, though perhaps less so in his rhythmic ideas. *Anything Goes* is an exception.

My feeling is that, though Porter songs seldom reflect any but the American musical atmosphere, they are nevertheless one step removed from the mainstream of the American musical revolution. He is closer to it than Kern insofar as he seems less appalled at the possibility of getting his feet wet. Still there is the "faint aroma" of social isolation. He would more likely have been found in the Drake Room

listening to Cy Walter than at the Hotel Pennsylvania listening to Benny Goodman.

In 1935, in the show "Jubilee," came the longest popular song ever written, *Begin The Beguine:* 108 measures. In spite of what some say, the song did not become a standard until the release of the Artie Shaw record with its famous arrangement by Jerry Gray. In this record there was no vocal.

The song is a maverick, an unprecedented experiment and one which, to this day, after hearing it hundreds of times, I cannot sing or whistle or play from start to finish without the printed music.

Because of its fame I feel guilty not making some solemn, dignified statement about it. But somehow it seems outside the purpose of this book to discuss a song that lives such an autonomous life. I suppose it conjures up for the listener all sorts of romantic memories embodying the ultimate tropical evening and the most dramatic dance floors ever imagined: "and now when I hear the people curse the chance that was wasted," and so on. Forgive me for not joining the dance. Along about the sixtieth measure I find myself muttering another title, *End The Beguine.*

On the other hand, in the same show there was another equally famous and more palatable song, *Just One Of Those Things.* It has a very casual and highly effective, mordantly witty verse, with music more as a support for the lyric than as a sample of inventiveness.

The chorus has a strong, aggressive melody, fashioned largely of chromatic steps and supported, in its main strain, by chromatic harmony. The latter, throughout, is highly inventive without allowing itself to distort the melodic line.

It is interesting to note that in the sheet music Porter prefers two opening notes which I doubt have ever been sung, unless they were used in the show itself. They are the same as those always sung, but an octave lower. The ones we always hear are printed in small optional notes.

Just One Of Those Things

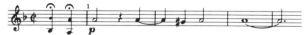

Someone has told me that in his search for a three-syllable adjective which he needed and couldn't think of, Porter accepted the word "gossamer" from, of all people, a *business* friend. The word is so familiar in its present context in the song, "gossamer wings," that it seems impossible that it wasn't sitting there on his piano, waiting for Porter even before he wrote the lyric.

Why Shouldn't I? is a very good ballad, the first section of which is curiously like Irving Berlin. From then on, however, it builds in a highly sophisticated fashion, moving, in the second section, into the key of E major (from the parent key of C major). It glides smoothly out of E into F major in the third section and neatly back to the main strain.

The form is *A-B-C-A¹*, unusual for Porter, in fact, for any writer.

The second section is too ingenious to pass up:

Why Shouldn't I?

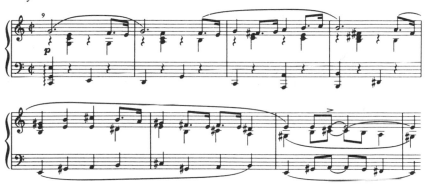

Could Porter possibly have been making a little fun of Noel Coward in *When Loves Comes Your Way?*. If he wasn't, it's hard to account for the existence of this song. It certainly has nothing to do with Porter, either in its lyrics or its music. And it is noticeably satirical, for it's an English music hall waltz with every cliché in the book, plus a most pedestrian lyric containing such nuggets as "Forget the world and say goodbye to sorrow" and "Simply live for today and never think at all of tomorrow." It had to be a pot shot.

In "Red, Hot And Blue" (1936), there wasn't very much. However,

I find *You're A Bad Influence On Me* very pleasing, perhaps less as a song than as an instrumental piece. It swings from the verse on. And, incidentally, it is murderously difficult for a singer to "find" the notes of the second half of the verse. But it would be a picnic to orchestrate.

It's a kind of throwaway song, if considered as a theater song. But it's so cheerful and nonchalant that, were there any ears left for dance bands, I'd want to revive it. It's not a recognizably Porter tune, but of course the lyric bears his mark, with such rhymes as "folly" and "Svengali."

At the close of 1939, "Du Barry Was A Lady" was produced and in it was a marvelously salacious song called *In The Morning, No!*. It had a very madrigal-like tune and a most un-madrigal-like lyric. If ever a song was sure to be denied the air waves, this was it.

There actually wasn't much to shout about in this show—a ballad called *Do I Love You* with a very simple line, many repeated notes, and a very marked similarity to Berlin's writing. Naturally, it is very professionally constructed, but it smacks of contrivance rather than creation. Other than that there is only a rhythm song called *Ev'ry Day A Holiday*, which depends more on its rhythms than its tune of endless repeated notes. And even its lyric fails to get off the ground. But it does have one phrase in the third section that's novel and deserves illustration.

Ev'ry Day A Holiday

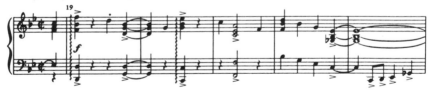

In "Born To Dance," a 1936 film, there were two great songs. The first, *Easy To Love*, is a superb piece of flowing, nostalgic writing. It's so well written that it seems not to be divided into eight sections. It's of a fairly wide range, an octave and a fifth, but this is not asking too much of a musical theater singer. Unfortunately, even the best of pop singers seldom have a wide range, which results, in the case of this

song, in their either not attempting it or else destroying it by trying to sing the dotted quarter note *a* of the second measure an octave higher.

If ever there was a song that shouldn't have a note changed, it's *Easy To Love*. Nor, as far as I'm concerned, any of its harmony.

There is in this song a stylistic device used for the first time, and I consider it a very weak one. Before this survey is finished, I believe it will be encountered many times. It's so weak that in a song of this stature it comes close to ruining it. The device is to be found at the end of the song. The weak measure is the thirtieth.

The other song is *I've Got You Under My Skin*. It's in beguine tempo and is fifty-six measures long. Its range is wide and its replete with repeated notes and eight measures of triplets, in other words, many things which I tend to shy away from. In this instance, though, I must waive all my prejudices, including such rhymes as "mentality" and "reality." For the song is so well composed and it develops in intensity and strength so remarkably as to demand acceptance.

Most unusually, its initial motif is repeated only once. After the thirty-second measure, the end of the second section, it continues to develop new material right through to the final cadence. Toward the close of the second section Porter magically moves the song out of its key, E flat, into D minor, then to G dominant, then to C major, and, as magically, back to F minor, B-flat dominant, and E flat.

I've Got You Under My Skin

In the section following, which contains the eight measures of trip-

lets, seven of them are supported by a pedal point *e* flat.

It is a very dramatic, theatrical, unique song. The form is hard to describe in letters. Perhaps the best way would be to break it down into eight-measure phrases. Then it would be (look out!) A-B-A^1-B^1-C-D-E/A^1. No, it's not simple.

Then in 1937, in "Rosalie," there was a very long song called *In The Still Of The Night*. There's no denying its initial evocative charm. I'm not convinced of the need for a four-measure cadence between both the first and second, and the second and third sections, but they are a minor matter.

Of major interest is the third section, which is marked "Appassionato" and scarcely reinforces the title, since here Porter pulls out many stops and, for me, all the wrong ones. For sixteen agonizing measures the song becomes bathos, pure and simple. The balance of this section regains its sanity somewhat and then the return of the "still" idea, the idea at the beginning, brings the song to its senses wonderfully. But by then it's too late, that is, for me. Perhaps, in its filmed context, it works splendidly. But, as a song, it's too bravura.

It is said of *Rosalie*, the song, that after having many versions of it rejected by the film producer, Porter went to his piano and wrote this version in a rage. There is also a less accredited story that he wrote it on a bet to the effect that he could make the producer accept the worst melody he could write. No matter: it was a big hit, and one of the worst songs Porter ever wrote, both words and music. It has nothing to recommend it.

Why Should I Care simply *must* have been a situation song in the film. Otherwise, there's little reason for its existence. As far as I can determine, it's a Jewish lament, with two swift trips into a major key. Its principal verbal message seems to be wholly concerned with prohibitive taxes and not minding them because "my sweetheart is still here." Yet its final cadence is in a minor key. Is this the same equivocal affirmation as in *My Heart Belongs To Daddy?*

V

"You Never Know" (1938) was, in Porter's words to his biographer George Eells, "the worst show with which I was ever connected." And yet in it there was a very good song, *At Long Last Love*.

It's another list song, but, in this case, a very tender ballad. And it's

extraordinary how one accepts the wry, bumptious lyric in juxta-position to the languorous, romantic melody. After all, practically the high point of the melody is accompanied by the words "is it Granada I see or only Asbury Park?"

The verse is in C minor and a beguine tempo. It's very effective, however much the placid nature of the chorus may come as a surprise. That may well have been the intent. The chorus flows gracefully, with only two quarter notes not of the scale of C major, to which the song shifts following the verse. It is a good, solid, straightforward song.

Also in 1938 there was the musical "Leave It To Me." In it there were two memorable songs, each for different reasons. *Get Out Of Town* was a very sophisticated, urbane and urban song, in spite of its injunction.

The verse is a good one, which it is not possible to say very often. Compared to Rodgers, Porter wrote verses as if they were a necessary evil. Not always, of course, but too often not to comment on.

The chorus has, in its opening measures, the quality of Berlin. In fact, for more than its opening measures. Not until it reaches its last eight measures does it have the true flavor of a Porter song. That section is by no means easy to sing, but it's very effective. Unfortu-nately the weak ending is back. It irritates me that such a discerning writer as Porter should resort to such a slide-off-the-platform device.

The last eight measures (but for the ending) are so ingenious, I'd like to show them.

Get Out Of Town

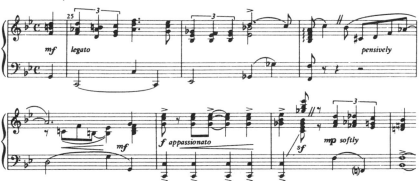

The other song is *My Heart Belongs To Daddy*, memorable for its lyrics. The melody disturbs me in its implication, rather rudely expressed in the broadly burlesqued cantillation of the middle section, that "Daddy" is Jewish. I find the inside humor in this song in poor taste.

I mention *Taking Steps To Russia* not because it's a great song but just because it truly swings, which few of Porter's songs do.

In the fllm "Broadway Melody Of 1940," there is another famous Porter song, *I Concentrate On You*. It is another song without a verse (see *Begin The Beguine, In The Still Of The Night, I've Got You Under My Skin*) and it's either sixty-four measures long (if you use the first ending) or seventy-two (if you use the second).

It's a very good song, not guilty of the whoop-la of *In The Still Of The Night* or *Begin The Beguine*. It develops beautifully and reaches a legitimate climax which, on this occasion, uses the less pretentious "passionately" as opposed to "Appassionata."

Its form is very interesting. It is *A-A¹-B-C-A* (four-measure cadence only).

The style is Porter at his most opulent and sophisticated. He employs his affection for chromatic steps throughout. He also uses a minimal number of notes. The song is so good, it's a temptation to quote the whole of it.

Ironically, his final cadence is once again a weak one. But in this instance there has been chromatic preparation for it; furthermore, it falls in an untypical rhythm.

I Concentrate On You

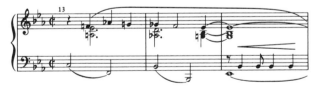

In 1941 came a theater score for "Let's Face It." In it there is a very pleasant, somewhat Gershwinesque ballad, *Ev'rything I Love*. It's a song of few notes, the principal idea of which is a quarter rest followed by repeated notes, a quarter and a half note. The continuous use of this could become monotonous. Somehow it doesn't, whether

because of its shifting harmony or its well-spaced words (which are so planned as to justify the melodic pauses), it's hard to say.

There's one very pleasant, unexpected measure of triplets toward the end that is quotable:

Ev'rything I Love

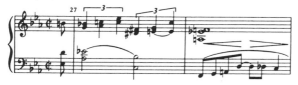

Farming is obviously intended to be just a piece of material. Yet it swings. Unfortunately, the second section bogs down into two imitations of a weak idea, which considerably weakens the song.

Not until the end of 1944, in the show "Seven Lively Arts," do I find another song I consider worth writing about. And that is *Ev'ry Time We Say Goodbye*.

Until recently I had no idea that this was a Porter song. And, in examining it, I see why. For there are no specific Porter characteristics in either music or lyric. Both are marvelous but untypical of his writing.

The harmony of the opening strain bears a marked resemblance to that of Rodgers' *It Never Entered My Mind*. In the latter song, Rodgers moves back and forth from the tonic to the minor third above it (in the key of E flat this would be E flat to G minor). In *Ev'ry Time We Say Goodbye*, the harmony moves from E flat to C minor, back and forth. In both instances this is unique since, ordinarily, either the G-minor chord would move to A flat or C minor and the C minor (in *Ev'ry Time*) would move to F minor. But in both cases they keep moving back to the tonic, E flat.

I also like the way the song moves up a half step from repeated g's to *a* flat, the fourth interval, the most loving, tender note in the scale when the song writer makes a point of it. Then, the phrase accompanying "a little." Cutting off on the last eighth note of the measure should sound abrupt. But it sounds only emotionally breathless, which is fitting.

The next neatness I notice is Porter's use of the G-flat major chord in the sixth measure. It's highly unusual, a spot of color, and no in-

trusion on the melody. In the second phrase he consistently lifts the *b* flat only a half step to a *c* flat, whereas one would expect a *c* natural. The *c* flat is much more an expression of loss.

Ev'ry Time We Say Goodbye

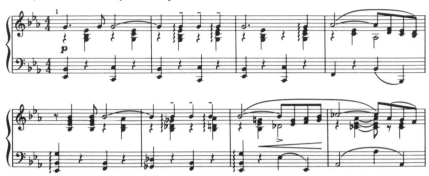

The imitative phrases in the second section are all carefully consistent: he moves down a half step from *e* flat to *d* in the tenth measure, to *d* flat in the eleventh, to *c* in the twelfth, *c* flat to *b* flat in the fourteenth.

The other pleasant conceit occurs in measure twenty-eight where the lyric says "major to minor," for an A-flat minor chord is present. Unfortunately, under the word "major," it is the same minor chord. But one should not ask for a miracle.

The form is *A-B-A¹-B¹*.

It also has an extended second ending which is very attractive and

which I have heard used only once, by Jeri Southern, who made a practically definitive record of the song.

Notice, in the first ending, how Porter returns to the strange harmony of the opening!

VI

For many years Porter had been suffering great pain from a shattered leg. It had been operated on countless times. His surgeon once told me that Porter's pain must have been so excruciating as to cause virtual sleeplessness for years. Yet this anguished man managed not only to write good songs and witty lyrics, but, in 1948, to create possibly his most successful score, "Kiss Me, Kate."

Right away, in the opening song, *Another Op'nin', Another Show,* he creates a marvelous device at the end of the song's first section.

Another Op'nin', Another Show

Notice where the stressed beats fall. On the fourth, third, and second beats of successive measures. This is a marvelous effect.

The big ballad of the show was *So In Love*. It happens not to be the kind of song I am most fond of. It borders on being arty; it has elements of pomposity and turgidity in it. Yet it is a perfectly written dramatic ballad, a treasure for any singer, "singer-proof," as one says of a great role, "actor-proof."

It is carefully, astutely, suavely conceived; it builds, never loses intensity, indeed, is a marvel of craftsmanship. For example, in the tenth measure the song has risen to a *d* flat. In the equivalent twenty-sixth measure, it has risen to an *e* flat. And at the still equivalent fifty-eighth measure, it is a high *f*. This is fine writing. Also, in the third section, which is divided into two long phrases, the high point of the first one is *e* flat, while the second is a half step higher, *f* flat.

The original version of *Wunderbar* was *Waltz Down The Aisle* in "Anything Goes." It was dropped from that show, put into "Jubilee," and dropped again. It's obviously a spoof, using Strauss phrases in the verse and generally poking fun at *Alte Wien*. Nevertheless, it is extremely ingratiating and has a most felicitous shift, in its middle section, from the main strain of G major into the key of E flat.

As I said, "Kiss Me, Kate" may have been Porter's finest score. It yielded both hits and standards. *Why Can't You Behave?*, a fairly good quasi-"lowdown" song, was too difficult for most singers for it to become a pop hit, although it endures as a Porter favorite. Its second note drops a major seventh and is out of the key, making it hard to "find." It is atypical Porter and, I think, a bit melodramatic. I recall that *So In Love* was played often, if seldom sung.

There were other delightful songs, such as *We Open In Venice*, pointedly written for the lyric but having attractive music, *Tom, Dick Or Harry*, a "material" song, *Too Darn Hot*, a good production rhythm song but not quite "with it" (polite society's idea of jazz), and *Brush Up Your Shakespeare*, a very clever patter song, a vehicle for the lyric.

In "Out Of This World" (1950), an unsuccessful show, the song *Use Your Imagination* was charming but only that. *Where, Oh Where?* was a truly delightful waltz with a somewhat predatory, wealth-minded lyric. Unfortunately, the intended big ballad, *I Am Loved*, simply doesn't come off.

In "Can-Can" (1953), the song *I Love Paris*, until it turns major from minor, might better be entitled *I Love Russia*. And even when the western sun breaks through in the C-major section, I am bored and baffled. Was the title strong enough to attract listeners, just as the loss of Paris to the Germans seems to have been enough to popularize Kern's *The Last Time I Saw Paris?*

I doubt that *All Of You* ("Silk Stockings," 1955) would have been quite so popular but for the dubious wit of the line, "The East, West, North and the South of you." I may risk stuffiness when I say that I find this to be school-yard snickering, but that's precisely how I feel. I mention this line only because the song doesn't have any particular distinction. But I'll admit that the quoted line is memorable.

I am sorry to say that after this song Porter never wrote anything further that, for me, merits discussion and analysis.

VII

I believe that the deterioration in the quality of Cole Porter's songs was due solely to his agonized physical condition, and not to his being, as it is so often shockingly said, written out. For me the high point of Porter's career occurred in the thirties, with only occasional flashes of this mastery after that. And, for me, so marked is the blunting of this fine line of creativity, that I'm certain it coincided with his tragic physical condition.

In some instances one might speculate about the decreasing urge to create coinciding with the vast increase of wealth resulting from suc cess. This, I'm sure, is true of many writers. But it can't apply to Porter, as he was born wealthy. Frankly, I find it extraordinary any time a wealthy person manages to create anything besides more wealth. Comfort and luxury can be a fearful deterrent to creative accomplishment.

Porter might very easily have become either a drawing-room composer or a dilettantish song writer who wrote for friendly occasions or even for the last-night-at-sea party in the first-class lounge. It is highly to his credit that he wrote professionally, that he was accepted as a professional, and that he never permitted his talent to be tainted by amateurism.

Granted that he could afford to risk acceptance better than other,

less well-protected writers, and therefore may have dared to write, occasionally, in such experimental forms as that of *Begin The Beguine*. And also granted that he often may have aimed his lyrics at the level of his social peers. Nevertheless, this was only an occasional practice. For the body of his work shows clearly that he constantly sought to maintain a high level, not of social frippery, but of professional craftsmanship. And this he manifestly achieved.

It is true that in some instances one feels he ignores this responsibility and is simply out to please his friends, as, perhaps, in *De-Lovely*. This he may have done, yet he also wrote a hit. And it is extremely unlikely that a song written solely for social reasons could have gained the acceptance of the public. And so, though he didn't so much have his eye on the till, he did have his creative mind on the exacting business of writing well within the framework of American theater music.

Overall, I find Rodgers warmer, Arlen more hip, Gershwin more direct, Vernon Duke more touchable, Berlin more practical. But no one can deny that Porter added a certain theatrical elegance, as well as interest and sophistication, wit, and musical complexity to the popular song form. And for this we are deeply indebted.

7

Harold Arlen
(1905-1986)

In an appraisal of Harold Arlen's work I must guard against over-enthusiasm. For just at the time I started to try to write songs, I came upon his own early published music. I had listened to Jerome Kern, in particular, as well as Vincent Youmans, George Gershwin, and early Richard Rodgers, but something resembling an electric shock occurred when I first heard Arlen's *Sweet And Hot* (1930). This shock has been repeated many times in the many years since.

I know now that some of the Arlen songs which excited and inspired me then no longer do so with the same intensity. But the same gooseflesh starts up again when I hear Frank Sinatra sing *Last Night When We Were Young*.

I have had quite a few red-faced arguments concerning the relative merits of the songs of Arlen and Gershwin, and have always, or almost always, been jeered at for preferring Arlen's. Although I know him, and interviewed him while preparing this book, I have never asked Arlen if the story is true that Gershwin was his hero. If it is, then as far as I'm concerned, the pupil surpassed the teacher. I should, of course, be very careful in comparing these writers insofar as they wrote at their peak in entirely different musical eras.

Arlen, to the best of my knowledge, has always had not only an astonishing melodic gift but harmonic sensibilities of the most sophisticated sort. As well, he thinks in terms of instruments, in the

aggregate and singly. Which is not to say that he wishes the potential singer of his songs to sing instrumentally. He couldn't do that, being a singer himself.

He, more than any of his contemporaries, plunged himself into the heartbeat of the popular music of his youth, the dance band. After all, he sang in his father's choir as a child, and he earned his living as a singer and orchestrator before he started writing songs. He was, for example, hired by Arnold Johnson, a well-known band leader of those days, not only because Johnson liked his singing but because he could orchestrate.

Interestingly, when I discussed song writing with him, Arlen never spoke of hits; he talked only of good songs. My feeling was that he simply didn't equate quality with sales. And it may be that the early songs of his I heard sounded more like those of a man who loved to write, and who loved the creative act for its excitement and fulfillment, rather than one who was simply in the song writing business.

I admit to having been impressed by his harmonic flair and opulence. His songs made me feel that I had a friend in court, and that were we to meet, he would be sympathetic and even encouraging. I envied his talent, but, strangely, I never tried to write in his fashion. I sensed that he lived at the heart of the matter, where the pulse was, and that I was an enthusiastic outsider. And I was right.

As this survey proceeds, I shall attempt to show why his turns of phrase and musical point of view please and satisfy me so.

Unlike Irving Berlin, who forged ahead in the days when there wasn't a great deal to get excited about, Arlen, my hunch tells me, might never have become a song writer had he grown up in those roiling but, to him, tepid times. For he needed the enriched and color-drenched sounds which had developed by the late twenties in order for him to want to be a writer.

One would assume from this description that he would have settled for orchestration, which was the expression of rich, fat sounds, whereas melody, per se, is, by comparison, almost a world of asceticism. But the harmonic furniture of dance bands never stifled Arlen's melodic flair; rather it gave it added dimension.

In my experience, the better the piano player or orchestrator, the less pure or autonomous are his melodies. For the inventiveness and dexterity of the fingers can so brilliantly clothe and decorate a tune

as to make any succession of top notes (melody) sound good. And
Arlen was, and is, a competent piano player as well as an orches-
trator. Yet who, except Berlin and Kern, has written a purer melody,
one less in need of harmony, than *My Shining Hour?* Arlen is ob-
viously able to compartmentalize, for which all song lovers should be
grateful.

His father was a cantor, and so, by the very nature of cantorial
music, an improviser. Arlen says of his father, "He was the most
delicious improviser I ever heard." Thus were combined in his first
musical inspiration the two basic elements of his own musical style:
a strong, flowing melodic line and a subtle but marked feeling for
improvisation.

Unlike Gershwin, who soon became distracted by the concert hall,
Arlen, except for his *Blues Opera* and a few piano pieces, settled for
popular music. He chose to develop his talent within its curiously
exacting limits.

I don't think Gershwin understood participating in and hanging
around the dance band world, in spite of the puzzling tale that he
used to roller skate to Harlem to hear a band play. As a matter of fact,
of all the better song writers, I can think of very few who have any
emotional kinship with the jazz musician and his bittersweet, witty,
lonely, intense world. Youmans would have loved the new bands, I
think, and Hoagy Carmichael certainly did. John Mercer, known
best for his lyrics, but a good melodist, has always been hip-deep in
the jazz world. This love for the jazz players and their marvelous
inventiveness has had a profound effect on Arlen's songs as it has on
Carmichael's.

It just might be that this don't-worry-about-the-mud-on-your-shoes
attitude of Arlen's was so in evidence in his early songs that I re-
laxed, much as might someone who upon arriving at a posh apart-
ment is asked to take off his jacket. Let our work be elegant, if the
occasion so suggests, but let's not behave like the denizens of suburban
Connecticut.

II

In the "Earl Carroll's Vanities of 1930" there was a waltz of Arlen's
called *One Love*, which still sets up for me the old shock of recogniz-
ing a familiar spirit. Arlen was not much given to waltzes, but this

one makes one wish that he had been. It is instantly ingratiating and does the unexpected as early as the second phrase, which restates the first phrase a third higher, giving the illusion of having changed keys. But the harmony is so astute that it stays in the area of F major, the parent key, and, effortlessly, the melody arrives back in F by the ninth measure.

One Love

The rest of the waltz is charming, if somewhat conventional, but shows marked evidence of a melodic talent. The harmonically opulent, swinging Arlen is not present in this song, but the warmth and decency of the man is revealed in the first eight measures. It is interesting that the very first song to be considered here reveals the melodist as being in charge and bears no allusion to the band world.

In "Brown Sugar," a Cotton Club show of 1930, there was a slightly cliché song called *Linda* which deserves mention for its use of a stylistic device which Arlen was to find fascinating on many occasions. I happen to love it. It's the use of the octave drop. In this song it appears in the release.

Linda

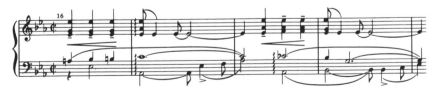

Arlen told me that he found the germinal idea of *Sweet And Hot*, from "You Said It" (1931), in a lick he got "from a trumpet player." It is a truly swinging song, as natural as the riff from which it stems. And when it develops beyond the riff, it's all of a piece. And in the third measure, there is his love, the octave drop. I think I was taken not only by the tune but by the step-wise bass line which I know I'd never seen before.

Since I'm one of few who seem to remember this song, it might be well to quote a few measures.

Sweet And Hot

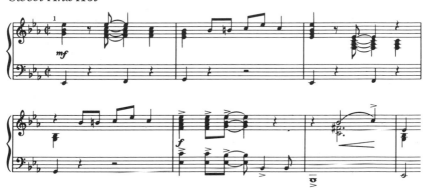

The form of the song is *A-A-B-A*, with all the *A*'s twelve measures long. It's interesting to note that the lyric writer for this song was Jack Yellen, who had advised Arlen's father not to force his gifted son to finish school. "Forget it," Yellen had said, "he's gonna be a song writer." In line with how I myself feel about jazz, it's also interesting that the opening lyric of the verse says, "I don't like high-brows who arch their eyebrows when a jazz tune is played."

In 1931 the Cotton Club produced another show, "Rhyth-mania." In it there was a beauty of a rhythm song, way ahead of its time, *Between The Devil And The Deep Blue Sea*. It takes off immediately with a swinging verse and never lets up. And its *A* section cadence is a marvelous riff which I must believe was written before the lyric.

Between The Devil And The Deep Blue Sea

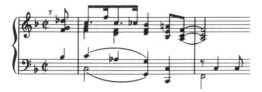

In the fifth measure, the last dotted quarter note is an *f*. I have never heard it played or sung as anything but an *a*, which I prefer.

The release daringly opens in A major with melody notes in that key, making it difficult to sing. In the fifth measure there is an unprepared C-major chord and ensuing notes of that scale. The cadence of the release is also riffish and very unusual.

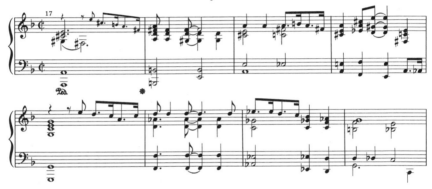

This song stemmed from the mind of an orchestra-oriented musician. If you're lucky enough to find an old Goodman record of it, you'll hear Helen Ward singing the vocal. It's the definitive performance.

Another Night Alone, a pop song of 1932, is one which I very much admire. The fact that it never entered the realm of standard song literature is due, I think, to the interlude which follows two statements of the main strain. This interlude is marked *poco mosso.* It is not related melodically or in spirit with what has preceded and, although perfectly good music in itself, it is too unrelated to the song to be more than what it is, an interlude. One could suggest that if the main strain is good enough, it should suffice. But it seems to need another section, one less concert-song-like, more of a piece with what went before and what follows.

In the "Earl Carroll's Vanities" of 1932 Arlen wrote one of his great songs, a standard if ever there was one, a song in the ethos of the jazz world, *I Gotta Right To Sing The Blues*. One naturally associates it with the great jazz trombonist Jack Teagarden, who could never get off the band stand without singing as well as playing it.

It has a strong, stompy verse, the first cadence of which constitutes another riff.

I Gotta Right To Sing The Blues

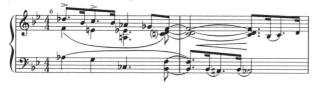

In the chorus, the melodic phrase that goes with "down around the river" is one of the chief distinctions of the song.

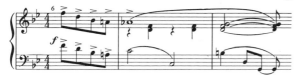

The half notes at the end of the first half of the chorus, each followed by strong chords with a pedal point *b* flat, are also very distinctive.

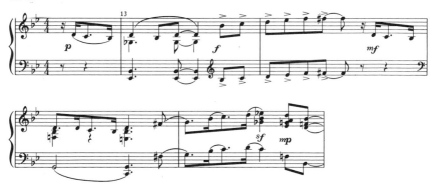

For "Cotton Club Parade" of 1932 Arlen wrote one of his loveliest songs, *I've Got The World On A String*. In looking at it again a moment ago, words and music, it occurred to me what innocent, pleasant, uninvolved demands were once made on our creators of the lively arts and how charmingly, wittily, straightforwardly they created for us. Why, even the verse of this song starts out "Merry month of May," and the music is springlike.

Indeed the verse is so delicate as to cause the chorus to come as a big surprise, not because it is indelicate, but because it turns from spirit to flesh. It has a rangy first phrase, an octave and a fourth, and it is instrumental in shape, but it's very singable and, heaven knows, memorable.

The sheet music of this song has the cadence identical in the first and second sections.

I've Got The World On A String

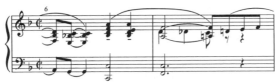

However, I have never heard the first *A* section sung the same as the second. I've always heard, in place of the two *a*'s in the last half of measure six, two *c*'s, and in place of the *f* in measure seven, an *a*. The same harmony as in the sheet music is used, but by suspending the melody on an *a* the ear is more prepared to hear a repetition of the *A* strain, whereas if sung as printed, one somehow expects to hear the release. I find the singers' choice of notes much more satisfying and logical.

The release is a classic and curiously reminiscent of the release of Berlin's *I Got The Sun In The Morning*. It is another instance of the accompanimental fill-ins becoming part of the song.

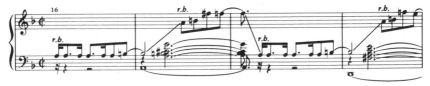

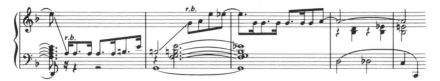

Before leaving this song may I mention that I've found a clear clue as to my special affection for Arlen's music. It's a simple clue and clear only to me and, in truth, it amounts only to a matter of taste. In the second and third measures there are leaps of a fifth within the first halves of the measures. I know of no other writer who would think of such a felicity but Arlen.

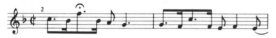

In a play, "The Great Magoo," which opened late in 1932 and ran for only eleven performances, there was a song called *If You Believe In Me*. In 1933 it was used in a film called "Take A Chance" and retitled *It's Only A Paper Moon.**

It's a straight *A-A-B-A* song, more in the pop idiom than the theatrical, but much superior to most pop songs of that, or any, time. It's one of the jazz musicians' favorites, and it has a very innocent lyric by E. Y. Harburg to which Billy Rose probably contributed the word "the" and so is listed as the co-lyricist.

The song is too familiar to illustrate, but I should mention that the release has the simplicity of a Rodgers release. As it should, it provides a perfect "release" from the greater activity of the main strain and winds up with a marvelous "snapper."

It's Only A Paper Moon

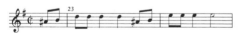

In "The Cotton Club Parade" of 1933, which included Duke Ellington's band, there were two outstanding songs. The first was *Happy As The Day Is Long*. It's a lively rhythm song in which Arlen uses a series of repeated notes, not, if my memory serves, a habit of his.

There is no particular comment to make except that his first phrase, which is repeated, is harmonically based on an ostinato phrase, or vamp, in the base, *c, c* sharp, *d, g*, each a half note.

Arlen had this to say about the second fine song from the show, the very affecting *Stormy Weather:* "When I broke away on *Stormy Weather*, I didn't break away consciously. It fell that way. I didn't count the measures till it was all over. That was all I had to say and the way I had to say it. George Gershwin brought it up and I didn't know it. . . . He said, 'You know you didn't repeat a phrase in the first eight bars?' And I never gave it a thought."

Arlen is speaking of the extra two measures in the second and fourth sections. I remember that when the song appeared it caused a degree of consternation in the rhythm sections of the bands, as they had been conditioned by years of playing strict eight-measure phrases.

The proof of the strength of this melody and its vitality independent of its harmony lies in my first hearing it. I was on the observation-car platform of the Empire State Express on a spring evening with a friend who was a great singer. He told me that there was a wonderful new song just out and proceeded to sing it, accompanied only by the sound of the wheels. There went the goose bumps again. And ever since all the extras like the harmony and band arrangements have been only fringe benefits. For I'd heard it under perfect circumstances, in unstormy weather, sung well, and on a spring night.

It has no verse and needs none. The bass line of the first two measures is one ostinato phrase, *g, g* sharp, *a, d*, and that of the next six is another ostinato phrase, *g, e, a, d*. Arlen again shows his predilection for octave leaps in the third measure.

What hit me on the observation-car platform, and still does, is the use of the fourth interval of the scale which goes with the word "sky" in the second and similar measures. I think I have suggested elsewhere that I have always considered the fourth and seventh intervals of the scale to be weak notes, which theory is supported by the strength of the pentatonic scale which eschews them. But in defense of the fourth interval I find that, if it is used adroitly, it creates a very gentle, romantic moment in a song: for example, in the syllable "fly" of Raymond Hubbell's *Poor Butterfly*, in the opening phrase. And the same effect occurs in the second measure of *Stormy Weather*.

In the second *A* section, the seventh and eighth measures are repeated, causing all the early furor. And it's a very touching repetition, like an extra pat on the head or, in this case, another sigh of sadness.

The release has the flavor almost of gospel music. The harmony is deliberately subdominant (C major) and tonic, nothing else. And it builds up to the high *d* in such a way as to give the illusion of having climbed even higher. Ted Koehler deserves much praise for his lyric setting at this point, for the phrase "walk in the sun once more" fits like a silk glove, besides being a lucent line.

During the next year, mind you, in the 1934 movie "Let's Fall In Love," there appeared three remarkable songs. *This Is Only The Beginning* is a sombre, almost tragic song, belied only by its lyric which implies that all will be well, that this is the beginning of a "love divine" (the latter a word I can do without). It's hard to understand such opposed points of view, unless there was an acceptance among interested listeners of the minor refrain as a dramatic device rather than as a presage of tragedy or sadness. Had I written the lyric to this music it would have sung of lost love and broken hearts.

The verse is a very fine piece of inventive and unusual melodic writing and the chorus is a series of marvelous surprises. It's so very good, in fact, that it amazes me it never became a long-term standard song. I just may be right about the lyric: the opposed points of view may have confused the listener to the degree that he rejected the whole song. This seems a great shame.

When I was examining Berlin's songs, I came to *Fools Fall In Love* and was convinced that I'd heard its first strain before and by another writer. I couldn't recall which song or which writer, so when I found traces of *Fools Fall In Love* in *Be Careful, It's My Heart*, another Berlin song, I assumed I'd found the source of the nagging memory. Then, when I examined the second of Arlen's songs from this 1934 film, *Love Is Love, Anywhere*, I found that it's the one which had been annoying me. It's interesting to note that in both instances the writers developed their ideas entirely differently. In the case of Arlen I am more pleased. I particularly like the way he handles the title phrase.

It's another of those songs which satisfies without the presence of

harmony. Nor is there any indication that harmony was a great consideration when the melody was written. It simply sets out all by itself on its merry way and arrives safe and sound.

The title phrase, which ends each *A* section, is particularly felicitous and witty in that it ends on the fourth beat instead of the more expectable following first beat.

The title song, *Let's Fall In Love*, was one of Arlen's loveliest. And so is the gossamer verse.*

It was years before I even thought of determining the harmony of its chorus. I didn't need to. There it was, one of those marvelous melodic lines that lived a life of its own. And the release, as is seldom the case, was a true development of the main strain. Again, this is a song too well known to need illustrating.

Early in the same year, 1934, there was another edition of "The Cotton Club Parade," and in it appeared *Ill Wind*. This is a great enough song for any composer, on no matter how high a level, to have been proud to have written. It is laid out in segments of ten, ten, eight, and twelve measures, in that order. It is *A-A¹-B-A¹* in thematic form. Here is the main strain of this unique and inspired song:

Ill Wind

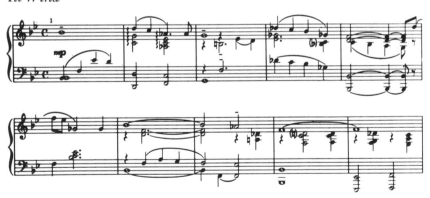

Notice Arlen's melancholy use of octaves in the release. They have a very instrumental cast, but in the hands of a competent singer they come off splendidly as song.

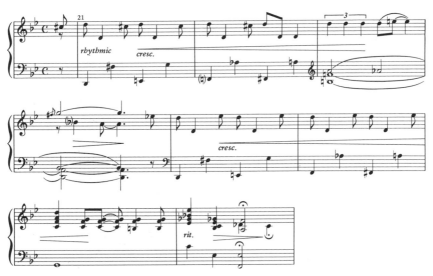

As Long As I Live, though copyrighted in 1934, hasn't a dated note in it. Among swinging songs, this is a beauty. It may be contended that the end of the release is a little cluttered, over-notey, and disinclined to allow itself an adequate cadence. Outside of that I find it only straight ahead, a joyous affirmation of a sadly neglected song form.

As in *I've Got The World On A String,* the verse, though very good and ingenious, particularly the doubling up in the third measure of the two phrases in the first and second measures, gives no warning of the chorus to follow. But I think that is deliberate, a way of creating more shock value when the chorus hits, not an indication the verse was written on another occasion.

Also in 1934 came the show "Life Begins At 8:40" with *Fun To Be Fooled.* This song has a definitely Kern flavor in the main statement and not until the *f* natural in the twelfth-measure cadence does Arlen reveal himself. I don't decry the melody, rather am I greedy for Arlen's special flavor and this simply doesn't have it. Perhaps I should be elated to find that the *A* section is fourteen measures long. But even though I love rule-breaking and upsets, this can't placate me.

In the release Arlen's style returns noticeably with three sets of octave drops which certainly please me, but not enough to make up for the loss of it elsewhere. On the other hand, the last eight measures

of the verse are just what I love, the way he turns the phrase around and the way he keeps returning to the quarter note *e* and *a*.

Fun To Be Fooled

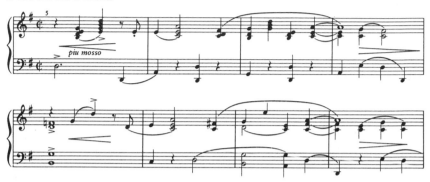

Let's Take A Walk Around The Block is an unlikely song to have come from Arlen. In fact I didn't know, until I started this survey, that he did write it. It's obviously a peg to hang the very cleverly rhymed lyric on. And, insofar as it is a "lyric" song, it's a much better than average melody. But in it there is none of that aspect of Arlen's talent that concerns me.

You're A Builder Upper is a good, solid rhythm song filled with portmanteau words like "thisa," "thata," "holder outer," and "giver in-er" that always throw me off, harmless as they are. Their contrivance comes off, to me, as over-cute.

Arlen told me that he wrote *Last Night When We Were Young* for Lawrence Tibbett. I frankly can't imagine a less likely singer for this song. But, after all, once you have heard the Sinatra version, you can't imagine anyone else singing it.

It was cut from Tibbett's 1935 film "Metropolitan," but the song was performed instrumentally behind the credits. This is a most remarkable and beautiful song. It is one which goes far beyond the boundaries of popular music. For me, it is a concert song without a trace of trying to be. It hasn't any artiness about it or pretense. It's obviously deeply felt, both by the composer and the lyricist, E. Y. Harburg. It is written with such intensity that it gives the illusion of being a song of great range, whereas it is only one step beyond an octave!

It is unlike any other Arlen song that I have heard. However, it is unmistakably his. This is only partly due to the harmonic sequences. It has more to do with the suspensions he creates in the harmony by means of his brilliant choice of melodic notes.

Take, for example, the end of the second measure. Although the E-dominant-seventh chord has been cut off in the piano part in an eighth note, the chord carries over in the mind, and any good orchestrator sustains it. Against it there is an eighth note triplet reading down: *c* natural, *b* natural, and *g* natural. The *c* causes a suspension as does the *g* natural.

This occurs again at the end of the sixth measure where the chord, this time sustained, has against it in the melody another triplet. The chord is a D-dominant seventh with a flat ninth and reading down the melody is *b* flat, *a,* and *e* flat (the flat ninth).

A characteristic of the melody is the ingenious chromatic writing and the triplet at the end of many measures. It is by no means a simple song but neither does it, in its complexity, ever get out of hand, or give the impression of doing so, as sometimes Kern's releases do. There are no extensions in it, no tags, and yet the illusion it creates is that it is a much longer song than it actually is. This, I believe, is caused by the unrelieved tension engendered throughout.*

In "Strike Me Pink," a movie of 1936, the song *First You Have Me High* was introduced. The melody does just what it should: goes to a high note and then, because the lyric so suggests in the line "then you have me low," goes to a low note. And it doesn't skimp. For the first jump (in the key of F major) is from a *c* to an *f* and the second is from a *c* to the *c* below, offering another opportunity for Arlen to use his octave leap. It moves sinuously about in the release with a series of ingenious chromatic descents and then shoots high and drops low one more time. A very cute little tune.

In another 1936 movie, "Stage Struck," is the delightful little song *In Your Own Quiet Way.* It's what I continue to call, for lack of a better word (or maybe there isn't one), a soft-shoe song. The most typical song in this genre is Arthur Schwartz's *I Guess I'll Have To Change My Plans.* They're passive songs, selling nothing, just pleasantly whistling their contented way down a quiet lane. This song fulfills itself with great sweetness, flirting with clichés but never proposing.

In Your Own Quiet Way

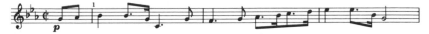

In "Hooray For What" (1937), there was a strong, driving rhythm song called *Down With Love*. It gets rid of all its harmonic fervor in the verse, which is quite long and bounces in and out of keys for thirty-two measures.

The chorus is not typically Arlen, good as it is. It's a true *alla breve*, cut-time song which concentrates on a return to the sixth interval, helping to bolster my "sixth" fix. It's of the same extravert type as *Somebody Loves Me*, no time out for tricks or subtleties. In this case the two eighth notes at the beginning of the second measure, and the subsequent imitative measures, perform the service of "kicking" the rhythm and sending the song on its way. And it probably worked marvelously in the theater. A real Act One curtain song.

In The Shade Of The New Apple Tree is, again, not typically Arlen, though there are occasional hints, as in the *d* flat of the sixth measure. (The song is in E flat and that *d* flat is *not* a leading tone to the key of A flat.)

It's a sophisticated country song, if such can be. And it's a delightful rollicker. It surprises the listener by not returning to the expected main strain after the release, though it does repeat the last phrase of it at the close.

In seven instances more than one note is used over a single syllable. Usually, even in concert songs, I find this painful. In this song, the device works plausibly every time.

III

"The Wizard Of Oz," the famous Judy Garland movie of 1939, contained a highly successful score, including probably Arlen's best-known song, *Over The Rainbow*. I think I have made it abundantly clear by now that I greatly admire Arlen's talent. And what pleases me and excites me most about it is his highly personal style, as individualistic as a Rodgers release or a Porter lyric. So when I fail to burgeon with praise over *Over The Rainbow* it is not because I don't like it as a song, but because I am disappointed that it bears no mark of Arlen's very special style. When Miss Garland sang it, and it was

her *pièce de résistance*, I was always deeply touched. But I was never listening to an Arlen song; I was listening to a very good, well-made ballad.

This may account in part for the occasional confusion I confessed in reviewing Berlin's music. For, in spite of the glittering parade of great songs, I could not find, search though I did, a specific style. In Berlin's case, however, I resigned myself to the fact that his is a unique talent, refusing to be categorized, a fantastic sponge that absorbed the entire musical world about him and managed to make a seemingly endless and original statement as a result of that absorption. It was not unlike a historian who, after reading every word ever written about, let's say, Napoleon, wrote a biography which presented a totally new concept of the man, yet which was based on material which had been previously published by others with less imaginative gifts.

In the case of Arlen, I am not only impressed but even exalted by his very personal point of view. I am concerned with a single man. With Berlin, who is like the spokesman for a school of popular music, I can't find the man. And maybe I shouldn't try. Yet with Arlen I usually can, except in *Over The Rainbow*. His profile is visible in the verse, but in the chorus I can find only the song.

Mysteriously, the next song on my list is a non-production song, copyrighted in 1941, which perfectly demonstrates the point I've been trying to make. No one but Arlen could have written *When The Sun Comes Out*.

As I recall, there was very little interest shown in this song for some time after it was published. I happened to find it in the publisher's stock room and made a nuisance of myself extolling its virtues to every musician I met.

The song is in the key of C, and for the opening half note (following a two-note pick-up) to be an *e* flat was, and still is, a minor phenomenon. Then, in the second measure, there is another phenomenon, a three-note phrase with a simply captivating drop of a sixth from *a* to low *c*. Also, to backtrack a bit, he avoids over-repetition by means of dropping a half step from the three *e* flats in the third measure, thereby keeping the melody sinuous and not a ruler line.

I am in awe of the sleight of hand at work in the release. It is so natural as to be merely an extension and development of the principal

statement. There is literally no separation between the two ideas. It all flows. It should be shown how he achieves this by illustrating the last two measures of the second *A* section, then the release and its expert leading back to the main strain.

When The Sun Comes Out

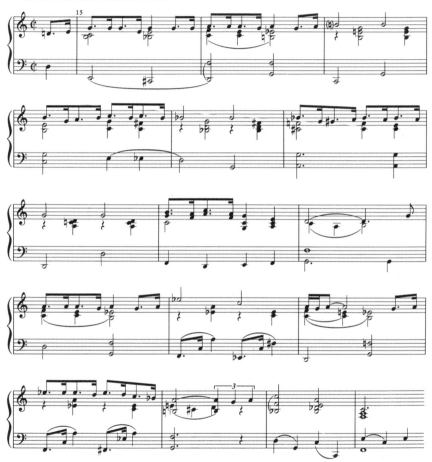

The phrase in measures twenty-nine and thirty has a warmth and tenderness seldom to be found in any song. The best example of a song with similar qualities by another writer is Rodgers' *Nobody's Heart Belongs To Me.*

In the movie "Blues In The Night," in 1941, Arlen wrote for the first time with John Mercer. This made for a very felicitous collaboration. They were not only two men who had been professional singers but they were profound lovers of jazz. Besides which, and most important, their love of the lonely and sentimental, the witty and the warm and the bittersweet, all part of the ethos of popular music, tended to make them work together like a single mind.

Says Who? Says You, Says I! is a very charming and eccentric little rhythm song, with one of Mercer's luscious lyrics filled with lines such as "the skies are full of butterflies" (that is, in that long-lost world before DDT), "that daisy crew is breaking through," and "within this dream of cake and cream." Ah, Mr. Mercer, who dares to write of a "Huckleberry friend"!

Arlen uses the last line of the verse for the cadence of the first half of the chorus, a device which is very seldom employed in a song. The form is *A-B-A-B¹*. The persistent rhythm of the song is too infectious to become monotonous. Here's a sample:

Says Who? Says You, Says I!

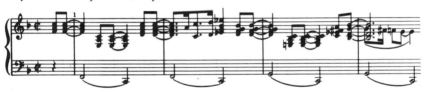

The film also introduced *Hang On To Your Lids, Kids*, another marvelous, happy riff song. And it has another great Mercer lyric. The riff is a good one and deserves to be repeated as often as it is in the song.

Hang On To Your Lids, Kids

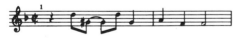

I'm so glad that Mercer was able to get his cheery point of view around, as in the lines "Why say that we're on the ropes? I say 'Hang on to your hopes, dopes!' "

Arlen had some interesting words to say about the title song, *Blues In The Night*.

> I agree with John most always. If the composer has good judgment in editing, a lyric writer can help you find a way you hadn't thought of before. It's nip and tuck. You never know where an idea began unless you zero in on it later and say this is what happened at that point. When Mercer wrote *Blues In The Night*, I went over his lyric and I started to hum it over at his desk. It sounded marvelous once I got to the second stanza, but that first twelve was weak tea. On the third or fourth page of his work sheets I saw some lines—one of them was "My momma done tol' me, when I was in knee pants." Now he had that as one of his choices, probably forgot about it, and I said why don't you try that. It was one of the very few times I've ever suggested anything like that to John.

Blues In The Night is certainly a landmark in the evolution of American popular music, lyrically as well as musically. The form of this song is unique. It is a series of twelve- and eight-bar phrases between two sections of which there are two measures to be whistled. And this is no high-flown pretense: *whistle!* By the way, this whistling motif is announced in the piano introduction to the song. The form of the chorus is *A* (12 measures), *B* (12 measures), *C* (8), *C¹* (8), whistle section (2), *A* (12), humming (2), ending (2).

It is much too earthy to be an aria, but it could be. It is fifty-eight measures long; unusual, of course, but still not as long as *Begin The Beguine*, a song that might be called a marathon.

I remember when *Blues In The Night* became a hit. All I ever heard the public sing was the "My momma done tol' me" phrase. That seemed all they needed in order to like and accept it. Some went so far as to complete the twelve-measure phrase. I've known only singers and a few musicians who could get through it all. And so, I'm fascinated that a song, which few could whistle or sing, could become a hit.

The initial introductory phrase sets the loneliness of the whole.

Blues In The Night

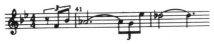

The *A* section is twelve measures, because that is the length of the blues. In the *B* section, instead of a full fourth-measure cadence, the first measure of the song is parenthetically restated as if to remind the singer what his momma was warning him about. And again this warning is made in the eighth measure. And it should be mentioned that while the *B* section is well in character with the *A* section, it is all new music (but for the connective warning phrase).

The *C* section is unlike either preceding section, but again, musically relevant. And the *C¹* section has only one difference, its final note. Then the lonely, evocative whistle motif and back to the first strain. Once more the whistle motif, now to be hummed, and then the terminal phrase of the song, two measures long, the first half of the first measure being identical with the first half of the tenth measure of the *A* section, where the lyric says "worrisome thing."

Where, oh where, did Mr. Mercer find that phrase? Or "when I was in knee pants," or "a woman'll sweet talk," or *any* of his indigenous, salty, earthy, regional, placename lines?

But I find that I'm not nearly through thanking Mr. Arlen and Mr. Mercer, for in the movie "Star Spangled Rhythm" (1942) appeared another of their extraordinary songs, *That Old Black Magic.* This song is a far cry from *Blues In The Night.* It is in *alla breve* time, spare in its use of notes, longer in measures, seventy-two this time, and totally dissimilar in character.

It is not as characteristic of what I consider Arlen's style, yet, by elimination, it has to be. For it couldn't be by anyone else, very dimly related though it may be to *Begin The Beguine,* not because of its length but because of its tendency to stick so close to the parent key for so long. But never could or would Porter have found the variant eighteenth measure with its *d* flat.

That Old Black Magic

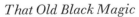

The form is as follows: *A-A¹-B-A²-C.* This song has the longest

pedal point (identical bass note) of any song I know. It lasts for fif-
teen measures. There are three places where Arlen uses his octave
drop, and one place where he employs another favorite device, in the
B section. In this device he uses the sixth of a dominant chord, usually
one outside the scale of the parent key, for his melody note.

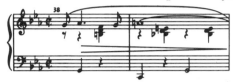

He has never resorted to the repeated note as much as he does in
this song, which fact may dampen my ardor somewhat. Fortunately,
he pulls out of this insistence in the *B* section.

Arlen told me that, because of Mercer's conviction that the lyric
needed to tell a longer story in order to make its point with sufficient
drama, he extended the melody that much more and thereby a better
song was written.

For the film "Cabin In The Sky" (1943), Arlen wrote another of
his distinctive songs, *Happiness Is A Thing Called Joe*. It has been a
favorite of girl singers since the day it appeared. It has a very instru-
mentally designed verse, including a couple of *appogiaturas* in the
sixth and eighth measures, very tough to sing, but marvelous music.

Happiness Is A Thing Called Joe

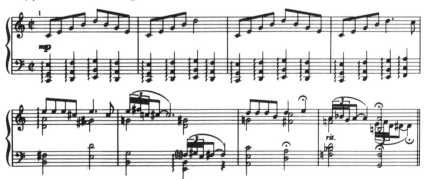

The chorus is very effective, played by a band or sung, but not adequate, really, on the piano unless played by some great pianist like Marian McPartland. I want to hear it played in the lushest, most groovily ornamented way.

It is the only song I know of in which the final cadence falls on the second interval of the scale. It's marvelous that way. When I used to hear singers end on it I assumed it was their little notion, but, no, it's on the sheet music. I should make two things clear: one, that only the second ending is on *d*, the second interval of C, and, two, that almost all singers do not sing the final phrase of the song leading to the first ending on *c*. They stop four measures ahead where the lyric reads "that's all I need to know." What follows is, basically, a tag and adds nothing to the song except to bring in the title. I much prefer the shorter version. And here is how that ends:

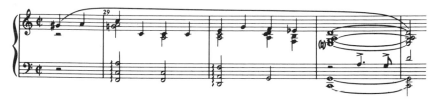

In the movie "The Sky's The Limit" (1943), Arlen and Mercer wrote two songs for Astaire for which he must have been profoundly grateful: *My Shining Hour* and *One For My Baby*. In the case of the first, I admit to being so admiring as almost to lose my critical sense. When I wrote of Berlin's *It's A Lovely Day Tomorrow*, I mentioned that the only other song I knew of with the same spare, hymn-like translucence was *My Shining Hour*. I should like to add here that I find the latter touches me more profoundly. I believe that both songs eminently achieve the objective of, let us say, sexless innocence and distilled simplicity.

There are several reasons for my favoring Arlen's song. They are tenuous, impalpable reasons and predicated on personal taste only. The first is the reiterated *g* in the fourth measure. Another note would have served as well, but this is like a last-second hand clasp.

My Shining Hour

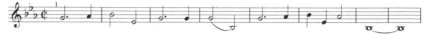

The second reason is the choice of that lovely, passive fourth inter-val, *a* flat, in the fifth measure. Next, the drop in the sixth measure to the *b* flat, a daring note, considering that it accompanies the word "bright" which suggests a higher note. Also, the continuation of the original line in the seventeenth and eighteenth measures, which maintains the melodic flow and eliminates the interruptive awkward-ness of a conventional release.

The strongest reason I have for loving this song is the double re-iteration of the phrase stated in measures nineteen and twenty.

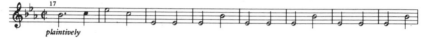

The shifting harmony accompanying these reiterations may increase their intensity, but so valid is the melodic insistence and, in a way, so like a repeated plea, that I don't believe it's necessary to cite the harmony.

The second to last reason is the by now familiar octave drop in measure twenty-nine. The final reason is the lullaby tenderness of the verse.

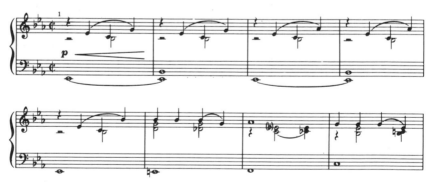

Note that the second melodic statement, under the words "will leave a glow upon the sky," ends on the seventh measure and doesn't extend its cadence another measure in order to maintain a balance of even numbers. Out of ignorance, the recent amateur writers have frequently written in odd-numbered phrases. I think I've said this before, but it can be said again. The lyric can sometimes demand music of an uneven number of measures. Indeed, music can lose its intensity if forced to maintain a cadence for too long.

Notice Arlen's use of the fourth interval in the verse as well as his octave drop.

IV

In *One For My Baby*, marvelous as is the musical setting, I believe the honors must go to the lyric. I've lived this story too many times, in too many towns, with too many long, long roads outside those doors, not to be hooked. Just imagine having the acuity and courage to start a song, as Mercer does, with "It's quarter to three"!

So, before I fall apart and start quoting from the lyric right and left, let me get to the melody. And please accept my word that doing so after extolling the lyric doesn't mean that I believe the melody to be of casual interest. It's a perfect melody for the situation, and obviously it's a situational song. Since it is unlike any melody of Arlen's I've ever heard, I must assume that the lyric had greatly to do with its almost old-time piano-player character.

It does several fascinating things. First is the close chromatic writing and the bone-simple piano part. The eight-measure pedal point with the key shift finally to A flat produces a definite feeling of an off-beat blues. Then the key shifts, even in signatures, from E flat to G and never returns to E flat. The *A* sections, though in different keys, are identical and sixteen measures long. The release is only eight, and the last *A* section has a two-measure tag. The release has

two spots where, due to sets of sixteenth notes, the tune takes on a feeling of double time. And drummers do double the beat at this point.

Arlen obviously respects Mercer's lyric very much as he never lets his melody do anything to disturb it. Of course I am allowing myself to get pretty far out on a limb by presuming that the lyric came first, as it did in *Blues In The Night*.

Evelina, from "Bloomer Girl," a Broadway musical of 1944, is a very cute, loose-jointed, semi-period-piece song, if I may seem to drop a few too many adjectives. It might be a clarinet solo, a dance, a song, or all three. Considering that it was written in 1944, but for a show called "Bloomer Girl," I'd say it was a deliberately dated song written by someone who had such mastery over his craft that he was able to provide the period-piece flavor with enough of his own current sensibilities to make it sit comfortably on two stools. Take the last phrase, for example:

Evelina

Right As The Rain, from the same show, is a very beautiful song, not notably characteristic of Arlen, bearing perhaps a slight flavor of Jerome Kern. It's a lesson in melodic writing, less sectionally conceived than even most great songs. It flows from start to finish in a long, increasingly intense and dramatic fashion.

The fact that it bears few characteristics typical of Arlen is of no consequence for me. So extraordinary is the song that I'm compensated for the absence of his more obvious stylistic predilections. However, the phrases beginning at measure nineteen are unmistakably Arlen. His dropping down to *c*, ascending to *b*, and again dropping to *c* has, somehow, his unique approach.

Right As The Rain

The structure of the song is such that it truly can't be divided into sections. It's too much of a piece. It has, besides, a lovely, eight-measure second ending, much too dignified to be called a "tag."

Ac-Cent-Tchu-Ate The Positive appeared in the movie "Here Come The Waves" in 1944. I feel certain that such a special lyric must have been written before the music. If this is accepted, the musical setting is brilliant. There are other ways it could have been done, but I can conceive of no better way than this.

It's a solid, strong melody good enough, in spite of Mercer's masterful lyric, to please by itself. It attempts no more than to move ahead and swing. The words and music fit perfectly, as, for example, in the release, where the lyric says "Jonah in the whale, Noah in the Ark."

Ac-Cent-Tchu-Ate The Positive

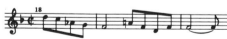

Or "just when everything looked so dark."

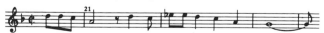

Out Of This World was the title song of a movie of 1945. This long-line ballad, without a verse, instantly sets up a *misterioso,* out-of-this-world mood. Its immediate melody point is, in the key of E flat, a long-held *d* flat. It creates a modal feeling, the mixolydian* mode to be precise. But unlike many other later and much less professionally written modal songs, this melody achieves an unearthly effect in its use of this one note.

Its sections are sixteen, twenty, eighteen, and twenty measures long, *A-A¹-B-A¹*. It is one of Arlen's most direct and deliberately un-rhythmic melodies, and unlike any of his other lyric ballads. Here is the first section:

Out Of This World

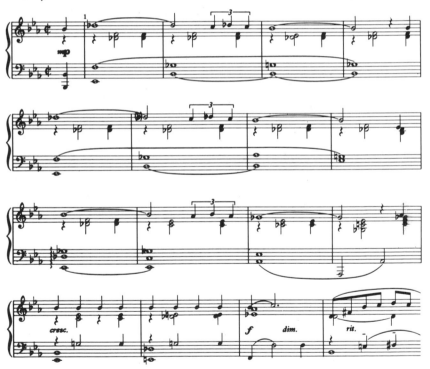

* A mode deriving from Greek music: a major mode with a minor seventh.

As you can see, he employs repeated notes in his second idea, in measures thirteen through fifteen. I find them less aggressive than intense. And the device in measure fifteen, of using two notes for the one-syllable word "knew," comes off effectively, partly because of the word "knew" and partly because of equivalent cadences in the other *A* sections which reiterate the device and so confirm it.

The cadence at the end of the *B* section, on the note *d* natural, perfectly sets up the return to the opening phrase employing *d* flat.

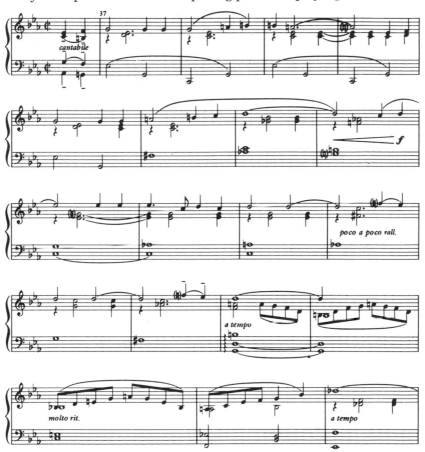

It is a very strong song, with splendid support in a John Mercer lyric. Though not typically Arlen in style, it would be difficult to assign its authorship to anyone else, unless just possibly Arthur Schwartz at his best.

I was lucky enough to see a performance of "St. Louis Woman" in 1946. It was one of the loveliest musicals I've ever seen—costumes, scenery, lyrics, and music. And it failed. Why, I shall never know. In it were some very lovely, funny, sad, and down-home lyrics, again by John Mercer, and some inspired songs.

Any Place I Hang My Hat Is Home is a free and easy song, just as the opening line of the lyric says. And it has a little of the flavor of *One For My Baby*, or perhaps the piano accompaniment makes me think so. The release does depend considerably on its harmony to be truly appreciated. As the lyric says, it's a "thank you, kindly," "howdy, stranger," on-the-road sort of song.

Legalize My Name has a very witty lyric and a much more gentle tune than one would presume from such an injunctive title.

I Wonder What Became Of Me is another gentle song, one which is more interesting when heard with its very interesting chromatic harmony. The release is a complex melodic line and richly harmonized, but more capable of standing alone. I should say here that melodies like this, which are conceived in terms of harmony, should not be criticized for not being so convincing when isolated.

The form of *I Wonder What Became Of Me* is not conventional. It is A (12 measures), A^1 (8 measures), B (8), A^2 (20). The second variant of A is not only extended, but calls for a four-measure ending to enable the accompaniment to restate the first four measures. Though no key change is made from E flat, the song ends in A flat.

I Had Myself A True Love is a long song, sixty-four measures, and very nearly an aria. But it's so beautifully made and under such adroit control that it never gets out of hand as ambitious, highly emotional songs often do.

The nature of Arlen's piano accompaniment, which is a notably good one, is such as to indicate another, more compositional concern for this song than any others I've seen. The use of thematic material in the cadences, the shifting styles in the left hand of the piano, the dynamic markings, the introduction, all bear out this opinion.

It's a sweetly sad, at times an angry song. It would be highly

acceptable as a concert song. I've heard Eileen Farrell sing it privately, and there went the goose bumps again.

As far as *Come Rain Or Come Shine* is concerned, the laugh is on me. For I'm the one who pontificated that Arlen was not given to repeated notes! Well, in the first two measures there are twelve! Now what do I say?

I say that it is a superb ballad which could never be so great unless the device of those repeated notes were the principal single element in the melody. The second section is without them, providing an essential contrast. The third and fourth sections continue to use them, interrupted twice by the most apt and satisfying octave drops. The whole last half of the song builds inexorably to the final *f* natural, though it is printed as one of two grace notes.

I am surprised that at this point the printed copy hasn't been changed to two full-sized sixteenth or even thirty-second notes, but full-sized. For the two descending notes, *f* and *e*, are an integral part of the song. Fortunately, most singers sing them.

The harmony, naturally, is opulent throughout. But the song can sing itself quite independently.

In the film "Casbah" (1948), there was *For Every Man There's A Woman*. It's a "moaner," in minor, with a slow beat and many juicy harmonic changes. The *A* section is, as far as the tune goes, only ten measures, but, due to a three-measure, small-noted section in which the song asks where the woman is, one could say that the *A* section is thirteen measures, a precedent in lengths. It is followed by another identical section and then only a four-measure release. This certainly is tearing up the formal pea patch. And the last section is ten measures using the first ending, plus thirteen measures using the second. It must be a singer's delight and surely an orchestrator's. Strictly Arlen.

What's Good About Goodbye? from the same film attempts no more than to be a good, clean, *alla breve* ballad. And this it succeeds in being. Not until the second strain are there true clues to its authorship. Then we find a climbing device which I believe Arlen loves. In this case the melody moves to an *e* flat and drops back to a *c*, then up to an *e* natural and back to the *c*. In an imitative phrase, he reverses it by ascending to a *c* sharp and back to an *a*, then to a *c* natural and back to the *a*.

Once more he uses the fourth as I believe it should be used, without repetition.

What's Good About Goodbye?

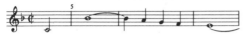

The song is *A* (18), *B* (14), *A* (18), an unusual form. It also has a second ending coda.

In "Mr. Imperium," a movie of 1951, there is another recognizably Arlen song called *My Love An' My Mule*. This is a slow, rocking song with a walking bass line. In the main strain there are no reinforcing chords in the right hand alongside the melody. And they're not needed, since the rolling left-hand part is enough accompaniment.

The principal characteristic of the song is a double-time measure which shows up throughout.

My Love An' My Mule

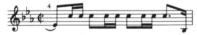

The cadence of the *A* section is odd and not easy to find without the harmony.

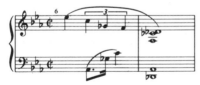

The *B* section is ten measures, and the over-all structure is *A-B-A-C*. It's a very groovy song which should have had a more prominent life.

A ballad in this movie, *Let Me Look At You,* is much too good not to have survived. It is by no means in the Arlen style. But it is a big-canvas, broad-lined song of great dignity, one not unlike Kern at his most independent.

I believe its obscurity is due to its difficulty. This is not in evidence

until the twenty-fifth measure, when it moves into F major from the parent key of C major. The ensuing melody continues in F for fourteen measures, entailing the use of many sharped notes not in C major, and returning to a *d* natural somewhat unexpectedly and, I feel, with inadequate preparation. None the less it is a splendid ballad. And the second ending contains a coda of twenty-seven measures which is very gentle, simple, and beautiful.

It was easy for the public to absorb the transition from the release to the main strain in *All The Things You Are*. Why wouldn't they work that hard for this song? It is certainly deserving of whatever concentration it would take to absorb it into one's musical memory.

Today, I Love Ev'rybody is from "The Farmer Takes A Wife," a 1953 movie. It's a bright, healthy, "walk-about" song, stepping out of its scale line only once with a *c* sharp (the song is in G). It is fairly conventional, but not cliché. Its chief characteristic is the fourth beat tied to the next measure, so thoroughly exploited by Youmans. And Miss Dorothy Fields supplies a cheery, civilized lyric, containing such fine lines as "if joy can be contagious, then catch this wild outrageous thing and get this world to sing: *Today, I Love Ev'rybody*."

The structure is *A* (16)-*A* (16)-*B* (10)-*A* (20).

V

In "A Star Is Born," the Judy Garland movie of 1954, there was an *alla breve* ballad called *Here's What I'm Here For*. Again, it is not my idea of Arlen; in fact, it has the flavor of Arthur Schwartz.

It is a very direct, uncomplicated melody, staying well within the boundaries of its key, E flat, saying nothing of great consequence but saying it well and cheerily. It sings easily, and my feeling is that the accompaniment should always be by a smoothly swinging band.

The other song in the film is one I played all day long in a Sunday bar room in Toms River, New Jersey. It was the Sinatra record, with a Nelson Riddle arrangement, of *The Man (Gal) That Got Away*. The customers and the bartender were either deaf or compassionate. Surely they couldn't have loved it for as long as I and my friends did!

This is a true Arlen song. If you are a good rememberer, try to

think of anyone else who might have written it. I don't see who it could have been but Arlen.

In this song Arlen makes marvelous use of the fourth interval. It occurs at precisely the apt places, the first cadence, the middle of the first release (yes, there are technically two releases), at the beginning of the second, and in the middle of the last strain.

In another 1954 film, "The Country Girl," there was an interesting song called *Dissertation On The State Of Bliss*, which title never appears in the body of the song. It's somewhat in the manner of *One For My Baby* in its use of chromatic steps and thirds in the right hand of the piano, also in its harmonic movement from the tonic, C major, through C-dominant seventh, to F major. This gives it what was clearly intended, the feeling of the blues.

Its form is A (10)-A^1 (10)-B (8), A^2 (12). There is also a coda.

Also in 1954, amazingly enough, appeared Arlen's most ambitious and beautiful score, that from "House Of Flowers." Though it had that great, stalwart performer, Pearl Bailey, it ran for only 137 performances. It was simply too elegant, too subtle, too far beyond the deteriorating taste of an expense-account clientele.

I Never Has Seen Snow has a melodic line which not only is much too beautiful for the expense-account ear, but it impresses me far more than the song-arias from "Porgy And Bess." These are hard words, and I presume I'll never hear the end of them. But I believe it, I've thought about it, I've carefully examined the music of both composers very carefully and without prejudice. I respect Gershwin, but I envy Arlen.

This is a curious state of affairs, since I made a point of bypassing "Porgy And Bess" simply because I believed it to be outside the boundaries of this book. But Arlen, though his melodic line in this song is musically in the category of "Porgy," does stay within the boundaries.

I should be clearer about my attitude. I am not comparing the scores of the two productions. I think what I'm trying to say is that Arlen proves in one song, *I Never Has Seen Snow*, that he is capable of writing within the territory of popular music and arriving at a quality of vocal composition which is superior, I feel, to that which Gershwin achieved outside that territory.

The introductory section of *I Never Has Seen Snow* is very beau-

tiful, the beginning of a long melodic flow which continues to the close of the song. Yet it is modestly called a verse. As a matter of compositional interest, the closing bars of this so-called verse introduce a figure in the left hand of the piano which prepares the listener for its tighter voicing in the chorus. It comes off as a shift in orchestral color.

This is the version in the verse:

I Never Has Seen Snow

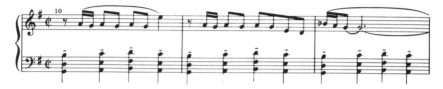

This is the chorus version:

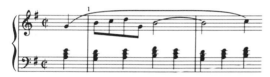

Note, if you will, the raised note, *c*, following the half note *b* in the second measure of the chorus. I know this is a vocal device Arlen is very fond of. But, in this instance, I am puzzled, as the *c* comes off as a scrape.* I do see the charm of the *portamento*,† but, to me, it should move to a higher note, *d*, or even to a high *g*. I notice in the Percy Faith record that he does not use the *c*. He uses, I think, a *d*.

Arlen's constant searching and growth kept reaching high plateaus. The first big one was in *I Had Myself A True Love;* and now, *I Never Has Seen Snow*.

I'd prefer not to isolate phrases from *I Never Has Seen Snow*, but rather to suggest to the reader that he view the song as a whole either by finding the sheet music, which comes in a bound folio, or buying a record.

* A dissonant passing tone.
† A slide. In more formal usage the technique of carrying the voice from one pitch to another through all the intermediate pitches.

Two Ladies In De Shade Of De Banana Tree is a great swinging, even driving song. And yet there is a grace about its aggressiveness which keeps it from sounding as if its only purpose in life was to be sold.

It risks monotony by sticking for eight measures to varying attitudes of only two notes, *b* and *c*. It's fantastic how, by means of shifting the rhythmic emphasis, Arlen manages to increase rather than decrease the intensity. And then, when the tune breaks loose with the title phrase, it's like a rocket taking off after the crescendo of the preliminary sizzle. Except that the first eight measures happen to be the very best sizzle you've ever heard.

That title phrase is repeated, then turns into the final cadential phrase. Here is the whole statement:

Two Ladies In De Shade Of De Banana Tree

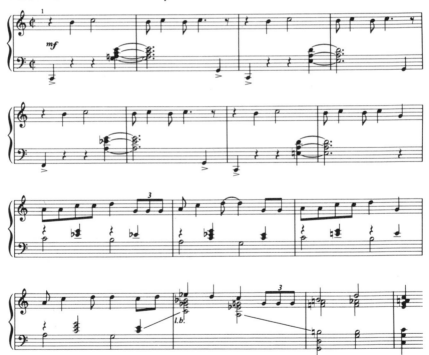

The form is very free insofar as, after two identical *A* sections, the following release is only eight measures and the restatement lasts only two measures, moving on into a new melodic idea and, after ten measures of it, suddenly returning to the original cadence.

A Sleepin' Bee is a very dear song from "House Of Flowers." Its initial and principal strain is self-sustaining and, in fact, resorts to no harmonic invention. It even maintains a pedal point for five and a half measures. The second strain, however, is enhanced by its engaging chromatic harmony.

VI

Although Arlen wrote more shows, and some complex experimental songs in "Jamaica," I feel that the songs already discussed pretty well cover the best aspects of his multifaceted talent.

He entered the field of popular music at a propitious time, one in which he could spread himself and experiment rhythmically, harmonically, and melodically as he never could have even ten years before. To me it is like an invention, let's say the camera, appearing, and before you know it there is a man who seems, by his aptitude, to have been born to be a photographer. Had Arlen been born sooner or later than he was, there would have been little in the musical air to inspire him to be a writer of songs. In just about the span of twenty-five years the whole lovely, warm-hearted, clear-headed, witty, bittersweet world of the professional song writer was gone.

Arlen, like Rodgers, reveals in his melodies a deep-rooted need to express himself. In both men there is a very personal, almost private approach to creation, rather than the professional capacity to contrive and produce reasonable facsimiles of the real thing. It is very much to the credit of the public that it has so wholeheartedly accepted the writings of these men. As I must have made clear by now, I am not precisely Pollyannaish about the layman's appreciation of the arts, and I am therefore astonished by his acceptance of, and enthusiasm for, many of the great unsimple songs.

The reader may notice the absence of any mention in this discussion of Arlen's music of his "American-ness." This is very simply because, even more than in the case of Youmans or Berlin, there is nothing else. Even in Arlen's later, more mature and ambitious melo-

dies, he never drew upon or was influenced by European music of any kind. He is wholly a product of American jazz, big band music, and American popular song.

VII

The following comments are in the nature of an aside, for they concern matters of almost entirely personal concern. But because I wish to remark a unique quality in Arlen's approach to song writing, I feel that they should have a place in this survey of American popular song.

Had I not been a musician, a lover of orchestral colors, and virtually a student of popular music in all of its manifestations, perhaps I wouldn't have been so aware of the broad musical implications present in even the simplest piano copies of his songs.

Here was a new kind of writer, one who could never tolerate being left out of all that followed the writing of a song. Naturally he needed middle-men, performers and promoters, but one knew that he would be as involved as he possibly could be all the way down the line to the ultimate fruition: the performance. And since I, too, knew more music than I needed to in order to write a song, I was immediately more sympathetic to his songs than I was to songs which I felt had been written by those who considered their responsibility over once the song was written.

Another element in his writing which drew me to him was my feeling that he knew how close vocal writing was to controlled, lyric instrumental writing, and that the fluid sinuosity possible to a clarinet, trumpet, or trombone, if carefully controlled, would help to suggest more inventive vocal lines. And his own vocal training was there to warn him of excesses.

In sum, the most specific reason for my affection for Arlen's music is that his songs suggested a greater musical thoroughness than those of other writers. By "thoroughness" I mean the sense of a finished product. Within the piano part there was evidence of the song in its performance. One sensed the seeds of orchestration, one knew somehow that he had thought the song through to its final phase, the performance of it, whether it be by a singer, a piano, a band, a jazz group, or a band with a singer.

There wasn't the usual feeling of the song's isolation. It was as if the writer of a book were to have seen his words through the presses, all the way to the bookstore. Not that the piano copy informed me that Arlen would be the orchestrator, or that he would choose the singers and the members of the band, but that his was a more thorough knowledge and involvement than that of other writers.

—8—

Vincent Youmans (1898-1946)

Arthur Schwartz (1900-1984)

I

VINCENT YOUMANS
(1898-1946)

The name Vincent Youmans is as well known, though not as famous, as George Gershwin. He was Gershwin's contemporary and, like him, died young.

One assumes that his reputation was based, not only on famous hits, but on a large body of work as well. So it comes as a surprise to learn that only ninety-three of his songs were published, though he did, in fact, write twice that many. In the words of Stanley Green, musical theater historian: ". . . his Broadway output consisted of twelve scores and his Hollywood contribution comprised two original film scores. He became a professional composer at twenty-two, an internationally acclaimed success at twenty-seven and an incurable invalid at thirty-five." He died at forty-seven.

Amazingly, to me, his reputation is based upon only a fraction of those ninety-three songs. Furthermore, and this is strictly my own opinion, among the famous songs there were only a few which possessed true theatrical flair and flavor. Most of his famous songs were very superior pop songs. In no instance was there a musical indication that he had as much as heard a Kern song or an operetta. In fact, though he did have stylistic idiosyncrasies, his songs revealed no reverence for any other writer, whether or not he, personally, had any.

The quality of "American-ness," which I have mentioned from time to time, was his from the first known song, *Hallelujah!*. Both

Mabel Mercer, who knew him well in Paris, and Irving Caesar, who wrote with him, say that he played very good piano, and Caesar adds that he always whistled his melodies and played accompanimental piano.

For some years a legend existed that Youmans had left a trunk filled with music written in a code-like shorthand no one could decipher. Theater historians Miles Kreuger, Alfred Simon, Stanley Green, and Robert Kimball have examined the manuscripts. The legend is empty, but the trunk is, indeed, full. And, one is happy to learn, Youmans wrote a quite orthodox notation in a meticulous hand.

Mr. Caesar remembers him as having been an indefatigable worker, a man of intense enthusiasm for song writing. Youmans was not a true trail blazer except insofar as his early songs were of a swinging nature long before the big bands were there to swing them. I do find the pop quality of his songs somewhat of a mystery. I naturally assumed that the songs in his theater scores would have had a broader sweep and a longer line than they do. His piano accompaniments show marked harmonic sophistication and great melodic ingenuity but little of that distinctive, however elusive, element that earmarked a theater song.

There is no way of determining whether the version of *Hallelujah!* used in "Hit The Deck" in 1927 was the same as that which he wrote while stationed at the Great Lakes Naval Training Station during World War I. Since, however, it was not published until it was used on Broadway, it will be considered later.

The Country Cousin, his first published song, appeared in 1921, and had nothing to do with the theater. Stanley Green says that Youmans and Alfred Bryan, the lyricist, "tried to cash in on" the silent film "The Country Cousin." I don't expect they did cash in. The song is of little account and undeserving of comment.

But in 1921 Youmans did write a very respectable song, *Oh, Me! Oh, My!*, for "Two Little Girls In Blue." It is still heard today, not often, but is certainly characteristic of his writing.

It consists of two ideas, the first more or less dependent on its changing harmony, as it is merely three sets of a drop of a fourth from *a* to *e*, and the second a quarter-note scale line. Even in its extreme simplicity, it is an ingratiating little tune. The key is C major, and the song has a repeated drop of a fourth, from *a*, the sixth note

of the scale. Any repetition of this note in the scale usually arrests one's attention. But I'm afraid that, because of the unsonglike rigidity of its repeated *a*'s and *e*'s, *Oh, Me! Oh, My!* barely gets under the wire as a song. It suffers from the same unvocal quality that later marked *I Know That You Know.* Splendid, musically, but lacking vocally.

In 1923, in "Wildflower," there were two big songs, both of which became standards. The title song is most certainly not characteristic of Youmans and is also, to me, contrived and arch. I find in it none of the characteristics of a great song.

The other, *Bambalina,* has never been one of my favorites. Its obviously deliberate monotonous melody bears no mark of Youmans at his best nor, I'm afraid, would I know it to be by an American (unless I knew who wrote it).

Until I read the lyric recently, while examining the song, I never knew that it had to do with an elderly fiddle player named Bambalina. The "a" ending gave me to think it was a girl. In the last lines of the chorus the name of the old man has become the name of a dance. Confusing.

Again, from the lyric, I gather that the whole thing is a form of Musical Chairs. This is by way of saying that undoubtedly the melody was hinged on a production number notion, and the fact that it turned out as it did was due to theatrical demands.

In it, however, is a characteristic of Youmans' writing, that of using material of the main strain in the release. The main strain consists of six measures of uninterrupted quarter notes, a great many of which are repeated *g*'s (the fifth interval in the key of C). In the release, the quarter notes are again used uninterruptedly for six measures, though the principally repeated note this time is *c*. The point is simply that Youmans, instead of "releasing" his melody, reinforces it. In this melody the result is truly monotonous. But I assume that this unrelieved insistence was exactly what made the song work on stage. Off stage my eyelids tend to droop.

In "Mary Jane McKane" (1923), there was a song called *My Boy And I* which was to serve as the source of the title song of "No, No, Nanette" (1925). In fact, it is very nearly identical throughout. Its major dissimilarity is its rhythm, which is 3/4 as opposed to *No, No, Nanette!*'s 2/4. Below are parallels:

My Boy And I

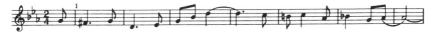

No, No, Nanette!

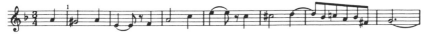

Come On And Pet Me, dropped from the same show before it opened, should be mentioned. Except for one note, it has the same melody as *Sometimes I'm Happy*. Also, the music of the verse is the same as that of the later song. The only difference in the choruses is that *Sometimes I'm Happy* is in *alla breve*, cut time, and *Come On And Pet Me* is in 4/4. As a result the note values of the latter are half that of the former. Also, the lyrics are by different writers.

"A Night Out" (1925) never reached New York, but its score included *Sometimes I'm Happy*, with lyric by Irving Caesar. A perennial favorite among jazz musicians for forty years, it is a loose, uncluttered song with plenty of open spots and no harmonic complexity, just the kind for improvisation or a swinging arrangement. Yet it is not specifically a rhythm song: it is what is called a rhythm ballad. It has one of the narrowest ranges I have come across, a half tone less than an octave. It was later used in the score of "Hit The Deck" (1927), where it became a hit.

The phenomenal hit of "No, No, Nanette" (1925) was, of course, *Tea For Two*. Because of the abrupt key shift in the second section from A-flat major to C major, it is very surprising to me that the song became such a success. And not only that, but after the key change and at the end of the C-major section, the song is virtually wrenched back into A flat by means of a whole note, *e* flat, and its supporting chord, E-flat-dominant seventh.

Irving Caesar has said that the opening section of the lyric was never intended to be more than a "dummy," one by means of which the lyricist is able to recall later on, while writing the true lyric, how the notes and accents fall. He also says that, in order to use the words he wanted in the second section, the C-major section, he persuaded Youmans to add notes which resulted in its being similar to, but not

an exact imitation of, the first section. Below are the rhythms of the first and second sections.

Tea For Two

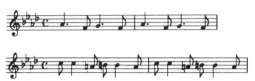

As you can see, the second eight measures consist of a pattern of eighth, quarter, and eighth notes instead of the earlier pattern of a dotted quarter and an eighth. Also you may note below, the cadence in the second section, an *e* natural whole note, supported by a C-major chord, followed by an *e* flat, supported by an E-flat-dominant-seventh chord.

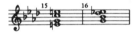

But for the rhythmic variance in the second section, the entire song is made of dotted quarter and eighth notes. This certainly ran the risk of monotony, yet the record stands: it was one of Youmans' biggest songs and it remains a standard forty-odd years later.

In it Youmans again stuck to his germinal idea, the dotted quarter and eighth note rhythm and hence avoided an interruptive idea. It is another narrow range song, this time only one whole tone more than an octave. The song does achieve a kind of climax by moving to a high *f* in the last section, but, for me, it in no way achieves the quality of a theater song.

The Boy Next Door, a very good, direct melody, not to be confused with the much later Hugh Martin–Ralph Blane standard, was cut before "No, No, Nanette" opened. It is a strong, independent-of-harmony melody, not typical of Youmans, but certainly worthy of having a longer life than it did. I had never heard of it until I started this survey, and so I must presume that any attempts to revive it must have been limited to obscure record labels.

It is not a series of two-measure imitations like *Tea For Two*, but a long-line, eight-measure phrase. In this case there is a release which

is the climax of the song, and the range is an octave and a fourth. The successive measures of the main strain are imitative, but these imitations constitute a continuous line. I find it a very sweet song. Below are the first eight measures.

The Boy Next Door

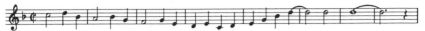

In "Oh, Please!" (1926), there was another of Youmans' well-known songs, *I Know That You Know*. It's a rousing rhythm song, using throughout verse and chorus a device by no means exclusively Youmans', but one he was fascinated by and handled very skillfully. In *alla breve* time it is the accented fourth beat tied to at least a half note in the following measure. It is likely that his success with this device brought it into such popularity that other writers continued to employ it. That is not to say that he was the first to use it, but that he made the most of it.

He starts right out with it in the verse, which has such character that I am able to recall it forty years later. This is very unusual for me, and, I presume, for most people.

But for the interruptions of two quarter-note scale lines at the end of the second half of the chorus and the end of the song, it is a series of dotted half notes followed by quarter notes tied to dotted half notes. This device again risks monotony and, frankly, does become monotonous without the chord changes.

I Know That You Know

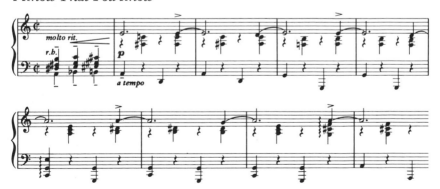

The chorus is introduced by three quarter notes which are marked *molto rit* and which I have seldom heard unless the performance has included the verse.

The dexterity of the melody lies in its quarter note scale line which provides an absolutely essential contrast to the reiteration of the rhythmic device illustrated above. And it is another melody with what I think of as a pop song range, an octave and a third, though the song is not in the pop song genre. This is in part due to the *alla breve* rhythm and the heavily accented fourth beat. No, this is distinctly a theater song.

I almost said "theater *piece*" instead of "song," for it isn't truly song-like except for the rather uninventive scale-line passage. This is also true, to a lesser degree, of *Hallelujah!*. They are both, as a friend calls them, theater set-pieces. They play better than they sing.

"Hit The Deck" (1927) had one of Youmans' best scores. In it was the song, possibly revised, that he had written in 1918, *Hallelujah!*. Here is an instance in which the accented, tied-over fourth beat is used throughout the chorus. It's a big, declamatory song set up by a long, strong verse, longer than the chorus.

The chorus is in strict *A-A-B-A* form with the widest range of any of his better-known songs up to this time, an octave and a fifth. Its main strain concentrates on *b* flat, the fifth interval in the key of E flat, and its principal interest lies in its syncopation created by the tied fourth beats. The release, though it continues to maintain the rhythm of the *A* sections, is much more interesting, both melodically and harmonically. It's only a series of imitations, but the *c* flat and *d* flat in the melody are highly effective.

Hallelujah!

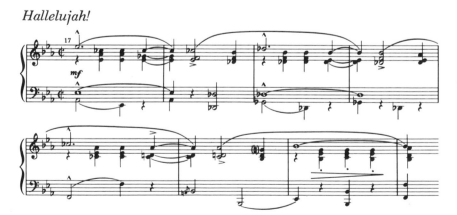

I might add that, up to this point, Youmans had not been very fortunate in the lyrics for even his most successful songs. Not one of them was better than those written for average pop songs. They had no stylishness, no inventive rhyming or wit, though written in some cases by writers of distinction.

An Armful Of You, cut before the opening, was a routine pop tune. But the first two measures of the verse should be illustrated to show the marked sophistication of Youmans' piano part. I have never seen another verse or chorus start out on so unexpected a dominant chord and then continue in this sequence, with this melody line (*d, e* flat, *c, d*), except in these two cases.

An Armful Of You

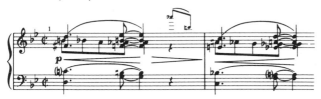

Lucky Bird is a pleasant little sixteen-measure song, again more pop than theater-like. Except for its first, second, and third cadences it is quite notey. But this is the nature of the song and it suggests that a slower tempo is required than the *moderato* marked at the beginning.

For its time, its harmony is interesting and helps make the song more provocative. The fragmentary idea which continues throughout is like a casual riff of that day. Here again Youmans doesn't write in the third section (measures nine through twelve) a release. Rather he develops his original idea.

Nothing Could Be Sweeter is a jovial rhythm song which surprisingly turns out to be thirty-two measures long. Its principal idea is made of two phrases, the second of which is an imitation of the first. And it has a two-measure cadence, as does *Lucky Bird*. In these days of unexpected odd-measured sections, I believe the cadences of both songs would be one measure, as there is an uncalled-for hiatus in a cadence which is as long as the melody preceding it.

The fifth through the eighth measures are identical with the first phrase except for the end of the cadence which leads into F major rather than back to C major. The form of the song is *A-B-A¹-C/A*. This is unusual for Youmans, as is the *C* half of the *C/A* section. The melody is based, and depends, on four dominant seventh chords, rising in each measure a half step. This makes for some difficulty in finding the melody notes, but it does build the tune up to its final restatement.

This song, like *Lucky Bird*, is cheery and memorable but nontheatrical in structure and intensity. In case the title is unfamiliar to you, it was also known as *Why, Oh Why?*, with an entirely different lyric except for identical lines in the first two measures of the verse. It was replaced in the show before the opening by *Why, Oh Why?* In either form, the music sounds more English than Youmans.

One inevitable scrape occurs in the second measure and all equivalent measures. The chord is D-dominant seventh. This chord contains an *f* sharp. Yet the second note of the melody is a *g* natural. Granted it's only a passing tone, yet due to the chord it comes as a surprise and, as I said, a scrape. Had the *f* sharp been delayed one beat and the first chord been a suspended D-dominant chord, there would be no scrape. Yet, curiously, it is more satisfying as it is. I admit I can't understand why.

Keepin' Myself For You (from the film version) is a cheery rhythm ballad. For 1929, the drops from *g* flat to *d* flat (in the key of E flat), then from *a* flat to *c* flat later on, were ahead of their time, and so characteristic of the song that either phrase could call to mind what song it was from.

Keepin' Myself For You

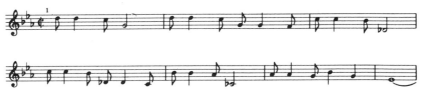

The release was highly unusual in that it begins in the key of E natural and stays there for three measures. Then it makes a cadence

on a *d* natural, supported by a sudden and unexpected B-flat-ninth chord, allowing the second phrase to return to E flat.

This song is another of those more in the pop than the theater category.

In "Rainbow" (1928), which lasted only thirty performances, there was a very snappy, exciting rhythm song called *The One Girl*. Unfortunately it did not have a long life, and this is understandable when one finds in it such lines as "waits until my troop comes over the trail" and "cheers me when I go out to the fight, boys." This muscled point of view obviously had to do with the Western plot, but it doesn't help make a standard song.

The basic rhythmic device Youmans used here is one I've never seen elsewhere. It consists in placing the stress on different beats in successive measures. Though this was not new even then, Youmans' device was, as the stresses fell on the third beat of the first measure, the second of the second measure, and the first and fourth of the third measure. The effect produced by this was as if these measures were all in 3/4 with the final beat of each measure accented. But, since the rhythm is 4/4, the result is one of almost bewildering oddity until the melody in the fifth measure straightens matters out with a succession of four evenly stressed quarter notes.

The One Girl

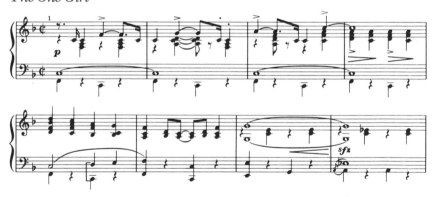

Also note the sly fashion by means of which the harmony in the eighth measure moves to B flat. Notice further that the rhythmic fig-

ure of the first phrase is restated at the ninth measure a whole tone higher.

I Want A Man from the same show is an extremely inventive song in every way, from beginning to end. I'm amazed that I've never heard of it before. In the first place, the piano part sounds more like one of 1938 than 1928. The passing tones, the major sevenths, the instrumental voicings are far ahead of the twenties. For example, note the voicing of the first measure in the following illustration and the extended quarter and dotted half note patterns.

I Want A Man

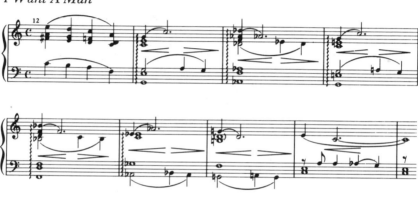

Also note how, in measure nineteen (repeated in twenty), the descending chromatic figure sets up the pattern which follows in the unusual piano part of the chorus.

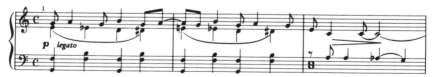

This rhythmic pattern in the chorus, for two measures, suggests the time signatures 3/4, 3/4, 2/4.

Again, in the last section of the song, note the voicing in the piano part and the skillful way it returns to the main idea. This song has an Arlen quality, though he had yet to be heard from.

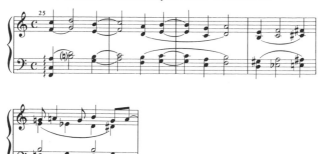

It isn't a particularly theatrical song, but it's very neat and sophisticated and ahead of its time.

It does seem that Youmans seemed to have had more fun in, and felt more at home with, straight 4/4 rhythm than *alla breve*. Though three of his big songs were in *alla breve*, they come off less as songs than as theatrical effects, while such an unknown song as *I Want A Man* reveals an element of personal care and pleasure in its writing.

In the movie made of "Rainbow" in 1929, called "Song Of The West," there was the song *Let Me Give All My Love To Thee*. It is subtitled "Hymn," and its harmony is deliberately four-square and hymn-like. Yet the melody, in the second and third measures, employs the device of 3/4 phrases, causing it to swing a little. In these days of jazz masses this would be old hat, but not in 1929.

It is a very attractive song, though not among Youmans' well-known melodies. There is no verse, and the song is only twenty-four measures long. But I believe it deserves much more attention than it has received. It is probable that the hymn-like change of harmony on every beat and the fact that it is called a hymn may have caused singers and bands to shy away from it.

It is strange that a piece of writing as uninspired as the chorus of *West Wind* could have been preceded by such an inventive, far-out verse. Though only eight measures long, it creates a mood which leads one to anticipate a whirlwind of a chorus. Instead of which, one is becalmed by a complete cliché. Not only couldn't verse and chorus have been written at the same sitting, they couldn't have been written in the same month.

In another flop show, "Great Day" (1929), there were three

worthy songs. The least known of these today is the title song. It's another rouser, a come-to-meeting song in the manner of *Hallelujah!*. I may be somewhat prejudiced in its favor as the result of having heard many times a Whiteman record of it which contained a great trumpet solo.

The verse is very florid and "inspirational." It isn't a verse as much as an exclamatory introduction to the chorus. The latter, for those who have never heard it, comes as a complete surprise in that it is much less dramatic than the verse.

The main strain comprises only three notes, not more than a step apart from one another. The second eight measures is a precise repetition of it a third higher. The release resorts to wider steps, and the final section is the same as the first. The syncopated fourth beat, tied this time to only a quarter note, is the rhythmic characteristic of the song.

Except for the release, the song is curiously subdued for one with such an enthusiastic title. Raising the main strain a third in the second section and then ascending to a high *e* flat (the key is E flat), does make for climactic intensity. But then to repeat the first section literally does seem a little lacking in dramatic appeal. Somehow the phrase "great day" demands a high ending.

Throughout the chorus the harmony is minimal with all but the release suggesting a possible pedal point.

*More Than You Know** is, for me, Youmans' best ballad. I was, however, surprised to learn that it was a show tune. It ranks among the best of the pop songs I have heard.

Its verse is nearly a complete song in itself. It is in C minor as opposed to the C major of the chorus and it was clearly written with great care and affection.

The principal characteristic of the chorus is the use of quarter note triplets, to be found immediately as the pick-up to the first measure. There is a concentration on the *a*, the sixth interval, interesting perhaps only to me as being such a provocative note when repeated.

And then there is the unusual, almost rhapsodic release. It has much more character than most releases of show or pop songs. And it makes a very unusual leap of a tenth from the low *b* at the end of its first phrase to the high *d* at the beginning of its second.

The song is so well known it probably needs no illustration. But here is the release:

More Than You Know

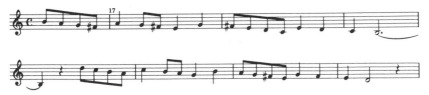

Without A Song is virtually an art song. And if not quite that, it is most certainly a favorite of concert singers. It has the wide range of an octave and a fifth. I'm sorry to say that I find it quite pretentious, both lyrically and melodically. It was probably intended, however, to fulfill a dramatic need in the show. It no longer could, I'm afraid, with such a word as "darky."

I suppose that, except for the opening *e*, the main strain could be called pentatonic in that it avoids the fourth and seventh intervals throughout. The melody concentrates on the notes of the F-major triad.

It truly does not contribute any added flavor to the world of great American popular songs. In its way it irritates me much in the same way as do the mountain climbing songs of Rodgers and Hammerstein.

It is interesting that Harold Arlen was to have sung a song in this show, *Doo Dah Dey*, but it was dropped before the opening. He also was drafted to take Youmans' lead sheets to the lyricists, Billy Rose and Edward Eliscu. As he observed to his biographer, Edward Jablonski, he came to know the music better than Youmans did.

In 1930, in the show "Smiles," which ran for only sixty-three performances, there was another famous Youmans song, *Time On My Hands*. It's a very good song and, though unusual, very easy to learn and impossible to forget.

It has a good verse, the best kind, in fact: one that sounds as if it had been written at the same time as the chorus. Many good verses fail to please because they are from a different bolt of musical cloth than the chorus. The verse of *Time On My Hands*, besides being a good piece of writing, leads naturally into the chorus. This "leading-in" quality is rare, as many good verses have cadences of a finality that tends to separate them from the chorus.

There are two specific characteristics of the melody of the chorus in this song. The first is the quarter note triplet. It is a constant factor even in the release, though employed there more sparingly. The result of the triplets' use in the release is that it comes off less as a release than as a development of the melody.

I find the return to the main strain following the release somewhat frustrating—due to two small notes in the voice line which have no accompanying words.

Time On My Hands

The *c* and the *g* sharp are an integral part of the melody, and it surely couldn't have been that difficult to find accompanying words or syllables.

It is a very gentle, persuasive melody with no dramatic intentions, yet it has a closing section with imitative quarter note triplet phrases which are higher each time, thereby increasing the intensity of the melody and providing it with a quality of fulfillment. Even in such a short, uncomplex form as the popular song, this quality can be achieved.

Again I must add that though the song is in *alla breve*, a time signature usually associated with theater songs, it still has the mark of a superior pop song. I would not make such a constant point of this were I writing of theater songs of the fifties, since pop writers had by then infiltrated the musical theater. Although the latter have managed upon occasion to write theatrically, they have failed, by and large, to create songs of the elegance, long lines, and special sophistication which one has come to expect from theater songs.

I should also mention that there still continued to be a parade of lyricists for Youmans' songs. This is most unusual, because after this many years in any song writer's career, particularly that of a theater writer, he has usually settled upon a single lyricist. And if there are changes, the new lyricists do not bob in and out so rapidly. It is conceivable that Youmans was unable to work with others easily, or that

he was never fortunate enough to find the sentiments he sought from the available lyricists. Certainly the level of lyrics for his songs was not high nor to be compared with that of Ted Koehler, writing with Harold Arlen at this time, Ira Gershwin, writing with his brother, Lorenz Hart, writing with Richard Rodgers, or Irving Berlin, writing with himself.

In another flop show of only twenty performances, "Through The Years" (1932), there was a semi-religious, semi-shouter song called *Drums In My Heart* which has maintained semi-standard status down the years and is in the *Hallelujah!* category. Its verse is replete with pedal points, simulation of bells, good works, hope for tomorrow, and everything but Salvation Army solicitations. It was probably highly effective in the theater, but for me it has the quality of a college production song.

The chorus again uses the syncopated fourth beat as its hallmark. It is also dramatic melodically and lyrically, but it suggests only the set-piece, the production number, and, I suspect, a battery of drums.

This song, like *Great Day*, has an unexpected low ending. If ever one anticipates a high climax, it is in this song. Since, by putting the last phrase up an octave, one would not take the song out of its comfortable range, it is doubly surprising that it wasn't done. For it would still have left the chorus with the narrow range of one tone more than an octave.

Through The Years is said to have been Youmans' favorite among his songs. I can't say that it's mine. And if, in my prefatory remarks to this chapter, I said anything to the effect that Youmans never engaged in pretentiousness or artiness, I must have forgotten *Without A Song* and, more particularly, *Through The Years*.

With its long single ending, the latter is fifty-two measures long. It has no verse. Its first phrase is very simple and definitely hymnlike. Then, as it attempts to develop, it seems to me to get out of control and starts to wander. After twenty-five measures (and why the cadence at measure twenty-four isn't limited to one measure I'm not certain, unless it be that an extra measure is needed to prepare for the return of the original idea) the melody builds up to a high *g* and then falls off with an inexplicably long, four-measure cadence, after which comes the final phrase.

Youmans' last Broadway show was "Take A Chance" in 1932.

However, the score was not exclusively his. Richard Whiting and Nacio Herb Brown also wrote songs for it.

One of the Youmans songs from this show which has been kept alive by Mabel Mercer is *I Want To Be With You.** It is a very warm and romantic ballad, with yet another lyricist. The fact that it has never become a true standard may be due to the extreme complexity of the first, third, and fifth measures of the release.

I Want To Be With You

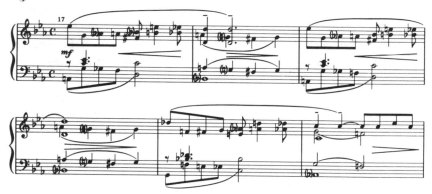

As you can see, the *e* natural in the second half of the first and third measures, and the *d* natural in the fifth, are extremely difficult to reach, even with the help of the harmony. In both instances the note is reached by means of a diminished fifth, an unnatural melodic step. Also, having established an *e* flat in the first instance, it is hard to find the half step above it so soon, indeed, in the same measure.

In the Mary Martin record these notes are very shaky, and even in the case of Miss Mercer, who has superb intonation, these notes are occasionally not as firm as one would like. Of course, musically, this release is great, very inventive and unexpected. Also the piano part is very well written.

I am pleased that the melody begins on the sixth interval, and I find especially endearing the movement of the melody in the third, fifth, and equivalent measures. The ascent to *b* flat with its drop of a fifth and then a half step is as tender as a touch. And then the ascent to *c* natural in the fifth measure, followed by the drop of a sixth and then a half step, somehow wraps it up.

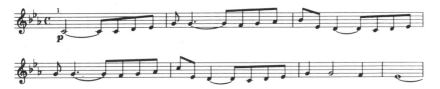

*So Do I,** from the same score, is a very solid, swinging song, verse and chorus. It is much too good to be so little known. Upon reading the lyric, however, it becomes a little more understandable. For it is a "list" song and, even excusing "names" no longer in the public eye or ear, it's a very far cry from the wry style of the master of list songs, Cole Porter. It's simply an uninspired lyric—too bad considering the neat nature of the melody.

The characteristic of the chorus is the very adroit use of chromatic lines, unused till now by Youmans.

So Do I

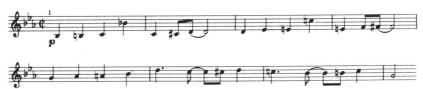

He changes the design of the melody in the release without deserting his chromatic lines. This, as I've said before, is a very good characteristic of his style, as it keeps the release from being too isolated from the main strain.

And I find the verse very much of a piece with the chorus and admire the chromatic bass line of the first two measures.

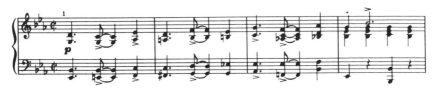

I suppose the almost forced good cheer of *Drums In My Heart* and *Rise 'N' Shine,* also in "Take A Chance," were reflections of the far

from good cheer of the depression years. *Rise 'N' Shine*'s injunction to grin and bear it is almost like a Christian Science recruiting song. After one chorus you feel that if you don't *Rise 'N' Shine*, you'll be arrested.

The music of the verse is a mystery to me. After all, by now it is 1932 and such a cliché as its featured phrase is well out of fashion. It belongs almost literally to the days of *Ev'rybody Step* by Berlin.

*Rise 'N' Shine**

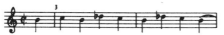

The chorus is as rousing as its lyric, if somewhat less peremptory. The second phrase of the melody pleases me by its ingenious reworking of the notes of the first phrase.

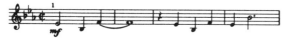

Youmans' last major effort was the highly successful score for the film "Flying Down To Rio." It was undoubtedly his most consistently theatrical score. And I should not be surprised if this fact were not to an extent due to the presence in the cast of Fred Astaire. (In the case of some "Astaire songs," I sense, very strongly as a matter of fact, that even before the song was written he had already worked out his dance sequence, and that the rhythmic patterns of the steps that he had created helped shape the music.)

Nearly all the songs in this score show a marked Latin influence—and should. As a result they don't truly add to the body of American song writing. The rhythmic and melodic devices are all those of another culture, engaging, to be sure, but characteristic of Latin style.

Carioca is a big production number interlarded with instrumental interludes and containing three distinct melodies. They are called "verse," "refrain," and "trio," but each is as strong as the others. I feel that there is no point in going into detail about it, simply because of its un-American-ness.

Music Makes Me, on the other hand, has no Latin flavor. It was sung by Ginger Rogers, but has a strong Astaire-like rhythmic feeling. Its

main strain consists of three smooth measures of half notes followed by a measure of quarter notes and then two very rhythmic measures and the cadence. The contrast thus provided works very theatrically. And the release is clever, made of an inventive rhythmic phrase followed in precise imitation a fourth lower. Its harmony is not so much complex as unexpected and highly satisfying, moving, to be sure, through a pattern of dominant seventh chords, but logically and expertly arriving at a G-dominant seventh on its last measure. Although he did not perform it, Astaire's influence may be felt in the song.

Orchids In The Moonlight is a tango, the verse of which is as strong as the chorus. The opening phrase of the chorus is like that of a later song by another writer in which the intent was to introduce a foreign flavor. It's a very well-written Latin song, a standard to be sure, but of no concern to this survey.

The title song is rather a pallid, bland piece of writing, to me, much less interesting than the verse. The latter's contrasting first eight measures have a bite and a wit not to be found in the chorus.

Flying Down To Rio

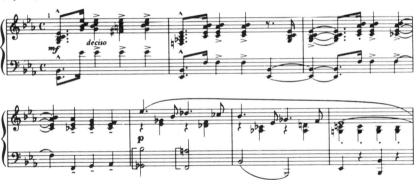

After reading over what I've written about Youmans, I realize that I've scarcely acclaimed him as one of the great innovators that he was. On the other hand, in all honesty I can't acclaim him as one of the great writers of theater songs, for with few exceptions his songs were better-than-average pop songs.

That this distinction between theater and pop songs existed and still does, sporadically, till this day, cannot be denied. But how any-

one could claim that *Keepin' Myself For You* or even *Tea For Two* were competent examples of theater songs is beyond my comprehension. *Hallelujah!, Rise 'N' Shine, Great Day,* and *I Know That You Know* are distinctly theatrical in flavor and not just because they are in *alla breve* rhythm or syncopate the fourth beat, though those factors help. It's because the canvas is larger, the line broader, the intensity greater.

But where are the long-line ballads outside of *Through The Years* and the little-known *The Boy Next Door*? Youmans simply didn't write them. He was a cheery, rhythmic, harmonically sophisticated writer. But was his flair primarily song as such or was it singable lines primarily conceived for piano or band? There is irony in his bursting into outstanding theatrical writing with a score that had a Latin flavor.

His interest in using ideas from his main strains in his releases was definitely an innovation and, as has been observed, his search for new ways to make simple, direct statements was almost always present. There is no doubt that his good songs are unforgettable and, while not always marked by an easily identifiable personal style, his songs certainly never sounded in any respect like those of his contemporaries. And it must be kept in mind that the bulk of his work was produced in more musically innocent days than those of, let's say, Harold Arlen, another totally American writer.

Comparison with Gershwin is inevitable, since they were writing at the same time and for the theater. My enthusiasm for Gershwin isn't as glowing as that of most theater music lovers, but I feel that while many of his theater songs didn't have a theatrical flavor, many more of them did than those of Youmans.

I am forced by fact to consider Youmans as a writer of theater music. If I weren't, I'd be able to speak highly of him as an advanced writer of pop songs. In his constancy toward the American musical point of view and his rhythmic and harmonic inventiveness he was, indeed, one of the innovators of American popular song, and one of the truest of the believers in the new musical world around him.

II
ARTHUR SCHWARTZ
(1900-1984)

Arthur Schwartz wrote some splendid songs. They have the character and sinew of the best of theater music. None of these songs concern themselves with anything but the American musical atmosphere of the time. Schwartz never looked over his shoulder at Europe or operetta or the concert hall. He wrote with total self-assurance and high professional skill and never lingered by the wayside to gaze with longing at the musically greener grass of Culture. He rolled up his sleeves and went to work.

The only mystery is that he didn't produce more. One would assume that a writer first heard from in 1926 and still writing great songs, even if for unsuccessful shows, in the early 1960's would have written more fine songs than he did. As this examination proceeds, however, you will notice that there are curious time lapses between the publication of his best songs, that is, after his first big spate of them in the early thirties. It's almost as if he interrupted his musical career to do other things.

Though he wrote for "The Grand Street Follies" in 1926, the first of his songs to attract public attention and the first of any distinction was *I Guess I'll Have To Change My Plans*, in "The Little Show," a revue of 1929. It came to be known as *The Blue Pajama Song* because of a line in the second stanza of the lyrics by Howard Dietz: "why did I buy those blue pajamas?."

It's in the "soft shoe" genre, suggestive of 6/8 rhythm, but actually in *alla breve*. This is an immediate puzzle, since the piano part and the tune itself are definitely in 4/4, a rhythm in which all four beats are stressed as opposed to the first and third beat stresses of *alla breve*. It's a very sweet, warm song suggesting a dance as much as a song, as charming as the lyric is. It's only twenty measures long. The form, considered in four-measure phrases, is *A-B-A¹-C-A¹*.

It attempts no unexpectedness nor unusual harmony, but is a true song in that it is completely satisfying as an unaccompanied melodic line. And it has an extremely tasty verse, not in the soft shoe idiom.

Since this chapter includes a discussion of Vincent Youmans' music,

it is interesting to compare the lyrics of *I Guess I'll Have To Change My Plans* with those written by Youmans' early lyricists. Although it came later, the lyric by Howard Deitz for Schwartz's song is a breath of fresh air, being so much more literate and civilized.

In "Three's A Crowd" (1930), there was a very song-like song, a melody as dignified and distilled as Kern at his best, though in no way resembling a Kern melody. It was *Something To Remember You By*.

It has a verse of distinction marked by a fine vocal quality. Halfway through, it moves very naturally from the key of F major to G-flat major for three measures and returns to F just as gracefully, an experimental move for those days.

The chorus attempts no extended or unconventional form, no startling harmony, or unexpected melodic steps. It's a straightforward, flowing, and moving melody.

Through the years I have heard an unsubstantiated story to the effect that this melody formerly has been used as an opening chorus number and was sung at least twice as fast as its later version. If the story's true, one can say only that the decision to slow it down to a ballad tempo and have a new lyric written for it was fortunate for all lovers of good songs.

In 1931 came "The Band Wagon," probably Schwartz's best score. From it came the fine standard song *Dancing In The Dark*. It is so much a standard that not only is the sheet music published in two keys, like an art song, but there are twenty-two other transcriptions of it, for everything from alto saxophone to symphony band.

It's a very strong song with a superb, poetic lyric, by Dietz, of course. It is of conventional thirty-two measure length, and mysteriously gives the illusion of being a very rangy melody, whereas it is only one and a half tones more than an octave.

Its principal characteristic is the use of repeated notes, which, because they are interrupted by stepwise, sinuous phrases, never become overinsistent. At the end of the first half, interesting harmony is injected without disturbing the melody's flow.

It has what in some songs is called a trio and which is not always used in performances of the song. It is a trifle melodramatic, but, after all, so is the whole concept of the song. Fortunately this extra sixteen-measure section doesn't get out of bounds or become too ambitious. It begins in C minor as opposed to the chorus's C major, pro-

ceeds to a C-major cadence, then returns to C minor and maintains a dark feeling till the end.

I wouldn't for the world criticize such a splendid model of melodic writing except to say that its mood borders on that kind of theatrical brooding which I find myself defining as a Mata Hari song.

Of a totally different mood in title as well as content is *New Sun In The Sky*, from the same score. It's so very good, so exactly what it sets out to be that had I written it, I would have been complacent for months. It had to be a great deal of fun to write, and it sounds as if it all happened quickly, with no panic or brain cudgeling, while the writer was feeling particularly well, confident, and hopeful. All of it, verse and chorus, is a romp.

For example, take the first two phrases of the verse:

New Sun In The Sky

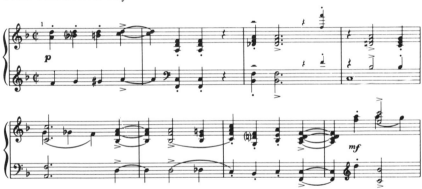

Or the first two phrases of the chorus:

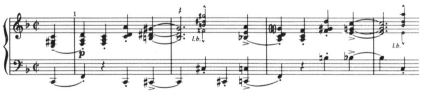

Or take the last six measures of the song:

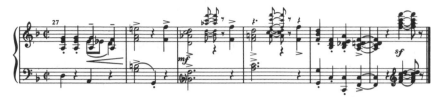

High And Low is another very good song, less forceful, more contemplative and smooth than *New Sun In The Sky*. But it has the same healthy cheeriness, the same forthrightness and follow-through.

Its verse is very attractive and inventive, the second idea particularly so.

High And Low

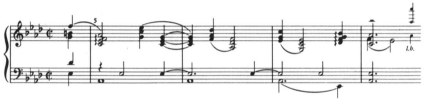

Successive fourths are a characteristic of the song, the first extended use of them I've seen outside of Richard Rodgers' songs. The release is, perhaps, not as strong or inventive as the rest of the song, yet its simple idea works smoothly and naturally. It's a good song and most definitely a theater song.

Confession is a lovely little duet for boys and girls, with a delightful lyric by Dietz. The verse is very delicately written, like a latter-day madrigal. It conveys a kind of humorously arch innocence, lyrically proven suspect, and though the lyric reveals less than innocence, the melody remains virginal.

The juxtaposition of viewpoints was what made *In The Morning, No* by Cole Porter so effective. The lyric of the latter, however, made the delicacy of its melody ludicrous. In the case of *Confession*, the lyric doesn't become gamey.

There are the opening measures of the verse:

Confession

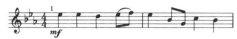

And this is the release of the chorus:

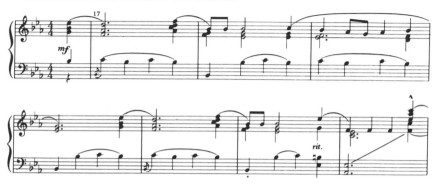

In the same show there was a lively, bouncy song called *I Love Louisa,* which was like something written for a children's party. It has the same healthy, fresh-air quality of the other songs, though of an entirely different melodic and rhythmic intent.

In "Flying Colors" (1932), there was another remarkable, brooding ballad called *Alone Together.* For some reason I've always thought of it as being a successor to *Dancing In The Dark,* as, more obviously, *Ill Wind* by Harold Arlen is a successor to his *Stormy Weather.*

The aloneness is made more of in the melody than the togetherness; nor do I say that flippantly. I'm simply surprised that the state of being together suggests such melancholy. However, the cadence suggests a more optimistic point of view since it is unexpectedly in D major.

The entire first section is marvelously continuous. It has no feeling of having been pieced together. The section is fourteen instead of the more conventional sixteen measures and does not sound curtailed. The second section is identical.

The third is eight measures, and in it the melody makes a lovely return to the first phrase of the song. The final cadence, I am happy to say, is in D major.

It's a very lovely and a very dramatic song, one which with less
expert handling could have fallen into artiness and pretentiousness.
It never does, and Schwartz deserves great praise for keeping in the
genre of legitimate theater music.

Here is the third section and a bit of the principal motif:

Alone Together

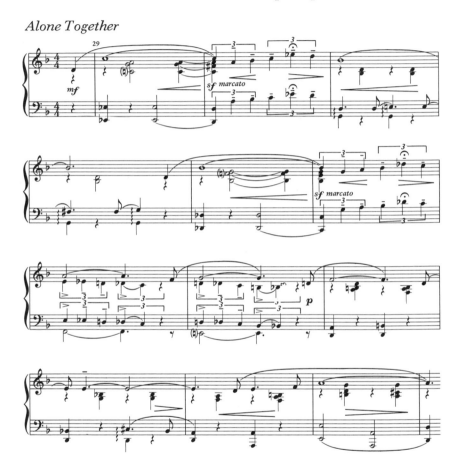

This is another song which lends the illusion of wide range but which
is only an octave and a third.

A song I've always loved is *Louisiana Hayride*, also from "Flying
Colors." I may be prejudiced in its favor because I once had so much
fun making a big band arrangement of it. It's a deliberate country

song with sophisticated handling. This is a special kind of song, not easy to write if both countrification and sophistication are desired. Arlen's *Shade Of The New Apple Tree* is one. So, to a degree, is Schwartz's own *A Gal in Calico*.

I believe this sort of song is best achieved, as in this instance, by keeping it as much as possible in the pentatonic scale. The chorus of this song is totally in the pentatonic scale, for there's not an *f* sharp or a *c* natural to be found from start to finish. (One might quibble over the presence of a single *c* sharp.)

Some people find this sort of song stiff and mannered. I find it as much fun as *Money Musk* or *Turkey In The Straw*, both of which are swinging country fiddle songs which evolved out of the rural heart of America.

A Shine On Your Shoes is another powerful swinger, verse and chorus. Frankly, if I'm to be cheered up, I'd prefer to try this musical accompaniment than to be exhorted to *Rise 'N' Shine*. For there is wit as well as a sinewy strength to this song. And besides, it swings; it's looser and less instructive than the other, not just lyrically, but musically.

The verse is extremely fine. It starts out *whap!* and never quits. In the sixth measure the singer has to practically use clarinet keys to make it. But that kind of vocal work is fun. Take a look at the "straight ahead" verve of this verse:

A Shine On Your Shoes

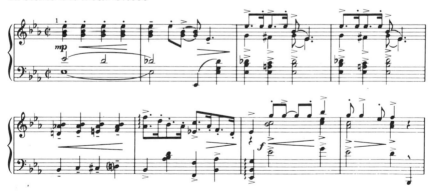

And the piano part is good, to boot.

All I need to know I'm home is this verse. But if you need more to convince you, I think the first four measures of the chorus should do it.

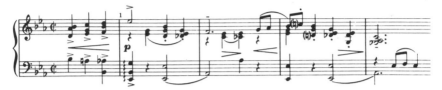

Once again Schwartz keeps his main strain in mind when he reaches the release and so further integrates the over-all melody.

This is a splendid song for any era, but particularly for 1932. It has the same awareness of the increasingly swinging bands as do Arlen's songs.

I haven't said much of anything about stylistic idiosyncrasies of Schwartz's songs, partly because I've been so carried away by their high quality and partly because he hasn't revealed any specific, re-curring predilections. Up to now he hasn't seemed to have been con-cerned with anything but writing good songs. In this respect he's stylistically as elusive as Berlin. No two songs may be compared as being alike, or obviously by the same man.

I admit that it's fun to find devices which begin to crop up, devices which cause you to be certain the song is by so-and-so and no one else. One might, in the case of Schwartz, accomplish this by the method of eliminating certain writers and assuming that if you're left with skill, wit, sophistication, sinew, and drive, it might well be he. Let's say, then, that up till now the style shows no specific devices but great flair and diversity of techniques.

In "Revenge With Music" (1934), Schwartz wrote one of his pur-est and loveliest ballads, *If There Is Someone Lovelier Than You*. It has exactly the tender, lyric quality that its title suggests. It moves gracefully, uncontrivedly, and with true creative inevitability.

I would be happier if the release were less a release and more in the flowing style of the main strain. It is quite adequate as a release, but such a lovely principal statement deserves only more of its own manner. A melody like this should never stop its singing line.

If There Is Someone Lovelier Than You

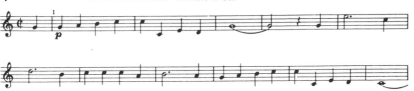

The form is unusual in that its main strain, the *A* section, is twelve measures, the release eight, and the *A¹* section eight. So it is *A-B-A¹*.

In 1934 Schwartz and his lyricist-collaborator Dietz wrote more than ninety songs for a radio serial, "The Gibson Family," some of which were later used in their shows and films.

In "At Home Abroad" (1935), there was a very sweet song, *Love Is A Dancing Thing*. It may not be in the same league with some of those just mentioned but it's too tender and natural and song-like to pass up.

It's made up of two identical fifteen- (not sixteen-) measure phrases. This oddity wasn't apparent until I counted the measures. In other words, the phrases all feel perfectly natural. The phrases would be sixteen but for the first phrase's being three measures instead of four. This is most sensible. Were the pause of two measures instead of one, the flow and pace of the song would be lost.

Love Is A Dancing Thing

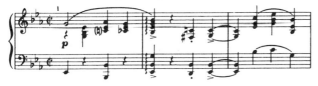

The section marked "interlude" I feel is less that than an extension of the melody. If the latter had been longer or had had another section in it, I might be less inclined to feel this. Assuming the role of song doctor for a moment, I believe that if the second half of the "interlude" had been used as the middle section of the song, it would be a more balanced melody, not that the "interlude" isn't very good by itself.

I spoke too soon in terms of the influence of composers on Schwartz's songs, since the opening and ninth measures of the "interlude" do strongly suggest that Schwartz had an affection for one of the Debussy *Arabesques*. Below is the section of the "interlude" I can hear as the middle of the main melody.

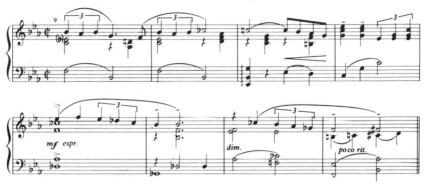

In 1937, in "Virginia," which was not a successful show, there was, to me, a very endearing little 6/8 song called *My Bridal Gown*. Its lyric is the first so far, among those songs here considered, which is not by Howard Dietz. It's by Albert Stillman and, of all people, Laurence Stallings. And it's not very good. But the melody is a deliberate period piece, with none of the verve or muscle of Schwartz's rhythm songs, and none intended.

It's the kind of song one would be happy to hear some stranger whistle on a spring day in a pastoral setting and never forget. Had I not examined all of Schwartz's songs, I'd never have known it, but even now, having sung and whistled it through many times, I still feel as if it were a spring day mystery tune, one which the whistling stranger would not know the name of. It's a lovely walk-about song.

My Bridal Gown

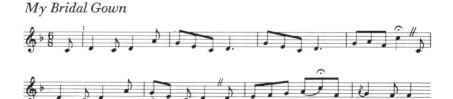

Also in 1937, in "Between The Devil," there was a marvelous ballad, *I See Your Face Before Me*. This time Dietz is back with Schwartz. The song is a beauty, all of it, words and music. The repeated note, which hitherto Schwartz has not made a point of, is here in strength. The song is based on it. And there is nothing of the aggressiveness with which I usually associate the repeated note device.

After a same-bolt-of-cloth verse which leads very naturally into the chorus, the melody sets out to charm and beguile. It's when, after the first eight measures, the melody starts to build that I am most touched by it. The repeated phrase of measure ten followed by the unexpected *e* flat in measure twelve, falling to the same *b* flat as in measures ten and eleven, is very touching, as in an equivalent phrase in measure fourteen.

I See Your Face Before Me

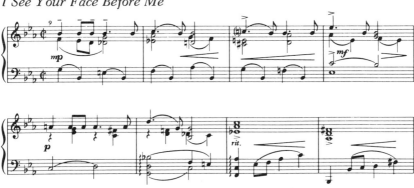

Measure sixteen fascinates me: the augmented chord resulting from the melody's dropping to the *f* sharp is rare in theater tunes because it's such a cliché. Here it does not sound like a cliché at all, but exactly right. I have a hunch that the use of augmented chords has been debased by amateur piano players who use it to fill in measures. Thus, it has become a chord which a professional would carefully avoid as being too obvious. This may have resulted in song writers also avoiding a cadence which incorporates it. For it's always in the cadences where it sounds so trite. Offhand I can think of only one other song in which it is perfectly used, the end of the first phrase of *Under A Blanket Of Blue*, a song of the middle thirties.

Then, toward the end of *I See Your Face Before Me*, in the measure

equivalent to measure twelve, the melody falls from *e* flat not to *b* flat but to a more passive and romantic fourth interval, *a* flat. It's a loving, almost tactile song. And it needs no harmony in order to please the ear.

Another fine song from "Between The Devil" is *By Myself*. This is not only a good song, it's a very special, virtually unique song. It's not easy to say why I have this conviction, but I'll try.

First, it accomplishes so much with so little. Its range is only an octave, yet it's so well conceived that it has the effect of wide range. Second, its harmonic invention is very special. The chorus is in F major, starts on a *g* natural, but the supporting chord is a G-minor sixth with the third of the chord in the bass. This produces an almost unreal effect. And then, by very adroit manipulation of bass notes, Schwartz manages to avoid monotony while being harmonically within the area of A-dominant seventh for six measures.

By Myself

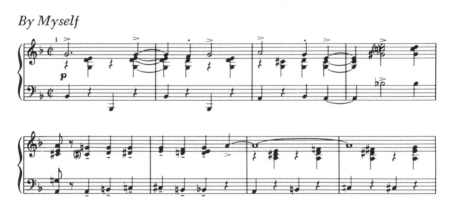

As you can see, an A-dominant seventh appears in the third measure and, but for a G-minor sixth looming up for half of measure six, it's all within the area of one chord. Third, whenever the bass notes move, they move musically and have their own private fun.

For those of you less concerned with harmony, let me point out that the melody is at all times under strict control. Not a note could be other than it is. And at no point does it become busy. Also, the use of the fourth quarter syncopation not only creates part of the character of the song, but it somehow never sounds over-used in spite of its continuous presence.

Another element that helps make it so good a song is the feeling of development in the third section instead of the interruptive quality of a typical release. The final elegance is that the third section continues into the last section instead of there being a restatement of the beginning measures.

Dietz's lyric measures up to the melody throughout. The verse is adequate but not quite what one would have liked to precede such a well-fashioned, strongly controlled chorus.

Between 1938 and 1946 Schwartz wrote many songs but, for me, none of the caliber of those previously discussed. I find nothing truly worthy of him until "The Time, The Place And The Girl," a film of 1946, in which there was a great rhythm song, *A Gal In Calico*. This is another song which has a slightly country flavor, less than *Louisiana Hayride*, but some. Again it may, in part, be induced by the pentatonic scale which is used in the first four measures.

The song has a marvelous, written-at-the-same-time verse. The chorus does, with great style, precisely what it sets out to do and even goes beyond the call of duty in its last measures. Below are the opening measures and the closing.

A Gal In Calico

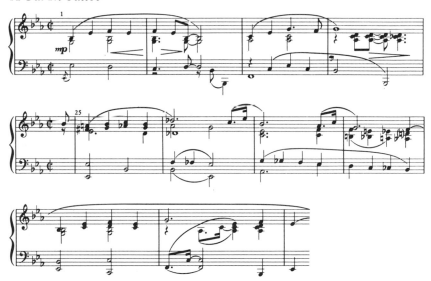

Cheery, strong, swinging, professional. It's a good song to sing and it's a perfect big band piece.

Haunted Heart, from "Inside U.S.A." (1948), sounds the mysterious signal.

Haunted Heart

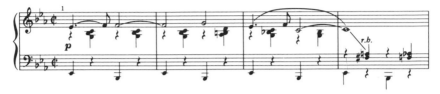

Maybe my eyes are too bright with memories, yet in the first three notes I find myself caught, lost, found, whatever it is.

It's another song in form like *Love Is A Dancing Thing*: two statements nearly identical followed by an "interlude," the latter, in this case, bordering on the bathetic. But unlike the other song, *Haunted Heart* has a quality of completeness. And this is because the second section is *not* identical. It is a definite development of the first section and, in so being, rounds out the song.

In "A Tree Grows In Brooklyn" (1951), there was a lovely ballad, *Make The Man Love Me*. Its principal idea is a gem of tenderness and warmth. I find, however, that the song is marred by a middle section which, though musical, somehow creates a kind of discontinuity and jars the mood which the original idea has created.

Then there was a decade of songs none of which I find of enough interest to discuss. Not until 1961, in "The Gay Life," was there, for me, a return of Schwartz's brilliance. While we were discussing the curious failure of this show, James Maher made the following unhappy observation:

> This score raises some interesting questions. I believe it to have been one of the finest of the Dietz and Schwartz scores. The music was tasteful, full of melodic invention, sophisticated, and, in another era, may well have found a wide audience outside the theater. But, it never had a chance to find such an audience. The rock era closed the door on all such music and its mature sensibilities. Further, the theater audiences may not have been aware

of the consistently high quality of the score because of the casting. America had been charmed by Ezio Pinza's broken English; it turned an indifferent ear to Walter Chiari's. Another point: the modern musical theater audience no longer distinguishes between routine functional theater music and songs that merit an independent career as standard popular songs.

I agree with every word. There is such sadness in the renaissance of Schwartz's high style just at the point when "good taste" became an obsolete phrase.

For The First Time is a marvelous, modest, romantic ballad in the best possible taste. And I never heard it until I started this survey. Just look at this phrase which closes the first half of the song.

For The First Time

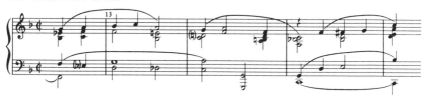

And at the gentle, touchable closing section.

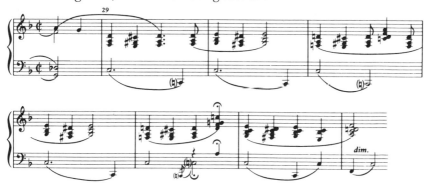

And, as for *Something You Never Had Before,* it's as refined and distilled and in as high style as any great Kern song. It does unusual, unexpected things and deserves to be listed among the great theater songs. Just consider the opening strain.

Something You Never Had Before

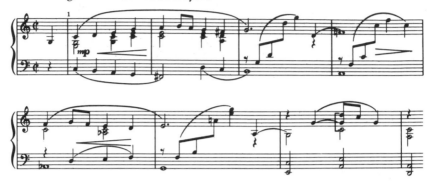

Or the release.

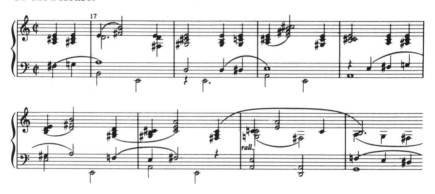

Why Go Anywhere At All? is another ballad as fine as *Something You Never Had Before*, filled with new melodic ideas; in fact, the song suggests a true renaissance of theater music. This is from the second phrase.

Why Go Anywhere At All?

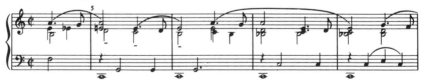

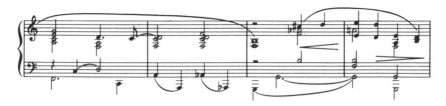

And here is the closing section.

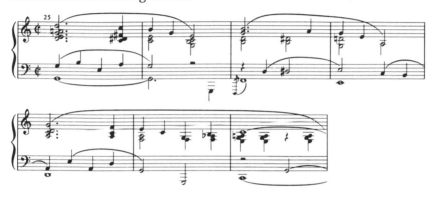

In this score there is as well a rousing waltz called *Oh, Mein Liebchen,* which, in spite of the title, never uses it as an excuse to wallow in Viennese sentimentality. Rather is it simply a strong, honest waltz, minus the aroma of Graustark.

The extraordinary score was written thirty-eight years after Schwartz had published his first song, *Baltimore, Md., That's The Only Doctor For Me.* I don't know of any writer who rose to such heights after such a long writing career except Kern.

For "Jennie" (1963), Schwartz wrote another very good ballad, *I Still Look At You That Way.* It's far better than average, if perhaps not quite of the stature of the "Gay Life" ballads.

The ballad *Where You Are* is very direct and simple, made principally of imitative phrases. But it has that choke-up quality which it is impossible to find the melodic cause of, but which is always instantly recognizable. The very first phrase of this song has it.

Where You Are

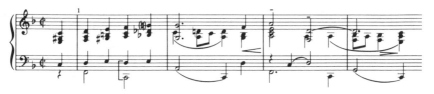

The shortness of this section about Schwartz should by no means be mistaken for a casual attitude. It must be clear that I greatly admire his songs, in fact, find them in certain instances unsurpassable. I must, however, admit that, in spite of the superlative quality of his best songs, there weren't a great many of them in comparison to some of the other great writers.

This I admit I find very puzzling. For, if on the one hand, one doesn't expect a winner in every song, on the other hand, one does assume that after a writer has proven himself to the public and to discerning professional musicians, his writing will all remain on that same high level. In the case of Schwartz this simply did not happen. Of course the most dramatic and ironic burst of talent occurred in "The Gay Life" when the handwriting of the Beatles was on the wall.

Creation in the arts is controlled by so many mysterious causes that it is a miracle that any high standard can be maintained by any creator. The sources of good or bad writing can be as pedestrian as matters of health, private life, neuroticism, depression or elation, finance, diet, or today's headlines.

Whatever the reasons for Schwartz's somewhat fever-chart graph line of writing, his published record contains some of the finest American songs in existence. He remains stylistically as mysterious and elusive as Irving Berlin. And so, one can say only that quality was his style. And that's plenty.

—— 9 ——

Burton Lane (1912-) *Hugh Martin* (1914-)

Vernon Duke (1903-1969)

BURTON LANE

(1912-)

Burton Lane's career is somewhat unusual in that his first full theater score, that for "Hold On To Your Hats," did not appear until 1940, in spite of his having written interpolated songs for the theater since 1930. Also he wrote only two other full theater scores, those for "Finian's Rainbow" and "On A Clear Day You Can See Forever," in 1947 and 1965 respectively.

Although he has written some extremely fine songs, his name is not well known to the general public. He has divided his time between New York and Hollywood and has confined his writing to films and the theater. There is no record of his having published any independent pop songs.

The first four of his songs published, two songs each in two 1930 shows, reveal little more than youthful enthusiasm for song writing. In 1931, however, Lane wrote a very charming song for "The Third Little Show" called *Say The Word*. It's both lyrical and just rhythmic enough to add a pinch of spice to it. And it's provocative enough to have deserved a longer life than it has had.

His first well-known song, *Everything I Have Is Yours*, was written in 1933 for the film "Dancing Lady." It became a standard and, while not great, still would be recalled by the average listener.

Everything I Have Is Yours

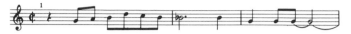

In 1939, he wrote a very pleasant, swinging song, *The Lady's In Love With You,* for another film, "Some Like It Hot." It became a standard song and, though slight, has a distinct character.

The Lady's In Love With You

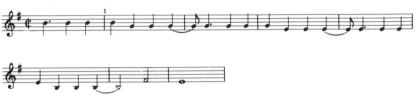

"Hold On To Your Hats" (1940) had, as I've said, Lane's first full score. In it there is one rouser called *The World Is In My Arms,* which probably served its purpose admirably in the theater, but somehow suggests a limited independent life. And I'm sorry to say that, in spite of its inventive release, *There's A Great Day Coming* does pretty much what its title suggests: spiritedly raise the roof, or the curtain.

A ballad, *Don't Let It Get You Down,* truly fails to become a song because of its relentless use of repeated notes. There's not a curve or a graceful turn of phrase in the whole chorus.

Then, in 1941, in the film "Babes On Broadway," Lane wrote a marvelous, healthy, rhythmic ballad, *How About You?.* Lyrically it's a "list song" and, as such, could have achieved its purpose adequately with a much less interesting melody. Granted that lyricist Ralph Freed's "list" is superlative. For usually when a tune is as good as this, I am unaware of the lyric. In this song I've remembered both since I first heard them.

It's a very authoritative melody insofar as, wherever it goes, one is instantly certain that it could go nowhere else. And it goes to unusual places, as, for example, at the end of the second eight measures.

How About You?

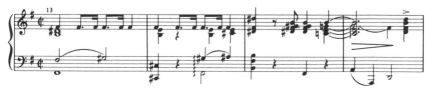

That *d* sharp in the fifteenth measure is most unusual and absolutely right.

The opening phrase of this song has the same grace and tenderness as that of Gershwin's *Dear Little Girl*. And then its second phrase kicks up its heels in simple well-being.

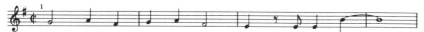

Then the repeated note device of the thirteenth and fourteenth measures is used more climactically in the twenty-fifth and twenty-sixth measures.

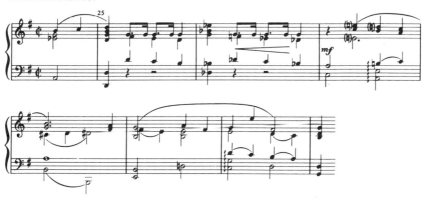

These uses of repeated notes, whether due to the lyric's demands or not, are extremely effective, much as are those of the "come to Papa, do" phrase in Gershwin's *Embraceable You*. They have an inevitable quality about them or, if that sounds excessive, a considered quality. One feels that only repeated notes are right at this point. And the lovely turn of phrase in measures twenty-seven and twenty-eight, though only a scale line, bears that mysterious mark of authority.

As is obvious, I have a marked affection and respect for this song. It is, indeed, a model of popular song writing. While it attempts no experimentation, melodically, rhythmically, or harmonically, it does present in thirty-two measures a perfectly fashioned melodic line. And it is, within these narrow limits, unlike any other melody.

The cadence in B major, in the fifteenth measure, is highly unusual, and therefore I'm wrong in saying there is nothing experimental in the song. But this cadence comes off so naturally that one forgets how unusual it is.

For those musicians who breathe the thinner air of more complex and extended composition, I would suggest as their next creative assignment an attempt to write as convincing a musical and well-fashioned melodic line as that of *How About You?*. I dislike inverted snobbery, but I think they would fail, not because such a task is too simple, but because it's too difficult.

Also in 1940, and in a film, "Dancing On A Dime," Lane wrote a similarly convincing melody called *I Hear Music*. In it he uses the same device of announcing a lyrical first phrase, followed by a rhythmic second phrase, except that in this case he warns the listener of the approach of the second phrase by splitting his first phrase into two, the first unrhythmic, the second somewhat rhythmic, and then the new phrase wholly rhythmic. It's neat as a pin.

One may assume that the germinal idea was found through harmonic "noodling." But, if so, it in no way minimizes its effectiveness.

I Hear Music

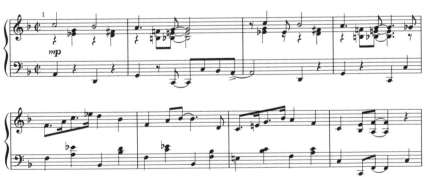

Granted that it's only a scale line and that it comes off better with the harmony. But its extreme simplicity provides marvelous contrast to what follows.

The *e* flat eighth note in the third measure is unexpected, though justified by the fact that it is part of the C-minor-sixth chord used in the first half of the measure. Not many singers use it, dropping to the more expected *d* natural. Then, the rhythmic, break-away phrase in the fifth and, later, in the seventh measure, is more instrumental than vocal. But it is very provocative and provides marvelous contrast to the initial phrase.

The construction of the two ideas which comprise the first, second, and fourth eight-measure sections is such that there is no obvious cadence, such as usually occurs at the end of a section. Here the cadence is only a half measure long, yet so authoritative is the writing that one does not feel cheated by this minimal pause.

This song has always been a great favorite with jazz groups—and deserves to be. It is witty, carefree, and direct.

The title song from "Dancing On A Dime" is a less than superior but better than average rhythm ballad. Its form is *A-B-A-C*, of conventional thirty-two measure length, and it makes no unexpected melodic moves. Nevertheless, it has charm and sturdiness and, to my way of thinking, deserves more exposure than it has had.

In the film "Ship Ahoy" (1942), there was a song called *Poor You*. It is more instrumental than vocal and, as is usually the case, more difficult than most truly vocal melodic lines.

Alternate measures are formed of the notes of chords in rising phrases. Fortunately there are whole note interruptions.

Poor You

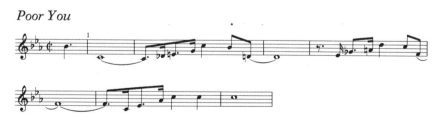

As you can see, the second measure follows a D-flat-diminished chord, the fourth a C-diminished chord, and the sixth, an A-flat-major chord.

This is, perhaps understandably, a little-known song, but worthy of illustration in that it is so unlike other Lane songs.

Feudin' And Fightin', from "Laffing Room Only," a show of 1944, is another sophisticated country song in the manner of *Louisiana Hayride* by Arthur Schwartz. And like that song it is, but for the release, all in the pentatonic scale. As I've said before, this scale is characteristic of much folk dance music, as well as of this genre of theater country music.

To make such a tune come off and not sound like others of its kind is not easy. I respect those theater country songs that make it, little as they may have to do with the world of romantic ballads or swinging rhythm songs. There is a good cheer and innocence about them that pleases, and the fact that they are four-square and suggest dancing in boots only enhances their charm for me.

I'm pleased by such a device as occurs in the tenth measure, that of the sudden introduction of two eighth notes in a melody made up of nothing less than quarter notes.

Feudin' And Fightin'

The second section, the release, does move about more sophisticatedly than this kind of bridge usually does, but with great effectiveness. At the end of this section there is a single-measure phrase which one finds in certain songs and for which I have never heard a technical name. As an illustration, there is the phrase in *Old Devil Moon*.

Old Devil Moon

Or the phrase at the end of the release of Harry Warren's *I Found A Million Dollar Baby*.

I Found A Million Dollar Baby

In the case of *Feudin' And Fightin'* it is:

Feudin' And Fightin'

In its most lyric form it is the phrase in Jerome Kern's *Look For The Silver Lining* just before the last statement of the main strain.

Look For The Silver Lining

To the lay listener it becomes the looked-for phrase in the song, just as he might anticipate with pleasure the spot in a band arrangement where the players stop to allow the drummer to play a "break." My hunch is that these song "breaks" originated in vaudeville as a performance trick. They occur as far back as *Peg O' My Heart*. In that case the "break" was a long one.

Peg O' My Heart

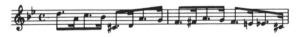

"Finian's Rainbow" (1947) was a highly successful show which has been a staple with amateur groups and summer tent shows ever since. *The Begat* and *When The Idle Poor Become The Idle Rich* are both extremely well-fashioned production numbers, in the latter of which there is even a closing section of very effective contrapuntal choral writing. But insofar as they are not essentially songs, they are outside the boundaries of this book. It is, may I add, extremely good production writing, both lyrically as well as musically, with *The Begat* a shade too self-consciously camp-meeting-Negro for me.

The big hit from this show was *How Are Things In Glocca Morra?*. I'm sorry to say that I find it a total contrivance. The point obviously was to write an Irish song. Well, lyrically one couldn't ask for more, place names and all, but musically it isn't specifically suggestive of

another musical culture. What is left, unfortunately, is only the vague sensation of someone having tried to write a regional song and having wound up with a cliché, or, at best, a contrivance.

Old Devil Moon, on the other hand, is a very well-written, wholly convincing song. It drives, and its initial intensity is sustained throughout.

There are a number of interesting elements. One is the very adroit control of repeated notes, which, though a characteristic of the song, are never used to the point of monotony. Another is the dangerous but in this case successful use of the mixolydian mode, in which the seventh interval is a half tone below its usual position.

In this instance, the seventh is *e* flat, because of the modal scale. Ordinarily it would be *e* natural. For the first six measures of the song (and it has no verse), this *e* flat is to be found not only in the harmony but in the melody.

Old Devil Moon

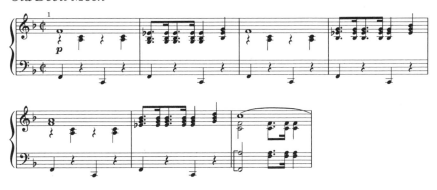

Nowadays, when there is so much modal writing, these measures are less surprising than they were in 1947. To move from a whole note *f* to a repeated *e* flat in the second measure had to come as a great surprise.

But at the point where this scale might have become monotonous, as might have the repeated notes, Lane wisely deserts the design and moves, in the ninth measure, into a wholly fresh idea. This idea repeats, with shifting harmony, and, with no warning, repeats again a half step higher, moving the melody into the key of G flat. Then, a

half measure before the cadence, he moves wholly rationally, but again unexpectedly, back to a C-dominant-ninth chord with *a* natural in the melody and to the cadence in F. This sequence is marvelous and, in the realm of popular music, magical.

Then follows a fascinating new section which builds up inexorably to the "razzle dazzle" break mentioned before.

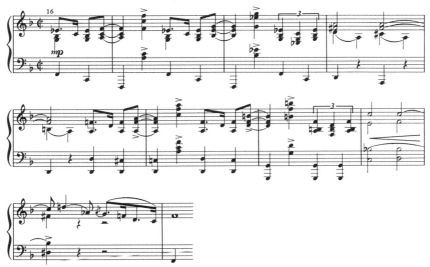

This is splendid writing.

The structure of the song may be considered as *A-B-C-A-B-A¹*. However, the first sixteen measures are so interlocked as to make them seem one rather than two sections. The closing *A¹* section is back to the modal scale and remains in it till the end of the song. It's a fine, inventive, vibrant song, among the very best of its genre.

I'm embarrassed by the sounds of cute, invented words like "disposish" or "delovely" or, to add another, "grandish." I'm made so queasy by them that until now I had never played, or even looked at, the melody of *Something Sort Of Grandish*. It's very pleasing, sort of elegant, even sort of madrigalish. It makes many neat and unexpected moves.

At the outset, its initial phrase leads you to believe it's in the key of F major, since the first three notes are *c*, *f*, and *a* and the sustaining harmony is an F chord. As a result the *b* natural in the second meas-

ure creates the illusion of another modal scale. Not until the fifth measure when the melody's three notes are *c, e,* and *g,* does this illusion disperse. But there are new surprises better cited than described.

Something Sort Of Grandish

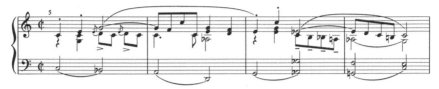

A fresh idea follows for four measures and, after that, another idea in A major and E major. The latter is as follows:

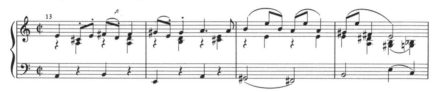

The song then repeats the first eight measures literally and ends. Considering that, in four-measure sections, the song's form is *A-B-C-D-A-B,* one would assume it to contain too many ideas to come off as a song. And yet it somehow works, deliberately mannered though it may be. Its lyric is so replete with cuteisms as to have made it useless outside the theater, but musically it is an elegant effort.

If This Isn't Love has had somewhat of an independent life outside the theater. It's a perfectly pleasant little tune, except that its uninterrupted similarity to Kern's style of writing makes it impossible to discuss in terms of Lane's writing. You search the lyric in hopes that you'll find a clue to the effect that it's supposed to be in the style of Kern. Alas, there is no clue but the melody.

There is a dear, loving little waltz called *Look To The Rainbow* which most certainly *does* sound Irish. I'm sorry to say that I'm not enough of a musicologist to state precisely why it does. All I can say is that I wouldn't be surprised to hear it played at a village dance in Ireland.

In 1951 came the very beautiful song *Too Late Now.* It was in the

film "Royal Wedding," with lyrics by Alan Jay Lerner. The song is thirty-four measures long, the last section being ten instead of eight measures. The form is *A-A-B-A¹*.

Within this almost totally conventional pattern there exists a very beautiful, lyric melody. The main strain revolves about the first three quarter notes. They begin each two-measure phrase, but upon each repetition the melody moves higher and descends in a different fashion. And the *f* natural whole note in the eighth measure is not only a perfect leading tone for the *e* natural first note of the ninth measure, but it constitutes a great use of the fourth interval of the scale which can be so tenderly romantic when used wisely.

Too Late Now

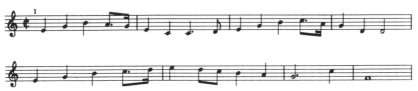

The second *A* section repeats the first except that its cadence is in the tonic.

The release is a marvel of invention. Though not simple, it is by no means cursed by cleverness. I can only say that once you have heard it, you would have it no other way.

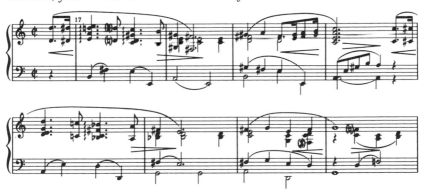

Between 1951 and 1965 the record shows that Lane had only one song of even minor interest published. Then, in 1965, he wrote the score for the Broadway musical "On A Clear Day You Can See Forever." The title song is another marvelous ballad in the grand tradition of theater ballads, with many lovely moments and ideas besides the initial evocative phrase.

It is a very lyrical, singing song which has the kind of strength and character that needs no harmonic support to satisfy the ear. The melody flows so naturally that it seems indecent to poke away at its structure. One of its most graceful qualities comes from the fact that its ideas are so lyrically interrelated that one is not conscious of the transition from one section to another. If it must be broken down into sections they are not by any means typical. They are A-A^1/B-C-A^1/B^1. And that's the best I can do. May I also add that the oddness of its form in no way implies that there is anything vague or unintegrated about it.

There are such lovely notions: for example, the variation in the pick-up notes to the half note a's and f sharps.

On A Clear Day You Can See Forever

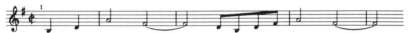

Then there is the unexpected twenty-second measure which repeats the notes of the twenty-first and is followed by a most endearing cadential twenty-third measure.

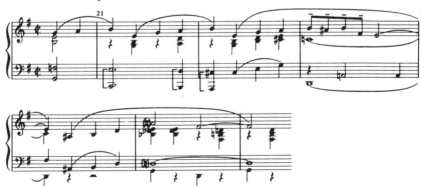

I find I am also beguiled by the unexpected *a* sharp in the pick-up to the original motif. I know it's only one more note, but therein lies the magic of great professional writing. That quarter note *a* sharp leading into the original pick-up notes adds a curious extra grace and dimension to the melodic line.

There is a strange parallel between Lane and Schwartz insofar as they both, after many years of silence for the one and undistinguished writing for the other, proceeded to write perhaps at the very top of their form. It's almost as if, after watching in stunned silence the ballooning cloud of amateurism, they made a last desperate plea for the cause of professionalism by producing its finest forms.

The rest of the score is adequate but not remarkable. The song *What Did I Have That I Don't Have?* is a good, relaxed, slow rhythm song, never without interest, and yet never quite catching fire. The reason I mention it is because, going over and over this song, I keep wanting it to do just a few little things more than it's doing. Mind you, I don't know what they are or would be, but its ideas keep capturing me and then, somehow, letting me go. I simply wish the song would have tried a little harder.

After rereading my remarks about Lane, I find that the parallels between him and Schwartz apply to more than the one I just mentioned. They were both very strong and inventive writers. They both had no specific stylistic devices. They were theater writers, Schwartz perhaps more consistently than Lane, and this, if true, may substantiate my contention that movie music is one grade under theater music, since Lane wrote more for Hollywood than Broadway. And, marvelous as *Too Late Now* is, it hasn't as broad and therefore as theatrical a line as *On A Clear Day You Can See Forever*. Both men had unexpected lapses after showing great promise. And, as I said before, both, in the sixties, wrote their very best melodies.

II

HUGH MARTIN
(1914-)

It's very strange to me that a man as talented as Hugh Martin hasn't written more songs. As far as I can determine he has written the

scores for five theater shows and five film musicals (plus some iso-
lated movie songs) since his first show in 1941.

Obviously quantity and quality aren't to be equated. And there are
many instances of good writers of words or music who have produced
less than one would expect for the number of years they have been
working. Great though all of his novels and plays have been, Thorn-
ton Wilder has published comparatively little during the fifty-odd
years he has been writing.

Ev'ry Time, from "Best Foot Forward" (1941), is a very dear,
warm song which, to me, is in the very personal, non-aggressive man-
ner one normally associates with a Martin ballad. It has a lovely,
singing verse which comes to a full cadence and is followed by a four-
measure accompanimental figure before the chorus begins.

I think that one of the reasons I find the repeated notes, which con-
stitute much of the principal statement, inoffensive is partly because
of their turning from quarter to eighth notes. This may sound like a
flimsy excuse for accepting them, yet I can say only that the shift in
note value causes the repeated note to escape monotony. This slight
shift stimulates attention because, after the three repeated quarter
notes, the eighth notes are unexpected. And only in this opening,
though partly repeated, strain do repeated notes take over.

Ev'ry Time

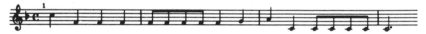

Curiously, even when in the last part of the song the melody rises
to a high *f*, the effect somehow is not that of a dramatic climax. My
belief is that any sensitive singer would be more inclined to sing that
f with a covered tone rather than belt it. I am surprised that the song
ends as abruptly as it does. I would have expected a tag, an extension.
Even if one sings the last phrase with a *ritard*, it still suggests a little
bit more.

What Do You Think I Am? is a very strong, solid rhythm song
which one still hears. It's essentially a band number. It forges ahead
without doing more than its job, until the last eight measures when
it performs unexpectedly.

What Do You Think I Am?

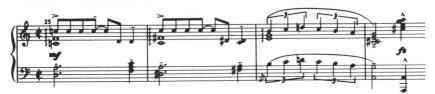

That's How I Love The Blues is really a lyric marathon on "blues" rhymes. And it's accomplished very cleverly. The accompanying melody is by no means easy; in fact, it almost demands a professional singer, but for the release.

It is, despite, or maybe because of, its complexity, a highly effective song. In view of its difficult, but interesting, intervals, I am surprised it wasn't at least taken up by more instrumentalists. For one could truly wail with this line. I haven't always been the most diligent radio listener, however, and so it may have had a more independent life in the bands than I know.

Just to indicate its complexity, here are the first two measures:

That's How I Love The Blues

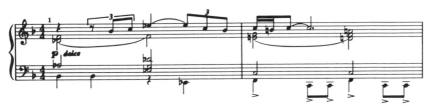

And the fifth through eighth measures:

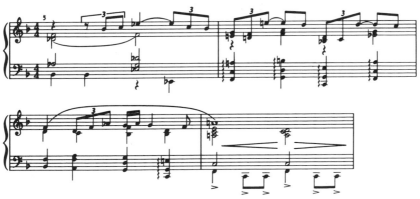

In 1944, in the film "Meet Me In St. Louis," there were several very good songs. *The Trolley Song* was a perfect vehicle for the star, Judy Garland. Besides which it happens to be a marvelously driving theatrical production number. But because it's so inextricably associated with Miss Garland and because of the period character of the lyric, it just may have never been properly considered as an independent song.

I admire it for its directness and strength and for its essential simplicity. From the first note of the verse to the end of the chorus it moves with a surcharge of energy and so uncluttered a melodic line that it suggests that everyone get out of the way. And it manages this inevitable motion within the confines of an octave.

It is so capably written that, until one stops to consider, it creates the illusion of having a much wider range. It is largely in step-wise writing, except for the repeated half notes used in the first sixteen measures for the purpose, I think, of establishing the "clangs," "dings," and "zings."

It is a long song of eighty-six measures, but it's in a very fast *alla breve* tempo and so doesn't seem as long as it is. It has a long extension which further increases the intensity of the song.

Its harmony perfectly fits the needs of the song but in no way intrudes. Nor is there a single resort to syncopation. The result of this is that it continuously lands on both feet, which I find a positive characteristic of the song, but which may cause some to find it too four-square.

Have Yourself A Merry Little Christmas has remained a seasonal hit ever since it was published. And a great relief it is from the fearfully overworked hymns and novelty songs. It is child-like in its innocence and remains the most honest and genuine of all the attempts to wish one well musically in a season which otherwise has come to be symbolized by guilt and the dollar sign.

The Boy Next Door is undoubtedly Martin's best-known song. It's very much a standard and deserves to be. It is based on, I must admit, a device. But it is an extraordinarily good one and results in a difficult melody. From a musician's point of view, it's a gem. And Martin very wisely introduces a second, much simpler melodic idea after the first eight measures.

But to begin at the beginning, the verse is not only very tender

and effective but its ending contains more repeated notes than have ever been encountered in any song. There are, in fact, twenty-four! And there is a very dear and sweet reason for them: they support the lyrical information as to the contiguous street addresses of the girl and *The Boy Next Door*. For she lives "at fifty one, thirty five Kensington Avenue and he lives at fifty one, thirty three."

The device of the chorus is a series of suspended dominant ninth chords. For example, the melody moves, at the end of the first measure, to a *c* sharp. The *c* sharp is repeated and supported by a G-dominant ninth. And it doesn't resolve itself until the last quarter note of the measure, which is a *d*.

The Boy Next Door

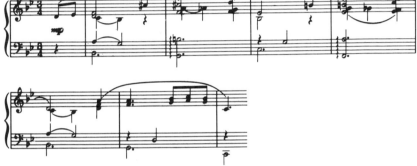

As you can see, he employs a similar device in the fourth measure. Granted that these constitute only two uses, yet the melody, until they are passed, is not easy to sing. Not only because of these suspensions, but because of the drop from the *d* to the low *e* flat in measure three and the drop from *c* to the low *d* in measure five. Except for these measures, the song is reasonably simple. It's a very intense and personal song, written, it is obvious, with great love and infinite care. It would be well to remember the suspension device, as he uses it later on in *Tiny Room*, a virtually unknown song.

In 1945, in the film "Ziegfeld Follies," Martin wrote a song for Lena Horne called *Love*. It is a production number more than a song. And it is very long, probably longer than it need be, yet, again, it

may have been just right in the production. As a song, for me, it's much too repetitive. However, it is memorable and does have its own distinct flavor of sultry, theatrically banked fires about to erupt, though I would be happier about it if it were shorter.

Tiny Room, which was written for "Look, Ma, I'm Dancin'!" in 1948, remains known only to theater buffs. I find it charming and justifiably clever. "Justifiably clever" will take a bit of explaining. In the first place, Martin used the suspensional device that he used in *The Boy Next Door.* In this case, he uses it almost continuously. And that results in a difficult melodic line. But it is so engaging that it is worth the effort it takes to find the notes.

He starts by dropping from *b* flat (the key is E flat) to *f* sharp, then rises a half step to *g* and thereby resolves the supporting harmony. The song continues to drop a third or a fourth but always immediately thereafter ascends a half step. Sometimes the half step up resolves the supporting harmony, sometimes not.

Tiny Room

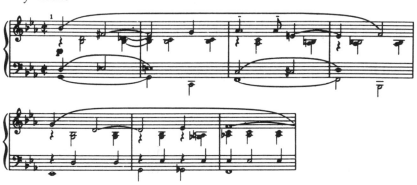

Where the justifiable cleverness enters is in the second half. For here he employs a *d* natural, the same note with which he has made his immediately preceding cadence, but now, astonishingly, the song is in B minor, not B-flat minor. And though the second note reads *a* sharp, remember that *a* sharp is *b* flat. As a result, though the *a* sharp will ascend a half step to *b* natural, for the length of a whole note it might as well be *b* flat, which is in the parent key of E flat.

I realize this is close to green eyeshade talk. But I, personally, am fascinated by the sleight-of-hand device of using two notes from the parent key while the harmony is about as far from that key as it can get.

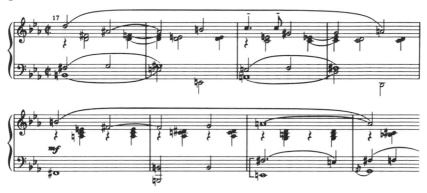

I find the return from measure seventeen to the opening melodic line, which occurs in measure twenty-five, absolutely brilliant. And notice how Martin drops his device in order to let the song end peacefully in a scale line!

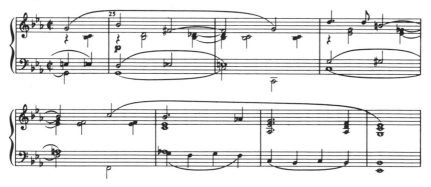

If You'll Be Mine, a song with a somewhat uninspired title, is a very tasty little rhythm ballad with, incidentally, a very tasty verse. In the verse there is a good use of the enharmonic note. In this case it is *a* flat/*g* sharp.

If You'll Be Mine

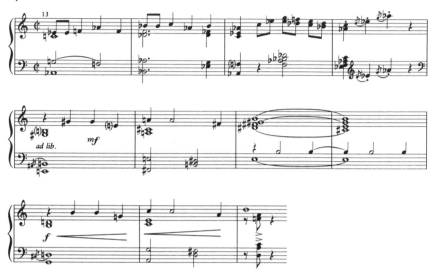

The chorus does depend on the harmony, but it comes off very theatrically and, I would have assumed, would have been meat and drink for arrangers and players. Yet I've never heard it since the time of the show.

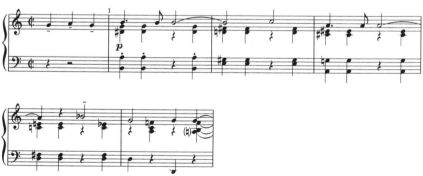

I'm always impressed by effectively employed passages which use a minimal number of notes. And the release of this song is a great illustration of this.

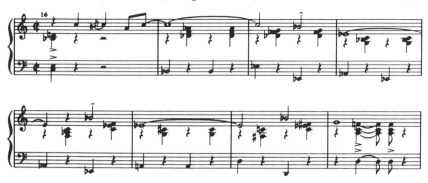

I am also fond of the final cadence, one which Martin used again in a song from "High Spirits" and other writers rarely risk writing, due not only to its novelty but to its somewhat unclimactic quality. Besides, without the accompanying harmony, it doesn't come off. But in spite of its being nearly an affectation, I am entertained by it.

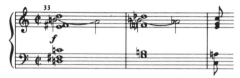

It's the whole note *d* flat I am referring to.

In 1951 the show "Make A Wish" was produced. In this score, as in "Look, Ma, I'm Dancin'," Martin wrote his own lyrics. Frankly, I find nothing in it which measures up to Martin's best writing or even to his second-best writing. The whole score lacks verve and delight and fun. Just when you think you've spotted a glass of champagne, you find it's stopped bubbling.

For example, the song *What I Was Warned About* has two cheery *B* sections, but the main strain might have been by Jimmy Van Heusen on an off day. Besides which, it moves in the fifth bar to a *b* natural (the key is F) when you expect *b* flat. Well, the *b* natural is very hard to find and furthermore it's left hanging. For the melody drops to a pick-up note, *e*, and then to a *g*.

What I Was Warned About

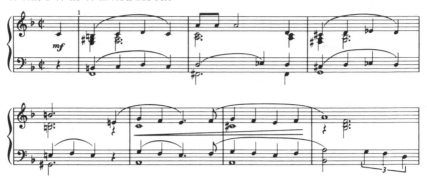

The *B* sections come off much better, to me, scrapes and all.

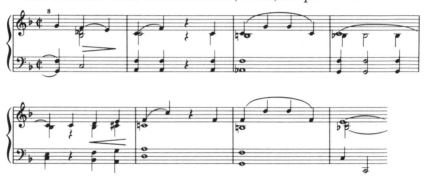

But somehow the bloom is off the peach.

There was a song in 1955, from the film "The Girl Rush," called *An Occasional Man.** It's seldom one hears tales concerning sources of song titles. Hugh Martin told me the source of this one: a lady who worked for his family always walked back home after work through the woods. Martin asked her if she weren't frightened to do so. She replied that she wasn't because all that ever happened was that she'd come across "an occasional man."

It's a good song which never attracted much attention, but which was recorded beautifully and definitively by Jeri Southern. There are no specific devices or phrases to cite. It's simply a good and unique song. It's one of those songs which you're made aware of in the first phrase and which keeps your attention throughout. In fact, it's in the

* By Hugh Martin and Ralph Blane. © 1955 Saunders Publications, Inc. Used by permission.

category of the song that you come across in a juke box and continue to play until you risk losing your welcome.

There is one curious measure in it which, I believe due to the harmony, makes the melody sound more difficult than it actually is.

An Occasional Man

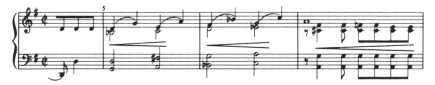

It's the second half of the sixth measure and I think that what throws the listener off is not the *b* flat in the melody but the *e* flat in the harmony. I don't see why, but it makes the *c* on the last quarter hard to find.

In 1964 came the show "High Spirits," based on Noel Coward's "Blithe Spirit." The song *I Know Your Heart** is certainly arresting in its opening and recurring phrase, moving, as it does, from a high *f* down to a low *c* in two measures.

I Know Your Heart

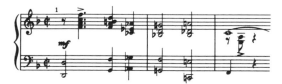

Frankly I could do without the four-measure cadences at the end of the two first sections. They may have had a use in the production, but as an independent song I think a two-measure cadence would keep the pace up better. The release, of sixteen measures, is a charmer. I'm surprised to have heard the song so little outside the theater.

If I Gave You is a very lovely, almost Elizabethan melody. The release is unexpectedly contemporary (not, to be sure, in the rock sense), but its difference in style from the principal idea somehow

doesn't disturb the song. Rather, it provides a sudden passionate plea which shocks but definitely appeals to the ear.

And *You'd Better Love Me** is a splendid swinging song, joyous, straightforward, and never stopping by the wayside or being cute or deliberately clever. If this were a time when such songs could flower, I'm sure this one would be in the books of every big band. Here is the principal idea:

You'd Better Love Me

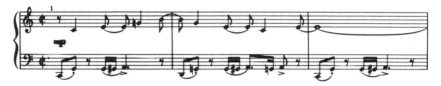

Martin's career is a strange one insofar as his talent is clearly one of great invention, sensitiveness, professionalism, discipline, and taste, and yet the evidence of these positive qualities has not often been revealed. I admit to being baffled. I believe that my mind is a reasonably open one, and yet when I carefully search through an entire score, such as that for "High Spirits," and find as little as I have, I worry for fear I must be allowing prejudice to creep in. Otherwise, how can such an obviously talented writer have failed to interest me to the extent of an entire score?

I can believe that someone could write very capably for the theater and still be incapable of producing a good independent song. And yet this is not true of Martin, since he has proven that he can write songs that do well both inside and outside the theater. But he is still a comparatively young man, and I wouldn't be at all surprised to hear a marvelous new score from him, provided a marvelous score is permitted on Broadway in these "Hair" days.

I await it with hunger and hope. And Martin has given me a solid basis for my hope. In the 1963 revival of "Best Foot Forward" came a new song, *You Are For Loving*, which ranks, I believe, among the best theater ballads ever written. I realize that this is a rather large remark. If I hadn't so recently examined almost all of the songs of every theater song writer, and certainly all of the most respected

theater songs, I might distrust my memory and say less. But when I come upon so pure and so soaring a melody, I find myself going back over all the other beautiful songs, and I realize that this one has the dignity and stature of the best of them.

I should make clear that my criteria are limited to the singing line and include the elements of intensity, unexpectedness, originality, sinuosity of phrase, clarity, naturalness, control, unclutteredness, sophistication, and honest sentiment. Melodrama, cleverness, contrivance, imitativeness, pretentiousness, aggressiveness, calculatedness, and shallowness may be elements which result in a hit song, but never in a great song. Sometimes one is deceived by devices, in other words, cleverness. The ingenuity implicit in cleverness is as dangerous as are the words of a hollow spellbinder or a beautiful but empty face.

Since we are living in an age of science, and science is highly complex, there has come to be an increasing obeisance to complexity in the arts and, as a result, a decreasing respect for the miracle of simplicity. Simplicity, per se, is valueless; but simplicity which is an expression and embodiment of beauty is the result of the most demanding discipline a creator can demonstrate.

You Are For Loving is not simply a good song fortuitously dashed off to fulfill a need in a theater production. It is the result of a lifetime of self-discipline, of sharpening one's sensibilities, maturing one's choices, restraining one's ability to dodge creative impasses by means of a clever device. It's part of the distillative process called taste, and it's recognizable as such instantly.

There is only a great sigh of fulfillment at the sound of the second statement of this song.

You Are For Loving

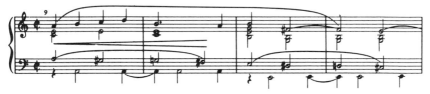

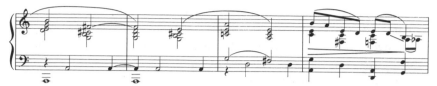

I am made glad with good feeling when the melody descends from *b* to *f* sharp, and doubly so when the phrase repeats, and triply so when, in its imitation, it becomes *a* and *e*.

But would my reaction be what it is if I hadn't first heard the innocent, undramatic statement of the first idea? I very much doubt it.

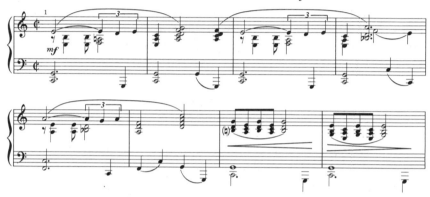

And then, after the restatement of this main strain, the song completely wins me over.

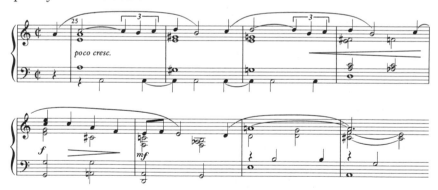

This, to me, is a perfect demonstration of all the bittersweet romantic longing and lovingness that good popular ballad song writing tries to capture.

III

VERNON DUKE
(1903-1969)

Vernon Duke was only one half of his musical self; the other half was Vladimir Dukelsky, a composer of concert works. Unfortunately for all of us, the concert, so-called "serious" side of this man's talent never, so far as I know, attempted to employ his popular side in a "third stream" fashion. For although he was born in another culture, his absorption of American popular music writing was phenomenal. One never was aware in his songs of his not being rooted in this culture, as I was, for example, when I listened to the theater songs of Kurt Weill. No, Mr. Duke-Dukelsky kept his musical selves compartmentalized. And it is only with the Duke half that I am here concerned.

His first complete theater score was for "The Yellow Mask" (1928), an English musical with a libretto by Edgar Wallace. I've not been able to find any of the songs from it.

His first complete Broadway score was for "Walk A Little Faster," a musical of 1932. In this score was his best-known song, *April In Paris*, with lyrics by E. Y. Harburg. There are no two ways about it: this is a perfect theater song. If that sounds too reverent, then I'll reduce the praise to "perfectly wonderful," or else say that if it's not perfect, show me why it isn't.

The verse is extremely good, but not as good as the chorus would lead you to expect. The latter has many interesting facets. The primary characteristic is the quarter note triplet which is encountered everywhere but in the *B* section. (The form is *A-A¹-B-A²*.) The second point of interest is that the melodic phrases containing the triplets are in chordal form in the piano part, in the manner of an instrumental trio.

April In Paris

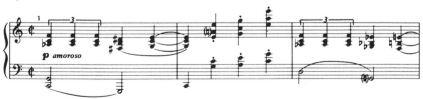

We have heard this song so many times that it is difficult to see or hear it new. But if one can do so, then it is immediately clear that melodically and harmonically this was an extraordinary beginning for a song in 1932, or any other year. The suspension of F minor over the pedal *c* and *g*, followed by another suspension of B major, resolving on the last quarter to C major must have been a hair curler to its first audiences.

Then, the astute shift to the dominant at the end of the third measure. And then the unexpected ascent in the sixth measure to the *d*, with the harmony taking the melody to F major in the ninth measure. I could sing the praises of this song measure by measure!

Best of all, though the harmony continues to excite and completely satisfy, the melody continues to soar above it, never seeming to be guided by it. For example, take the last measures of the *B* section:

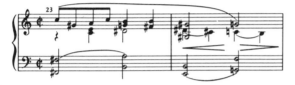

That *g* sharp in measure twenty-four sounds absolutely natural, as does the following *g* natural, leading beautifully to the *f* natural of the restatement. Given that harmony, it would take true mastery to find such a believable and beautiful melodic line.

I'm certain that Duke's musical sense functioned so that his melodic line and harmonic pattern were always in balance, with the stress, or control, being on the melodic side. Certainly this is so in *April In Paris*.

In the "Ziegfeld Follies of 1934," there was a swinging song, so American that for years I thought Rube Bloom, another great writer, had composed it. It's *I Like The Likes Of You*.

It's a strict *A-A-B-A* song, as alive and undated (in terms of professional writing) as any great song should be. It's particularly remarkable when a rhythm song doesn't date itself. *Puttin' On The Ritz*, great as it is, had to be a product of its time. But this song jumps, and I'm sure any surviving arrangers who work with rhythm songs would feel the same way and not as if they would be forced to rub makeup into the wrinkles.

Just the design of the main strain is a delight, the way it returns to the *e* flat while dropping down from the *b* flat to *a* flat, *g,* and *f.* And then, breezily and quite in charge, it fulfills itself in the following phrase.

I Like The Likes Of You

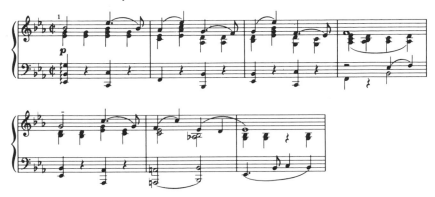

I'm completely captivated by the release, which has a marvelous, slithery idea and sticks to it by repeating it twice more with shifting harmony. And then, so well written is it that it still has time to coast and also build with two measures of half notes.

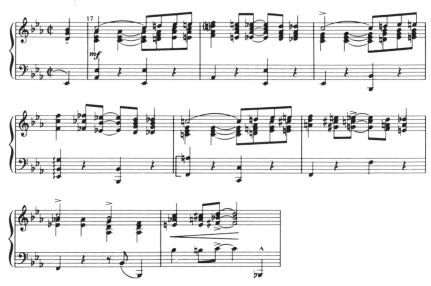

In the same show was another of Duke's best-known songs, *What Is There To Say*, again with lyrics by Harburg. It's another *A-A-B-A¹* form. And it's one more great model of theater song writing. Again it's a case of every note counting and not one false move along the way.

The chief characteristic of the song is the four sets of triplets in the second phrase. Here again is an instance of adroit contrast. Were the repeated first phrase not as simple as it is, the triplet phrase might not be as effective and desirable as it is.

What Is There To Say

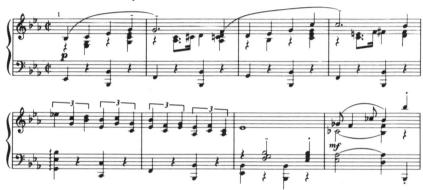

And the release is another demonstration of subtle taste and choice. The repetition of the first phrase with shifting harmony, followed by another quarter note triplet in which a second repetition is implicit, comes off as a series of urgent, stressed romantic needs.

Then, in the last measure of the release, one's reaction to the *f* sharp, after hearing the following measure which starts on low *b* flat, is that one has been cheated of the progression up to the *g*. But one hasn't. The *g* has simply been delayed until the end of the following phrase.

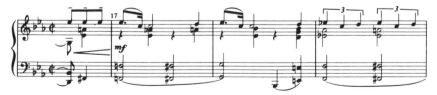

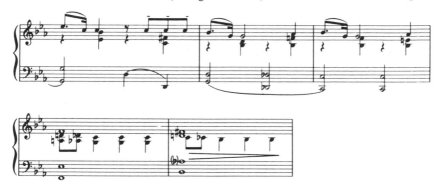

The variant in the second phrase of the last statement has so often been sung wrong on records that the average listener by now assumes that the last note of the twenty-seventh measure is an *f* instead of its so much subtler and unmelodramatic *e* flat.

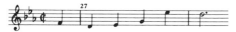

E. Y. Harburg's unusual rhyme of "deadlock" and "wedlock" is almost always mentioned whenever the song is.

The same year, 1934, in "Thumbs Up," the closing song, a production number, was *Autumn In New York*, for which Duke wrote his own lyrics. Usually a closing song in a revue or any theater musical attracts little attention. In addition to which, "follow-up" songs are seldom successful. But this song, of a completely different character from *April In Paris*, turned out to be a standard of almost equal prominence.

The verse may be the most ambitious I've ever seen. It begins simply enough, but halfway through it's almost as if the other musical half of the man couldn't be silent and the rest of the verse was finished by Dukelsky. It's extremely difficult and very lush. But I find it very interesting, and I approve of its experimental nature. After all, it's in the verses that the writer should be freer, for in practical terms it's the chorus that's being sold or promoted. So if the writer wishes to break loose, that is, if he is talented enough to, that's the place to do it. As difficult as this one is, it's been sung by many singers. So they must like it well enough to master it.

The form of the chorus this time is *A-B-A¹-C/A*. Though in the tenth measure it moves into a new key (from F to A flat), it moves back to C with great dexterity.

Autumn In New York

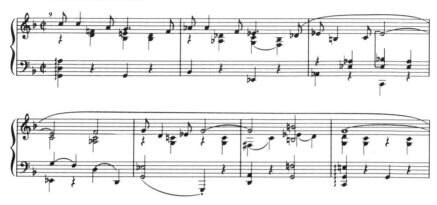

In the second half, Duke again slips away from the key of F, and works his way to D-flat major and, with a casual twist of the wrist, he's back in F with his opening phrase.

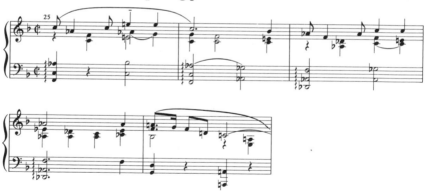

The fill-in piano phrase at the end of the first statement is very nearly an integral part of the song. Arrangers constantly have used it.

It's an interesting commentary on the untutored public that it accepted a song as complex as this as an independent popular song.

The thirties were surely Duke's years, for in "The Ziegfeld Follies Of 1936'" came another of his great songs, *I Can't Get Started*, with lyrics by Ira Gershwin. This song is a classic example of the use of the ostinato bass line, I, VI, II, V, or in simpler terms, the "we want Cantor" bass.

It's an extremely good song, with an equally good lyric. And it's been a big favorite with jazz groups. Curiously, a great trumpet player but a non-singer, Bunny Berigan, made a record of it in which he sang. As I recall, this record had much to do with establishing the song as a standard.

Through the years singers and players have altered a few passing tones so that one is surprised not to find those new notes in the sheet music. For example, in the third measure of the release, the last eighth note *f* sharp is sung and played as an *f* natural. Two measures later the last eighth note *e* is sung as an e flat. And frankly I like the resulting chromatic phrase better than the original.

This release, by the way, is extremely ingenious in its insistent return to the whole note *a*, each time supported by different harmony.

I Can't Get Started

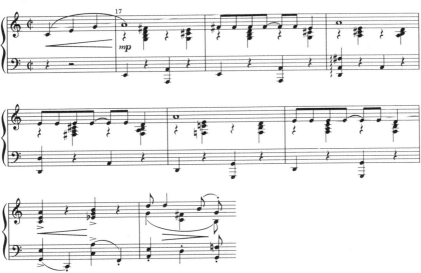

There are two other good songs in this show, a bit on the wild side, but full of marvelous surprises. As a matter of fact, *Words Without Music* is so far out I'm amazed the song was accepted. I'm particularly envious, even if it all happened so long ago, because this is the kind of song I was constantly being discouraged from writing on the grounds that no sane producer would take it. Well, not only was this song taken, but it didn't even die on the vine. It never became a big standard, but I've heard it sung and played, perhaps not by Guy Lombardo, but by other reputable people.

The verse has itself a lot of fun, and then the chorus, though in the key of B flat, starts out on a high *e* natural. My feeling is that the editor would have done better to use the key of F major and introduce *e* flats later on, where needed. For the main strain of the song except for the final cadence is in D minor and D major. One's eye is thrown off by seeing an *e* flat in the signature and an *e* natural in the voice line, first crack out of the box. But I suppose that because the cadence of the first section is a B-flat-major-seventh chord for two beats, the assumption was that the song was in B flat.

Words Without Music

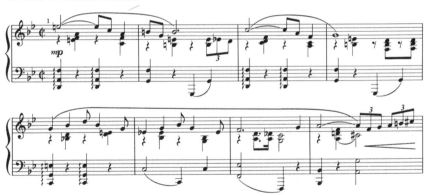

No matter what key it's in, it's a good wailing song, perhaps more instrumental than vocal, but original and juicy.

The other song is *That Moment Of Moments*. It's a simpler song than *Words Without Music*, not as exciting or unusual but solid and unbusy. The release contains an imitated phrase which is very ingenious.

That Moment Of Moments

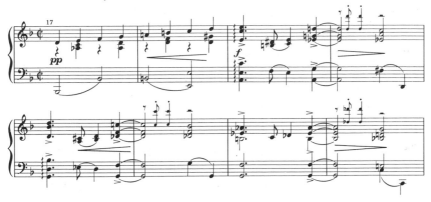

This song also managed to escape from the show and have a small standard life of its own.

Also in 1936, in "The Show Is On," Duke wrote a very good song, *Now,* which was played a great deal during the thirties but less so later on. Its verse is difficult and ingenious, based for the most part on a *d* natural pedal point and not specifically a vocal line. But it's musically interesting.

The chorus, for Duke, is fairly conventional. It is another I, VI, II, V bass line song, but it makes marvelous use of chromatic scale writing, as in measures five through seven.

Now

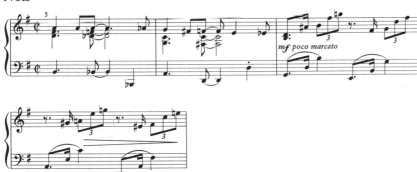

The last measure of the release is, for me, another of those "break" measures I spoke of earlier in discussing *Old Devil Moon* by Burton Lane.

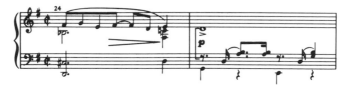

In 1940 came "Cabin In The Sky," in which there were several good songs, but the most successful of these was probably as big a hit as Duke ever had, *Taking A Chance On Love.* I'm afraid the song doesn't reach me, however. I've heard Ethel Waters sing it and that helps, but I find the song a contrivance, practically a potboiler. At no point is there any aspect of Duke's invention and musicality. I don't even consider it a theater song.

The title song is better in that it has a theatrical flavor to it. But again it has none of what one looks for in Duke's music. It's competent and professional, but that's about it.

Honey In The Honeycomb was a very good vehicle for Ethel Waters and has some pleasant moments but continues to sound like an assignment.

In *Love Turned The Light Out* there is a definite return to the invention and turn of phrase which one associates with Duke's songs. Right away, in the first two measures, one's attention is captured. And I'm not certain why. It's not from having heard a great performance of it. It's right there in the phrase.

I think it's the *g* going first to the *b* flat and then to the *a*, and by different rhythmic means. And I'm glad to see a quarter note triplet phrase again, not that it's exclusively Duke's but *What Is There To Say* causes one to associate it with him.

Love Turned The Light Out

And the release is another beauty, even if, as is usual with Duke, it's not easy.

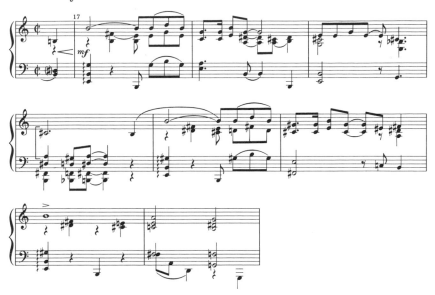

In 1941, in the show "Banjo Eyes," there was a very good rhythm song called *Not A Care In The World*. It's in strict *A-A-B-A* form and it attempts to do no more than be cheerful and bouncy. It's a sweet little lamb-skipping springtime tune.

"Sadie Thompson" (1944) lasted only two months. Quite frankly I think the score is, for Duke, inferior. There are no bad songs, but none of them seem to catch fire.

In "The Littlest Revue" (1956), there was a very complex and interesting ballad called *Born Too Late.** It's much too difficult to have had any life outside the theater, but it remains a fascinating piece of melodic writing. Usually a song which has moved beyond the limits of comparative simplicity set by an unwritten rule of practicality tends to become arty and pretentious and flounders in a vacuous area, neither of the theater nor of the concert hall. In this instance there is no extension of the conventional form, though the eight-measure sections are *A-B-C-B¹*. The first statement is never repeated, though it is imitated. You can see from the illustration below that the song is very complex.

Born Too Late

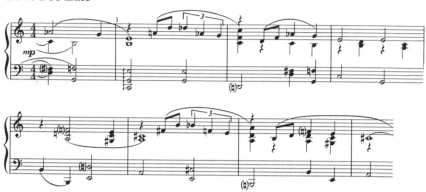

Of all the great writers whose songs have been discussed in the preceding pages, one would assume that Vernon Duke would have been the first to break out of the framework of popular music forms. Yet he has shown the least tendency to do this. He has kept to the conventional forms and thirty-two-measure lengths, and even when he does write a complex melody, such as *Born Too Late*, he doesn't move out of the framework more than melodically.

This is not to say that it is wrong to write extensions, to experiment with forms. Some of the best songs have had the most unconventional shapes. But it interests me that a schooled composer who has written a body of complex concert music should have been the man least inclined to experiment in popular music forms.

He has used his great sophistication to marvelous effect melodically and harmonically. And he has seemed very little concerned with rhythmic innovations, not that he was incapable of writing good rhythm songs, as *I Like The Likes Of You* attests. But his primary talent as a theater writer was as a romanticist, a true innovator in the world of the sophisticated love song.

It is also interesting that he was noticeably free of a predilection for repeated notes. Probably *April In Paris* was the only one of his songs in which there was definite concentration on repeated notes. But even at that, they were limited to the three notes within the quarter note triplet.

All three of the men I've been discussing were concerned with quality and style. They had varying degrees of creative fortune with those elements, though all three were successful financially. Vernon Duke has died, but Martin and Lane may miraculously be able to force the new, insensitive public to listen to a reputable score. My cynical conviction is that a score by either of them, written at the top of their talent, would fail miserably during these "like it is," "meaningful" days of bad wine and artificial roses.

—10—

The Great Craftsmen

As I have already said, the most sophisticated innovations in popular song writing have come in theater music. It is interesting to me, however, that from the late twenties on the non-theater pop songs got better and better. I'm convinced that this was simply due to the fact that the better pop song writers were paying closer attention to the superior musical sophistication of the best theater songs. What happened was that the gap between the best theater songs and the best pop songs began to close. And, of course, writers from both areas met on the common ground of musical films.

In my opinion, the song writers who closed the gap between the pop marketplace and the theater—that is, the great craftsmen of the world of the independent song—worked at almost the same level of innovation as the best of the musical comedy composers. And I should point out here that they certainly worked at a higher level than the Broadway hacks who ground out yard-goods music. Maybe the good pop writers I'm talking about deserved even more credit for breaking loose, because they were working against very hard-boiled commercial restrictions. When *they* took chances it was a risky matter indeed.

It should be kept in mind, of course, that even before the beginning of the thirties there were a few pop song writers who rose above the run-of-the-mill songs that poured out of the Tin Pan Alley publishing offices.

After careful study of non-theater songs I have concluded that there have been twelve great craftsmen among the hundreds of song writers who have composed capable, competent independent pop songs, and in some instances, film songs, who merit a place among the most significant innovators of the first half of the century. (The extraordinary Mr. Berlin, who leaped the gap between theater and pop music, has been treated in an earlier chapter.)

There would be more writers included among the great craftsmen but for the fact that some of the best of them wrote so few songs. And some of them wrote only a few songs altogether. And so, while these men produced an insufficient number of great songs to be considered in this chapter, due credit shall be given their best work in the following chapter, which is devoted to distinguished individual pop songs from 1920 to 1950.

I

HOAGY CARMICHAEL
(1899-1981)

I think is it unquestionable that Hoagy Carmichael has proven himself to be the most talented, inventive, sophisticated, and jazz-oriented of all the great craftsmen. He made but one venture into theater writing, for a show called "Walk With Music," from which no great song emerged.

He wrote songs for films, as did many pop writers. But, in every instance I know of, his were single songs, never scores consisting of at least several songs. As I have already said, I am convinced that movie music has always been one grade up from pop music and one grade down from theater music. And the reason for its secondary position to theater music is that the bulk of it has been supplied by men whose profession has been the writing of pop songs.

I have always been surprised that Carmichael never made further attempts to write theater scores. It is possible that his primary concern was "the song" as opposed to "the score." In the latter case, the requirements of the theater demand many songs of a casual production or comedy quality. And insofar as these kinds of songs are needed, the music must adjust to other than musical elements.

No score can consist solely of, let's say, great ballads, great rhythm songs, and nothing else. And while I believe Carmichael to have been quite capable of producing whatever the situation might have called for, I have a hunch that he simply wasn't really interested in anything less than writing unattached, isolated, independent great songs. No matter what the reason, pop music is the richer for his decision to stay out of the theater.

Carmichael is not, chronologically, the earliest writer in this group, but since I find him the most talented among the earlier innovators, I am placing him at the top of the list as a gesture of deference.

The first time I became aware of Carmichael was in a Paul Whiteman recording of *Washboard Blues*, a washerwoman's lament. It was a twelve-inch record in which Carmichael both played and sang. The orchestration was very dramatic, of shifting tempi, and for a large complement of players.

I found it extremely evocative and very well sung. Strangely, I never sought out the sheet music until I started this phase of the survey. And to my astonishment, I find the song still exciting even in this simpler form.

Though a verse, chorus, and patter are indicated, I find the song more like one long melodic line. The verse is much more than a verse. The chorus does not sound like a separate entity but a continuation of the line of the verse. The patter in no way resembles any patter I've ever seen. It, too, is a natural development of what has preceded.

I was so impressed by the Whiteman record that I must guard against my memory of it, since the conviction it left me with was one of cohesiveness, of a long melody which lyrically lamented the dreadful fatigue caused by washing clothes under primitive conditions, and of something unique musically. By the fifth bar of the verse, one is aware that for 1926 something extraordinary is taking place.

Washboard Blues

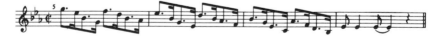

Then, immediately in the opening measures of the so-called chorus, one is further pleasantly startled by these measures:

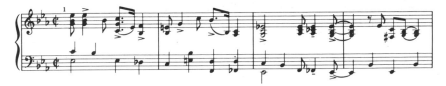

In the fourth measure the melody drops down to a *b* flat, and a beat and a half later jumps up an octave and a fourth. Such a wide step in such a short space is unheard of in popular music and is difficult for almost any singer. Indeed, the melody in the fourth measure is almost like a phrase to be sung by the bass voice in a vocal quartet.

When Carmichael sang it, it sounded easy. But one must remember two things: first, the melody of the fourth measure is not essential to the line of the song; second, Carmichael was deeply influenced by instrumentalists and dance bands. So if this measure is more instrumental than vocal, it may have been due to this penchant, which is not a justification but a reason.

And again further evidence of an experimental talent is revealed a few measures later.

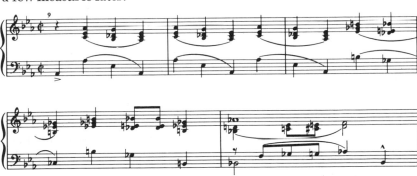

This phrase is basically in 3/4 time, as you can see. The unexpected shift in key feeling in the middle of the eleventh measure to the key of C flat is remarkable for the twenties or for any later, more sophisticated era, as is the resolution in measure twelve to a B-flat-seventh chord.

Of course one must acknowledge that another writer's name is listed, Fred B. Callahan. And since no distinction is made between lyric and composing credit, one cannot deny the possibility that Cal-

lahan may have contributed to the unusual musical creativeness of
Washboard Blues.

Irving Mills' name is also, as they say, "on the song." But since his
name appeared on so many songs, even those of Duke Ellington, it is
as absurd to consider him a contributor to them as it would be to
consider as composers or lyricists those band leaders whose policy it
was to insist that their names be listed on songs they promoted. It was
known as "cutting themselves in."

I might add that, though I never heard *Washboard Blues* performed
or recorded other than in the Whiteman version, so definitive was
Carmichael's performance that any other would have seemed want-
ing. The song was never a hit but I consider it a marvelous piece of
invention for its time.

*Rockin' Chair,** copyrighted in 1929, became well known undoubt-
edly because Mildred Bailey made it her theme song. In fact she was
known as the "rockin' chair lady." Here again is an instance of forc-
ing oneself to forget a definitive interpretation of a song. Miss Bailey
sang *Rockin' Chair* so completely satisfyingly that it is hard to erase
the memory of her voice in order to consider the song critically. But
by this time I believe I've managed to discipline myself. I can ex-
punge from my mind even some of Sinatra's definitive performances,
so I think I have myself well under control. For Sinatra could make
every song but *Jealous Lover* and *American Beauty Rose* sound
reputable.

Rockin' Chair is a simple song, yet it never resorts to a cliché. Its
form is not conventional, being $A\text{-}B\text{-}C\text{-}A^1$. This produces a surprise,
since after the B section one expects a return to A. There are small
but rewarding moments, such as the g flat in measure thirteen and the
a natural in measure fifteen.

Rockin' Chair

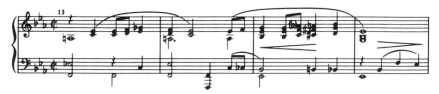

And throughout, the harmony is more satisfying than that of most songs of that time. For example, I don't remember having seen the harmonic pattern of the final cadence in any songs of that era or having heard piano players use it.

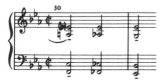

Then we come to not only Carmichael's most famous song, but to perhaps the most recorded of all popular songs, *Star Dust* (1929). This song started out in life as a piano piece. It is said that Carmichael's first recording of it was quite unlike the way in which it was later presented to the public in an Isham Jones record. It was played faster and almost in the style of ragtime; Jones was the first to play it as a ballad (even though it had no lyrics as yet).

When Mitchell Parish put a lyric to it, and a very smooth job of work it was, a verse was added. In fact, the verse has such a well-rounded shape that Sinatra once recorded it by itself. It was, I admit, somewhat frustrating not to have it followed by the chorus, but the point of the verse's completeness was thereby made.

One has heard the song so often and for so many years that it is difficult to view it with a fresh eye. Its instrumental beginnings are obvious. The melodic line is not, in the pure sense of the word, vocal. And this fact makes its huge success as a song all that more remarkable. And besides, it's no trifle to sing or whistle. Oh, by now, after forty years, it may be, but it's very far out for a pop song of any era.

The form, as well as the melodic line, is unconventional, *A-B-A-C*. The main strain follows chord lines. Though the song is in C major, the opening measure moves through pick-up notes to F major, and the melody for two measures is made up of notes of this chord. Then, daringly, in the fourth measure, the melody is made up of notes of the F-minor chord, but in eighth notes, which are not easy to sing as one of these notes is an *a* flat. Then (and I'm sure the song is too familiar to require more than harmonic illustration) in the sixth measure are the notes of the E-minor triad. And in the seventh meas-

ure is the phrase which undoubtedly was the source of the verse, which was added later.

If ever there was an instrumental phrase, as if improvised at that, it is the phrase of the thirteenth and fourteenth measures.

Star Dust

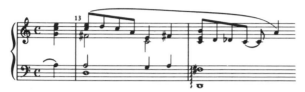

As for the verse, though only sixteen measures long, it does have a life of its own. And its principal motif bears the stamp of an idea which might have been Bix Beiderbecke's. Not to imply that it was, but that such an idea must have come naturally to Carmichael, since the trumpet player was his particular hero, about whom he wrote in his autobiography.

Star Dust is truly a most unusual song and absolutely phenomenal for 1929. As well, the public deserves great credit for having accepted it so enthusiastically and for so many years.

In 1930 *Georgia On My Mind* was published. This was another song associated with Mildred Bailey. It's a very sweet, warm song in conventional *A-A-B-A* form. And again, though it makes but one unusual melodic move, it has its own distinct character, instantly recognizable.

In the release, the use of the *b* natural in the twentieth measure constitutes an innovation for its time.

Georgia On My Mind

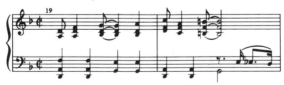

This *b* natural is particularly interesting insofar as it doesn't resolve to a *b* flat or rise to a *c* natural. In fact, it and its accompanying har-

mony create the effect of modal writing, specifically suggesting the mixolydian mode.

Though there are many more songs to discuss, and without instantly calling them to mind, I will guess that Carmichael will be found less given to the device of the repeated note than many of the other great writers. And this may be due to the instrumental influence in his writing. Also I might hazard the guess that the repeated note is to be found more often in theater than in pop songs. That, of course, remains to be proven. But if it is true, I admit to having no theory as to why.

Jumping to 1933, Carmichael wrote an uncharacteristic song called *One Morning In May*. It is an *alla breve* song of a long, strong line, quite capable of pleasing by itself in the manner of a great Kern melody. In fact were Carmichael's name not on the cover, I'd be puzzled as to which theater writer had composed it.

It's made up of sixteen-measure phrases and is in A-A^1-B-A^1 form. I've heard it for years and never known the writer. It's certainly like no other Carmichael song. And it's a perfect illustration of his theatrical flair.

One Morning In May

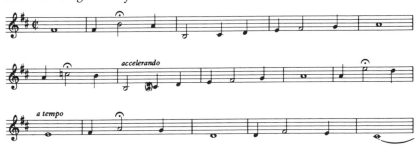

It's a superb melody which builds and resorts to no cleverness. I'm particularly impressed by the way the intensity is increased by raising the half note *b* in the second measure to the *c* natural in the parallel sixth measure, and again to the *e* natural in measure ten.

I would not be surprised to learn that this song had been written to be the "big ballad" for a show which never materialized. It's a beauty.

Also in 1933 came *Lazybones*, much of the popularity of which was

due to John Mercer's perfect regional lyric. It's a song of narrow range, if one ignores the parenthetical phrase at the end of the song, "well, looky here." Otherwise, it's within the range of an octave and moves as lazily along as the title suggests. I particularly like the chromatic harmony in the fifth and equivalent measures.

Lazybones

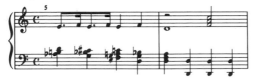

Judy, in 1934, is a pleasing, innocent little song, always good to hear again. It has no particular innovations, but my remembering it after all these years suggests to me that it has a special charm. And I believe that on one of its earliest recordings Red Norvo could be heard for the first time—and on xylophone not vibraphone.

"The Show Is On," a musical comedy produced in 1936, was one in which many great writers submitted single songs. Carmichael's contribution was one of his most successful, *Little Old Lady.* I'm sorry to say that it is so cute and so stereotypically little-old-ladyish that I find it mawkish. It certainly does what it sets out to do, but old as I am it makes me consider that perhaps everyone over, not thirty, but seventy, may not be dead but certainly never should be the subject of a song.

In 1937 Carmichael wrote *The Nearness Of You.* It isn't a typical Carmichael song, but it is a marvelous example of youthful sentimentality. It's the sort of song that an academic musical mind would sneer at, yet it is a very tender, forthright expression of the romantic world in which boys and girls once were wont to dream and dance and gaze and hold hands. It's simple and unclever. Its line is sensuous without being sensual, and I'm sad to see such songs out of fashion.

Two Sleepy People (1938) should be mentioned in the same category. In this case, the melodic line is not so spare, needing many more notes to accommodate the very tender lyric by Frank Loesser. Not is there any innovative element in the song. Its main idea, but for the engaging first measure, is made up of scale lines. Musically it at-

tempts little, and the melody with another lyric might never have become known.

Small Fry, introduced in the film "Sing You Sinners" (1938), is somehow unmistakably a Carmichael song. And the lyric, though by Frank Loesser, has such a Mercer flavor as to suggest that Loesser greatly admired Mercer's work.

In the second measure of the chorus the return to the *e* sharp is what one would expect of very few writers but Carmichael.

Small Fry

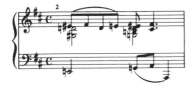

And in measure fifteen there is an echo of both *Washboard Blues* and *Star Dust*.

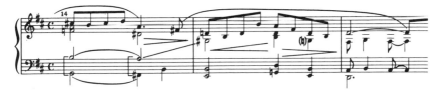

As well, note the harmony and melodic phrase in measure fourteen.

The release makes immediate use of the latter phrase and effects a most pleasing cadential phrase in measures eighteen and ninteen to the words "oh, yes."

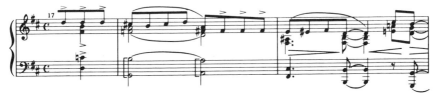

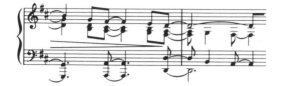

And then, in the last expanded section he ends his song with this same cadence. It's a very charming, inventive song from every point of view.

Now comes *Heart And Soul*, also in 1938. Frankly, I find it on the pedestrian side, not nearly up to Carmichael's usually high standard of writing, except for the release. It is in *A-A-B-A¹* form and the *A* sections are based almost entirely on I, VI, II, V harmony. But what does fascinate me and has never been explained is how it came to be more popular with small children than *Chopsticks*. I have never known a home which contained both children and a piano in which *Heart And Soul*, without the release, was not the principal pianistic effort. And it was always for at least three hands. The rhythm was almost always a form of "shuffle" rhythm and more often than not the bass line was scalar and in dotted quarter and eighth notes.

The copyright date is 1938, and I first found children experimenting with it around 1950. Even though it had been a great hit, it never did become much of a standard song. So where, oh where, did the children come across it a dozen years later? How did it manage to spread over the face of the nation? If there is an even faintly reasonable answer, I'd be very grateful for it.

In 1939 Carmichael wrote the words and music of a song called *Blue Orchids*. It has always been a great favorite with arrangers and and solo instrumentalists. As a song it suffers from two faults: a weak, somewhat maudlin lyric and a very difficult melodic line, truly instrumental in character. It's a perfect case of a song written at the piano. For the harmony leads the melody every step of the way. This limits its use but not its inventiveness. It constantly startles and resorts to such unheard-of devices as runs of four sixteenth notes.

In the seventh measure it is suddenly in G major (the key is E flat), and the second half of the measure is a run of four sixteenth

notes based on a D-major-seventh chord. Since only a half measure before, it startlingly arrived at G major on a high *d* natural, the run up from the low *d* in the second half is extremely difficult to sing.

Blue Orchids

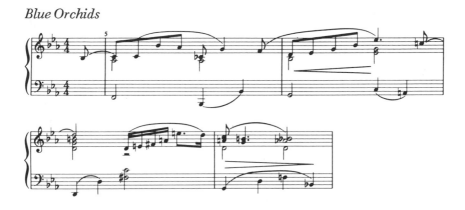

And, as you can see, its return to B-flat seventh in the next measure is a trifle abrupt.

There are, to be sure, resting places in this twenty-four measure song, but otherwise it's extremely notey. Fortunately, it is marked *Very Slowly*. It is inventive, as I said, and clearly jazz-oriented, but, juicy as it is, it is as little song-like as are many of the Duke Ellington so-called songs. It takes more than a lyric, even a very good one, to turn an instrumental piece into a song.

I Get Along Without You Very Well is a long, sixty-four measure song and is the only one of Carmichael's I know which uses so many repeated notes. It is a very clean, direct melody, as far from *Blue Orchids* as Kern is from Gershwin. I respect it more than I like it. For, to me, it borders on the saccharine.

It most certainly is without an ounce of cleverness. Nor is there any attempt to create interesting harmonic sequences. Indeed there are sections which linger so long in the area of the dominant seventh of the key (B flat), that it tends to stagnate harmonically. But it should be considered solely as a melodic line. As such, it works best for me in its *B* section.

I Get Along Without You Very Well (Except Sometimes)

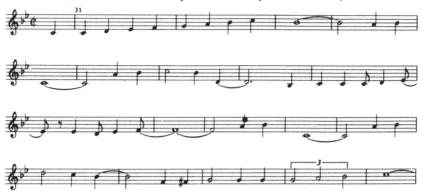

This section keeps the song from falling very nearly into a class I choose to call Ladies' Luncheon Songs. It is unique in that it is unlike any other popular song I know.

In 1939 Carmichael wrote the very entertaining *Hong Kong Blues*. And his recording of it is definitive and marvelous. It's more a vehicle than a song, and its insouciant range of a half step less than two octaves makes it prohibitive for any but an unusually adept singer. Its lyric, also by Carmichael, is very witty and since the song is a story, it must be sung "from the top." In these days of drug addiction, I'm surprised that this song hasn't been revived.

In 1940, there is the short, cheery *Can't Get Indiana Off My Mind*. It bounces along, just on the edge of 6/8 rhythm, of the "Blue Pajama Song" (*I Guess I'll Have To Change My Plan*) genre. It's innocent and deliberately notey without sounding cluttered.

Although used later in "To Have And Have Not" (film: 1944), *Baltimore Oriole* was published in 1942. It's very unusual, words and music alike. Though in 4/4 time, it is made up almost totally of quarter note triplets. This is not to imply that therefore the signature should be 3/4, as the song is a slow jazz lament.

I find it odd that, though knowledgeable people are aware of the song and that the music is by Carmichael, it never has had a great deal of exposure. This conceivably may be due to the lyric which, though extremely good, concerns only the amorous dalliance of a bird, feathered this time. And while there may have been overtones

in the film beyond bird life, as a song it may, to a singer, seem too limited.

It should be cited in full, but for those who might be interested, it is still in print. I'll tempt you with the first four measures:

Baltimore Oriole

Another feathered friend shows up the same year in the form of *Skylark*.* This, like the oriole, has no verse, and it also has a superior lyric, this time by John Mercer. It starts on my favorite interval, the sixth, and it proceeds on its memorable, distinguished way through an A and an A^1 section until it arrives at one of the most extraordinary releases I've ever heard.

Skylark

* By Hoagy Carmichael and Johnny Mercer. © 1941, 1942, 1969, 1970 Carmichael Music Publications, Inc. and Mercer Music. Used by permission.

This song is a solid standard, loved equally by singers and players.

Two years later in "To Have And Have Not" Carmichael sang *Baltimore Oriole* (see comments above) and also performed a song called *How Little We Know.* I say "a song" instead of "the song" because there was another song with the same title which was made popular by Frank Sinatra.

This may account for the fact that I have only heard this version performed by Mabel Mercer. She has sung it for many years, but always as a fast waltz. I have asked her how she came to sing it this way, since it is printed in 4/4, and she was uncertain if she had heard a recording of it in waltz time or simply concluded that it would be more effective that way.

Well, she's right. It's a happy, romping, delightful song sung in a fast three and almost out of focus in four. The whole song is engaging, but I'm particularly fond of the release.

How Little We Know

I find the melodic move into F major at measure twenty-two very beguiling and ingenious as well as the drop to the *d* flat in measure thirty-one, finally resolving on *e* flat in thirty-two.

And this brings up the fact of the double length release of sixteen

rather than eight measures. It flows so smoothly, as does the entire melody, that for all the years I've listened to it, I've been aware of the length of the long release only since I've recently examined the sheet music.

One added word. In order to avoid the abrupt return of the main strain, Miss Mercer adds a measure. And in 4/4, it is even more abrupt. Nowadays the odd number of measures resulting from adding one wouldn't cause the twitch of an eyebrow, and this, maybe, is a positive contribution, breaking up the insistence on even numbers of measures.

A 1945 song of twenty-six measures is *Memphis In June*, from the film "Johnny Angel." This is typical Carmichael, written as if with a rhythm section, and a very attractive song. I'm surprised it is so little known. It would have been perfect for Mildred Bailey and, if she did record it, why did it never become better known?

And it has one of those great regional lyrics which some city folk find embarrassing, but which, when capably written, I find very solacing. I like lines like "Everything is peacefully dandy" and "up jumps a moon." A very fetching little song, and it would be fun to orchestrate for some old believers.

In 1947 Carmichael wrote a very sweet, little known song, *Ivy*, to promote the film "Ivy" (in which it wasn't heard). It's a song which I don't believe anyone would assume to have been written by Carmichael, as it has none of his characteristic harmony or melodic or rhythmic idiosyncrasies. I find it one of his gentlest melodies.

Those are the first eight measures. Later on the song has phrases which are like Kern and Rodgers. The second and third measures of the release, for example, are close to a phrase from *All The Things You Are.*

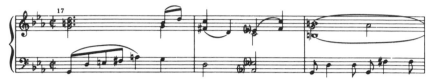

And the second-to-last phrase of the melody is like that of *Isn't It Romantic.*

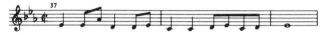

I'm not mentioning these similarities for "I spy" reasons, but rather to show the song's curious admixture of unexpected melodic phrases. Even the eleventh measure recalls the verse of a Rodgers song, *I Didn't Know What Time It Was.*

Were, for example, this measure developed or related to any other measure, I'd not have mentioned it. Yet, with all these strange excursions which should give the song a quality of discontinuity, it all comes off as an expression of great tenderness and unity.

I think that the relationship of the first phrase (made of two whole notes) to that of the eighth-note phrases of the third and fourth measures creates the special character of this song. And it certainly deserves to have been played more often.

Four years later Carmichael *did* write a fast waltz and *with* an odd-numbered phrase. In this case the main strain is nine measures, and it's absolutely great. The song is called *My Resistance Is Low,** which Carmichael performed in the movie "The Las Vegas Story" (1952). For seven of those nine measures there's an *e* flat pedal note which adds to the witty gaiety of the song. One would expect it to stultify it.

* By Hoagy Carmichael. © 1951 Carmichael Music Publications, Inc. Used by permission.

The release is sixteen measures, five of which repeat a one-measure phrase. This shouldn't work, particularly as it is supported by another pedal point, *g* natural. But it does work. Here's the whole release:

My Resistance Is Low

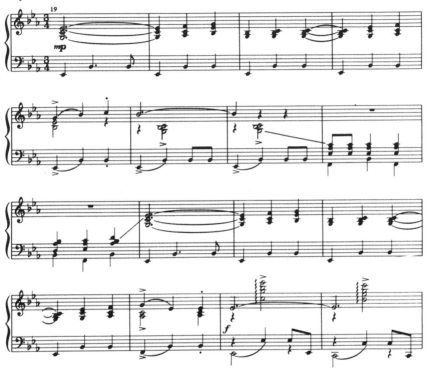

I'm very fond of the sudden run of eighth notes in measure thirty-four that leads back to the refrain. I find it all very pert and neat and smiling.

Those, to me, are the high points of Carmichael's writing. Obviously he wrote many more songs, but I think the songs considered here best reveal his many-sided talent, certainly many-sided enough for all the needs of a show.

There is an interesting fact about this man which continues to puzzle me. Why have disk jockeys, ever since there were record programs on radio, almost invariably mentioned his name whenever they

have played one of his songs? Harry Warren, Richard Whiting, Walter Donaldson, Jimmy McHugh all wrote great songs. But seldom have their names been announced with a recording as has Carmichael's. Theater writers are often mentioned, Ellington occasionally, but the other superior pop song writers, very seldom.

II

WALTER DONALDSON
(1893-1947)

Walter Donaldson wrote a great many hits, which go all the way back to *How Ya Gonna Keep 'Em Down On The Farm?*. Some of them were run-of-the-mill, some of them were fair, some were superior, but all of them were competent. He was a highly respected writer and is remembered with great affection and praise by all writers and especially by one of the truly great lyricists, John Mercer.

Pop song writers are less likely to have stylistic characteristics than theater writers. They write more direct and harder-sell songs, and write them singly to reach the marketplace and not for an integrated score to reach á more discriminating theater audience. Even if they wanted to, and could, they would have been highly impractical had they set their sights too high.

It is true that very high-sighted songs did become hits, songs like *You Go To My Head, Star Dust*, and *I've Got My Love To Keep Me Warm*. But they were exceptions, and it is my guess that they became hits because of special circumstances above and beyond their being good. Either a very popular singer or band sang or played them insistently, or the writer's name added instant luster, or the public had been inundated with a long series of very dull songs and found itself wide open to anything less so, no matter how un-poppish they were.

Donaldson not only was a writer of innumerable hits, but in between the hits were as many songs which attempted this eminence. Unlike many fine writers whose output was sporadic or whose level of writing was too complex to interest the publishers, Donaldson was an indefatigable worker. I make a point of this because the songs I have chosen for discussion constitute such a small percentage of his body of work as to suggest my indifference to it.

This is the problem connected with the consideration of pop songs. For while many of them deserved their popularity they simply do not possess the innovative quality with which I am concerned and which this study is all about. In the choosing of songs I have set up arbitrary qualitative rules which often may seem academic to the point of snobbishness. So I must repeat that my primary concern is to demonstrate how a popular art form can rise to the dignity and grace of a non-popular art form, and to contend that popularity does not automatically presuppose or demand pedestrian or "hack" invention.

My Buddy (1922), an early waltz by Donaldson, has mistakenly been assumed to have been a belated concern for a war "buddy." This is of little consequence, but it happens to be a false assumption. The song moves back and forth between two notes, a very simple device already used by Kern in *The Siren's Song*, but in this 3/4 rhythm bearing no relationship to it. Curiously, though no burst of invention, *My Buddy* remains unlike any other song.

It may be noted here that Donaldson liked this device. The same year, in fact, he employed it in one of his big hits and a perennial standard, *Carolina In The Morning*.

Carolina In The Morning

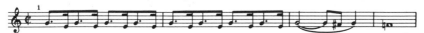

Granted, it's monotonous, yet its very insistence was what caught the public's fancy. Not that this constitutes a mark of quality.

The song, toward its close, does an unexpected caper which pleases me. After another to-and-fro restatement the song suddenly performs this little romp.

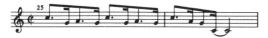

For 1922, I find the phrase in measure twenty-six unexpectedly inventive, specifically its drop to low *c*.

My Blue Heaven (1927) I mention only as one acknowledges the landmark of an era. Big a hit as it was, there is nothing of any musical interest to mention.

The "Molly and me" in the close of the song was unusual in that it limited the use of it to male singers. This was something pop writers and particularly publishers avoided like the plague. True, Miss Garland dared to sing it later on, just as Mabel Mercer sings other male lyrics, but their special position as performers has permitted them this license.

Changes, in 1927, I associate inevitably with the Rhythm Boys record. It's a swinging little song which does a few unexpected things. For example, at the end of the third measure it moves to a C-dominant-ninth chord. This normally would take the harmony to F major or minor. But in this case it returns to a G-major sixth, resolving to G-dominant ninth. It's technically wrong, and yet here it works.

Then, obviously because of the title, it does a little harmonic experimenting. In the ninth measure it moves unexpectedly to an F-dominant seventh, in the eleventh to a B-flat-major seventh, then back and forth. In the sixteenth measure it winds up on a B-flat-major-seventh chord, and in the seventeenth, directly in C major. In the release, in Charleston rhythm, Donaldson shows off his harmony as follows:

Changes

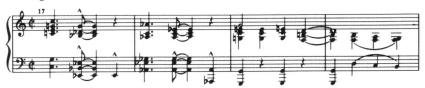

The lyric is sweetly naïve. For example, at the ninth measure, where the melody is an *a* and the harmony is an F-dominant seventh, the lyric says "C," the end of the line beginning with "he starts in." Later, where the chord is B-flat-major seventh, the lyric says "then changes to 'D.' " And in the release, after a major and two dominant-seventh chords, the lyric is saying "Hear that minor strain." Of course, there isn't a minor chord within earshot. But I think "minor" in those days meant "unusual."

In 1927 there was also *At Sundown.* This song has been around so long that its natural and felicitous phrases may have become lost in familiarity.

The four chromatic pick-up notes leading to the main strain, of

themselves are nothing. But as a lead-in to the main idea, they become essential. Consider the idea without them!

In the second eight measures, the phrase in measure eleven is not only extremely graceful, but is developed very adroitly and with seeming effortlessness.

At Sundown

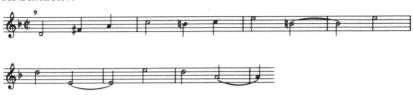

Whenever I am chided for my loyalty to the world of popular music, my impulse is to ask my condescendor to write me an eight-measure phrase as well made and memorable as the one he derides. Were he to try and find how much more to it there is than meets the ear, he might back down a peg.

In 1928 Donaldson wrote one of his best-known songs, a permanent part of the jazz library, *Love Me Or Leave Me*. It is a most unusual and marvelously conceived song. Strict *A-A-B-A*, to be sure, but every note is right.

Its initial ideas of two measures is in F minor. It is repeated, and then, totally without preparation, it moves to A-flat major. Not even is the harmony ready for this change. So abrupt is it that it should come as a wrench. But instead, in words of that day, "it's just what the doctor ordered."

Love Me Or Leave Me

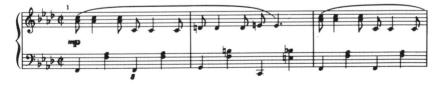

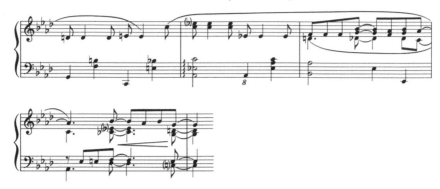

And I would be proud, if given the lyric and the restriction of one chord to be held for two measures, to write as neat a phrase as measures seventeen and eighteen.

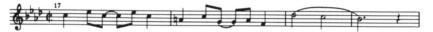

It is said that other, and well-known, songs have been written to the exact harmony of this song.

In 1930 came *You're Driving Me Crazy*, another hit and long-term standard. The *A* sections of this *A-A¹-B-A¹* song are bone simple, with just enough of an idea to constitute a main strain. For a rhythm song it contains a minimum number of notes. Insofar as it does, it's innovative.

In the opening *A* section there are three measures in which the melody moves and in the *A¹* section only two. This is perfect for a jazz player to maneuver in, and understandably the song is a favorite with jazz groups. The release is highly unexpected: it is entirely in A major, as opposed to the parent key of F major. And it is considerably busier than the *A* sections.

For 1930 this was a landmark of inventiveness. Even the verse is much more considered and inventive than most pop verses, which usually sound as if they'd been written at top speed and with cynical indifference.

Donaldson wrote many songs between 1930 and 1935, but it wasn't until the latter date that I have found anything worthy of discussion.

Clouds is no world beater, but it does have an unaffected charm about it. Of course one should keep in mind that by now theater songs

had become extremely sophisticated and daringly inventive—melodically, harmonically, and rhythmically. So I am perhaps less impressed by such a song as *Clouds* than I would have been had it appeared in 1930. Not that I expect as much from pop song writers as theater writers. But I would have expected some of the increased lushness and dance band atmosphere to have spilled over into more of the pop songs. Of course so ingenious and bright were the arrangers that, if one's first hearing of a song were by a band which employed one of the good ones, it was possible to mistake the woods of the arrangement for the tree of the song. Also one must remember that the continued conservatism of pop songs undoubtedly stemmed from the conviction by the merchandisers that the direct, unclever statement was what sold.

The first three measures of *Clouds* lead one to expect more inventiveness. But, for me, the song falls away into clichés.

Clouds

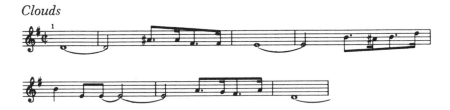

The release does risk a modulation from G major to B major, unusual for a pop song. But nothing much is done after it gets there.

It's Been So Long, a song from the film "The Great Ziegfeld" (1936), shows immediate ingenuity by moving through pick-up notes to a whole note *d* flat in the key of E flat, and that's surely unusual. But its double return to the *d* flat, as if to reassure the listener "yes, that's what I meant," takes the bloom off the peach.

It's Been So Long

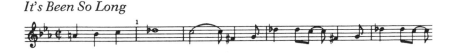

And then, as if having taken the high dive, the writer returns to the side of the pool from which he makes safe and sane plunges.

Did I Remember, from the film "Suzy" (1936), is somehow, on the other hand, a much more open and free melody. It doesn't suggest a small room in the Brill Building (the center of music publishers in New York) or its equivalent. One smells no cigar smoke, one sees no gross faces leaning over the piano. This song simply happens, or at least it gives that illusion. It's direct and unbusy, containing no notes of less duration than a quarter note. In fact, it is in that one degree higher than pop song category.

I find the second idea even more ingratiating than the first.

Did I Remember

The drop from *b* flat to *c* and back up to *g* has that fugitive element of sweet sadness. And the release is a gem.

The drop from *d* to *a* natural in measure twenty-nine is completely unexpected.

In 1936 Donaldson wrote a melody so unlike any he had written up till then that I only recently found out it was his. It's *Mister Meadowlark*. The lyric is by the bird man, John Mercer, and it's great, as usual.

The tune, verse and chorus are simply splendid. Take the first four measures of the chorus:

Mister Meadowlark

The phrase starting at measure nine is another beauty.

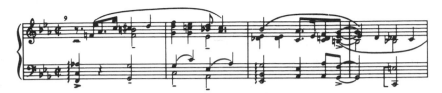

Because of the two measures reserved for whistling, the song may have come to be considered special material. Any song in which a lyric line is intended to be spoken, I put aside with a shudder. But whistling, particularly in this song, I find charming.

Not to be rude to Donaldson, may I suggest that it seems to me possible that the delightful and inspiring presence of Mercer might have caused Donaldson to find a fresher style of writing in this song. I'm sure if I were to ask Mr. Mercer he, with his impeccable good manners, would vehemently deny such a possibility, even if it were true. To me, *Mister Meadowlark* constituted a breakthrough for Donaldson. But I have been unable to find other songs to bolster this new style.

III

HARRY WARREN
(1893-1981)

Harry Warren, another writer of many hits, nearly all of them from films, was first heard from somewhat later than Walter Donaldson. And I find his anonymity to record program listeners an ill-mannered lapse on the part of the disc jockeys. It is true that he wasn't in the same category as the best theater writers, but he certainly was among the foremost pop song writers.

The first song which especially pleases me, at least musically, is *Would You Like To Take A Walk*. It is from the Broadway musical production "Sweet And Low" (1930). Until I carefully examined this song I could take it or leave it. And I now see that it was the over-cute lyric which prejudiced me. The melody, verse and chorus, is very good writing, suggesting a wider knowledge of music than popular songs.

Take the verse:

*Would You Like To Take A Walk (Sump'n
Good'll Come From That)*

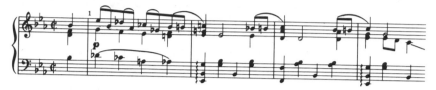

The base line in the first section of the chorus is a clue to Warren's
musicality.

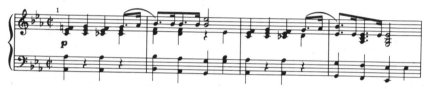

And after the almost sedate statement of the first four measures, the
sixth and seventh break loose almost as if the suitor had suddenly
gained confidence and indulged in a skip or two.

I find interesting the cadence at the end of the release in C major,
as it doesn't suggest a return to A flat except through the kindness of
an E-flat-seventh chord. The latter is common practice in many songs
which indulge in out-of-the-parent-key junkets. This time there is
merely an octave scale line leading from *c* to the *f* of the melody.

Of course it is probable that the lyric which embarrasses me had
much to do with the song's acceptance: the "mm-mm-mm" with
which it starts undoubtedly took a bit of daring, but it throws me off.

In 1931 came a song which is as typical and famous a product of
the United States as Coca Cola. It's *I Found A Million Dollar Baby*,
from the Broadway revue "Crazy Quilt." Judging by the opening
measures of the verse, Warren was acquainted with concert compos-
ers, Debussy in this case. It's a charming song, with a very good lyric.
But there's no special virtue in it outside of a phrase in the release and
the parenthetical "Incident'ly" at its cadence.

The phrase in the release is as follows:

I Found A Million Dollar Baby (In A Five And Ten Cent Store)

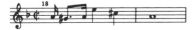

Of itself it isn't much, but since the song has just moved from a cadence in F major, the *c* sharp is a pleasant surprise. And the "incident'ly" is simply a delightful fortuity, a charming afterthought.

Usually when Bing Crosby sang any note other than that in the printed copy, the only recourse was to call the publisher and acquaint him with the new note. The plates would then be changed and Mr. Crosby's wrong note became the right note. But they didn't go through this ritual with "incident'ly." For Crosby sang, to me, a better note than that printed on the syllable "in." He sang an *a* instead of a *c*.

You're Getting To Be A Habit With Me was another big song in 1933, from the film musical "42nd Street." It *is* a pretty notey song, but it still "works."

I'm usually thrown off by eighth note triplets in this kind of song, not the kind in the second measure but in the third.

You're Getting To Be A Habit With Me

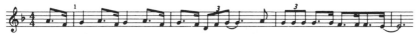

In the second measure the last note of the triplet being tied to another note causes it to come off as a jazz phrase. Not the triplet in the third measure. The latter has a tendency to give the rest of the phrase a "ricky-ticky" 6/8 feeling unless carefully controlled.

The phrase beginning at measure twenty-one is neither remarkable nor a cliché. It is simply very cheery and saucy. And the old time "I really mean it" extension in measure twenty-four has this same grin on its face.

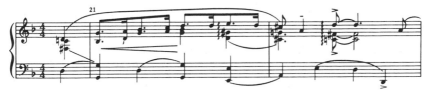

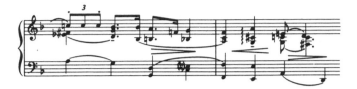

Such comments may read as straw-grabbing to cover the song's minimal interest. I admit that, were I to come across this song amongst a stack of theater songs, I would pay it less attention. But I think that, considering the marketplace limitations of pop songs, I must slightly lower my sights. However, I shall not stop each time I come upon as work-a-day a song as this. In this instance I find myself more entertained than impressed.

Perhaps I can clarify this by saying that I was inclined to linger over *You're Getting To Be A Habit With Me*, but I am not so inclined toward a 1934 song of Warren's called *(You May Not Be An Angel, But) I'll String Along With You*, introduced in the film "Twenty Million Sweethearts." One has a creative flair; the other is, to me, a hack job.

But I most certainly will linger over *I Only Have Eyes For You*. It's a very lovely melody, beautifully and dramatically fashioned. It is another of those songs that needs no harmony in order to please.

The step-wise writing is effective throughout. The cadence of the first section on *b* natural, followed by the cadence of the second on *c* sharp, followed by the cadence in the equivalent place at the end on high *e* natural are in a class with the best of theater writing.

In the second phrase of the release the *a* flat, the fourth quarter of the fifth measure, is a small but subtle variant of the first measure of the release. I also find the last measure of the release particularly fascinating in that it has none of the character of a pick-up phrase leading into a restatement of the main strain, but rather the beginning of the phrase. After the high *e* toward the end, the high *f* that follows is marvelous and masterful.

To go back, the ninth measure, which has dropped a half step from *b* natural to *b* flat and which is followed by an *a* flat leading to the first restatement, is highly inventive, even original.

Lullaby Of Broadway (1935) is a very simple, swinging little song from the movie "Gold Diggers Of 1935." Its interest is primarily

rhythmic, yet its neat little tune is riffish and shows a splendid use of repeated notes.

After twenty-four measures, the true lullaby takes over only to be interrupted by a rhythmic measure. It then continues, all in whole notes, and winds up swinging. The song is very theatrical in its opposed points of view and is more a production number than a pop song.

One of Warren's more pure and beautiful melodies, published in 1936, was *Summer Night*, first sung in the film "Sing Me A Love Song." And, as is often the case with great melodies, it is one of his least known.

Here is the first half of the melody:

Summer Night

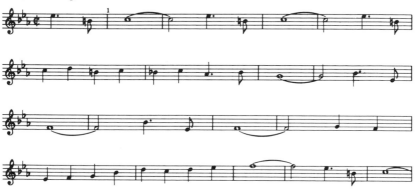

This is in the category of theater songs and deserves much more recognition than it has received.

Jeepers Creepers (1938) is a wonderful rhythm song, with an equally wonderful lyric. Louis Armstrong introduced it in the movie "Going Places." It begs no quarter, merely rolls up its sleeves and goes to work. It pretends to nothing clever or ingenious or elaborate. But it swings and is its own marvelous salty self. And to recoin a phrase, as American as apple pie!

At Last (1942), played by Glenn Miller in the film "Orchestra Wives," is another very good example of step-wise writing. It's also another I, VI, II, V bass line song. Its principal characteristic is its

use of the minor third and the minor seventh, in each case used very
effectively. Since it isn't one of Warren's big hits, here is a reminder.

At Last

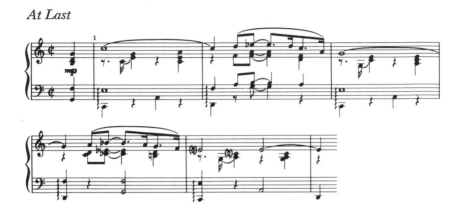

My only complaint is its rather angular ending. Since it in no way
uses thematic material, why then were these notes chosen?

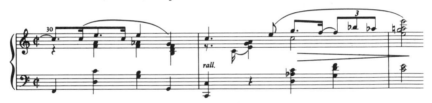

Another marvelous song from "Orchestra Wives" was *Serenade In
Blue*. This one I would puzzle over the authorship of, so uncharacter-
istic of Warren is it. It just might be Carmichael, or, listening to the
release, even Arlen. It's full of notes, to be sure, but every one a good
one, and has very pretty changes.

The release is a very daring reiteration of notes. Six measures start
with the same four notes. But there is a very subtle variation in each
of the second halves of these measures. These variations not only
avoid monotony but they almost demand the repetition of the first
halves of the measures. It's a very groovy song, deservedly a favorite
of all the singers and bands.

Also in 1942, Warren wrote a very warm and tender song called

There Will Never Be Another You for the film "Iceland." It just may be the loveliest of all Warren songs. It brings on the kind of goose bumps spoken of in another chapter. It tantalizes me instantly with its first phrase, then hooks me with its third measure harmony, and winds up enmeshing me with its succeeding phrases.

There's not a poorly chosen note in the melody. It's sinuous, graceful, gracious, sentimental, totally lacking in cliché. The whole chorus deserves to be illustrated. Just for example, here are the first four measures:

There Will Never Be Another You

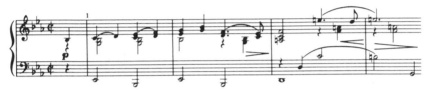

And here is the lovely, lovely ending:

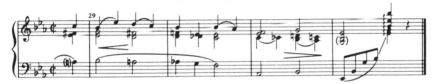

The More I See You, from "Billy Rose's Diamond Horseshoe" (film: 1945), is another lovely, pure, long-lined melody in the manner of *There Will Never Be Another You*. It sings by itself, even though the second eight measures are ingeniously harmonized.

The More I See You

It has that limpidity so often associated with Kern, as, for example, in one of the closing phrases:

I have heard it said that Warren is a great opera lover. In such as the above song one may note his love of the singing line.

IV

ISHAM JONES
(1894-1956)

Isham Jones not only had a great band but he wrote some great songs. This was an instance of a leader properly cutting himself in on the royalty. For he wrote every one of them.

One might assume that the songs of a band leader would have an instrumental cast to them. On the contrary, all of Jones's songs were markedly vocal.

The earliest of his songs which I am fond of is *On The Alamo*, written in 1922. It has a very attractive verse, which was unusual for those days when verses were treated as necessary evils. The chorus is very smooth and even builds to a dramatic climax. Its form is *A-B-A-C*.

The initial phrase repeats, and the value of the repetition lies in the change of harmony. It is one of those songs in which one mysteriously senses that the harmony will change even before it does. This supposition is shaky after hearing it so many times, yet even now, singing it over, I feel this expectancy of change.

On The Alamo

Jones uses the device of the opening pick-up notes (two eighth and two quarter notes) throughout and most effectively.

The only puzzlement I have is the shift from A minor in the twenty-fifth bar to C major in the twenty-sixth. I would assume that the A minor be retained, but with the seventh interval in the bass. It's a small point and almost irrelevant, since the melody is virtually self-sustaining but for that first change.

In 1923 Jones wrote a song which the average listener (elderly) still remembers: *Swingin' Down The Lane*. It's a cheery song which in another's hands could easily have become a cliché. But Jones never allows his motif to become a series of parallel imitations.

I'm very happy about the absence of an expected pick-up phrase preceding the thirteenth measure. It's this kind of good sense that keeps Jones from cliché writing.

It's interesting, to me, that in the closing measures of the song, one hears almost the identical ending of a great song Jones wrote the following year, *I'll See You In My Dreams*.

Swingin' Down The Lane

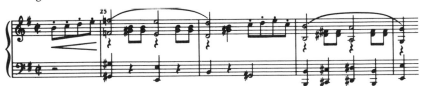

And even with the same harmony.

I'll See You In My Dreams, perhaps the best example in all of popular music of minimal notes, was only one of three great standard songs Jones wrote in 1924. It has exactly fifty notes, only two of

which are quarter notes, the rest, of course, being longer. Two other well-known pop standards which have very few notes are *Sleep* by Earl Lebieg (forty-two notes) and *Linger Awhile* by Vincent Rose (forty-four notes).

It is one of very few songs which I would not mind hearing an orchestra play in unison. The harmony is quite adequate, but the melody is such a model of lyricism and economy that it makes the harmony almost irrelevant.

It is the section from measure twenty-five to measure twenty-eight which had its first trial in *Swingin' Down The Lane*.

I'll See You In My Dreams

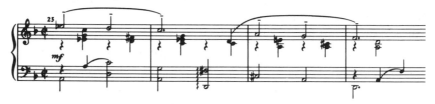

Simply transpose this passage up a whole tone and you'll see how close the two are melodically and harmonically.

I've heard it said only recently that *It Had To Be You* (1924) is John Mercer's favorite pop song. I'm not sure if I have one favorite song but certainly this song is a good choice.

Moving from a series of pick-up notes to the major seventh of the scale of G major, *f* sharp, with a G chord supporting it was by no means typical of the twenties in pop songs. Then to move up to a *g* sharp was even more unusual. It's again a case of a song's being so familiar that the unusual elements have become usual.

Other than these notes, however, there is nothing experimental in any way about the song. But its character is so uninterruptedly maintained and certain phrases so deftly fashioned that it reaches the listener as a wholly agreeable moment in time.

For example, the phrase in measure fourteen could have been step-wise and not have moved from the *b* up to the *e*: no harm would have been done. But one would not get the good feeling that comes from having heard a good musical phrase.

It Had To Be You

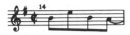

This is true of the third section.

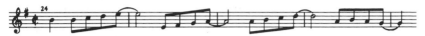

That drop of an octave in measure twenty-five is one of those mysterious choices that a good writer makes that constitutes good taste.

Also Jones' insistence on maintaining the device of the four eighth-note pick-ups, had it been handled with less deftness, could have resulted only in monotony. And it most certainly did not.

The One I Love (Belongs To Somebody Else) is still another 1924 song. I am pleased to find the sixth interval in such prominent use. The specific characteristic of the melody is the constant use of the dotted quarter and eighth notes.

Such insistence could have resulted in no more than hard-sell aggressiveness. But in Jones's hands it is only strong and forthright. It is less dramatic than *On The Alamo*, less lyric than *I'll See You In My Dreams*, but it is an honest, well-conceived pop song, memorable enough to have been a standard for forty-five years.

Jones wrote other songs, including the beguiling *The Wooden Soldier And The China Doll* (1932). A song with such a flat-out cute title could well have turned into another *Mickey Mouse's Birthday Party Day*. But Jones was too expert to let this happen, and, as a result, I remember it with great affection. It never did become a big standard, perhaps because of its title and subject matter.

<div align="center">

V

JIMMY MC HUGH

(1894-1969)

</div>

Jimmy McHugh wrote a great many songs, among them some of the best pop songs ever written. I admit that some of his best-known songs are not my favorites, but I don't feel so guilty about that since this book is less concerned with popularity than with quality.

One of his earliest and best-known songs is *On The Sunny Side Of The Street*, from "Lew Leslie's International Revue" (1930). It's one of the jazz musicians' favorites, having precisely the springboard from which they love to leap. Singers, as well, love it as much for its extremely fine lyric, by Dorothy Fields, as for its music.

I think it catches the ear at the second measure, where the melody unexpectedly jumps up to an *e* from a *g*, a sixth below. And again, the *b* natural in the sixth measure, though dropping only a half step from a *c*, is another unexpected note. I admit I don't know why it is unexpected, except that few writers would have used a *g* for a melody note, particularly if they used the D-dominant-ninth harmony. They'd probably have used an *a*. Also one subconsciously expects in measure five, I think, a repetition of measure one. Instead McHugh uses for his last quarter note a *c* instead of a *g*. And the *g* in measure six would then have been arrived at with much less skill. For the drop from the *c* is much more provocative than the rise from the *g*.

This may read like a tempest in a teapot, and so, indeed, it may be. But these are the fine points of song writing and the things that create surprises instead of simply good but uninspired writing.

Below are three choices. The first (A) is to use measure five as a repetition of measure one. The second (B) is to use five as it is but with an *a* instead of a *b* in six. And the third (C) is what really happened.

On The Sunny Side Of The Street

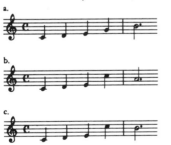

The release is very deft with its recurrence of *c*'s with shifting phrases between them.

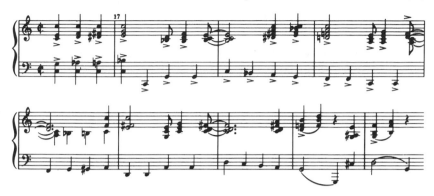

And also the two phrases at its close in measures twenty-three and twenty-four are very neat.

That same year McHugh wrote *Exactly Like You* for the same revue. It is a less bumptious melody and one I find more to my taste. This may be because I am drawn less by the driving than the evocative melody.

For a pop song it's very rangy, an octave and a fifth. This vocal demand is seldom found even in a theater song. It very much interests me that this in no way limited the popularity of the song. Most publishers in those days would have flatly refused to sign a contract for a song of this wide a range. If they were so convinced of the impracticability of such songs, and if writers obviously submitted to this conviction, why didn't the success of *Exactly Like You* cause them all to change their minds?

The song's principal device is the use of successive fourth intervals.

No attempt is made to allow for a breath at the end of the release; in fact, there is no cadence at this point, as in most songs. Yet I've never heard a singer carp about this. What with the wide range and no cadence one must conclude that if the public decides in favor of a song, it will make adjustments and forget its own limitations.

McHugh was a very fortunate man to have such a talented lyricist as Dorothy Fields to work with. Her lyrics often swung, and their deceptive ease gave a special luster to McHugh's music.

Blue Again, from "The Vanderbilt Revue" (1930), is a very delicate melody, almost like something written for a formal dance. It has a deliberate stance and elegance about it. I am sorry to say that the

release not only loses this flavor but is very nearly a cliché. This is unfortunate, considering the superior quality of the *A* sections.

The verse is not elegant, but very good. It ends with the lyric line, "What is this thing called love?" And the music for the line is as follows:

Blue Again

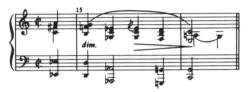

In 1932 came *Don't Blame Me*, introduced in the revue "Clowns In Clover" in Chicago. It was another winner. A standard if there ever was one. It's a very sparely though lushly written song. The melody is self-sufficient, yet all the harmony is as welcome as an extra dividend.

The opening phrase in the music is as absorbing as a great first sentence in a story, though it consists of only three half notes, *g*, *b* flat, and *a*. The quarter-note triplet is a characteristic of the melody and adds to its charm, but still one waits for those three half notes.

The first four measures of the release are very simple but very effective, whereas the cadence of the release I find disappointing. It consists of two descending half notes and a whole note. After all that's gone before, *a, a* flat, and *g* come as a disappointment.

Don't Blame Me

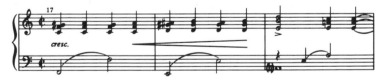

I Feel A Song Comin' On, from the film "Every Night At Eight" (1935), is a real show stopper. It's in the grand theatrical production number style, it swings and syncopates, and it's replete with interesting harmonic patterns.

Where Are You?, from the film "Top Of The Town" (1937), is an honest, sentimental ballad which we all remember with affection. But it simply has no single moment of innovation or seeming desire to wriggle out of a comfortably fitting skin. There is a feeling of complacent competence about it that irritates me.

Opposed to this is *You're A Sweetheart*, the title song of a 1937 film. There's nothing terribly innovative about this song, but there is a lot of breezy well-being and strength in it that never borders on complacency.

It's an *A-A-B-A¹* song, as are most of McHugh's. The two principal points of interest are the first four (and, obviously, their equivalent) measures and the release.

You're A Sweetheart

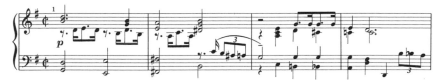

The harmony used in the first two measures is interesting and a sequence I've never encountered in the opening measures of a song. Then, the half-measure rest before the tune continues is very attractive.

The way the release shifts from the cadence in G major, the parent key, to E major for four measures is pleasantly surprising.

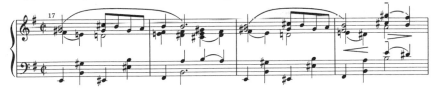

I admit to a weakness for a song of 1940 which appeared in a movie, "Buck Benny Rides Again," a song called *Say It*, with lyrics by Frank Loesser. I'm well aware that it's not a great song and that its sentimental sweetness stems from only a single phrase. But that phrase has pursued me down the years. Since it wasn't a big song commercially, my pathetic attempts to sing this phrase met with fail-

ure less a result of my poor performance than the listener's not recognizing the phrase. And for years I thought the title was *Over And Over Again*. There is a song, maybe more than one, of this title, so, as you can see, my years have been filled with frustration. But my unnumbered memory-bank account, James Maher, knew the phrase and the right title, *Say It*.

After all that, and seeing the phrase, you may wonder why I searched so long and why I have been so taken by it.

Say It (Over And Over Again)

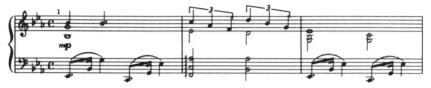

The second and third measures are the phrase. It not only says what the words do, perfectly, but it's as sad as romantic loneliness. And it's a vocal line. Undoubtedly it would not be as dear as it is to me had it not been preceded by the first measure's phrase, which is a perfect preparation. And then to have the "over and over" phrase repeated in the fifth and sixth measures gaffs me. In the release, the repetition of another phrase is monotonous without its harmony. But my pet phrase needs only its words.

Since the final cadence of *Can't Get Out Of This Mood*, from the 1942 film "Seven Days' Leave," is three measures, the length of the song is thirty-three measures. Examined a second time, one sees that, were the final note allowed only a two-measure cadence, the song would be thirty-two measures. But a three-measure cadence is more relaxed and works better. I wish there had been more of this oddity than there was. I'm sure many song phrases would have sounded more natural with odd numbers of measures. But, until the young people took over, it was a virtual sin to write a phrase that couldn't be divided by two.

In 1948, the song *It's A Most Unusual Day*, from the film "A Date With Judy," I find to be a waltz in the grand Richard Rodgers manner. It's what is known as a waltz "in one," that is, the three beats of the measure are conducted in one sweep of the baton. And it's

everything one asks of a truly waltzing waltz. It's romantic, direct, uncluttered, and extended beyond normal length. It's seventy-two measures, and none too long. It sweeps and soars and sings.

Here is its principal strain.

It's A Most Unusual Day

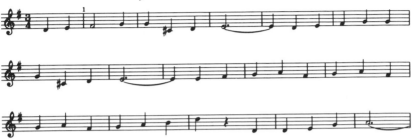

The repetition in measures nine and ten sweeping up to the quarter note *d* in measure twelve is great writing with its apt word "most."

Then the cadence of the release:

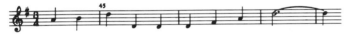

And finally, the extension at the end of the song:

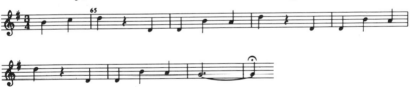

This is a great, free, happy, healthy waltz.

I have ignored such favorites as *I'm In The Mood For Love* simply on qualitative grounds. I wouldn't want you to think that I'm like the snobs who refuse to read the books on the best seller list because too many tasteless readers enjoy them. I think I've disproven such an attitude by admitting affection for many songs which have been high on the hit list.

McHugh wrote a great many songs about which I've said nothing. This does not imply I dislike them, only that I feel whatever virtues

they have have been better exemplified by the songs I have mentioned.

<div align="center">

VI

DUKE ELLINGTON

(1899-1974)

</div>

Duke Ellington has become a legend in his own time. His seventieth birthday has been celebrated at the White House; he is the darling of jazz enthusiasts and scholars wherever records or radio exist; and his band has been working steadily for over forty years. Indeed, it has been his medium of expression as much as canvas is to a painter or paper to a writer. More, in fact, as the band has also been his paint and his palette.

Since Ellington is a creator, his band has been a constant outlet for his creative ideas. This was true to an extent of Isham Jones's band, but never as much. The bulk of Ellington's enormous discography lists his name as composer. And many members of his band have contributed to the ethos of the Ellington sound: Barney Bigard, Bubber Miley, Juan Tizol, Ellington's son Mercer, Billy Strayhorn, his chief orchestrator, Johnny Hodges, and others. But Ellington himself has been the chief contributor and catalyst. Whatever ideas have been contributed by band members have been controlled and distilled by Ellington himself.

The only problem with discussing his songs is that very few of them are essentially songs, nor were they meant to be. They were composed as instrumental pieces to which words have been added and for which simplified releases have often been substituted. But the cardinal fact remains that Ellington himself is the judge and jury. Without his personal taste, his sense of fitness and aptness, the vast library of Ellingtonia would not exist.

Before considering these instrument-oriented songs, I'd like to make clear that one of them, which is constantly referred to by otherwise knowledgeable disc jockeys as an Ellington song, is in truth by Strayhorn. It is so listed on the sheet music and is called *Take The A Train*. And the proof of this song's instrumental nature is the travesty of a lyric which was desperately added to the piece to try to turn it into a song.

I remember hearing the instrumental version of *Sophisticated Lady* in the early thirties. I was mightily impressed—as much by the opulent colors of the band as by the piece itself. The song version is copyrighted 1933, with words by Mitchell Parish.

It is certainly a unique piece, particularly the release which shifts from the parent key of A flat to G. Its very ingenious return to A flat is a piece of linear wizardry and is enormously difficult to sing. It is interesting that even in the song version of this piece the grace notes of the instrumental version are retained in the piano part of the release. One almost wonders if Parish tried and failed to find syllables for those grace notes.

The piece is much more satisfying to hear played than sung, partly because of the excruciating line in the release, "dining with some man in a restaurant, is that all you really want." Scarcely lyrical.

The very lovely *In A Sentimental Mood* (1935), though probably originally an instrumental piece, does make a delightful song. Much of it is step-wise writing and, but for the lush release in D flat (the parent key is F), the song uses little special harmony, unlike *Sophisticated Lady* which would be lost without it. There is a memorable *a* flat in the fourth and equivalent measures.

In A Sentimental Mood

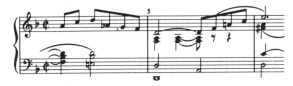

It is idle to speak of it, yet my sense of line suggests to me that the cadential *d* flat at the end of the first half of the release might well have been, let's say, a low *a* flat in the instrumental version, assuming it to have been such originally.

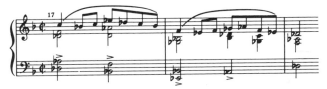

And who, may I ask, is Manny Kurtz? We know by now of the omnipresence of Irving Mills on the credits of Ellington songs, but had he by this time taken in a partner? I'm bemused! Mr. Kurtz is obviously the lyric writer. And frankly, only by the skin of his teeth, as the words certainly don't fall very fluidly.

Prelude To A Kiss (1938) is another chromatic idea supported by very gratifying, satisfying harmony and, except for a totally instrumental release, comes close to being a song. Even the lyric by Irving Gordon (in lock-step with Irving Mills) has a few moments, though the image of a "flower crying for the dew" somehow fails.

Here is that chromatic line and those fat chords:

Prelude To A Kiss

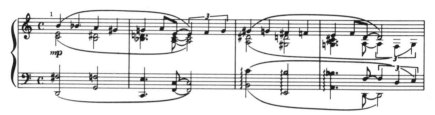

And here is the whole, marvelous, very difficult-to-sing release:

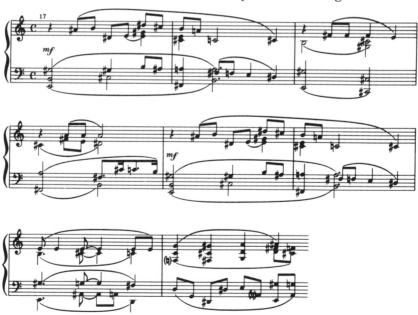

I Let A Song Go Out Of My Heart (1938) I remember so vividly as played by Ellington's band that I have difficulty reassessing it as a song. It's a swinging piece of music, but for the first half of the release and, were the lyric better written, I might be more inclined to think of it as a song than I do.

I Got It Bad (1941) *is* a song. Granted the jump of a ninth in the first measure isn't easy, yet it's the key to the whole song.

I Got It Bad (And That Ain't Good)

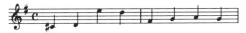

The release I find so pale compared to the *A* sections that it's hard to believe that Ellington was responsible for the first four measures of it. The second four have a flair, but the first four just sit there, and don't even count their fingers.

Certainly *Don't Get Around Much Any More* (1942) is a familiar song. In fact I know some who believe the title to be *Mister Saturday Dance*. Bob Russell did a splendid job with the lyric, and I bow to him for such a daring opening line as "missed the Saturday dance." This song is very singable, though originally an "instrumental." Again, the release. It simply hasn't the verve of the main strain.

Do Nothin' Till You Hear From Me (1943) works well as a song, again due in part to Russell's very apt lyric.

I Didn't Know About You (1944) works well as a song in this series of Ellington instrumentals with Russell lyrics. The main strain is the most melodic, vocally, of the three Russell wrote lyrics for. And yet it doesn't have quite the flavor of the other two.

Satin Doll, copyrighted in 1958, may have been written as an instrumental much earlier. But since the concern here is the song, it shall be considered as 1958. Having heard it recorded definitively by Blossom Dearie, I'd have to admit to its being a song. However, since Strayhorn's name is listed with Ellington's, I assume that the honors must be divided. It's a soft-spoken, underplayed little song with a marvelous, perfect Mercer lyric, and it truly swings.

Of course there were many other Ellington songs. But since they are more truly instrumental pieces, I feel that the ones already discussed give a clear enough picture of Ellington's single-line talent.

This obviously has been only a minor aspect of his orchestral talent, but it is the one with which the general, non-jazz-oriented public associates him.

For those seeking a thorough study of Ellington in his broadest musical contribution to American music and particularly jazz, I suggest you read the brilliant study of him by Gunther Schuller in his book *Early Jazz.*

<div align="center">

VII

FRED AHLERT
(1892-1953)

</div>

Fred Ahlert was another better-than-average writer, and though his best songs were not many, he deserves mention among the great craftsmen.

*I'll Get By** (1928) was, I believe, his first big song. It deserved its success. It's one of those flowing, long-line melodies. To be sure, it doesn't go as far as it might have had it been written for the theater, but it's so good that one wishes it hadn't been confined to the unwritten limitations of pop song writing. The first seven measures clearly show what I mean.

I'll Get By (As Long As I Have You)

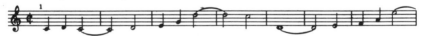

After this point it by no means deteriorates, but it doesn't continue to soar. It settles for an innocuous phrase and imitates it twice.

Mean To Me (1929) has managed to stay fresh down the long years, at least with me. There is an apocryphal, unsubstantiated tale to the effect that Ahlert found the seeds of this melody in a counter melody used by an arranger for an anonymous song. The band, so goes the tale, was that of Gus Arnheim. If it is true, I'm grateful to the arranger. May I add that for all these years I have tried unsuccessfully to find a tune of the twenties which would work contrapuntally with the main strain of *Mean To Me.*

After all this time I still am very pleased by those rising phrases, which so neatly avoid monotony by employing different rhythmic devices.

* Words by Roy Turk; music by Fred E. Ahlert. © Copyright 1928 and renewed 1956 Fred Ahlert Music Corp. and Cromwell Music, Inc., New York, N.Y. Used by permission.

*Mean To Me**

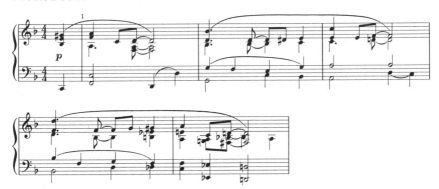

I find the bass line unusually inventive for 1929, and I am very fond of the harmony in measure five.

The release could be stronger, but it is my recollection that no one ever minded very much in those days what the release did as long as it was a release from the main strain or was a "bridge" between two main-strain statements. My great enthusiasm for Richard Rodgers' bridges in part stems from my instant boredom with so many pop song bridges. This one isn't boring. It's just not worthy of the rest of of song.

Walkin' My Baby Back Home (1930) is so cheery that it should be mentioned. Besides which, it swings. And in this case the release does work and does add to the "other half."

Love, You Funny Thing! (1932) is above average for a couple of reasons. First, the first four measures, without seeming disparate or unrelated, are all different.

Love, You Funny Thing!†

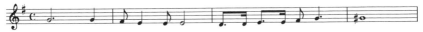

This may have been due to a lyric written ahead, but, in any event, what it does is escape the monotony of imitative phrases. Sometimes,

as in Warren's *Serenade In Blue*, imitation is essential, but beware of it generally: it is the mark of a hack writer.

The *g* sharp in measure four is pleasing in the manner of Isham Jones's *It Had To Be You*. And the desired *a* natural, a resolution to the *g* sharp, is delayed two measures, which is also a deft device.

There is another unusual phrase at the outset of the release, the *g* natural following the *a* sharp, where one would expect *g* sharp, as well as the *c* sharp in the release's third measure.

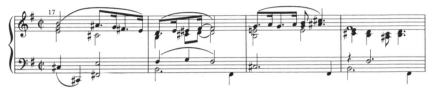

In 1934 came *The Moon Was Yellow*, another canoe song, with its aura of the "mystery of it all." It's in minor and does resort to imitative phrases, effectively. The only thing about those phrases that irritates me is that they suggest a dramatic acceleration during them and a *ritard* at their end. Granted that there is no such marking, still the fact that the phrases suggest it bothers me in its implication of more "drama" than I can tolerate in a pop song.

The Moon Was Yellow

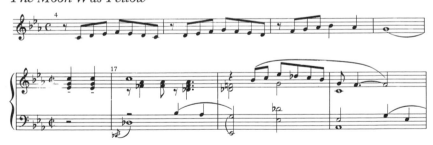

However, the release is a beauty, particularly the phrase in measures eighteen and nineteen.

In 1935 came *I'm Gonna Sit Right Down And Write Myself A Letter*. It's hard to dissociate oneself from the Fats Waller recording of this song. The lyric idea is delightful and so is Ahlert's treatment of it. For it easily could have been a sad ballad. Instead it's a swing-

ing romp. I am impressed by the turn-around nature of the first phrase. To consider such a circular phrase requires more than a casual impulse. It could as well have been a scale line or repeated notes. Instead Ahlert chose a more provocative method.

I'm Gonna Sit Right Down And Write Myself A Letter

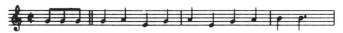

VIII

RICHARD WHITING
(1891-1938)

Chronologically, Richard Whiting belongs back in the time of Walter Donaldson: the best remembered of his early hits was published in 1920. It was *The Japanese Sandman*. There's a strange irony in the fact that it has managed, as we survivors have, to stay alive. And the song is once again an acceptable one, unlike another happy song the title of which now makes it not only unplayable but unsingable, *Nagasaki*.

The Japanese Sandman is a phenomenon for its time, and a half century later it's still good. The verse is marvelous and when I made a nutty arrangement of the song shortly before the war with Japan, I naturally included the verse. Just look at its first phrase!

The Japanese Sandman

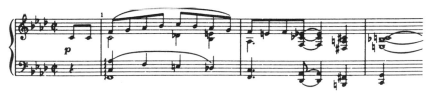

Later on it jumps tastily into A-flat major and then back to F minor.

Just as in *On The Alamo* by Isham Jones, one senses the same change in harmony in the first imitative phrase. The use of the back-and-forth minor third phrase which continues throughout the song is perfect since it is the Western concept of Oriental music. The

wholly unexpected shift to A major, with the melody moving to *c*
sharp is masterful. And remember, it was only 1920!

Again, it was very bright to make no attempt to return to F major
by means of the almost inevitable device of C-dominant seventh until
the last split-second. And then it was the original *c* natural with
which the pick-ups to the song started that established for the ear the
return, even though the C-dominant ninth had just been heard in the
accompaniment. It is that *c* natural that really brings you back.

The only place Whiting deserts his Oriental figure is in measure
eighteen, where he unexpectedly resorts to this:

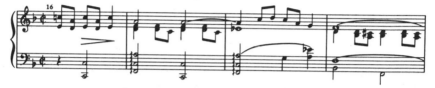

And he pulls one last splendid stunt later when he takes the tune
up to a high *f*.

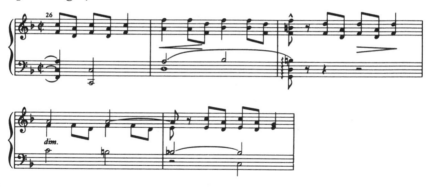

Bravo!

In examining *Sleepy Time Gal*, a song of 1925 with the added music
credit of an Ange Lorenzo, I've learned an interesting lesson. Some
time ago I had occasion to arrange this song for a concert group, a
woodwind quintet. I had no copy and chose not to buy one, presuming
I had heard it enough times to know it. It *was* a presumption, for I
find that I didn't, after all those hearings, truly know the melody.

I believe that singers and players take great liberties with pop

standards and almost none with theater songs. One singer picks up from another, as do arrangers from each other, until the melody contains many new notes. Without belaboring the point I find that in at least four places I presumed the melody to be other than it actually is, and I sinned in not being aware of the old-fashioned many-noted return to the main strain.

There was nothing arbitrary in my choice of notes. I had simply heard it played and sung unlike the printed copy. Sometimes these changes are for the better.

The song may seem a cliché to lovers of chic, distinguished theater ballads. And perhaps those phrases which follow the notes of chords are close to cliché writing, yet they are offset by other inventive phrases.

It is interesting that a recurring phrase is the same back-and-forth minor third of *The Japanese Sandman*, as in measure seven.

Sleepy Time Gal

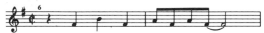

The old-fashioned phrase which I forgot and which in songs of that and earlier times was sung while the band, as they say, laid out, is this:

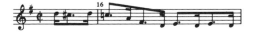

The words are so nostalgic and innocent in terms of 1970: "It's gettin' late and, dear, your pillow's waitin'."

I wish Whiting had written the music for *She's Funny That Way* (1928). For then I could wail and carry on about how I feel about this very haunting song. But I'll still have the chance in the chapter concerning great individual songs of the twenties, thirties, and forties. For Whiting, in this case, wrote the lyric. And very, very good it is.

My Future Just Passed, from the film "Safety In Numbers" (1930), is as irresistible a title as one William Engvick once wrote, and which died aborning: *You Wrong Me When You Never Write Me.*

This song has a very distinguished, inventive verse, with phrases like this:

My Future Just Passed

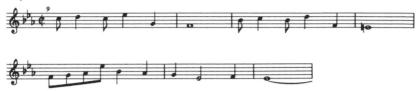

It's a cheerful, swinging song, doing what you want it to do and going where you hope it will go. And it has a very neat release.

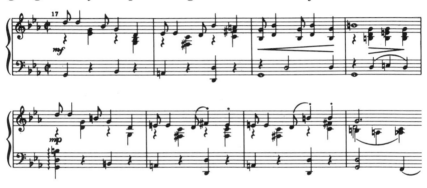

This song is quite good enough to have been a theater production rhythm song.

In 1930 Whiting (and a Newell Chase) wrote a very lovely melody, *My Ideal*, sung by Maurice Chevalier in the film "Playboy Of Paris." It's a short, sixteen-measure song, but sung or played very slowly, as not indicated in the copy, it is most effective.

The song makes constant use of chord lines, and the skips are not always easy: in the first measure, the leap from low *e* flat up a major seventh to *d* natural, for example. And in the fifth measure, the third note, *d* natural, is not easy to find. One's impulse, without the help of the harmony, is to sing an *e* flat. Of course, Whiting is quite consistent, since here too he makes a leap of a seventh, to *a* flat from *b* flat.

For those days the eighth measure came as a shock.

My Ideal

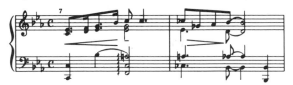

The fourteenth measure is very attractive as well as difficult.

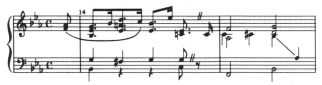

Altogether this is one of the most highly respected songs of its era.

In 1936, there was a fair-sized hit which never became a proper standard, *Peter Piper*. And it has another marvelous lyric by John Mercer. I find the song a swinger, and I even go so far as to say that I hear measures which had to have been encouraged by Mr. Mercer.

In the 1937 film "Ready, Willing And Able," there was the marvelous *Too Marvelous For Words*. This is a model of pop song writing, musically and lyrically. Just see how Whiting presents the idea two different ways.

Too Marvelous For Words

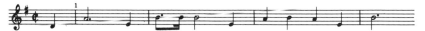

And then how gentle and almost tactile are the phrases to fit the "words."

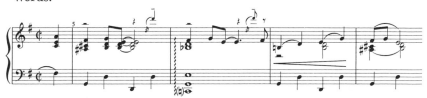

Remarkably, but by now to be expected from Whiting, in the second eight measures, after leading you up the garden path of simplicity, he launches out in B major. More than that, he makes the release seem continuous with what precedes it, a rare trick.

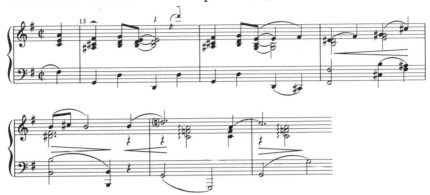

Note how simple the *d* natural is at the beginning of the release, made so by the *c* sharp in the preceding measure.

Measure fifteen really is a shocker for any song, having, as it does, three notes out of the G-major scale, *d* sharp, *g* sharp, and *c* sharp. Well, good for Mr. Whiting! Such departures not only shook the complacency and pedestrianism of the average writer, it proved that one could take big chances and still make a happy living.

As in the case of the other writers, Whiting wrote many other songs, but these seem to me to best exemplify his style.

<div style="text-align:center">

IX

RAY NOBLE

(1907-1978)

</div>

Ray Noble, whose band played in the United States during the thirties, wrote only a few songs, but all of them were very good. Insofar as he is not an American, it might be suggested that his songs don't belong in this survey. Yet his songs are so American in style and so loved by Americans that he is musically American by adoption. I doubt, in fact, if most of those who like his songs know that they were written by an Englishman.

Noble's first and most famous song was *Goodnight, Sweetheart,*

copyrighted in 1931. Anyone who has danced till the end of an evening between then and now knows that it has become the quasi-official close of any dancing evening. It is bone simple, fashioned principally of half steps, contrasted by lines of melody which follow the notes of triadal chords.

Successful songs using these close relationships are fairly rare. *White Christmas* is one, *Just In Time* from "Bells Are Ringing" by Jules Styne, is another. And they're much harder to write well than you might think. *April In Paris* is another one, after a fashion.

In 1932, Noble wrote *Love Is The Sweetest Thing*. It has a I, VI, II, V bass and chord line for its first four measures, but the melody is so distinctive that one is hardly aware of this. It's a very pure, as opposed to sensuous song, and so simple that it's not easy to define why it's so appealing.

The first two-measure phrase is immediately repeated, but for one added quarter note. And the fifth and sixth measures are an imitation. There is no specific innovation. I feel, after examining it, only that I have looked at the work of a distinguished melodist, and that the song was written as much to be sung as played, indeed, more.

Love Locked Out (1933) is a perfect song of the early thirties, one which can still evoke that era; one which I respect, but which is almost limited to its decade. Even though sad, romantic songs will always be written, bad guitar chords or not, this particular kind of ballad is a product of an age. I could list many of them, but I prefer to note them as they pass by in the next, more general, chapter on pop songs.

Love Locked Out has a well-written, thought-out verse that moves beautifully into the chorus. The second note of the latter, a *d* sharp, moving not to an *e* but to an *f* sharp, is innovative, as are the two sixteenths which I feel could as well have been the first two notes of an eighth note triplet.

Love Locked Out

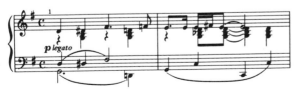

The shape of the first *A* section is four phrases, three of which are imitative. My only complaint is that, though the imitations are well-written, they are almost monotonous. Of course, imitation was a device of that time and subsequent years in all popular music.

In 1935, Noble wrote words and music for a song called *Change Your Mind*, from a film "Ship Cafe." I never heard this song until I undertook this project, and I am surprised that I didn't. For it is a very good, strong ballad with a good verse, though the lyric is sorely lacking in quality. It is possible that the poorness of the latter may account for the song's obscurity.

The piano copy would never serve the needs of a good piano player. I can see how he would immediately change the first chord of the chorus to D-dominant seventh, keeping the *e* flat in the bass to make an interesting dissonance, and do the same thing in the third measure where the melody repeats itself an octave higher.

Change Your Mind

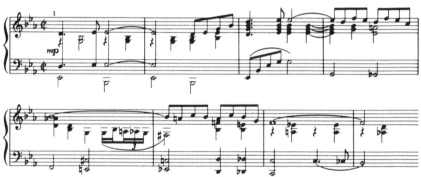

When I consider the urbane and charming personality of Ray Noble, I find it sad that the mysterious workings of commerce seldom include urbanity and charm. When they do, the writing of such a book as this is a delight. And, happily, much of the need for musical quotation from songs has been smooth and civilized.

I would like very much to be able to show Mr. Noble's stylistic felicities by means of musical notation. But because of the impossibility of obtaining permission to quote anything from what I believe to be his best song, *I Hadn't Anyone Till You*, I can say only that it

is stylish throughout, verse and chorus. There are no attempts to be clever rhythmically, harmonically, or melodically, unless one considers a modulation from the key of F to the key of D flat in the verse to be such.

It is a smooth, direct, slightly rhythmic ballad of no great range and unmistakably a song of its time, the late thirties. It makes a move in the second half of the B section (the design is *A-B-A-C/A*), into the key of A major from the parent key of F major, which adds that dash of color needed in a song of so direct and unpushy a nature. It is a song with both sophistication and a flavor of the past.

Measure thirteen is a new idea, and, though fourteen is an imitation of measure ten, it, in turn, is new.

I only wish there had been some way to resolve the problem of the end of the phrase in sixteen and the immediate beginning of the new phrase. For at a steady tempo this is awkward. But it's a very lovely song, with the last phrase a duplicate of the first.

Certainly these songs are a fine contribution to pop song music, whether by an Englishman or not. They scarcely sound like importations.

X

JOHN GREEN
(1908-1989)

Johnny Green has written some very fine songs, though very few in all. His principal career has been as orchestrator and writer of film scores, and, in recent years, as a busy concert conductor.

His first big song, *Body And Soul*, was copyrighted in 1930. It was an interpolation in the Broadway revue "Three's A Crowd." Because of a recording by Coleman Hawkins that was almost immediately recognized as a jazz landmark, the song became a standard part of the repertoire of the improvising soloist. Hawkins in the 1920's had created the first jazz solos on his instrument, and he brought to Green's melody a rhapsodic exuberance that astonished the ear. Except for *How High The Moon* and, possibly, *Star Dust*, there have been more improvised solos of *Body And Soul* than any other song.

Its verse is as strange and unprecedented as its chorus. Based on an

f pedal point, it moves up to a high *g* by means of difficult intervals, each one supported by a chord. After four measures the key signature changes from four flats to one flat. After these dramatic eight measures, we find ourselves with a new idea in A minor, and now no longer with each note wrapped in a chord. Then after working back to a C-dominant-seventh chord, a last quarter note *a* flat warns of more innovations to come and sure enough, we are now back in three flats and it's F minor which is the chord the chorus starts in.

The eighth-measure cadence is in E flat major. The section repeats. But look out! For now we're in E major, a half step higher, but only for four measures. Then we're in G major for another four. Here is how the song gets back to its F minor *A* section:

Body And Soul

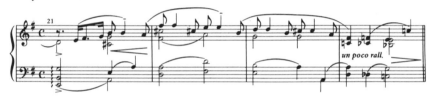

And then the *A* section repeats as at first.

I honestly feel that the final *c* natural of the release is asking an awful lot of any singer. But the miracle is that the public not only accepted this song, they've gone on accepting it for forty years. This is the same public which the publishers were convinced were capable of absorbing nothing more difficult than *I'm In The Mood For Love*.

Of course, I'm absurdly ignoring the simple fact that, though part of a composite score, it *was* introduced in the theater and so, I suppose, has wrongly been discussed in this chapter. I grant it may not belong here, but then perhaps neither do those songs I've written about which appeared in films. The problem is simply that Green's other efforts were non-theater songs. And so he belongs more in a chapter on pop songs.

Body And Soul remains a landmark, then, in the category of interpolated songs, for it has one of the widest ranges and one of the most complex releases and verses. It is obviously an enormously innova-

tive song but may well have achieved its standard status through the comparative simplicity of its main strain.

Also in 1930, he wrote *I'm Yours*. It's hard to believe that the man who wrote *Body And Soul* wrote this. It's a pleasant enough song which did become a standard, but which is truly of no great account. It never surprises, has no interesting harmony, and evokes no strong emotional response.

Out Of Nowhere (1931) does much better. It has surprises, interesting harmony, and a flowing melodic line. Its first surprise is the *d* flat at the third measure, supported by a C-flat-major-seventh chord. In the restatement of the phrase, the note becomes *d* natural.

Later on the phrase leading back to the main strain is a series of quarter note triplets which are of a piece with the over-all melody but which constitute a new idea.

Out Of Nowhere

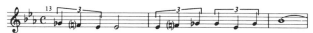

After eight measures of the restatement, the closing measures are very warm and tender.

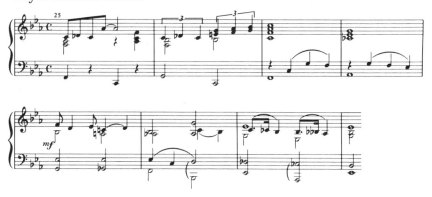

I am surprised that the first half of measure twenty-nine is not a quarter note triplet: that way it would move so much more smoothly.

Hello, My Lover, Good-bye (1931) is a marvelous song, every way

but lyrically. It was sung by Frances Langford in the musical "Here Goes The Bride."

The verse is very good, good enough, in fact, to use as the main strain of another song.

Hello, My Lover, Good-bye

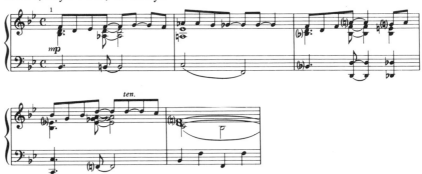

The chorus is the soul of innovation. Here is the main strain:

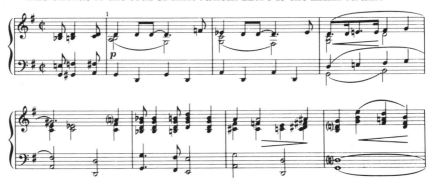

At measure four, to support the *g* sharp, an E-dominant chord might have sufficed, but the A-minor sixth changing to a D-dominant seventh with a flat ninth—oh, well, anyway, it's very good. And to continue the chromatic steps into the following measure is very special.

The release is a dream. Of course, I'm conditioned by Harold Arlen's writing to love octave drops.

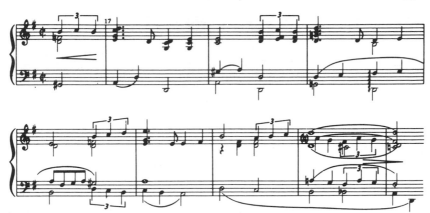

Instead of repeating the *A* section at the end, he does this after five measures which are the same as in the first section.

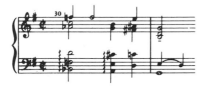

A great song, really a theater song.

Two years later Green wrote *I Cover The Waterfront*. This song was written to promote a film with the same title and was then used in the film as the title theme. However, I know it only as a pop song. Whether a movie or pop, it's a great ballad.

It is a singer's song, reaching legitimately dramatic heights in the release and returning from the area of A major to the area of the parent key, G major, by the beautifully simple expedient of dropping the melody from *c* sharp to *c* natural, giving the singer and listener ample time to adjust to the original key center.

This is the whole release:

I Cover The Waterfront

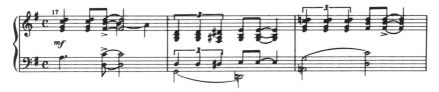

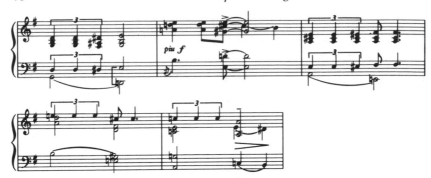

It's a most evocative song.

In 1934, Green wrote another beauty, *Easy Come, Easy Go*, first used instrumentally in the film "Bachelor Of Arts." It's a lovely song, verse, chorus, and lyric. It's all of a piece. Take the first section of the verse:

Easy Come, Easy Go

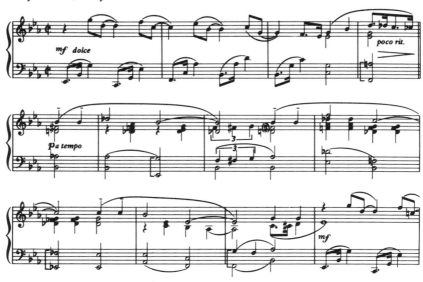

Notice the introduction. For it is used not only in the cadences of the verse but later in the cadences of the chorus.

And here is the first section of the chorus:

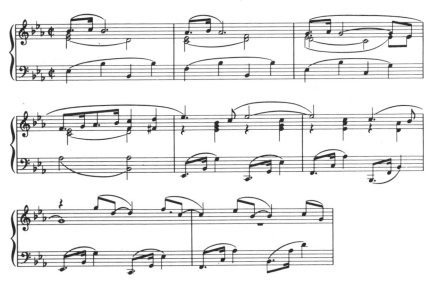

The melody is simple and, as well, the piano part. I'm sure the word "easy" was given consideration in the music. My sense of balance makes me wish that the eighth note *c* in the fifth measure and the *b* flat eighth note in the sixth had been *f* and *d* respectively in order to maintain the motion of the initial phrase. In the seventh and eighth measures there is a return of the introduction as well as its rhythm in the fifth and sixth.

In the admirable release, the third measure has that lovely turn about which I became so rhapsodic in discussing Hugh Martin's new song for the revival of "Best Foot Forward."

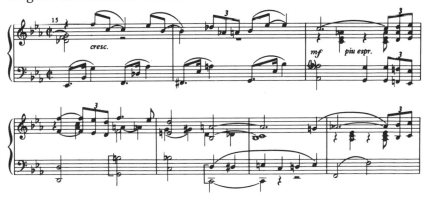

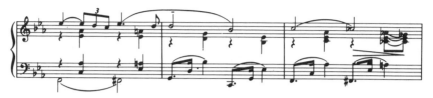

This ranks among the best of theater ballads.

You And Your Love (1939), which was totally unfamiliar to me until this survey, is another splendid ballad. I am always amused by the convictions of some non-musicians that a phrase of one song was taken from another. For it always turns out that the notes are never the same, only the rhythm of it. I find myself in somewhat the same spot with this song: its second phrase keeps reminding me of one in *Love For Sale*. Being a musician I know it's not the same, but its rhythm causes the comparison.

You And Your Love is a long, sixty-six measure song. But it holds up throughout and deserves to be better known. I'm very fond of the first cadence.

You And Your Love

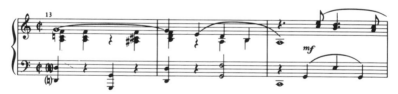

The release is a marvel. It keeps the flavor of the main strain and by so doing makes itself more intrinsic to the whole song.

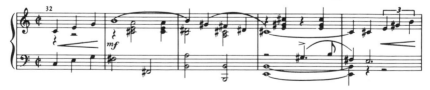

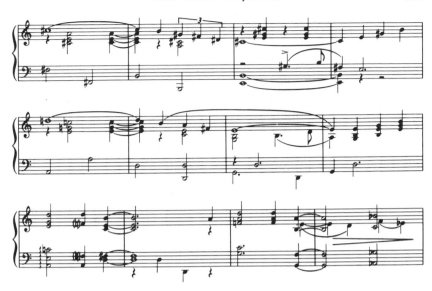

I am particularly taken by the two closing phrases, starting at measure forty-five.

In 1956, Green and Mercer wrote a very good song called *With You With Me*. In the verse there is a very good example of the beguiling nature of repetition, if properly handled. It occurs here after the first two phrases.

The first eight measures of the chorus are enough to hook me.

There's something compelling about the second interval supported by the tonic chord. Every time a point is made of it, I'm immediately and properly sad. It happens in *On A Clear Day You Can See Forever*, for example, and in *There's A Small Hotel*. And it's not simply the second interval, for its magic is an amalgam of that interval with the tonic chord. And the major seventh must be part of it. Every time I've been able to use this combination adequately I've wound up with a good song.

I also like the D-major-seventh chord underpinning the pick-up *d* naturals. And then in the twelfth measure, the sudden introduction of a new idea which is repeated in measure fourteen, is very ingratiating.

I suppose I was so angered by publishers' prying and poking at my ideas when I used to submit songs to them that I am unreasonably irritated by, among others, certain clichés which they liked. One of them was the third interval for the penultimate note instead of the second interval, which they considered weak. In *With You With Me,* I wish the final note before the cadence were not that third interval, *g* natural, but the second, *f* natural. I'd find it so much more tender and romantic.

After reviewing John Green's songs, I am greatly surprised that he never moved into the world of theater music. For certainly his songs are far above the level of pop music.

XI

RUBE BLOOM

(1902-1976)

Rube Bloom started in the popular music world as a piano player. He first attracted attention when he won a prize for *Soliloquy,* a piano piece, which was recorded in 1927 by Paul Whiteman in a charming orchestration. Later, he wrote a few phenomenally good songs. It is very sad to me that he wrote so few.

I remember, in 1939, being given a song to arrange for a new singer who never caught the public's fancy. The song was *Day In— Day Out.* I hadn't seen the song before and was astounded by both the melody and the lyric by John Mercer. It was a great pleasure to work with, and unlike any song in the pop field I'd ever seen.

In the first place, it was fifty-six measures long. The melodic line soared and moved across the page like a lovely brush stroke. It never knotted itself up in cleverness or pretentiousness. And it had, remarkable for any pop song, passion. For any academic, musicological person reading these pages, this may sound absurd. But limited as may be the spectrum of popular music, within its confines, this song achieves great emotional intensity.

I'm delighted that such concentration is given to the sixth interval which I believe so compelling when made a point of.

Day In—Day Out

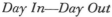

That's the understated, smooth way the song opens. And when this melody is repeated after sixteen measures, notice how Bloom develops it and increases its intensity.

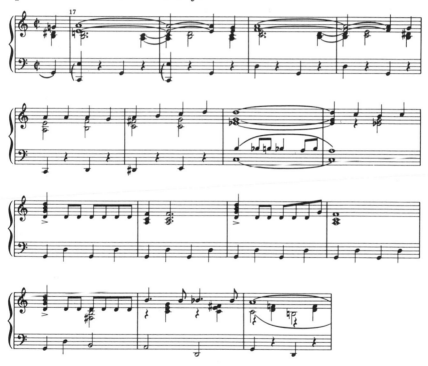

Of course, the lyric superbly supports it. Notice, too, Bloom's use of modal writing in measures twenty-five through twenty-eight! And how he returns to the *a* natural, even though he shall return again to it in his restatement!

Then, instead of rising, as it has, to a *d*, it now rises to an *e* which comes off very dramatically, topped by the following *f*.

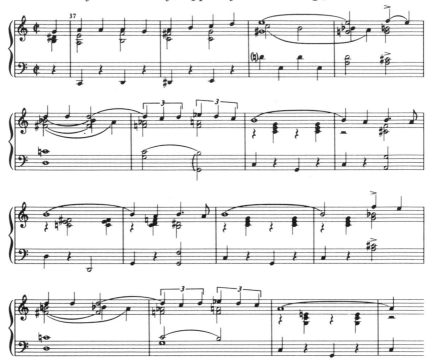

He is replete with surprises. For see how he unexpectedly stretches his phrase in measures forty-four through forty-eight and returns in romantic desperation to the high *f* with the perfect word "can't," of the phrase "can't you see it's love." And then his return to his home base, *a* before his final cadence. It's an absolutely great song.

The same year he did it again. Not as extendedly or as soaringly, but in *Don't Worry 'Bout Me* he certainly created that same kind of heartbreaking intensity and longing. It was introduced in the "Cotton Club Parade (World's Fair Edition)."

The first eight measures of the verse are virtual recitative but curiously affecting. In the second eight the time signature changes from 4/4 to cut time and the line becomes more melodic. The verse is like a sad soliloquy.

The melody of the chorus is an immediate refutation of the title.

Don't Worry 'Bout Me

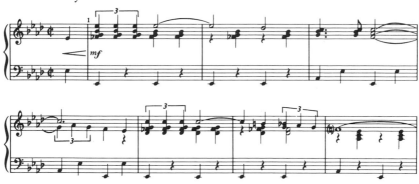

If you examine the altered dominant chord which accompanies each of the opening notes, you will sense the anguish. The phrase before the seventh measure is tender and more passive.

I am pleased that Bloom moves his melody in graceful curves in the second section, in contrast to the repeated notes of the first.

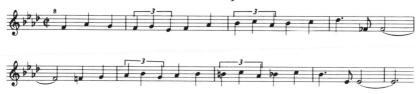

Then the song begins its restatement, but after four measures it unexpectedly develops the quarter note triplet motif and returns to the sinuous idea of the second eight without, however, using the same note terminating that section, with an octave drop.

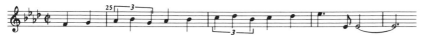

And finally it restates the initial phrase. This is a very tense and touching song.

In 1940, Bloom wrote *Fools Rush In* with John Mercer. What could be a more touching phrase than that which opens this chorus?

Fools Rush In

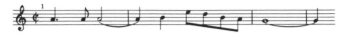

Notice that again he starts on the sixth!

In imitative phrases Bloom brings his melody down from the *g* in measure three to *f* in measure five, *e* in seven, *d* in nine, and, finally, *c* in eleven. That, to me, is the mark of a professional, especially since he achieves this descent by other than the device of imitation.

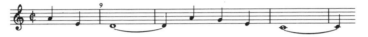

In the last section he again reveals this strong intensity.

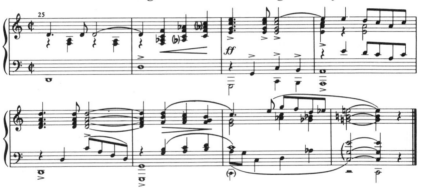

It's another very, very special song.

And how about the closing lyric line "So open up your heart and let this fool rush in"? This is popular music at its best.

In *Here's To My Lady* (1951), with another Mercer lyric, Bloom wrote a very pure and less intense melody, due, doubtless, to the subject, which is a lyrical toast.

The verse is very charming, as these opening measures suggest.

Here's To My Lady

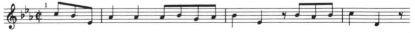

Much of this song might have been by Kern, particularly the second section.

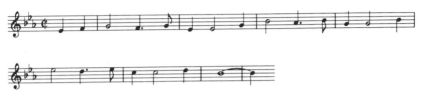

What Kern never would have written, however, is the third and fourth measures.

I am fascinated by Bloom's refusal to restate his opening phrases. At measure seventeen he starts to, thinks better of it, and keeps only the original rhythms. And in the closing section, he restates two measures of the beginning. I so love what he does in the third and fourth measures that not hearing it again disappoints me.

I've not only never heard this song performed, I've never as much as heard its title until now. This is far more a theater than a pop song and, since it uses no rhythmic or harmonic tricks except at the fourth measure, it may have remained obscure because it was presented without a showcase.

In 1945, Bloom wrote a marvelous swinging song called *Give Me The Simple Life*, from the film "Wake Up And Dream." Introduced by a Gershwinesque verse, particularly in the fifth and sixth measures,

Give Me The Simple Life

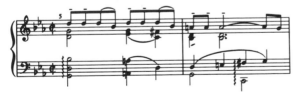

he starts out in the chorus with a winning rhythmic phrase.

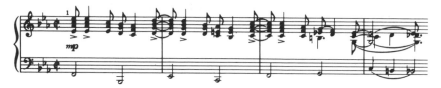

The release is not up to the main strain, but by that time, you don't really care. For here is a case in which the *A* sections suffice. And as long as it's that way, here's the rest of it.

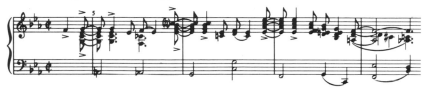

There were a few other songs by Rube Bloom, but very few. He certainly set his sights high and he certainly proved that pop songs can be in impeccable taste.

XII

JIMMY VAN HEUSEN
(1913-1990)

Jimmy Van Heusen was another latecomer, showing up about 1938. I well remember a thin young man sitting around outside an arranger's office, endlessly playing the piano during the late thirties. Little did I realize that he would turn out to be an immensely successful song writer.

Van Heusen has maintained good taste ever since he started. His songs have never carried the acrid odor of cigar smoke. He has always been inventive and usually related to the world of the bands as well as the singers. And while he has written many fine ballads, he has been more a 4/4 than an *alla breve*, cut time writer. The long-line, spare, pure melody has rarely been his forte. For there is almost always the suggestion of a rhythm section in the background.

Right here I must come to a grand pause. So eager have I been to neaten everything and everyone by means of categorization that I am forgetting that this isn't always possible. For instance, I am blithely assuming Van Heusen's predilection for 4/4, completely forgetting a beautiful cut time song called *Like Someone In Love,*

and *It Could Happen To You*, which isn't but which should be in cut time. And what of *The Second Time Around*? In other words, Van Heusen writes many ways.

Also there is the problem of including him among the great craftsmen. For this category applies to pop song writers. Many of them, it is true, wrote for films, but their major output was in the pop market. But Van Heusen, though he started out by writing pop songs, graduated to Hollywood and spent all his creative time writing for films. Plus which he wrote a couple of Broadway shows, from one of which came a great song, *Here's That Rainy Day*.

The difficulty is simply this: there is no film writer category. Also those who have been written about as theater writers spent the major part of their creative life writing shows. This, Van Heusen hasn't done. And many of his film songs, it must be admitted, are not on a par with great theater music. Some of them are, but that truly doesn't make him a theater writer either. He is a great writer, but he refuses to make life simpler for me by staying put like Carmichael. I can only apologize for finding no proper niche for him.

One of his first published songs was *Deep In A Dream*, 1938. Sinatra has recorded it so wonderfully that it is a temptation to stop and discuss it. But while it blossoms in its release, its main strain is not on a par with his best writing.

Another of his early songs in 1939 was *All This And Heaven Too*, a promotional song for a film with the same title. It's a rhythm ballad that does pleasant, unstartling as well as unexpected things. For example, the *e* flat in the fourth measure:

All This And Heaven Too

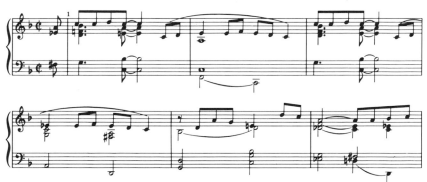

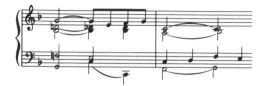

And the release is well on a par with the main strain. Here are the first four measures of it:

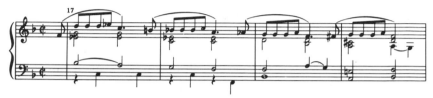

Also in 1939, he wrote *Darn That Dream* for the disastrous Broadway production "Swingin' The Dream." I was inclined, without having more than met him, to dislike him at this point, since I had written an entire score for this show and had to take it back due to the duplicitous character of the producer.

Darn That Dream has a very interesting and difficult melody in that its chromatic character makes the notes hard to find. It's a melody, I'm certain, built around the chromatic harmony. But it's an original, for sure, as I've never heard a song quite like it.

The release is also very far out, moving instantly into E flat from the parent key of G. Only by means of the harmony are the melody notes easily found.

In other words Van Heusen had arrived at the time when sophistication and chance-taking had become a way of writing for those who chose to do it. The public, through the bands with their highly complex arrangements, had opened their ears and become used to more daring pop tunes.

Blue Rain, also 1939, doesn't quite come off as a song. Its melodic interest is not strong enough to have true vocal identity. To me, it is more interesting as an "instrumental." *Blue Orchids*, by Carmichael, has the same problems, but its ideas somehow get off the ground more convincingly.

In 1940 Van Heusen wrote one of his best-known songs, *Imagination*. It's a good song, to be sure, and its release is much better than average, but it hasn't the sweep and freedom of his later and perhaps

less-known songs. The release, though reminiscent of *Mimi*, deserves illustration.* I feel that very soon after this song he would not have resorted to the *f* sharp in measure twenty-four.

Also in 1940 he wrote *Polka Dots And Moonbeams*, a title I can do without. But it's a very good rhythm ballad, primarily based on I, VI, II, V chords. The song moves into A major from the key of F major for most of the release. The main strain is made up mostly of a series of ascending and descending scale lines, a little too notey for me, but very effective instrumentally.

In 1943, Van Heusen wrote a very dear little song called *Sunday, Monday Or Always*, for the film "Dixie." Its main idea follows chord lines for two measures and then changes for the title phrase. The four-measure release is a gem. Notice how, in its final repetition, it prepares for the restatement.

In the two *A* sections the note is *c*, where in the fourteenth measure it is *c* sharp. I find something extremely charming about this variant as well as the writer's desire for it.

Well, here I am, hoist by my own petard. For in 1944 Van Heusen not only wrote *Like Someone In Love* in cut time, but it's a pure melody. That's what I get for not looking ahead! The song was introduced in the film "Belle Of The Yukon."

Here are the first sixteen measures:

Like Someone In Love

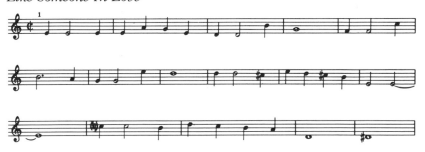

The influence of Kern is manifest. It's a simply lovely melodic line.

Nancy, written in 1944 for Sinatra's daughter, with the lyric by the comedian Phil Silvers, is a very warm and tender ballad.

The same year Van Heusen wrote another Kern-like melody

called *It Could Happen To You* for the movie "And The Angels Sing."

I'm beginning to notice a stylistic device which Van Heusen is very fond of. It's concerned primarily with harmony. He loves diminished chords not for themselves but in order to make chromatic bass lines. In all of his songs you will find him, thank heaven, very respectful of bass lines.

Some writers settle for scale lines, but Van Heusen is more fond of chromatic lines. And, in order to have them, he must have diminished chords. So when he reaches one he must find a way for his melody to move, with them as the foundation. In *Darn That Dream* he moves one way, and with *It Could Happen To You* he moves another. In the key of G he moves to an *f* natural in the second measure, *f* being one of the notes of a G-sharp-diminished chord. He drops to *e*, but moves up to *b*, another note of the chord. Then, in the third measure, where he uses an A-sharp-diminished chord, he lands on *g* and arrives at *c* sharp, another note of the chord. It makes not only for a logical bass line but for a more experimental melody. More power to him!

It Could Happen To You

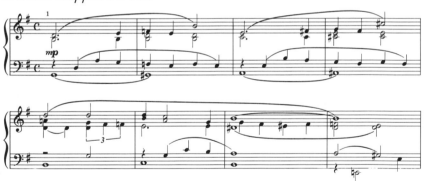

The verse to this song is very pretty, and its first four bars contain a descending chromatic bass line as opposed to the ascending line of the chorus. I should also mention that Van Heusen is one of the few writers I know who has a clear sense of the value of a first inversion (a triad the bass note of which is the third interval and when used should have that third only in the bass). I believe he came to under-

stand its value in the course of his experimenting with bass lines.

In 1953, Van Heusen became even bolder. Of course the situation was different in that the song, *Here's That Rainy Day*, was from a Broadway musical, "Carnival In Flanders." And he certainly took advantage of the freedom afforded him. It's a very difficult song, almost demanding its harmony's presence for a singer not to get lost in the complex line.

The song is in G major. The opening measure's harmony is G, the second B flat, the third and fourth E flat, and the fifth a suspended D-dominant chord. Then D-dominant seventh and G. In the ninth measure, however, the melody, which has had its cadence on *g* natural, goes to *e* flat.

Here's That Rainy Day

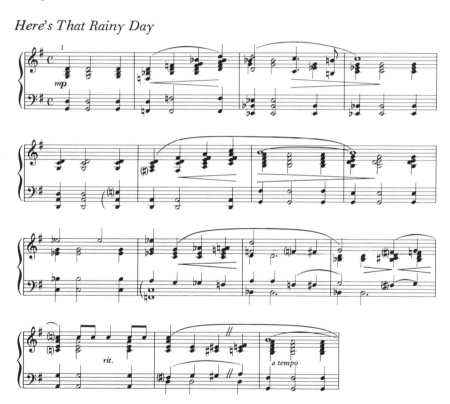

The last section is much simpler, after the hurdle of its second measure, which is the same as the second measure at the beginning.

It's a very powerful and affecting song. It has great weight and authority and must have been a song written under extremely intense circumstances. In my opinion it is a great illustration of absolute honesty, quite irrespective of its extremely inventive character as a melody.

A late song by Van Heusen in 1958, the title song from the movie "Indiscreet," is a very good illustration of a balance between melody and harmony. For while its harmony ingeniously enhances the melodic line, the latter has sufficient distinction to sustain interest by itself. To have been able to find as provocative a melody for such an unmusical title was a minor triumph in itself. The song is virtually unknown but is one of those songs which good piano players are on the look-out for. It does, I admit, suggest in its first phrase Kern's *I Dream Too Much*, but its development of the motif is entirely dissimilar.

Indiscreet

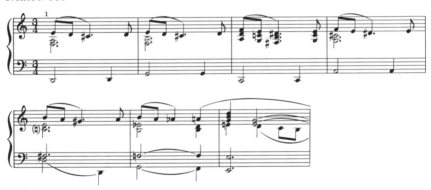

There is great pride amongst piano players to know those songs which have failed to receive great recognition. Sometimes they are songs which have highly inventive harmonic patterns and little else, but more often they are songs like *Indiscreet* and *You Have Cast Your Shadow On The Sea* (Rodgers) which contain both harmonic and melodic interest to the degree that their obscurity remains a puzzle.

I should have a prejudice about *The Second Time Around* (1960), since I had just written the best lyric of my life the week before it hit the juke boxes. Mine was called *Next Time Around*. Van Heusen's song was the title song of a film, and a lovely one.

The device is a chromatic one again, but this time in the melody. It's to be found in the second, fourth, sixth, eighth, tenth measures and throughout the song. Van Heusen has used that fourth interval I mention from time to time as being weak when misused and romantic when wisely used. And subtly he keeps lowering the melody from the first through the ninth measures from *g* to *c*, diatonically.

The Second Time Around

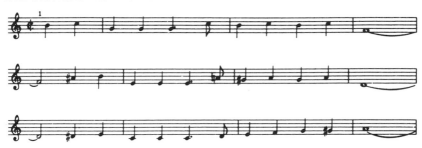

Extraordinarily, he manages to write this very lyrical, understated song within the confines of a single octave. And actually the upper *c* is used only as a passing note. There is no effort made to achieve a climactic point; in fact, at the measure one would anticipate one, the note is only a *b*. As well, this is the creative aspect of Van Heusen which needs no harmony in order to gain his melodic points. He is truly a near master of two distinct styles.

Call Me Irresponsible, from the 1963 film "Papa's Delicate Condition," is a very strong, inventive rhythm ballad, one in which Van Heusen again resorts to his chromatic bass line, creating new melodic patterns and good ones to fit the diminished chords.

He does marvelous things in this song: for example, his chromatic descent through two whole notes in measures eleven and twelve to the *f* natural in measure thirteen and the drop to a wholly unexpected *b* flat in measure fifteen.

Call Me Irresponsible

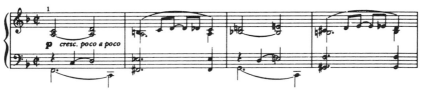

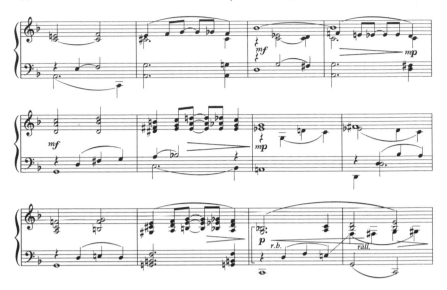

In the last half of the song, with shifting harmony, he twice repeats a phrase, a very risky thing to do. But it comes off perfectly. This results in a four-measure extension of the melody.

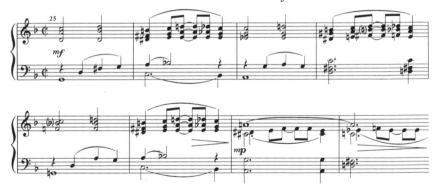

My Kind Of Town (1964), from the film "Robin And The Seven Hoods," is a deliberate rouser and in the film I'm certain a big production number. It's a solid, swinging song, or so I feel after hearing the arrangement made for the Sinatra record.

Its principal interest to me is a single phrase; that in the second half of the third and all of the fourth measure as well as its variant in measures seven and eight. Granted that it's almost parenthetical,

but it falls so deftly after the half notes preceding it that it serves as an unexpected kicker, an almost sung riff. They're both only falling or rising chromatic notes, yet they constitute an unexpected pleasure.

The song drives, but cheerily rather than rudely. This is a type of song needed in every production, and I prefer it to the older, bunched fist, sit-there-and-like-it type.

I must add about Van Heusen as I did about the other writers that the songs discussed here comprise only a small part of his output and do not include many of his biggest hits. But they do represent, I think, his writing at its best.

It seems that each time I have been my most enthusiastic about a song by any of these craftsmen, I have equated them with theater songs. This seems sensible to me, since theater songs are undoubtedly the finest examples of popular song writing. And yet there are many very competent and sometimes inspired songs in the pop field which would be out of place in the theater, songs which lack that special theatrical flavor and which do not even attempt to achieve it.

Berlin, that phenomenal double talent, knew all about this fine line of distinction. And he never crossed it writing pop songs, nor failed to achieve theatricality in his scores. In other words, there is more to it than an increase of sophistication. It just may be controlled or distinguishable by the nature of the lyric. Of course the exceptions to that possible rule are lyrics by such a poetic lyricist as John Mercer. But even he wrote untheatrically in such songs as *Jeepers Creepers* and *Lazybones*, let's say.

It is true that there is a greater tendency to play safe in pop writing, and undoubtedly those who never moved out of it, with a few notable exceptions like Rube Bloom, knew that they weren't competent to handle the larger horizon of show tunes. They did, however, often manage to write better songs for films, which bolsters my conviction that film songs are generally one degree less polished than theater songs.

— 11 —

Outstanding Individual Songs: 1920 to 1950

This chapter provides a survey of outstanding pop songs composed by writers other than those whose work is covered elsewhere in this book. It is, as a matter of convenience, arranged by decades, an arrangement which, happily, tends to point up the increase in musical sophistication revealed in the best pop songs as the first half of the century advanced. With only a few exceptions the songs discussed in this chapter are, to define them briefly, non-theater songs.

The first decade to be considered is the 1920's; however, earlier songs by Berlin and Kern have been discussed, and analyzed, in separate chapters. Also, the opening chapter, "The Transition Era: 1885 to World War I," dealt with influences leading up to the twenties and examined a number of early trail-blazing songs. The chapter preceding this one, "The Great Craftsmen," considered those pop writers who, I believe, created a superior body of work exemplified by their finest songs. So, if any musically outstanding songs from the decades between the turn of the century and 1950 seem to be missing in the present chapter they may have been discussed elsewhere.

I

1920–1930

What better song to start with than *Whispering?* It is said that, in terms of the number of record players in existence in 1920, the equivalent sale today of Paul Whiteman's famous record of this song would be in the neighborhood of twenty or more million singles.

The song is so very familiar that it is difficult to examine it without the bias of memory. There is no doubt about its being a strong song. Its step-wise writing never allows the singer to lose his way for an instant. Nor does it cease to be step-wise until the eleventh measure when it jumps up a fourth. But it drops right back and continues step-wise. From that point on there are only four more places where the melody moves more than a step away. And those steps, two of a third and two of a fourth, are completely natural.

The harmony throughout is simple and of little interest. There is no syncopation or turn of phrase which one could call distinctively native, and the melody, one could say, was constructed rather than created. But it's a strong, porfessional picce of writing by John Schonberger, Richard Coburn, and Vincent Rose. The last of them wrote many hits. The first two names I've never seen on another song.

A Young Man's Fancy (1920), with music by Milton Ager, was, according to the sheet music, from a production called "What's In A Name." There is a much higher degree of creativity in this song than in *Whispering*. Bone simple as it is, it has an air about it, a pastoral gaiety. And, indeed, it was known as the Music Box Song.

At only one point does the rough hand of manufacture reveal itself. And it comes as a bit of a shock after the daintiness of what has come before.

A Young Man's Fancy

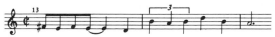

That *f* sharp and the syncopation are like a belch at a formal dinner party. Other than this slip, it is a special, almost distilled song, unlike

any other of its or any other time. It belongs in the same category as Carmichael's *Little Old Lady*. But I like it much better.

Now here is a great surprise, a song perhaps never properly considered in the pop field, since it was published by G. Schirmer, a non-pop house, and by a lady, Lily Strickland, who had never tried her hand at pop music. It's called *Mah Lindy Lou* and it's more native than anything since Handy's blues.

Mah Lindy Lou

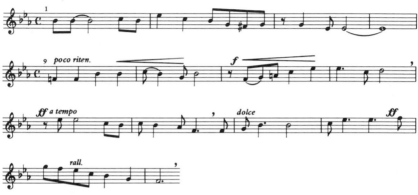

If that's not a swinging song, I don't know one.

Since it's an alleged art song, the piano part does not contain the melody. But take my word for it, the harmony is as good as if it had been worked out by a good band arranger.

How come such a truly American song, with all the ingredients of a much later swinging song, should wind up in the art catalogue of G. Schirmer? Was Miss Strickland from the South? It certainly sounds like it. And where did she pick up such loose, free, rhythmic, and melodic ideas? One must assume from Negroes. Certainly not from Tin Pan Alley.

In 1921, Eubie Blake, in "Shuffle Along," had a song that's very much alive fifty years later, *I'm Just Wild About Harry*. I vividly remember the many performances of "Shuffle Along" I saw in the months before it caught on. The theater was so sparsely occupied you could sit where you pleased. I used to move down to the front row during the first act and listen to Mr. Blake play the piano in the pit.

I'm Just Wild About Harry was the one song from the show which

has survived, though *Love Will Find a Way* is occasionally heard. The big survivor is a strong, simple, direct song, the principal device of which is the strong fourth beat tied to the down beat. It's of the genre of *Hallelujah, Fine And Dandy*, and all those cut-time theater rhythm songs.

It uses a lot of step-wise writing and only one note out of its C-major scale, a *d* sharp. For a theater song it is not rangy, being only an octave and a third. Perhaps "the hook" is the tag.

I'm Just Wild About Harry

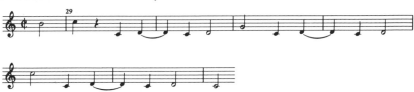

I'm Nobody's Baby (1921), was by Benny David, Milton Ager, and Lester Santly. This is another carefully constructed song in cut time with minimal notes. Unlike *I'm Just Wild About Harry*, it has no rhythmic character, just a strong melodic line, not as good as, but comparable in character to, *I'll See You In My Dreams*.

It has two phrases which are more created than constructed. They occur just before the restatement.

I'm Nobody's Baby

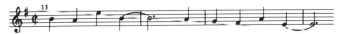

So calculated was the construction of straight pop songs that I can imagine one of the writers arguing with another that the sudden freedom of these two phrases was too far out.

April Showers, from "Bombo" (1921), with music by Louis Silvers, is another cut-time song, very forthright and strong. In the instance of songs whose melodies were especially believed in by the composer, I've noticed that the melody was placed in the left hand of the piano part and the bass part sacrificed. This is such a song. The device in the main statement is a quarter note chromatic phrase rising to higher and higher notes, from *a* to *d*. And it is a song in which

the melody continues in the area of what would otherwise be called the second cadence.

April Showers

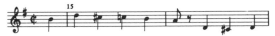

It's a good melody, a long-lasting standard made popular by Al Jolson, but one which shows no traces of the contemporary shift in musical directions as did *I'm Just Wild About Harry*, or the even earlier *There'll Be Some Changes Made*. And, though it is better than average, it is in the tradition of the song writer/businessman song.

As opposed to this type, *'Way Down Yonder In New Orleans*, in 1922, by Henry Creamer and Turner Layton, bore the fruit of the ragtime, Negro instrumentalist tree. It's a slight song of twenty-eight measures. But it has that sought-after quality of American-ness.

Right away, in the third measure, instead of announcing everything four-square, there is a quarter rest. It is unexpected because one has become used to strict imitation. In the thirteenth measure there is a marvelous moment in which the melody stops, due to the lyric saying "stop." Furthermore, the note is an *e* flat (the key is F). And, again, it stops on the second "stop."

'Way Down Yonder In New Orleans

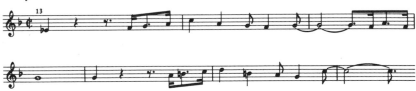

Then it provides another surprise in the twenty-fourth measure, a whole note *d* flat.

All of the songs mentioned above, except *I'm Just Wild About Harry*, just might have been written anywhere, but *'Way Down*

Yonder In New Orleans is as indigenous a product of America as the blues, even if more deliberate.

My Honey's Lovin' Arms (1922), with music by Joseph Meyer, was what might be called a white jazz tune, but its American flavor can't be denied.

The shift in the third measure from F major to B-flat-dominant seventh was without precedent in pop songs, and I can remember the shock when I first heard it. Also the harmonic patterns of the second eight measures are unconventional for its time.

My Honey's Lovin' Arms

Consider, as well, part of the closing section, in terms of harmony.

This song makes it look as though the writer had been listening to more than the pounding out of tunes in adjoining Tin Pan Alley cubicles. For this song, by a white man, had a new flavor.

Runnin' Wild (1922), music by A. Harrington Gibbs, was scarcely a song. But I mention it because it, like *My Honey's Lovin' Arms*, was a definite departure from the hack writing of that era that was ignorant of the changing musical atmosphere.

The reason for including *Stumbling* (1922), by Zez Confrey, is

that it may be the first pop tune that used the rhythm of 3/4 inside a 4/4 time signature. For the first two measures could just as well be two measures of 3/4 and one of 2/4. Yet if they were printed as such, the song would lose its nutty, off-centered feeling.

Except for the measure containing this trick there is little of interest. However, the closing measures work splendidly.

Stumbling

This rhythmic idea, used many time later on, is not so much American as it is unconventional. And anything which managed to crack the conventional mold was healthy.

Chicago (1922), by Fred Fisher, is a much better-than-average pop song. I'm sure that many of the listeners to recent recordings of the song think of it as having been originally a ricky-tick song which modern arrangers have managed to dress up and "contemporize" by means of their sophisticated skill.

Well, this skill cannot be denied. But the song is a straightforward swinging tune, as written. (But was it originally printed in 2/4 time?) Such phrases as that in the second section are valid for the later swing band era. And so are the phrases at the end of the song. Fisher wasn't one of the new crop of writers. So if he wrote a song like this, the new musical ideas must have started to move in.

In 1923 came the very lovely ballad *I Cried For You*. The writing is credited to Arthur Freed, Gus Arnheim, and Abe Lyman. This is a puzzler, since both Arnheim and Lyman were band leaders and therefore suspect as writers. Ray Noble and Isham Jones were the rare exceptions: band leaders who truly wrote songs they were credited with.

The opening phrase of this song is not only highly unusual in its two large steps of a fifth and an octave, it is instantly beguiling. It is so good that I would have forgiven a few clichés in the following

measures. But the entire melody holds up. Here are some sample excerpts:

I Cried For You

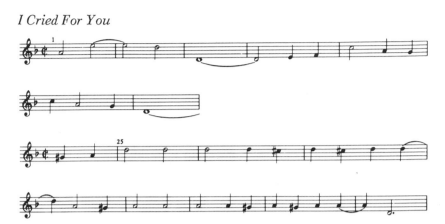

I believe this melody ranks among the great melodic inventions of the type exemplified by *I'll See You In My Dreams, Tell Me, Little Gypsy,* and *My Shining Hour.* They are all, as far as I'm concerned, inspired, whether of American heritage or not.

Mama Loves Papa (1923), by Cliff Friend and Abel Baer, is mentionable only for its use of the minor seventh (*b* flat in the key of C) in the melody line. So much was made of this note in Gershwin's *I'll Build A Stairway To Paradise* that I might as well note its use in the pop field.

Charleston (1923), by Cecil Mack and James P. Johnson, wasn't a particularly good song. But it did achieve success through the almost hysterical popularity of the Charleston dance.

I keep shelving such songs as *Charley, My Boy* and *California (Here I Come)* simply because they have nothing to recommend them but their immense popularity. And they don't even have the virtue of, may I call it "canoedling"?

Mandy Make Up Your Mind (1924), with music by George Meyer and Arthur Johnson, is a run-of-the-mill rhythm ballad, doing nothing special but somehow managing to create an atmosphere of cheer and gentle well-being. This feeling may merely be nostalgic, and wonderful as some musical evocations can be, one must beware of mistaking the experience evoked for the agency that evokes it.

Everybody Loves My Baby (1924), by Jack Palmer and Spencer Williams, is little more than a riff repeated three times. It doesn't go anywhere or do very much, but it still does have a flavor more of the new than the old, of the dive rather than the ballroom.

Dinah (1925), with music by Harry Akst, happens to be virtually a fixation with me. It actually is not all that wonderful, so my devotion may well be due to superlative performances I've heard of it. One such was by a band which chose to play it at a very slow tempo with rich harmony and a chocolate soda sax section.

The insouciant lyric with its reached-for rhymes for "Dinah" and its "Dinah might" in the release helps, of course. I love it because it's so relaxed and without pretense. I love it for its absolute naturalness. It's almost as if it simply happened rather than was written. The jazz men must have felt good about it, too, for they've been having fun with it for over forty years.

Peaceful Valley (1925), by Willard Robison, became well known because Whiteman made it his theme song before he used the slow theme from *Rhapsody In Blue.* But before considering the song, a word about Robison.

He, if ever there was one, was the maverick among song writers. Everyone loved him and many tried to help him, among them John Mercer. Mildred Bailey revered him and sang every song of his she could lay her hands on. I became aware of him in the late twenties when he recorded for Perfect records. He would sing mostly his own songs, such as *The Devil Is Afraid Of Music, We'll Build A New Church In The Morning,* and *Old Deserted Barn.* He did manage, during his almost euphoric life, to write a few successful songs—*Cottage For Sale* and *'Taint So, My Honey, 'Taint So*—but generally his songs were known only to a few singers and lovers of the off-beat and the non-urban song. He had a special flair for gentleness and childhood, the lost and the religious.

Peaceful Valley is one of the looking-back songs with a lyric better-fashioned in the verse than the chorus. It included such lines as "old mud turtle there on his side, laying where the creek had dried, and even he was so satisfied . . . in Peaceful Valley."

The melody is so memorable that I've never forgotten it since I first heard it.

Peaceful Valley

I suppose it's not part of the growth of popular music, nor perhaps were any of Robison's songs. But if they could so much bolster John Mercer's conviction that there was more to write lyrics about than city life, that the world of memory, of remembered sayings and scenes, was as evocative as the whispered words of lovers, then he did make a contribution.

Sweet Georgia Brown (1925), by Ben Bernie (a band leader), Maceo Pinkard, and Kenneth Casey, has been one of the big songs for jazz players since it was written. It's easy to see why, since it is based entirely on chord lines. I, personally, am astounded that it became a standard song, simply because it's so difficult. After all, keeping in mind that it's in the key of G major, the first four measures follow the notes of the chord E-dominant seventh, the second four, A-dominant seventh, and the third four, D-dominant seventh.

That's great for improvisation. But in order to sing the first four bars you have to find *g* sharp and *c* sharp and only once is the *g* sharp approached step-wise. So the job of grabbing notes in the scale of the key signature has to pose a problem. More power to the public.

I find it pleasing that the most prominent phrase of the verse is, with a slight variation, used twice at the end of the chorus, which helps tie the whole song together. In case you've forgotten how difficult the song that you may have whistled down the block really is, here are the first four measures:

Sweet Georgia Brown

Just in passing I must mention *'Deed I Do* (1926), by Walter Hirsch and Fred Rose, not for any innovative elements but for its spareness and the proficient way in which the writers have made use of the eighth note and dotted quarter tied to a half note. Instead of breaking up this design, they adhered strictly to it for five measures of each *A* section. The fact that they did, I believe, is what

created the character of the song. This constitutes conviction and self-discipline.*

A marvelous, truly swinging song of 1926 is *If I Could Be With You* by Henry Creamer and James P. Johnson, the great stride pianist (and co-composer of *Charleston*). It's a short, sixteen-measure song which hasn't a dead spot in it. For years a tag was always added with the words "for just an hour" to these honky-tonk notes.

If I Could Be With You

for just an ho - ur, If

This is another "get out of the Alley" song and a favorite with jazz players.

In 1927, *I'm Coming Virginia*, with music by Donald Heywood was another lively rhythm song. The main strain is a series of strong rhythmic imitative phrases which establish the swinging character of the song, but I find the release and its continuous motion into a variant of the *A* sections the most interesting.

I'm Coming Virginia

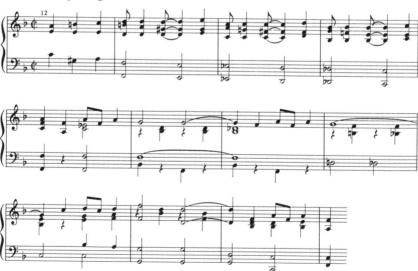

I shouldn't have said "*A* sections" since the first section, though it repeats the first phrase of the song, then moves away and almost immediately into what I suppose should be called "the release."

It's a twenty-four measure song, and the only feeling of stopping and starting up again (too often the awkwardness of pop songs) is in the seventh-measure cadence. But even this, due to adroit use of harmony, conveys continuous motion. It's an unusual and a very good song.

In 1928 there was a lovely slow rhythm ballad, *Sweet Lorraine*, with music by Cliff Burwell. After hearing Nat Cole and Frank Sinatra perform it, I was sold. Fortunately, it's worthy of both of them.

It's a song of imitative phrase, not one of which would I alter by a single note. The harmony isn't essential but it gives an added warmth to the melody. The release is an unexpected and very effective one, preceded by a parenthetical phrase which I have never heard sung or played (and that's all for the best). For it's superfluous and out of character.

Sweet Lorraine

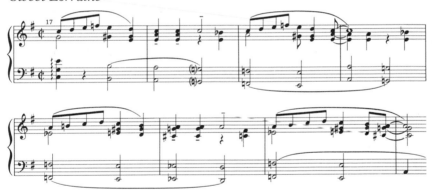

I should confess that I did not know until now that the music for *Sweet Sue—Just You* (1928), was by Victor Young. It's a very well-known song, one of those with relatively few notes, in this case, sixty-one. The form is *A-A-B-A*.

The song is astoundingly simple. Here one has a repeated phrase, which is made of repeated notes, and a cadence. And then precisely the same thing in the second *A* section. The release has a similar form

for the first four bars so that the only real motion in the song is in the last four bars of the release which, again amazingly, consists of seven *c*'s and two other notes, if one doesn't include the pick-up notes.

This seems to me to be the most thin-ice skating imaginable. And yet it works, and all within the range of an octave. The fact that Victor Young was a superb orchestrator and so knew how to dress up simple melodies is beside the point, as *Sweet Sue* worked with the public as a melody, unadorned.

Manhattan Serenade (1928), music by Louis Alter, was taken from an instrumental piece and, while attractive enough, has the feeling that measures have been added to fill out the requirements of song form, measures which sound just that way and not part of the original concept. I frankly prefer it in its instrumental form.

Crazy Rhythm, from "Here's Howe" (1928), with music by Joseph Meyer and Roger Wolfe Kahn, seems timeless upon examination, even though it is only a two-measure fragment, slightly developed in the release. Kahn was a band leader; however, Irving Caesar, the lyricist of the song, assures me that he did, indeed, write this revue tune.

You don't mind such a small musical gift, for it takes repetition very well and "pays off," as the dreadful expression has it, in the last section which I had completely forgotten *does* develop the fragment.

Crazy Rhythm

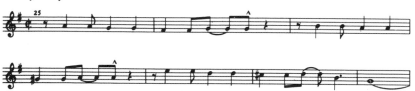

It isn't Carmichael but it's good, honest rhythmic writing.

And now comes the song from 1928 I wanted to write about in the section on Richard Whiting. But he wrote only the lyric of *She's Funny That Way*. Not that it's "only" a lyric, for it's excellent. Neil Moret wrote the music. Though a series of five imitative phrases, it works beautifully. I was never a fan of Gene Austin, but I played his recording of this song so many times I was asked to stop or leave the premises.

The release is made up of two scale lines and their cadential phrases which again work wonderfully in contrast to the eighth note phrases of the *A* sections. For the scales are made of dotted quarter and eighth notes. And they truly supply a "release" from the imitative phrases. It's another bittersweet, late-at-night song, not innovative unless the fact that I've never heard a song like it may be said to constitute innovation.

In 1929, Louis Alter wrote a good solid rhythm song with an unusually good verse, called *My Kinda Love*. To show you the unusual nature of the verse, here are the first four bars:

My Kinda Love

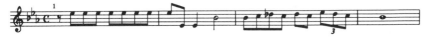

And four measures of the chorus will convey its sturdy, swingable nature:

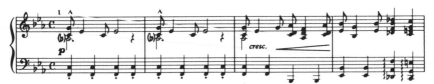

The release has too much the "tossed away" quality that so many pop songs have. They're almost insults, in that they imply you already have been hooked by the main strain, so why bother further? It's almost like the hostess who starts watering the drinks after the guests have begun to get happy.

You Were Meant For Me, from the 1929 film "The Broadway Melody," with music by Nacio Herb Brown, is another of the few-note songs. This time it's sixty-two.

It can be complimented for its economy and for its principal phrase. But its second section's chromatic writing lowers the quality of that principal phrase's lyricism, even though it may have been written to provide contrast.

Paul Denniker belongs on the list of one-song song writers, insofar as *S'posin'* (1929), was his only well-known song. It's an innocent,

unsophisticated little melody, using no syncopation or harmonic tricks. It's simply a straightforward line with a quality of great tenderness. And I think its special flavor lies in its avoidance of any cliché.

Usually the simpler the melody of a pop song the more likely a cliché will crop up somewhere in it. But not this time. The principal idea of the melody manages this by discontinuing the rising line of the first measure in the second measure, using two sets of repeated notes instead.

S'posin'

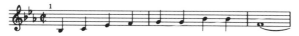

And the second-to-last phrase is unlike any other phrase, and especially endearing.

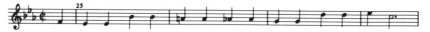

Am I Blue?, introduced by Ethel Waters in the motion picture "On With The Show" (1929), with music by Harry Akst, is dangerously interwoven with Ethel Waters' recording of it. And she made it sound like a masterpiece. It isn't that, but it is a good song, using a device somewhat similar to the one in *April Showers*.

In this case, having moved up to *c*, it unexpectedly moves through *c* sharp up to *d* and back down to *f*. This phrase is very telling, though the following one, descending *a* flat, *g*, and *f*, always makes me a little embarrassed, as if I were being poked in the ribs to show that this is a bluesy song and I'd better start snapping my fingers.

Am I Blue?

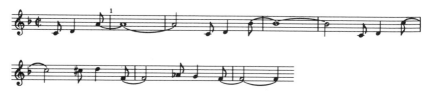

One of the last songs of the twenties to be considered is *Ain't Misbehavin'** (1929), with music by Fats Waller and Harry Brooks. There is a tale that the composers of this song deliberately set out to fashion a new melody on the harmony of another famous one. It's of no matter, as they found a good rhythm ballad. It is a dated song, to be sure, and tends slightly to plod. However, its spillover in measure four helps considerably.

Ain't Misbehavin'

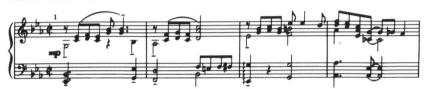

It is the release, however, which interests me more. Because of the changing harmony I don't mind the repetitions, but I am very pleasantly startled by the release's third measure, which rises unexpectedly to an *e* natural.

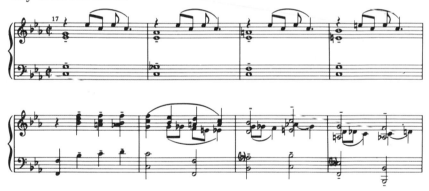

Though a show tune, *Can't We Be Friends?*, from "The Little Show" (1929), music by Kay Swift, has all the earmarks of a pop song. This may be due to its notiness or to its verging on cliché. I hate to say this as I heard Libby Holman sing it marvelously in "The Little Show" and was very impressed.

The song does do nice things: for example, the drop to *d* flat in the third measure and the run down in the next measure to a low *d* flat.

Considered as a pop song, it's better than average and, heaven knows, very well remembered by the listening public. Actually, I find the verse more inventive than the chorus.

Can't We Be Friends?

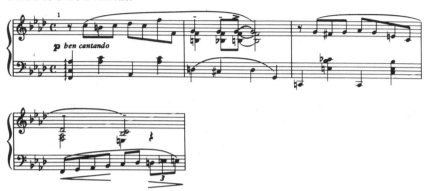

It is clear that, but for those of the great craftsmen and a few exceptional writers like Pinkard and Burwell and Blake, the pop songs of the twenties don't show a great deal of reaction to the increasingly new sounds emerging from jazz bands, dance orchestras, piano players, and blues singers. The bulk of what has proven, in song, undoubtedly to have been the result of hearing these new sounds came mostly from Negro writers. Carmichael was exceptionally aware for a white man, as was Berlin, but more as an observer than as a participant.

No, it would take the thirties to provide the true meeting and blending between the new-sound makers and the song writers. However, that is not to say that good and, on occasion, even beautiful songs were not written during the twenties, merely that the strange qualities of American-ness were still often wanting.

II

1930–1940

The thirties was a time of deep depression, both national and personal, and of high hopes. Each of these opposite states was reflected in the popular song.

I must once more make clear that the songs I don't mention are absent for one of two reasons: either I don't consider them good enough, or whatever innovative features they possess have been as well, or better, exhibited in other songs. I dislike passing by songs I have liked through the years, but limited space imposes very severe discrimination in choosing songs to be discussed.

The first 1930 song I find to talk about turns out to be *Fine And Dandy*, with music by Kay Swift. It was the title song of a Broadway show, and it not only was a theater song, but it *sounded* like one. Kay Swift's 1929 song, *Can't We Be Friends?*, was an interpolated song that, for me, had no theatrical flavor. This one most certainly does. Its rhythmic device is the strong syncopated fourth beat occurring throughout.

Usually theatrical songs are of wider range than pop songs. But *Fine And Dandy* manages very well to state its case within the confines of an octave.

Fine And Dandy

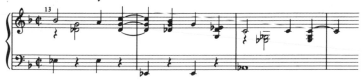

I must mention, if only in passing, a sweet little 1930 song by Harry Barris called *It Must Be True*, which he wrote originally as a counter-melody to another song. It's in the soft-shoe category, only sixteen measures and up to nothing but fun and games. Its honesty and camaraderie deserve illustration.

It Must Be True (You Are Mine, All Mine)

For any reader who feels that this breaks my own rule concerning innovation, I can say only that whenever I see a song which seems free of strict commercialism, and has the quality of having been fun to write as opposed to having been ground out, I am impelled to mention it.

Them There Eyes, by Maceo Pinkard, William Tracy, and Doris Tauber, is another swinging song in which I see Pinkard's as the principal influence. There are treacherous moments in the melody when you're sure it's going to slide into cliché. But it always just evades it. For example, take the cadential phrase at the end of the first half.* It's the octave drop in the fifteenth measure and the *c* sharp in the sixteenth that save it. And though it's on the thin edge of hokiness, I like the riffish quality of measures twenty-seven and twenty-eight.* This is another jazz musician's favorite.

When It's Sleepy Time Down South (1931) is by Leon and Otis Rene and Clarence Muse. Except for the fact that its main strain starts in F major, though in the key of C, and that its release is in E major, it's a fairly routine song. But these exceptional features constitute chance-taking and are therefore innovative.

Also, under ordinary circumstances the second and equivalent measures would have used an F-minor chord. Here a B-flat-dominant ninth is used, and since the melody note is an *e* natural, that adds a flatted fifth to the chord.

Sweet And Lovely (1931), by Gus Arnheim, Harry Tobias, and Jules Lemare, impressed me mightily when it first appeared, due, I'm certain, to its unusual harmony. Actually, its four-measure concentration on C-dominant seventh and its suspension should have irritated me somewhat. But looking at it after all these years I don't know what else the writers could have done—insofar as they wanted such a beginning and they also wanted the F-dominant seventh in the fifth bar as well.

What is particularly unusual is the B-flat major chord in the sixth measure, moving arbitrarily on in the seventh measure to a G-dominant chord.

Sweet And Lovely

The release is even more innovative. Here the song moves way out from its key center and very deftly back.

Just Friends (1931), music by John Klenner, though a not-better-than-average cut-time ballad, is saved, for me, more by the lyricism of measure thirteen than by the unusual *e* flat and *d* flat in measures three and seven respectively, despite the fact that the character of the melody lies in those two notes.

I am pleased also by the harmony used in the first measure, C-major seventh (in the key of G major).

Just Friends

And here is the passage that includes measure thirteen.

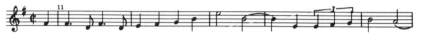

Penthouse Serenade (1931), by Will Jason and Val Burton, is a unique song. While it does nothing specifically innovative, it nevertheless has a character all its own.

First off, it's a great example of step-wise writing, particularly in the beginning and in the last half of the release. Its harmonic use of a dissonance in the second and equivalent measures is very musical and full of suspense, tender though the over-all song may be. And the repetition of the fourth measure is remarkably tender and by no means monotonous. Also the octave jump in measure seven is most effective and affective.

The quarter note triplet is the chief characteristic of the song. Below are the first eight measures and the last half of the release.

Penthouse Serenade (When We're Alone)

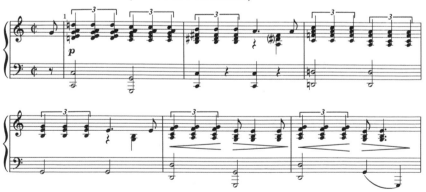

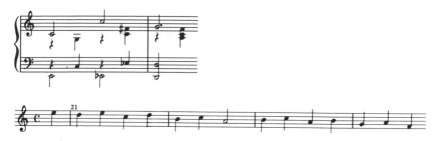

It is one of the most gentle songs I know.

You're Blasé (1931), music by Ord Hamilton, an Englishman, is from an English show, "Bow Bells." So it doesn't belong here, doubly. However, it is such a product of its time and written so like a good American pop song that I have included it. Such lyric lines as "You're deep just like a chasm, you've no enthusiasm" could only have come out of that era.

It does sing pretty much by itself, but it's a song that begs for its accompanying harmony. Its break away from convention occurs in the release, which is, remarkably, only four measures.

You're Blasé

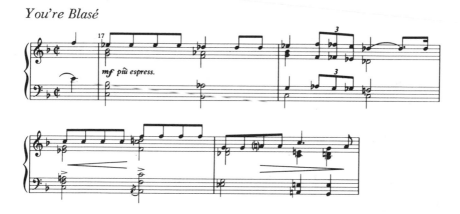

I'm very pleased by the triplet in measure eighteen.

A lovely little song, verse and chorus, interpolated in "The Third Little Show" (1931), was *You Forgot Your Gloves*, music by Ned Lehak. The verse immediately ingratiates.

You Forgot Your Gloves

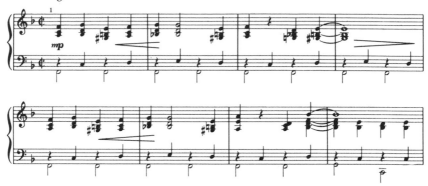

And here is the main strain of the chorus. Who could ask for a more
engagingly graceful line?

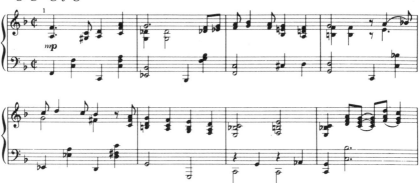

Or the release.

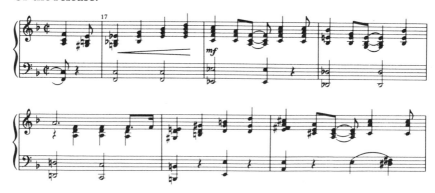

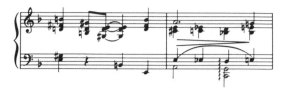

I used to think its obscurity was due to its complexity. But after having looked at songs as complex as *Body And Soul, Here's That Rainy Day*, and *Star Dust*, I realize that there must have been another reason. And the lyric is good, so that's not the reason either. Fate, I suppose.

When Your Lover Has Gone (1931), sung in the film "Blonde Crazy," music by E. A. Swan, is not my kind of song, with its incipient melodrama (and the piano copy's dramatic format suggests the writer's almost art song attitude), but it does have a few innovative moments.

Retaining the *f* natural on the first beat of measure four and the *b* flat on the first beat of measure eight is unusual.

When Your Lover Has Gone

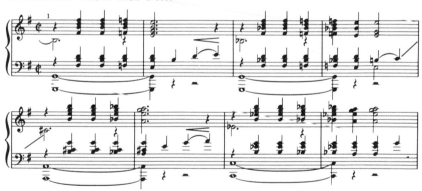

Also the *d* sharp on the first beat of measure twenty-eight. But the self-conscious "blue note" ending embarrasses me.

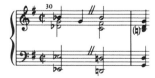

It Was So Beautiful (1932), music by Harry Barris, one might guess to be by him, since it starts with the same three pickup-notes to the same first note, is in the same key, is only sixteen measures, and suggests the soft shoe, as does his other song *It Must Be True*.

It's notey. But that's part of its charm. And played or sung not too fast, it's a very sweet song. The release is most unusual, being a series of octave drops which ascend chromatically each measure. Here it is, as well as the last statement:

It Was So Beautiful (And You Were Mine)

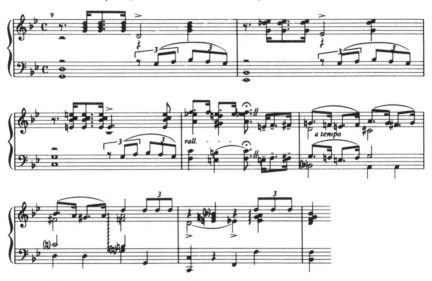

Moon Song, from the 1933 film "Hello, Everybody!," music by Arthur Johnston, is a fascinating study in chromatic writing. From the last measure of the verse on, this style is set up.

Moon Song (That Wasn't Meant For Me)

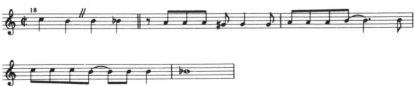

The release is made of two nearly identical phrases, of interest in their variation.

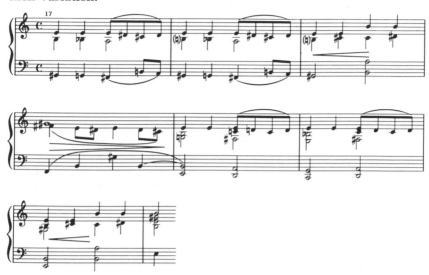

This is one of those late-at-night songs that the piano player doesn't know the title or writer of and you sometimes, unless you're writing a large book about songs, never do find out.

Were Victor Young's name to crop up oftener as the composer of good songs, he'd have to be transferred to the list of great craftsmen. This is not to imply that he wasn't one, but simply to observe that I wasn't aware that he had written more than one or two of the finest pop songs.

A Ghost Of A Chance (1932) is a case in point. It's a very special, extremely tasteful ballad. After nine repeated *g*'s, the melody moves up to a *b* flat and back through *a* natural to *a* flat on the downbeat of measure four. This I find a marvelous, innovative phrase. As well, the very lyric phrase in measure six.

(I Don't Stand) A Ghost Of A Chance (With You)

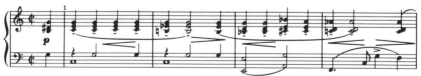

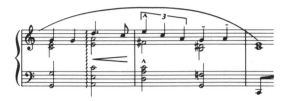

The first four measures of the release I find a little weak, but certainly not the last four.

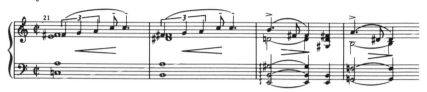

If I Love Again, from the 1933 musical "Hold Your Horses," was composed by Ben Oakland. It is a true triumph of melodic writing, a song of true theatrical quality. It puts Mr. Oakland, not so often heard from, in the front rank of pop writers. (In 1937 he confirmed this status with a fine waltz, *I'll Take Romance,* a film title-song.)

This melody is as good and as strong as Kern, whose absolute control and economy it has. I am sorry only that he ended the song as he did. I would have found a *d* and *e* natural so much more fitting than the *d* flat and *e* flat he employs. Here is the first half of the song, needing, as in Kern's case, no harmony:

If I Love Again

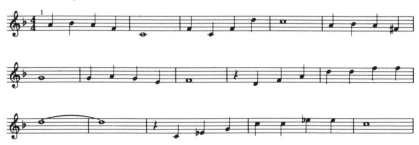

It's a superb melody.

George Bassman, later a Hollywood arranger, wrote the music for

I'm Gettin' Sentimental Over You (1932). It later became Tommy
Dorsey's theme song.

Having for so long associated this music with Dorsey's trombone,
I never bothered to consider it as a song. And, frankly, it isn't one.
It's a very, very good instrumental piece, twenty measures long and
with an unexpected tag. It can be and has been sung many times. But
its melody is instrumental in its disposition of intervals. The first four
measures demonstrate this:

I'm Gettin' Sentimental Over You

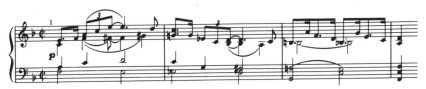

And look at the release:

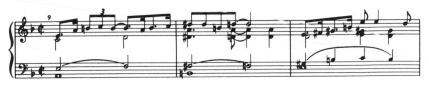

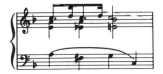

This song, like most of Ellington's, has been heard more times in-
strumentally than vocally. But because they have words, they have
the status of songs. And such "songs" are usually more innovative
than songs. Generically, however, they are instrumental pieces.

Ralph Rainger's *Here Lies Love* (1932), suggests his having dipped
into the realm of concert music. It sounds to me less like a popular
song than a deliberate arty affectation, even though the release

(which reminds me of still another song) does move expertly, if somewhat self-consciously, through F-sharp minor and unconvincingly back to A-dominant seventh in preparation for the D minor with which the restatement begins. I'm thrown off by the pretense.

Willow Weep For Me (1932), words and music by Ann Ronell and dedicated to George Gershwin, is an exceptional song. It's on a par with Carmichael's experiments and was written, I'm sure, far from the maddening crowd of commercial song writers. It's as if the writer didn't need any profit from it. By that I don't mean that it's dilletantish, merely that it does exactly what it pleases.*

For all that the chorus is unique, it strangely ceases to resort to the harmony-conscious devices of the verse. Not until the fifth measure does it bother with harmony. And then the accompaniment moves into double time and out again the next measure. This is one of few examples of a shift in rhythm I've ever seen in a piano part. And it's almost always followed by arrangers of the song.

Another departure is that in all the *A* sections the cadence is on the fifth intervals, never the first.* I've always felt that the *f* natural quarter note at the end of the seventh bar, dropping to a *d* natural, should have words to go with them as they seem an integral part of the melody.

A truly fascinating song.

Nostalgic as is *It's The Talk Of The Town* (1933), music by Jerry Livingston, its melody simply isn't that good. It's simple and makes its point, but I've noticed that, when reminded of it, the average person launches into the lyric, specifically that of the release: "We sent out invitations," etc.

The measures I like best in the song are the fifth and sixth (and their equivalents) and the twenty-third and fourth. Here they are:

It's The Talk Of The Town

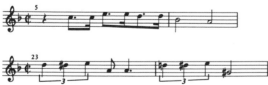

Usually I shy away from the augmented chord created by the melody falling on the minor third of the scale, supported by a dominant chord. But in this case, and only a few others, notably *Under A Blanket Of Blue,* I do find it effective.

A Hundred Years From Today, from "Lew Leslie's Blackbirds, 1933-34," a song by Victor Young, is of only average interest. But I admit to a special fondness for it, due undoubtedly to the definitive recording by Lee Wiley.

It's a pleasant I, VI, II, V bass line song, using well that minor third based on a dominant-seventh chord I shortly ago made mention of, this time in the second half of the fourth and equivalent measures. And it's a typically thirties song, somewhat sad, and why not, when one considers the lyric's implications.

Irving Caesar, best known as a lyric writer for George Gershwin and Vincent Youmans, reveals himself in *If I Forget You* (1933), as capable of writing a very good, long-line melody. The melodic line continues uninterruptedly for half the length of the song, which can be said for few melodies. This half happens to be twenty instead of the more conventional sixteen measures.

It makes very good use of repeated notes insofar as they, by repeating, increase the intensity of the melody and enhance the following phrase.

If I Forget You

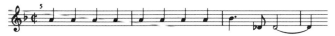

It also unexpectedly employs a one-measure cadence at the end.

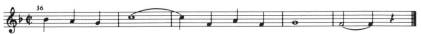

I believe this ending would have been more relaxed for the singer had two more measures of fill-in accompaniment been added to the piano part.

Under A Blanket Of Blue is another 1933 song by Jerry Livingston. It's one of those songs an essential characteristic of which is the minor third (or raised second), *f* sharp based on a B-flat-dominant-seventh chord. And here is another case in which, over the years, a note has been changed. In the sixth and equivalent measures the first note, *g* natural, is now and has for some time been sung *b* flat. And I prefer it. Like *A Hundred Years From Today*, this song is not great, of no special virtue, but evocative, safely sad, and oh, so young!

Blue Prelude (1933), was composed by Joe Bishop, Isham Jones's tuba player. It may have originally been written as an instrumental piece: even so, it makes an interesting, if somewhat gloomy song. It has a double-length release of sixteen measures, but outside of that oddity makes no great bid for innovation. The song is in D minor and very effectively uses the flatted fifth, *a* flat, in its *A*-section cadences and further uses the *a* flat in the release almost as a capper to the *a* flat used before.

Close Your Eyes (1933), by Bernice Petkere, is an essentially dark song except for the major cadence at the end of the second section. And so it is slightly incongruous to read an ungloomy, rather lullabyish lyric along with it. Even in the release, which is a development of the main idea, the lyrical phrase "love's holiday" is set by a minor (key) musical phrase. And when the words say next, "and love will be our guide," the music continues to remain dark. This curious juxtaposition may have to do with the thirties' love of safe gloom in a melody, which comes off as a kind of shopgirl Shakespeare. I guess my antipathy arises from a sense of the song's self-consciousness, well written musically though it may be.

When A Woman Loves A Man (1934), with music by Bernard Hanighen and Gordon Jenkins, is another of those somewhat notey rhythm ballads like *A Hundred Years From Today* and *Under A Blanket Of Blue*. They're all better than average, but let me describe them this way: one would have a hard time picking their releases out of the air and one feels as if all the releases are interchangeable.

Blame It On My Youth (1934), one of two well-known melodies by Oscar Levant, is the better of the two by far. The other is *Lady, Play Your Mandolin*. The first four measures reveal the true melodic flair the whole melody has.

Blame It On My Youth

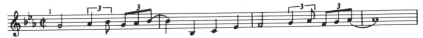

I am, I admit, puzzled how Levant, after such sinuous writing, could allow such a measure as fifteen to slip by him.

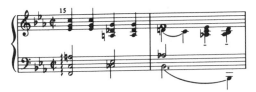

And I feel the same way about the final phrase.

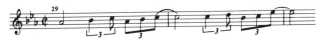

Why the *b* flat in twenty-nine? Why not, in that 1st triplet, *c, d,* and *e* flat? Is the *b* flat there in order to keep a stricter imitation with the previous measure? The song is so finely fashioned that any phrase less polished than the rest stands out that much more.

My Old Flame (1934), from the film "Belle Of The 'Nineties," by Arthur Johnston and Sam Coslow, beautifully uses a device which many songs have used down the years, that of dropping down to a note not in the scale of the key in which the song is written. I won't stop here to recall others, but there are dozens. In this song, the device is employed twice, as follows:

My Old Flame

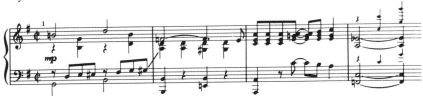

Then, as a marvelous contrast to the opening measures, the melody goes into a small dance for itself:

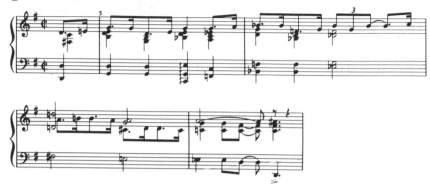

moving into the key of B flat quite unexpectedly. The whole release, again returning to B flat for a moment, is a particular prize.

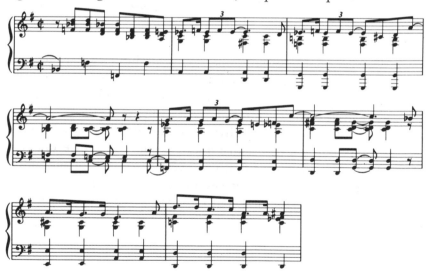

A very fine song!

Brooks Bowman, a Princeton student, wrote the score for "Stags At Bay" (1934), a college production. From it emerged a big commer-

cial hit which became a long-term standard song. It is *East Of The Sun.**

It is a very good ballad, the chief characteristic of which is the quarter-note triplet. Incidentally, it's another of those songs, like *On The Alamo,* in which you can anticipate the harmony of the second phrase. And it's one more song in which singers have changed a note. In the sixteenth measure I have heard the second quarter only as a *b* flat, never as it is written, a *b* natural.

East Of The Sun (And West Of The Moon)

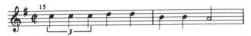

The drop from *c* to *e* flat, whole notes of the seventh and eighth measures, is very endearing.

Another changed note in measure thirty is the first of the two quarter notes. Singers always use *a* sharp instead of *b* natural.

Here are the first eight measures in case you've forgotten the song.

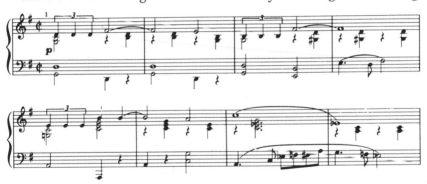

Moonglow (1934), is by Will Hudson, Eddie De Lange, and the omnipresent Irving Mills. I first heard it frequently in an Ellington instrumental before 1934. Then, much later, it was juxtaposed with the theme song from "Picnic." Frankly, I like it best as an instrumental.

In *Stars Fell On Alabama,* music by Frank Perkins, I find the release much more interesting musically than the imitative chromatic phrases of the main strain.

Stars Fell On Alabama

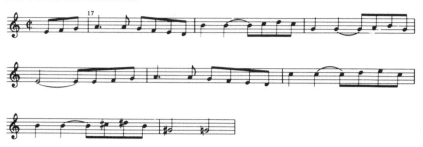

What A Diff'rence A Day Made, music by Maria Grever, was re-
corded long after its 1934 publication, with enormous success, by
Dinah Washington. I very much like the first seven measures and,
I'm sorry to say, nothing more.

What A Diff'rence A Day Made

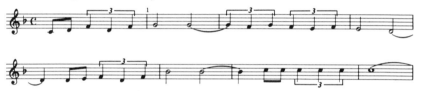

The Continental (1934), music by Con Conrad, I find eminently
satisfying. It is from the film "The Gay Divorcee." Right off the bat
I'm hooked by the accompanimental half note chromatic ostinato. It's
by no means just a song. After two widely separated single phrases,
it sets out on its trip. After the first swinging idea has been stated
twice in eight-measure phrases, it goes into a *B* section of an entirely
contrasted, minimally-noted, character and then repeats the *A* section.

I suppose you could say that this is the song proper. Except that
there is no first or second ending, implying that it continues to move
ahead. And this, perhaps, may also be called a song, since it is made
of *A-A¹-B* and a long extended version of *A*. Then returns the half
note chromatic ostinato (or vamp), the widely repeated phrase of the
beginning is repeated, but this time in a more swinging notation, and
it's over.

It is too extended a song to reproduce here in its entirety, yet no

single part of it can convey its remarkable character. It's like *Waltz In Swingtime*, but with words.

If I Should Lose You (1935), from the film "Rose Of The Rancho", by Leo Robin and Ralph Rainger, is a serious ballad, as the title suggests. It's a very good song, bordering at times on the pretentious but escaping miraculously.

Its harmonic direction is interesting in that it starts on G minor, moves to E-flat major, to B-flat major (the parent key), to G minor, and then makes its first big cadence in F-dominant seventh. The second half does pretty much the same except that it, disappointingly, for me, ends in B-flat major, even with the closing lyric phrase "if I lost you." But this song may be another illustration of safe gloom.

I have the same problem with *You're A Heavenly Thing*, (1935), by Joe Young and Little Jack Little, as I did with *Stars Fell On Alabama*. I like the release better than the main strain. So here's the release.

You're A Heavenly Thing

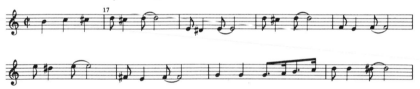

There, in measures twenty-three and twenty-four, is one of those old-fashioned "breaks."

Benny Goodman's closing theme song was a song by Gordon Jenkins called *Good-Bye*. It was published in 1935, and may I say that it's as welcome as *The Continental*, but in a much different way. *The Continental* bubbles and froths and dances its head off. *Good-bye* is as sad a song as I know. And beautifully as Goodman played it, it holds up marvelously right here in the song copy, though I admit I must hum Jenkins' afterthought phrases which became so integral a part of the Goodman arrangement, but which here are reduced to an accompanimental figure.

Here is most of the twelve-measure main strain, which repeats only at the end:

Good-Bye

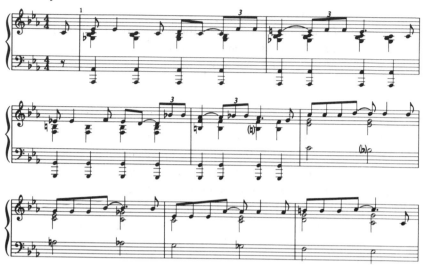

That cadence in C major is a treasure. And here's the release:

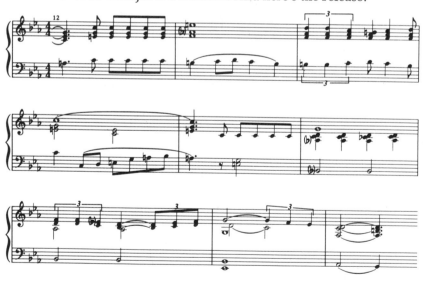

Note how the second statement takes on the quality of a lonely echo of the first. This is a very beautiful song.

I must mention *The Dixieland Band* (1935), music by Bernie Hanighen and lyric by John Mercer. It is, in all honesty, not a true song. It's a marvelous instrumental to which wonderful words were added. But that's not quite the case either. Because the story here is of a second cornet player in a Dixieland group who insists upon playing sweetly, which is against all Dixieland principles. So, as Mr. Mercer says, one night he hit a note that wasn't in the chord, and "apoplexy got him and he went to the Lord."

Well, Hanighen obviously had to adjust the music to this musician's heresy. And he did such a splendid job that I find myself singing all the wordless places in the piano part because they're so fine.

Helen Ward, with Benny Goodman, made the definitive recording of this song. She also recorded the definitive performance of *Restless*, a song which has haunted me ever since I heard her sing it with the Goodman band.

It was published in 1935, with words and music credited to Sam Coslow and Tom Satterfield. Since the latter was a well-known piano player, it is likely that the music is his. And since I have never seen his name on another song, he may have been a one-shot writer. It's much too good to be as little known as it is. However, its obscurity is understandable insofar as it's murderously difficult to sing.

I take instant issue with the spelling of the notes at the beginning of the verse, simply because, by using sharps in the parent key of E flat, the innocent buyer is scared off.

Restless

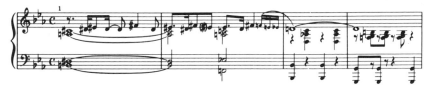

None of it's simple; all of it's good. The chorus has the deterrent of a very wide range, an octave and a minor sixth. This would be asking a lot of even a theater song.

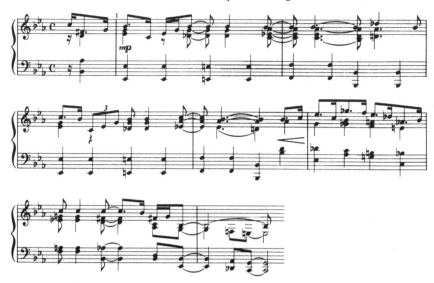

And as for the release, well, take a look!

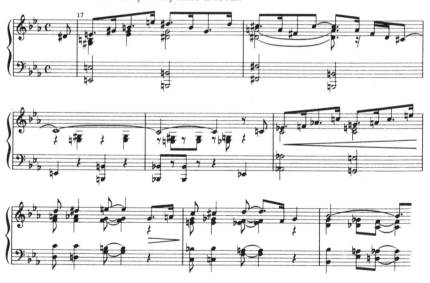

It's great! But is it a song? I must believe so, having heard Miss Ward sing it. But, as is often the case with songs by piano players, this one bears the mark of the instrumental mind. It nevertheless deserves a fate kinder than obscurity.

*Until The Real Thing Comes Along** (1936) was by Mann Holiner, Alberta Nichols, Sammy Cahn, Saul Chaplin, and L. E. Freeman. Now who do you suppose wrote the tune? My money is on that poor innocent little Miss Nichols. Actually, it's a potpourri of all that kind of song and doesn't take on much character until the release.

(It Will Have To Do) Until The Real Thing Comes Along

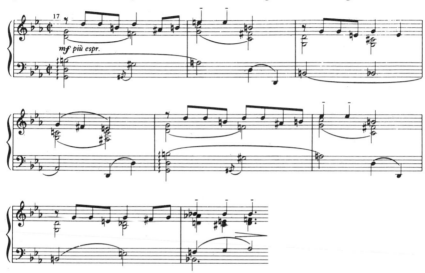

You Turned The Tables On Me† (1936), music by Louis Alter, had the great virtue of not being that eternal *A-A-B-A* form, and of swinging. It was introduced in the film "Sing, Baby, Sing." Its form is *A-B-A¹-C*. And what a relief! The very opening pick-up phrase swings.

You Turned The Tables On Me

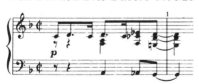

Take the *B* section for an example of moving right.

Once more here is a song which singers or players or both have changed through the years. One change is minor, in measure eleven. The second-to-last *e* natural has turned into a *g*. A larger change is in measure twenty-seven. But first, the last section:

And here is what measure twenty-seven became:

The change, I think, is the better of the two. Incidentally, if ever a song was not in cut time, as the time signature reads, it is this one!

In 1937 came a very unusual and experimental ballad, *There's A Lull In My Life*, by Mack Gordon and Harry Revel. (Obviously, or almost so, one of these men wrote the words and one the music. For contractual reasons usually, the credit for both is listed simply as "by." Only rarely have both writers worked on both music and lyric.) It was "featured" in a film, "Wake Up And Live," which may account for its experimental character.

The whole notes interspersed with eighth note scale lines, that is, after the spectacular second-measure phrase, returning each time to the low *d*, makes me very happy.

There's A Lull In My Life

And the release is extraordinary, even with the twelve *c*'s in the middle measure.

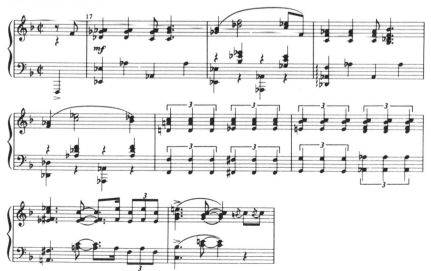

The Gypsy In My Soul, with music by Clay Boland, though copyrighted in 1937, still swings. It's a truly marvelous tune with the, as far as I know, unprecedented form of *A-A-B-A-C-A*. In simpler terms, it has two releases, wholly unlike and one as good as the other. Mildred Bailey's recording of it was definitive, as were her recordings of many other songs she graced with her talent.

Bob White (1937), music by Bernie Hanighen and lyric by John Mercer, is another but different kind of swinging song. Just let me show you the extended last section of this free and easy, happy-go-lucky song:

Bob White (Whatcha Gonna Swing Tonight?)

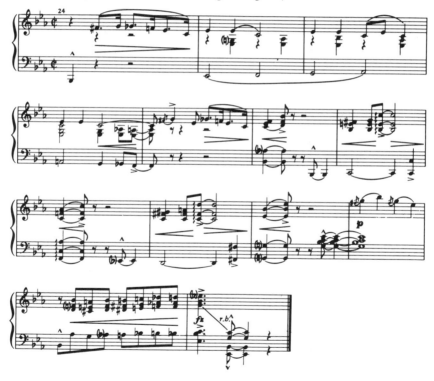

"*Gone With The Wind*" was written because of the release of the film of that name. The music was by Allie Wrubel, who never wrote

a song nearly like it, any more than J. Fred Coots ever wrote another song like *You Go To My Head.*

These exceptional songs from competent but unexceptional writers fascinate and plague me. For if they could write one sensitive, inventive, exceptional song, why not more? Cynicism? No faith in the buying public? But how can one be cynical about public taste after the exceptional song has made money? In my bafflement I cast about for the solution to this phenomenon, but I can't find it.

If you wrote songs, and were to examine the first eight measures of this song, or the last seven measures,* you'd be envious. This is superb writing, on a par with the best theater writers and yet still in the pop song genre. Not that it's a shade less good than a show tune nor that it lacks intensity or a dramatic quality. It simply isn't theatrical. Nor need it be.

That Old Feeling (1937), by Lew Brown and Sammy Fain, is better than average, probably due to the whole notes *d* flat in measure three and *c* flat in measure seven. Also, the closing measures are quite lyrical. But the second section with its stiffness, due to repeated notes, is disappointing. With all the possibilities which one has in order to write a closing phrase, why pick one as pedestrian as the ending in this song? After all, the writers have just written a very warm and loving last section, so why measure thirty-one?

That Old Feeling

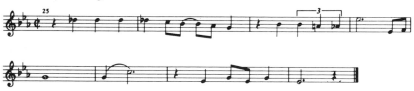

You Leave Me Breathless (1938), from the film "Cocoanut Grove," with music by Frederick Hollander, is my idea of an adult, civilized, open, musical pop song. There's no faking or stalling or "getting by" with it. Right away your attention and affection are involved with the major seventh fall from *c* to low *d* flat. And then you're convinced when the melody resolves the *d* flat by means of the fall from *a* to *c* natural.

Also you may note that the upper line of the melody moves stepwise from *c* to *f*. Not content with pleasing you, Hollander throws in a dividend by moving, in the next phrase, down to *b* natural, and then proceeds to resolve that by moving through *d* to *c* natural. Then, instead of moving up to high *c*, as most writers would have, he goes to high *d*, thereby saving the *c*'s for the quarter note pick-ups. All of this, may I snobbishly attest, is *music*.

He provides an extra dividend in the release. But first, here are the first eight measures.

You Leave Me Breathless

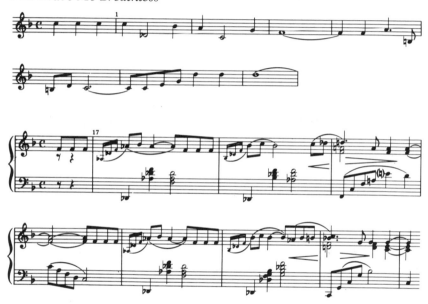

I'm well aware that Mitchell Parish must have had a difficult time in 1937 finding words for Edgar Sampson's instrumental piece, *Don't Be That Way*. It's very obviously an instrumental line, but it *is* singable, difficult as it may be. It's so enormously evocative and innocent that I'm glad it was made available in sheet music. Most of those buying it won't be able to sing it, but the tune is in the piano part and at least they'll have the pleasure of playing it, while I go on stubbornly trying to sing it.

Don't Be That Way

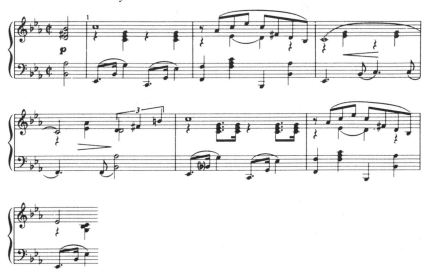

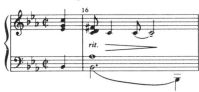

And how nice of it to have a sixth interval to start and end the first phrase!

The phrase I like best in *I'll Be Seeing You,* a song from the 1938 show "Right This Way," music by Sammy Fain, is the sixteenth measure (with its pick-up note).

I'll Be Seeing You

I'm sorry to seem so unfeeling, but the music has never reached me. It seems boneless and insipid and written as if at an organ with the Vox Humana stop out. I simply don't believe that the experience of writing it was one of deep involvement.

You Go To My Head (1938), with music by J. Fred Coots, I spoke

of a moment ago as being a phenomenon. It's as affecting a song as
"*Gone With The Wind*," though of a groovier nature, and not so
pure.

Here is the first section:

You Go To My Head

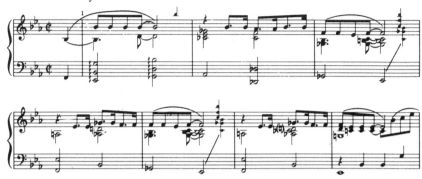

And the release:

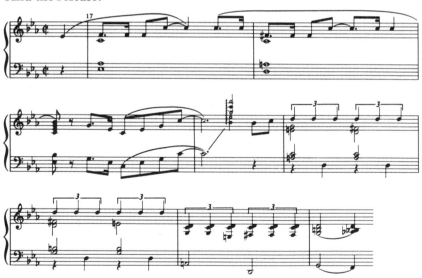

Notice that the nineteenth and twentieth measures are so strong that they need no harmony, though small notes have been added in a chord, timorously.

There are nineteen, count them, *d* naturals! And I, with my distaste for repeated notes, love every one of these, especially when they unexpectedly drop an octave for the last seven.

The last section contains eighteen as opposed to the conventional eight measures. And if space allowed, I'd show you more wonders. The song is a minor masterpiece. And it's still a pop song, not a theater song.

In 1939, James Monaco, one of the older writers, wrote a song for the film "East Side Of Heaven" and, incidentally, Bing Crosby, called *That Sly Old Gentleman.* It's not very well known and definitely should be.

He uses a device which I've seen only once in pop music, a song by one of the great craftsmen which I'm sorry I can't recall. It's that of moving from *d* to *d* sharp to *f* sharp and then back to *e*, in this case. In the other song the writer stays on the *f* sharp.

The second eight measures, or *B* section, is particularly sweet and unconventional.

That Sly Old Gentleman (From Featherbed Lane)

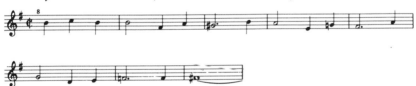

Unconventional also is the closing section in which you may see the restatement of the beginning.

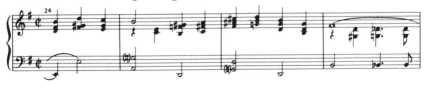

* By Johnny Burke and James V. Monaco. Copyright 1939 by Santly-Joy-Select, Inc. Copyright renewed 1966 and assigned to Anne-Rachel Music Corporation. Used by permission.

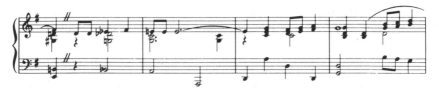

Sam Coslow wrote *(I'm In Love With) The Honorable Mr. So And So* for "Society Lawyer" (film: 1939). His words and music were definitively recorded by Jeri Southern some years ago. So gracefully and lovingly did she perform it, and out of rhythm, if I'm not mistaken, that I was unaware of the preponderance of repeated notes in it. Nor was I aware that it was so long, fifty-two measures. In spite of the repeated notes, the song has many unusual and lovely melodic moments, but I fear it is one which needs to be examined in its entirety in order to catch its special flavor.

In 1939 Al Dubin put words to a Victor Herbert piano melody and called it *Indian Summer*. Never having been a Herbert fan, finding his music too Viennese and alien to my environment, I first heard this song with a sense of great shock. For it's unlike anything of his I've ever heard, and bears no European mark on it.

It's a thirty-two measure song with the form of *A-B-A-C*. The melody sings marvelously throughout without a single cliché or let down. It's another song which needs total examination. Let me remind you of the first measures, though I'm sure you know them:

Indian Summer

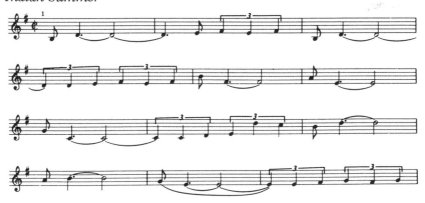

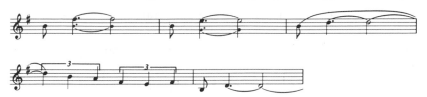

Bob Haggart, who once whistled a great tune of his own called *Big Noise From Winnetka* on a record, also wrote, in 1939, a great, marvelously sentimental and groovy ballad called *What's New?*, originally composed as a trumpet solo for Billy Butterfield. Johnny Burke wrote the song's wonderfully conversational lyrics.

Here is the first section:

What's New?

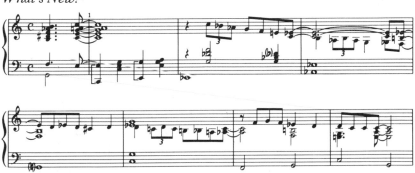

In the release Haggart, with great élan, simply moves the same melody up a fourth into F major and, in a space of a single measure, makes his way back to C major.

The insouciance of the knowledgeable jazz musician is irresistible.

Well, as far as I'm concerned, that's the thirties. And as you can see, the songs are much more inventive and interesting than those of the twenties. The pop song has definitely grown up.

Unfortunately, some of the biggest hits of the thirties I find dreary and pedestrian. Some that I dislike I've mentioned, and many I have simply ignored, even though I'm well aware that they are favorites. I must defend myself once again on the grounds that this is a subjective study, and I am interested, at this late date, in quality, not popularity.

At the beginning of this section I mentioned the depression as well as the hopes of the thirties. But it looks as if the depressive songs I've mentioned here have had to do only with the normal manic-depressive rise and fall of love with its seemingly inevitable frustrations and losses.

III
1940–1950

The songs of the early forties didn't shift to war themes to the extent popular songs had during World War I. The innocence, the slogans, the idealism had vanished. An *Over There* would have been jeered at this trip. It was no longer possible to sentimentalize any aspect of war. People knew too much. There was too much cynicism among the young. The big impersonal war machine had taken over and everyone knew it.

It is interesting that this growing refusal to be fooled had its effect in the song world in the two following wars. For songs about the Korean War were simply not written, and the lack of songs for the Vietnam War has its own awesome eloquence. No one would play or sing them, and the writers and publishers knew it. There will be no mention in this study of the World War II songs.

In 1940, there was a song called *How High The Moon*, from "Two For The Show," a Broadway revue. Morgan Lewis wrote the music, and it became virtually the "bop" hymn. For years it was the most played tune in jazz, its chord progressions supplying the harmonic basis for a number of "new" bop tunes. Upon examination of the

song's harmonic sequences, one can see why. They were highly unusual, and they changed just often enough to please an improvising player.

It's basically a very simple song, but for the pick-up notes in the fourth measure. Here are thirteen measures of the song to show you how it moves out of its parent key and back. That's how long it takes.

How High The Moon

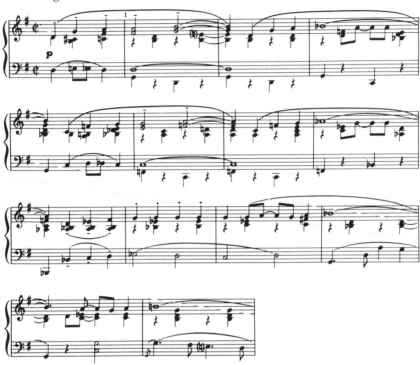

As you can see, the sequence is quite logical: G major, G minor, C-dominant seventh, F major, F minor, B-flat-dominant seventh, E-flat major, C minor, D-dominant seventh, G minor, C-minor sixth, and, at long last, G major. It's quite a routine, and meat to the improviser.

Easy Street, in 1941, by Alan Rankin Jones, happens to be one of my favorites. I have never known of another song by Mr. Jones. It seems a shame, considering the virtues of *Easy Street*.

It's of conventional length and form, *A-A-B-A*. Its special virtue is that it's a slow swinging, rocking (as opposed to "rock") melody, eminently singable and with good words. It's a song with a lyric written in the Mercer manner. Here's a sample of it:

Easy Street

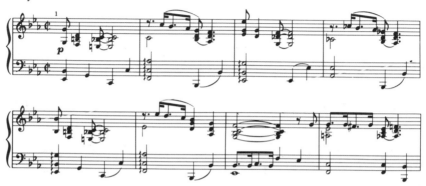

And here's the release:

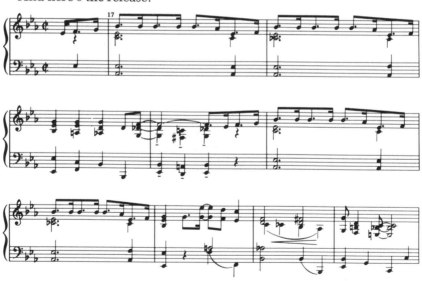

Notice how his main strain never uses repeated notes, probably avoiding even one in view of the great number in the release. I'd love to

hear a Basie recording of this song played and arranged like his record of Neil Hefti's *L'il Darlin'*. I'd wear it out.

Lover Man (1941), by Jimmy David, Roger Ramirez, and Jimmy Serman, was associated with Billie Holliday. And her performance was superlative. One would expect only an echo in the sheet music. Nevertheless, the song is all there. It's a song of narrow range and needs the harmony to bring out its character. It's a slow swinging song with a curious reminiscence of Gershwin's *Fascinating Rhythm,* if the latter is played at a very slow tempo.

When Frank Sinatra recorded *Angel Eyes,* by Matt Dennis, he used a new device in which he started not at the beginning of the chorus, but at the beginning of the release where the lyric says, "Drink up, all you lucky people." It was most effective, and Sinatra's unusual performance served to remind us that Dennis was an unusual song writer. He was, in fact, much more than a composer. He was a pianist, a singer, and I first began to hear about him when Tommy Dorsey hired him as an arranger-composer, an assignment I have never heard of again, except for Billy Strayhorn's work with Duke Ellington.

I have in front of me four songs, all published in 1941, for which Dennis wrote the music and Tom Adair the lyrics. They're very attractive songs, and they're all, lyrically, very literate. The first of them, *Everything Happens To Me,* is, I feel, more to be admired for its lyric than its melody. The lyric is extremely charming, but the melody, while well written, is simply too notey to be considered as anything more than a framework for the lyric.

The second of them, *Will You Still Be Mine?,* is much more spare melodically. It's gentle and unpretentious.

Will You Still Be Mine?

That's the opening phrase, and while it does become less bland as it progresses, there's nothing specific to be said of it analytically.

The next of them, *The Night We Called It A Day,* is a more ambitious song harmonically. But I am thrown off by the repeated

notes, which in this case are not so much aggressive as they are de-
terrents to more melodic motion. The song is a ballad, after all, and
one looks for sinuosity in such a song. Repeated notes have a way
of creating lines and angles. When the curves come in this song, it is
too late.

Although he may not rank among the great craftsmen, Dennis
came to be known as a kind of insider's song writer. He most cer-
tainly wasn't part of the hard core of commercial writers. *Violets
For Your Furs* is the fourth of his songs from 1941 that I want to
discuss, and, for me, it has the best melody among them. It moves
and does lovely, inventive things, as its first four measures reveal:

Violets For Your Furs

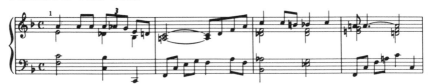

And the verse is a beauty:

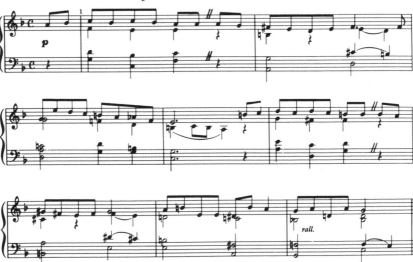

There is a great difference between the quality of a song written by a performer and one written by a non-performer. I believe that one of the reasons John Mercer's lyrics have an added zest, a crackle and shine to them, is that he probably sings them as he writes them. For, after all, he began his career as a singer. Matt Dennis's songs also suggest the presence of the performer in their composition. And Dennis's harmonies are as rich as one would expect from a good pianist.

In *I'm Glad There Is You* (1941), by Paul Madeira and Jimmy Dorsey, though there are some repeated notes, the melody moves sinuously for the most part.

I'm Glad There Is You (In This World Of Ordinary People)

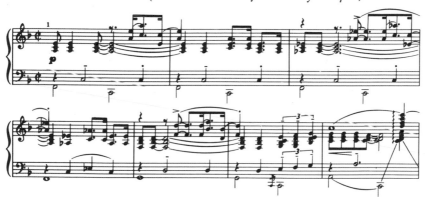

The form is unusual. It's *A-A¹-B-A* (plus tag). The tag is so abrupt the listener might wish for a more graceful way out of the song. In terms of this desired motion, take the *B* section.

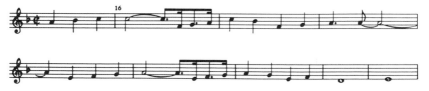

I believe that Mabel Mercer, who believes in good songs and sings them no matter what, was responsible for the revival of this song.

The melody of *I'll Remember April* (1941) is the creation of Gene de Paul. It was introduced in the film "Ride 'Em Cowboy." It's an unusual and "haunting" melody. Its main strain is a model of step-wise writing.

I'll Remember April

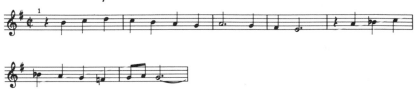

The second section, though it contains repeated notes, does so without losing the melody's motion.

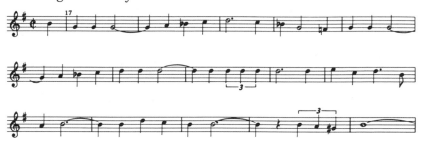

The form is strange, too. It's *A-B-C-D-A-B¹*. And the song is doubly fascinating when one remembers that Gene de Paul was a fairly well established commercial writer. One would have expected such a melody from an unknown, one-song writer. It's clearly a very personal statement.

Joe Bushkin, at one time Tommy Dorsey's piano player and a most entertaining person, wrote the tune of *Oh! Look At Me Now,** also published in 1941. It's as cheery as he is, and it swings. The release was thrown in, I feel, but the main strain is a happy statement.

Oh! Look At Me Now

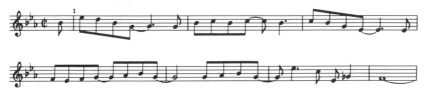

The harmony suffices, but it asks for no illustration.

Another strange and intense song by Gene de Paul that same year was *You Don't Know What Love Is*, from the film "Keep 'Em Flying." This is gloom in the raw, not that fake melodrama the commercial boys turn out. Take the first strain:

You Don't Know What Love Is

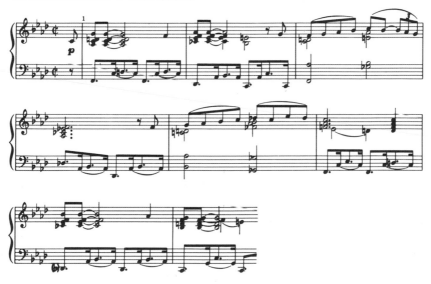

Or the release:

I believe the validity of this melody lies in its believability. It wasn't the result of song writers getting together and deciding that the time was ripe to put a sad song on the market. Mr. de Paul was sad and had to write about it.

In 1942, Fulton McGrath, another piano player, wrote the melody for *Mandy Is Two*, a song in honor of John Mercer's child. Naturally the lyric, by her father, is a gem and so is the gentle, sweetly swinging tune. If a song must have many notes, let them move across the page like this:

Mandy Is Two

The nonsensical title *I Lost My Sugar In Salt Lake City* gave rise to a very native melody by Johnny Lange, introduced in the film "Stormy Weather." Actually it's made of a series of down-home riffs and, even if they're semi-stereotypical, they're fun and they're surely from no place but here.

It's the kind of song I used to hope to find in a roadside-diner juke box back in the days when roaming about the countryside was free and easy, when life hadn't begun to imitate suspense movies, and when a song writer wasn't planning to buy San Simeon with the proceeds from his next tune. In those days there was nothing "relevant" about losing your sugar in Salt Lake City. It was just one of those things. There surely were others in New Orleans, Memphis, or other way-stations about the country.

This song brings me a big sigh of relief—relief, that is, from much of the self-consciousness of the "special" song writers and from the

dollar signs in the eyes of the hacks. It's as honest and relaxed as *There'll Be Some Changes Made.*

I've always been inclined to believe that Frank Loesser, whose theater career fell outside the time limit of this book, never wrote great ballads—great production numbers, great novelties (*Baby, It's Cold Outside*), great comedy songs, but inadequate ballads. Well, as I seem often to have done in this survey, I must prove myself wrong again. For his 1943 song, *Spring Will Be A Little Late This Year,** from the film "Christmas Holiday", is a very lovely, finely-fashioned melody and bears not a trace of the green eyeshade.

The main strain is in the grand style.

Spring Will Be A Little Late This Year

And, without any dramatic whoop-de-doo at the close of this song, he merely restates his simple, sentimental first phrase. Notice the pick-up notes.

Spring Will Be A Little Late This Year

I happen not to be a Kurt Weill fan. I don't swoon at the mention of "The Three Penny Opera," as I'm told I should; I don't weep at the downbeat of *September Song*; and I find *Mack The Knife* no more than one more proof of the appeal of the sixth interval of a scale. Part of my irritation in listening to his music stems from my feeling that there was no personal involvement on his part.

However, *Speak Low*, from "One Touch Of Venus," 1943, is a very good song and one in which I feel that Weill was, indeed, involved. It is a fairly long song of fifty-six measures, *A-A-B-A¹* in form, with

B only of eight measures. Its phrases repeat more often than I care
for, but the melodic line generally is a well-made one and the short
release very fine.

Speak Low

Bud Green, Les Brown, and Ben Homer are credited with having
written *Sentimental Journey* (1944). It's an extremely simple song
of great evocative quality. Frankly, had anyone presented me with a
recurring series of *e*'s and *c*'s for my opinion, I would have tried to
be polite but nothing more. Nevertheless, those *e*'s and *c*'s are what
create the mood. And then the transparently simple chromatic ca-
dence in the fourth measure, plus the variant of *e* flats instead of *e*
naturals.

Sentimental Journey

The sheet music rightly indicates "very slowly." It would be a trav-
esty otherwise.

There's No You (1944), music by Hal Hopper, does some pleasant melodic things but, by this date, when theater music had graduated from rote, even these few melodic variants simply aren't enough to get excited about. The only occasions when a near-cliché is acceptable to me is when it's topped by vital rhythmic drive.

Carl Fischer, Frankie Laine's pianist, and a very dear man to boot, in 1945 wrote the music for a splendid pop ballad, *We'll Be Together Again*. The first eight measures will, I believe, account for my enthusiasm.

We'll Be Together Again

And the release maintains the level of the *A* sections, even using the material of the seventh measure as its basis; it's a rare occurrence.

This song is a great illustration of pop ballad sophistication and its difference in character from a theater ballad. For example, can you imagine Kern or Rodgers or even Gershwin writing such a song? Perhaps Arlen, but no one else. Berlin wrote a somewhat similar song for a show but not with such sophistication.

Moonlight In Vermont (1944), music by Karl Suessdorf, is a very good pop ballad, made of two six- and two eight-measure sections. And the six-measure sections are so natural that the added two in the last section seem at first to be a tag to an eight-measure section. The "hook" of the melody is, I think, to be found in the fourth measure with its odd phrase of two eighth notes and a dotted half on the note *c* flat.

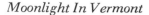

Moonlight In Vermont

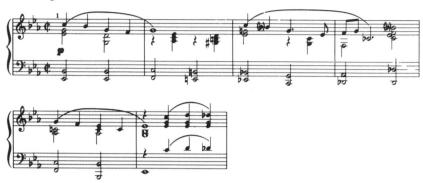

The release is made mostly of repeated notes over shifting har-
mony and, without it, the return to the main strain sounds unnatural.
So this should be considered as a song not wholly, but somewhat, de-
pendent on harmony. Here are the last two measures of the release
so you can judge for yourself:

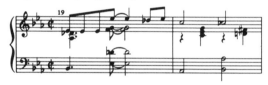

Laura (1945), music by David Raksin, was the theme for a film. I
was present when the publishers played it, before the lyric had been
added. Unanimously it was concluded that so complex a melody
would be highly impractical to publish. But the day they heard it
sung with Mr. Mercer's most distinguished lyric, it was all different.

And it is a very complex, however beautiful, melody. I believe that
had a less lovely and loving lyric been written, the piece, for that's
what it was, would never have budged.

My concentration here, granted, is on the music. But, of course, a
song is more than that. I am reminded that Arlen failed to at-
tract Gershwin's attention with the melody of *Last Night When We
Were Young* until after it had that wonderful Harburg lyric.

I've never asked Raksin if his hope had been to have the theme from the picture turned into a song. If he did, he was a brave man. For it does move about with far more freedom than even most theater ballads.

The song is in C major. It begins on an A-minor-dominant chord and is in G major by measure three, G-minor seventh by measure five, and F-major seventh by measure seven. By measure nine it is in F-minor ninth, and E-flat-major seventh by measure eleven. At this rate the melody has to be far from the norm. And yet it is a big standard song.

I noticed, during the popularity of *Blues In The Night,* that whenever I heard it whistled in the street, I heard no more than the first six-note phrase. That was enough, evidentally. And I doubt if the average person, even after taking lessons, could have whistled much more. Well, perhaps all that was needed in the cast of *Laura* was the opening phrase.

Laura

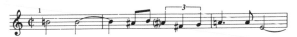

In the song *Tenderly* (1945) the title phrase falters because it causes the stress of the word to fall on the last instead of the first syllable, but, obviously, the melody triumphed. Walter Gross, a marvelous pianist, wrote it, and very few other songs besides.

Not often does a waltz of this kind catch on as *Tenderly* did. Usually it must be something as obvious as *Beautiful Ohio* or *Three O'Clock In The Morning.* Even the odd notes like the *g* flat in measure three and the *c* flat in measure seven were acceptable. The harmony is much less lush than one would expect from a harmony-minded pianist.

I must mention *Baby, Baby All The Time* (1946), with music and lyrics by Bobby Troup. I admit it's really not a song, if only because so many repeated measures, unless performed by a very groovy singer, would become unbearably monotonous. Yet there is some marvelous insanity about Troup's insistence. I try to look away and it's no use.

Here is the opening phrase and its slight variation.

Baby, Baby All The Time

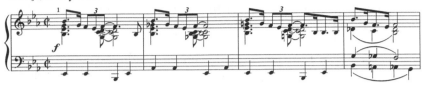

It may be monotonous, but it sure isn't Viennese.

Josef Myrow wrote a simply great rhythm song in 1946 called *You Make Me Feel So Young* for the film "Three Little Girls In Blue." I'll grant you that Sinatra's recording and many performances haven't hurt any, but the song's there, like a rock, Sinatra or no.

As in *The Gypsy In My Soul*, great strength is brought to the fourth interval of the scale. The song has irresistible vitality. It almost says "get out of my way till I finish." It's written with enormous professionalism. In fact it's as great a rhythm song as *Day In— Day Out* is a ballad.

Here are some excerpts. The first is the main strain.

You Make Me Feel So Young

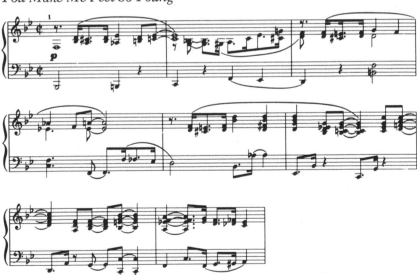

It has one of those "breaks" at the end of the release, where every-one but one player in the band, or the singer, drops out.

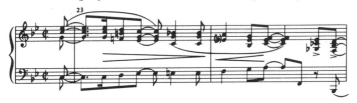

And, in this case, there is a marvelous bass line in contrary motion to the melody.

And here is part of the last section's development. This follows the first four measures.

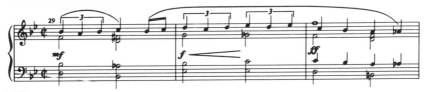

In 1947 Jule Styne wrote what is, for me, his best song, *Time After Time*. It was introduced in the film "It Happened In Brook-lyn." It's a strong, pure, dramatic, uncluttered, un-selfconscious mel-ody. It bespeaks personal involvement and great warmth. I know of no other ballad by Styne equal to it. I'd have been proud to have written it.

I'll assume you recall the first strain. The second is a lovely series of melodic curves.* And the high ending is very effective.*

You Came A Long Way From St. Louis (1948), with music by John Benson Brooks, I find very entertaining musically and certainly lyrically. It goes its relaxed, jazz-oriented, funky way as casually as a stroll down the block. And its notey-ness is balanced by pauses in the right places.

I'm very glad to have heard Ray McKinley sing it, for his perform-ance was definitive. It's as native as the corner diner and lyrically

admonitory in the best of all possible words: "but, baby, you still got a long way to go." It was Bob Russell's lyric.

I mention *Buttons And Bows* (1948), a film song by Livingston and Evans, from "The Paleface," only because it's another of those artfully contrived country songs like *Louisiana Hayride*. And, as is usual in such melodies, the main strain never uses the fourth interval (and uses the seventh for only one eighth note). I'm sure the reason songs like this sound so strong is just because they avoid the fourth.

In 1949, Evelyn Danzig wrote the music for a song associated solely with Harry Belafonte, called *Scarlet Ribbons*. It's not truly a pop song. But it was published by a pop publisher and is not "got up" in an art song copy. It's very simple and very evocative in the manner of a true folk song. The bulk of it is an eight-measure phrase.

Scarlet Ribbons (For Her Hair)

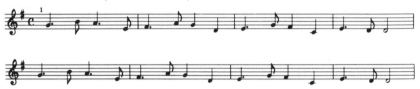

That's All, with words by Alan Brandt and music by Bob Haymes, the singer, bears the copyright date of 1952. It is therefore beyond the time limit set for this book, but I wish to include it for special reasons.

First, it is one of the last free-flowing, native, and natural melodies in the grand pop style. Second, it has had a curious career insofar as it went through no initial hit phase but became an immediate standard. I am somewhat proud to say that I sensed this likelihood the first time I heard the record on which the writer of the music, Bob Haymes, was the singer.

It is verseless and of conventional *A-A¹-B-A* form.* The use of octave jumps in the release should produce monotony, there are so many of them. But, due to the mysteries of creation, they don't.*

It's one of the warmest, most natural, and least "studied" songs I know. May I add that the harmony of the main strain in the pub-

lished copy is not followed in any of the arrangements I have heard. The preference is for I, VI, II, V.

The last song for the forties is a theater song from "Guys And Dolls" (1950) by Frank Loesser. Although, as noted earlier, Loesser's famous Broadway scores fall outside the time span of this study, I feel compelled to round out the three decades covered in this chapter with *More I Cannot Wish You.**

My illustration of this very touching song, a maverick indeed, the more especially so because it came from Mr. Loesser, is a passage toward the end of its seventy-six measures.

More I Cannot Wish You

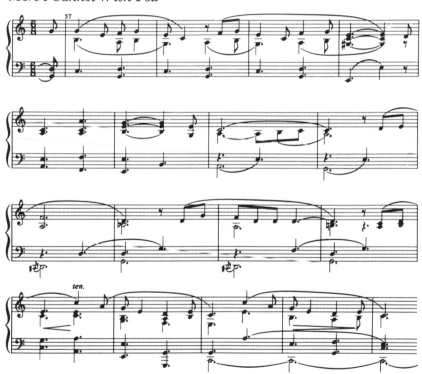

It's a very special song, shining with tenderness, as natural as if it had simply happened. And the lyric, also by Loesser, is most distinguished and truly poetic.

Thus, the end of an era.

* By Frank Loesser. © 1949, 1950 Frank Music Corp. Used by permission.*

Index of Composers

Index of Lyricists

Index of Song Titles

526 *Index of Song Titles*